LINES OF DISCOVERY

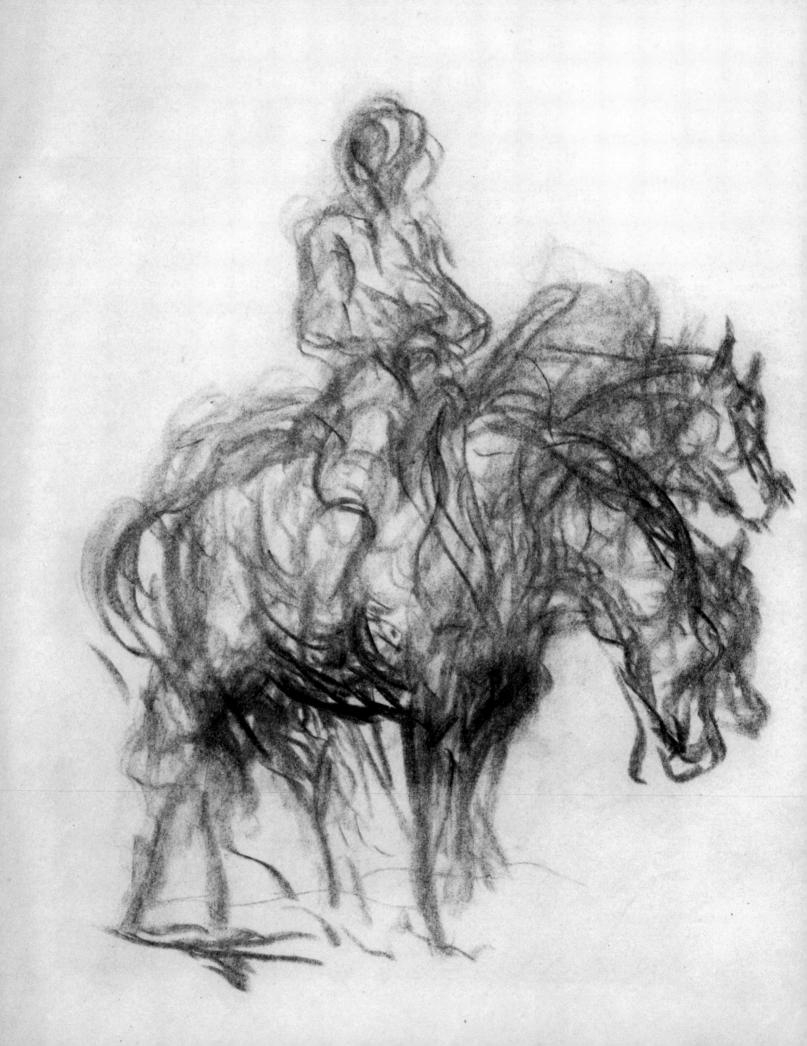

LINES OF DISCOVERY
225 YEARS OF AMERICAN DRAWINGS
THE COLUMBUS MUSEUM

Philip L. Brewer, M.D.
Commentary

Charles T. Butler
General Editor

Theodore E. Stebbins, Jr.
Introduction

Bruce W. Chambers
Marilyn Laufer
Stephen C. Wicks
Principal Essayists

This book is dedicated with great affection to Betty Corn

The Columbus Museum, Columbus, Georgia
in association with D Giles Limited, London

g

Front cover:
Mary Cassatt, 1844–1926
Sara and Her Mother with the Baby (no. 1) ca. 1901 (detail)
Pastel on wove paper
Museum purchase with funds provided by a Friend of the Museum 2005.14

Back cover:
Hananiah Harari, 1912–2000
218 E. 12th Street 1945
Ink, gouache and crayon on wove paper
Promised Gift, Dr. and Mrs. Philip L. Brewer Collection

Frontispiece (Fig. 1):
William Morris Hunt, 1824–1879
Figure on Horse ca. 1855–1860; on verso: *Woman with a Pail*
Lithographic crayon on wove paper
Gift of Dr. and Mrs. Theodore E. Stebbins, Jr. 2004.21.2

Exhibition Tour Schedule:

Gilcrease Museum
Tulsa, Oklahoma
June 17 – August 27, 2006

Kalamazoo Institute of Arts
Kalamazoo, Michigan
September 23 – December 31, 2006

Arkansas Arts Center
Little Rock, Arkansas
January 26 – April 22, 2007

Authors
Philip L. Brewer, M.D. (The Columbus Museum Trustee and Collector)
Charles T. Butler (Director, The Columbus Museum)
Theodore E. Stebbins, Jr., Ph.D. (Curator of American Art, Fogg Museum, Harvard University)

BA - Bruce Altshuler, Ph.D. (Director, Program in Museum Studies, New York University)

JEC - Jay E. Cantor (Director of Research, Mary Cassatt Catalogue Raisonné Project, Adelson Gallery, New York)

BWC - Bruce W. Chambers, Ph.D. (Independent Scholar)

DD - Douglas Dreishpoon, Ph.D. (Senior Curator, Albright-Knox Art Gallery)

RF - Ruth Fine, M.F.A. (Curator of Special Projects in Modern Art, National Gallery of Art, Washington, D.C.)

ARK - Anne R. King, M.A. (Author/Curator, *Walls of Light: The Murals of Walter Anderson*)

AL - Andrew Ladis, Ph.D. (Professor of Art History, University of Georgia)

ML - Marilyn Laufer, Ph.D. (Adjunct Professor of Art History, Auburn University and Adjunct Curator, Georgia Museum of Art)

CL - Constance Lewallen, Ph.D. (Senior Curator for Exhibitions, University Art Museum, Berkeley)

JMM - Joan M. Marter, Ph.D. (Professor of Art History, Rutgers University)

DM - David Meschutt, Ph.D. Candidate, University of Delaware (Consulting Curator, New York State Office of Parks, Recreation, and Historic Preservation)

JM - Joann Moser, Ph.D. (Senior Curator, Smithsonian American Art Museum)

EBN - Emily Ballew Neff, Ph.D. (Curator of American Painting and Sculpture, Museum of Fine Arts, Houston)

LNP - Lisa N. Peters, Ph.D. (Director of Research and Co-author of the John H. Twachtman Catalogue Raisonné, Spanierman Gallery, New York)

SCW - Stephen C. Wicks (Curator of Collections and Exhibitions, The Columbus Museum)

TWolf - Tom Wolf, Ph.D. (Professor of Art History, Bard University)

TWolfe - Townsend Wolfe, M.F.A. (Past Director, Arkansas Art Center, and Independent Curator)

Catalogue Entries
Dimensions of artworks are height before width. Essay authors are identified by their initials.

All measurements are in inches and centimeters; height precedes width precedes depth.

Abbreviations
The following exhibitions and texts are abbreviated for the sake of avoiding repetition:

A Collector's Pursuit of Drawing – *A Collector's Pursuit of Drawing: The Brewer Collection*, The Federal Reserve Board Building, Washington, D.C., January 29, 2001 – April 13, 2001

Intimate Expressions – *Intimate Expressions: Two Centuries of American Drawings*, Georgia Museum of Art, Athens, Georgia, December 6, 1997 – February 1, 1998; The Columbus Museum, Columbus, Georgia, November 16, 1998 – March 1, 1999; Harn Museum of Art, Gainesville, Florida, August 29, 1999 – November 28, 1999; Columbia Museum of Art, Columbia, South Carolina, June 5, 2000 – August 18, 2000

New Drawings – *New Drawings from the Permanent Collection*, The Columbus Museum, Columbus, Georgia, October 29, 1998 – February 21, 1999

Making a Mark – *Making a Mark: Drawings, Pastels and Watercolors from the Permanent Collection*, The Columbus Museum, Columbus, Georgia, July 13 – October 12, 1997; gallery brochure

People, Places, Animals – *People, Places and Animals: American Traditions in the Graphic Arts, Works on Paper from the Permanent Collection*, The Columbus Museum, Columbus, Georgia, December 14, 1993 – April 3, 1994

A Select View – *A Select View: American Paintings from The Columbus Museum*, Knoxville Museum of Art, Knoxville, Tennessee, September 4 – October 18, 1987; Madison-Morgan Cultural Center, Madison, Georgia, December 20, 1987 – March 29, 1988; Pine Art Center and Arboretum, Oshkosh, Wisconsin, June 19 – July 31, 1988; R. W. Morton Art Gallery, Shreveport, Louisiana, August 28 – October 9, 1988; Louisiana Arts and Science Center, Baton Rouge, Louisiana, October 23 – December 4, 1988; Brevard Art Center and Museum, Melbourne, Florida, December 18, 1988 – January 29, 1989; The Columbus Museum, Columbus, Georgia, April 16 – October 15, 1989

Building on a Legacy – William W. Winn, Karol P. Lawson, Frank Schnell, and Charles T. Butler, *Building on a Legacy: The Columbus Museum* (Columbus, Georgia: Columbus Museum, 1996)

Celebration – *Celebration of Creativity: Three Centuries of American Masterworks on Paper*, The Columbus Museum, Columbus, Georgia, May 11, 2003 – August 31, 2003

Building on Strength – *Recently Acquired Drawings: Building on Strength*, The Columbus Museum, April 9 – August 1, 2004

TABLE OF CONTENTS

FOREWORD AND ACKNOWLEDGMENTS: AMERICAN DRAWINGS IN THE COLUMBUS MUSEUM

CHARLES T. BUTLER, DIRECTOR

Paul Klee said, "A line is a dot that went for a walk," while Saul Steinberg confessed, "I am among the few who continue to draw after childhood is ended, continuing and perfecting childhood drawing—without the traditional interruption of academic training." I still remember the comment made by one of my art history professors years ago about a great French artist who once declared to a young student that a competent draftsman ought to be able to draw with certainty a man falling from an open second story window before he hit the ground.

I have a series of indelible museum memories: Michelangelo's drawings at the Art Institute of Chicago from the 1987 exhibition of Italian master draftsmen from the British Royal Collection; the major cartoon by Leonardo of *The Virgin and Child with Saint Anne and John the Baptist* at the National Gallery in London; John Elderfield's 1983 exhibition of modern drawings at the Museum of Modern Art, and most recently an exhibition of drawings by Arshile Gorky at the Whitney Museum of American Art. Unfortunately, such important drawing exhibitions are rare due to the inherent fragility of the objects and a perceived sense by some that they are not significant enough to drive the blockbuster exhibition mentality that pervades much of our American museums today.

This "bigger is better" approach is easily challenged if one considers that a drawing is an artist's immediate response to an idea, a scene before one's eyes or a reflection of a memory long past. It is, to use Matisse's words, "like making an expressive gesture with the advantage of permanence." This study of the drawings in the Columbus Museum's permanent collection offers a special glimpse into the insights and emotions of a selection of American artists from the second half of the eighteenth century through the beginning of the twenty-first century.

Fig. 2

Fig. 3

Fig. 2
Alejandro Aguilera
b. 1964, Holguin, Cuba
Black Drawing 1997
Ink, charcoal, coffee wash, and crayon on Kraft paper
83 x 47 inches (210.8 x 119.4 cm)
Museum purchase made possible by the Art Acquisition and Restoration Fund 2004.14
Provenance: Purchased directly from the Artist
Exhibited: *Redefining Georgia: Perspectivas en Arte Contemporáneo*, Columbus Museum, May 2– August 22, 2004

Fig. 3
Blanche Lazzell
b. Maidsville, West Virginia 1878– d. Morgantown, West Virginia 1956
Abstract Drawing V ca. 1924
Graphite on wove paper
10 x 8¼ inches (24.4 x 21 cm)
Gift of Ira Spanierman 2000.23
Provenance: Estate of the Artist; Spanierman Gallery, New York
Exhibited: *Towards a New Century: Contemporary Art from the Permanent Collection*, Columbus Museum, October 31, 1999– January 23, 2000; *Celebration*

Graphite, charcoal, crayon, pastel, ink, wash, gouache, chalk, oil, acrylic, monotype, mixed media and even earth pigments and organic stains, such as coffee, are the primary vehicles that these four centuries of American artists have used to make permanent these "expressive gestures." Paper is the underlying structure, and it comes in many forms ranging from traditional laid paper made by hand through to more contemporary (and perhaps a bit more temporary) sheets of Kraft paper. My colleague—and collaborator—in this project, Townsend Wolfe, says that a drawing is any "unique work of art on paper," and perhaps he is correct with this straightforward assessment. The broad selection of subjects in this publication and the larger collection of the Columbus Museum would seem to bear out his determination.

Many of the artists here are classified foremost as painters. John Singleton Copley, Thomas Cole, William Morris Hunt, Winslow Homer, Lilian Westcott Hale, Blanche Lazzell, Robert Motherwell, Jay DeFeo, and William Beckman are regarded highly for their paintings, as are most of the artists under review. However, a study of their works being documented shows that they had, or have, a solid foundation in drawing. The same can be said for the sculptors whose sheets are reproduced in this publication, such as David Davis, Dorothy Dehner, Chaim Gross, Jacques Lipchitz, Theodore Roszak, and David Smith.

Making sense of the divergent styles of a varied group of American artists whose work spans from 1780 until the present requires categorization, sometimes specific to the works and at other times arbitrary. Eighteenth- and nineteenth-century themes encompass a transatlantic migration of aesthetics, an appreciation of the American landscape, and a desire to glorify the natural world and to celebrate the transformation of a pastoral community into an urban, cosmopolitan environment. With the twentieth century, a parallel approach to art emerges with one camp championing the modern era and the international avant-garde and the other looking deeply into the human condition of the growing immigrant population and the social issues of the time. After World War II and continuing to the present, American artists have produced work in which influences and ideas flow from an international environment and are varied in imagery, scale, and media.

Thus, this assemblage of drawings is a reflection of the American melting pot of artists and their ideas over the past 225 years. Within, the reader will discover new images never before published, and encounter a new body of scholarship on the featured artists. It is a discovery of line and a celebration of imagination and thought. John Elderfield deems drawing to be closest to

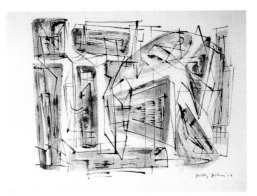

Fig. 4

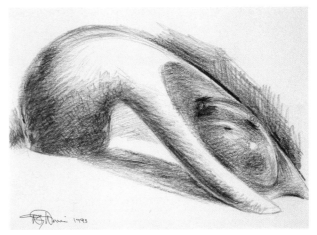

Fig. 5

Fig. 4
Dorothy Dehner
b. Cleveland, Ohio 1901 – d. New York City 1994
The Letter 1954
Watercolor and ink on wove paper
15½ x 15⅜ (39.4 x 39.1 cm)
Signed lower right: *Dorothy Dehner*
Gift of the Dorothy Dehner Foundation for the Visual Arts
2003.19
Provenance: Dorothy Dehner Foundation for the Visual Arts
Exhibited: *Celebration; Building on Strength*

Fig. 5
David E. Davis
b. Rona de Jos, Romania 1920 – d. Cleveland, Ohio 2002
Untitled (Supplicant) 1993
Charcoal on brown-colored wove paper
12 x 14 inches (30.5 x 35.6 cm)
Signed and dated lower left:
D.E. Davis 1993
Gift of Bernice Davis in memory of her husband, David E. Davis
2004.16
Provenance: Estate of the Artist

pure thought and, in many ways, these drawings support his thesis, but taking a more hedonistic approach, I agree with Vincent van Gogh's summary, "There is nothing so delightful as drawing."

In the mid-1970s the Columbus Museum's Collections Committee and curators decided to focus entirely on American art. Today the Museum has established its collection with notable works of painting, sculpture, furniture, ceramics, glass, textiles, photographs, prints, and, of course, drawings. Future possible acquisitions of drawings will expand Wolfe's definition as new media and new techniques challenge our traditional approach to the term "drawing."

This publication is a result of many important contributions. Museum trustee Helen J. Olnick, chairperson of the Collections Committee, and the valued members of this standing Museum committee have been supportive of the effort to build a center of excellence within our Museum's overall collections. Many donors have assisted in the growth of the Columbus Museum's drawing collection by gifts of artworks or by financial contributions. In particular, Life Trustee Ella Kirven, through her philanthropic foresight, provided for the establishment of a notable acquisitions fund for the Museum that over the years has brought about not only the acquisition of many of the drawings recorded in this publication, but also a number of other pivotal artworks to be found in the Museum's permanent galleries. Many of these works have been documented in the recently published book *American Art in the Columbus Museum: Paintings, Sculpture and Decorative Arts*

(Seattle and Columbus: Marquand Books and the Columbus Museum, 2003).

For their assistance in developing this publication, I thank Douglas Dreishpoon and Paul Schweitzer, who offered much-needed advice on the organization and the inclusion of artists. Such collegial support is always appreciated and never fully recognized by readers of the text.

I would be remiss if I failed to mention the important influence that two individuals and organizations have had upon this author and many American drawing collectors. Over the past thirty years Townsend Wolfe and the Arkansas Arts Center have set a standard for research into drawings that has resulted in magnificent exhibitions and collections. Equally, Paul Cummings in his earlier work at the Whitney Museum of American Art and through his work with the Drawing Society set a high bar of expectation in scholarship in American drawings.

I wish to thank the following American art scholars who have contributed expertise to this project through the individual object entries: Bruce Altshuler, Bruce Chambers, Jay Cantor, Douglas Dreishpoon, Ruth Fine, Anne King, Andrew Ladis, Marilyn Laufer, Constance Lewallen, Joan Marter, David Meschutt, Joann Moser, Emily Neff, Lisa Peters, Stephen Wicks, Tom Wolf, and Townsend Wolfe. These authors have been assisted in numerous ways by colleagues and researchers, and these important sources are noted in the respective catalogue essays. I also wish to acknowledge the invaluable and instructive conversations on American

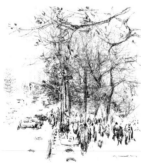

Fig. 6

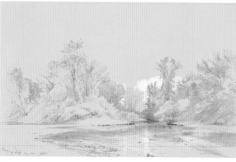

Fig. 7

Fig. 6
Chen Chi
b. Wusih Kiangsu, China 1912 –
Shanghai, China 2005
Fifth Avenue, New York
ca. 1978–1980
Ink on wove paper
12½ x 11½ inches (31.8 x 29.2 cm)
Signed lower right: *Chen Chi*

Gift of William E. and Joann
Scheele 85.40
Provenance: Artist; William E. and
Joann Scheele
Exhibited: *Celebration*

Fig. 7
Aaron Draper Shattuck
b. Francistown, New Hampshire
1832 – d. Granby, Connecticut 1928
Stratford, New Hampshire 1860
Pencil and wash on buff-colored
wove paper
10½ x 17 inches (26.7 x 43.2 cm)
Inscribed lower left: *Stratford, NH,
Aug., 1860*
Dr. and Mrs. Philip L. Brewer
Collection, Museum purchase
made possible by the Ella E. Kirven
Charitable Lead Trust for
Acquisitions 2003.1.14
Provenance: Katherine S. Emigh,

the artist's granddaughter; Dr. and
Mrs. Philip L. Brewer
Exhibited: *Arcadian Vales, Views of
the Connecticut River Valley*, George
Walter Smith Art Museum,
Springfield, Massachusetts,
November 22, 1981 – February 7,
1982, Center for the Arts, Wesleyan
University, Middletown,
Connecticut, March 4 – April 4,
1982, no. 45; *Hudson River in Private
Collections in Georgia*, Georgia
Museum of Art, Athens, Georgia,
March 1995, no. 20; *Celebration*
Literature: Martha Hoppin,
*Arcadian Vales, Views of the
Connecticut River Valley* (Springfield,
Mass.: George Walter Smith Art
Museum, 1981), cat. no. 85

drawings that I have been fortunate to have with Curtis and Jackye Finch, Jack and Russell Huber, and Hunter and Cathy Allen. The many efforts of my colleagues at the Columbus Museum have been essential to the success of this project, and to this end, I thank Kimberly Beck, Aimee Brooks, Mellda Alexander, Steve Ellis, Chris Land, Jim Livingston, and Roger Reeves. I especially wish to acknowledge my Administrative Assistant Patricia Butts for her careful reading of the manuscript and Curator of Collections and Exhibitions Stephen C. Wicks for his exceptional work in all aspects of this publication and exhibition.

The photography for the book is again the superb work of Michael McKelvey, who has produced the images for a number of significant publications for this Museum. The production team of D Giles Ltd. in London has been a genuine pleasure to work with over the past few years, and I have especially enjoyed Dan's good humor and constant eye to excellence.

In 1976 Theodore E. Stebbins, Jr. wrote his seminal text, *American Master Drawings and Watercolors* (Boston: Drawing Society), and he continues to maintain a presence in the field. Ted's introductory notes here on the history of scholarship and his review of the development of the major centers of study for American drawings in public collections provide a suitable beginning for the catalogue entries that follow. His reference to the Karolik Collection at the Museum of Fine Arts, Boston (hereafter MFA) underscores the importance of this great assemblage of American drawings and paintings as a resource and inspiration for generations of American scholars. More so, the scholars whose essays are gathered in this text have deliberately sought to place each of the drawings in a context beyond well-documented personal histories of the artists, thus focusing their investigative efforts on the uniqueness of each drawing. When this survey of scholarship and collections is combined with a compilation of the history, stylistic analysis, and connoisseurship of these works on paper from the Columbus Museum (many reproduced for the first time), and the comprehensive bibliography contained herein, I am confident that we have been able to add to this rich and important scholarly research.

Dr. Philip L. Brewer, Columbus Museum trustee, collector, and retired cardiothoracic surgeon, has been kind enough to share some of his personal thoughts on American drawing, especially on the impetus that led to his collecting these artworks over thirty years. It is interesting to note that this entire project came to fruition during a walk in Georgetown following the opening reception for the exhibition of some of the Brewers' drawings at the Federal Reserve in Washington in 2001. A question about their collection's future brought about an exciting and directed discussion. Suffice to say that this widely admired collection now resides at the Museum, with the balance of the collection to come as promised gifts. Spending time discussing drawings with Philip and his wife, Lorraine, is never dull, and our trips to see other such collections are ardently anticipated. I have been fortunate to meet many other scholars, collectors, and drawing advocates thanks to Philip and Lorraine, and I am immensely grateful to them both.

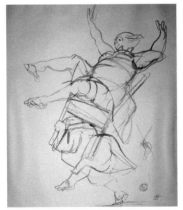

Fig. 8

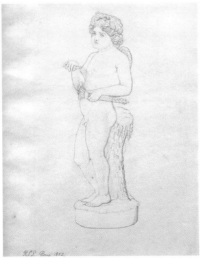

Fig. 9

Fig. 8
Federico (Rico) Lebrun
b. Naples, Italy 1900 – d. Malibu, California 1964
Sewing Accident ca. 1925–1935
Pencil on brown-colored wove paper
11½ x 9½ inches (29.2 x 24.1 cm)
Signed with initials, lower right: *RL*
Dr. and Mrs. Philip L. Brewer Collection, Museum purchase made possible by the Ella E. Kirven Charitable Lead Trust for Acquisitions 2003.1.29
Provenance: Private Collection, New York; Michael Rosenfeld Gallery, New York; Dr. and Mrs. Philip L. Brewer
Exhibited: *Celebration*

Fig. 9
Robert Swain Gifford
b. Naushon, Massachusetts 1840 – d. New York City 1905
Untitled (Roman Statue) 1852
Graphite on wove paper
12 x 8¼ inches (30.5 x 21 cm)
Signed lower left: *R.S.G. Roma 1852*
Gift of Philip L. Brewer, M.D. 97.28.1
Provenance: Christie's Auction House, New York, lot 65, December 2, 1988; Dr. and Mrs. Philip L. Brewer Collection

Funding for this entire project has been provided by generous and dedicated friends of the Museum who, upon seeing the publication of our painting, sculpture and decorative arts book in 2003, felt that we now needed to turn our attention to the drawing collection. We are appreciative of their trust and commitment.

One of the important components of this large project is the national tour that will accompany the publication of this book. Approximately 145 works reproduced in this volume will be shared with audiences and cognoscenti of drawings beyond the immediate region of Columbus. We count ourselves fortunate to have such friends and colleagues at respected arts organizations outside of the South who echo our love of works on paper and American art. As such, I thank Joseph B. Schenk, Executive Director, and Gary Hood, Senior Curator, Gilcrease Museum, Tulsa, Oklahoma; James Bridenstein, Executive Director, and Susan VanArendonk, Registrar, Kalamazoo Institute of Arts, Kalamazoo, Michigan; and Nan Plummer, Executive Director and Thom Hall, Registrar, Arkansas Arts Center, Little Rock, Arkansas, for their willingness to bring these beautiful artworks to their communities.

This five-year project has provided a tremendous amount of pleasure in its conception, research, development, and execution. The search to find additional works on paper has been equally enjoyable. Throughout this project as well as my professional career, I have come to rely on the invaluable advice, constructive criticism, and sound editing work of my wife and partner, Marilyn Laufer. I owe her a great debt of gratitude for understanding those long evening and weekend hours in the office and home and for taking the time from her own busy schedule to assist our team in the production of this book.

Fig. 10
Ernest Lawson
b. Halifax, Nova Scotia, 1873 –
d. Miami Beach, Florida 1939
Landscape ca. 1919
Monotype in oil on wove paper
9 x 12 inches (22.9 x 30.5 cm)
Signed lower left: *E. Lawson*
Promised Gift, Dr. and Mrs. Philip L. Brewer Collection
Provenance: Mrs. Ernest Lawson; Kraushaar Galleries, New York; Private Collection; ACA Galleries, New York; Private Collection; Kraushaar Galleries, New York; Dr. and Mrs. Philip L. Brewer
Exhibited: *Ernest Lawson Retrospective*, ACA Galleries, New York, November 27 – December 24, 1976, cat. no. 79, illus.; *Intimate Expressions*, cat. no. 45, illus.: 79, pl. 22; *A Collector's Pursuit of Drawing*; *Celebration*

Fig. 11
James Meikle Guy
b. Middletown, Connecticut 1909 –
d. Moodus, Connecticut 1983
Discovery 1940
Pencil on wove paper
8⅜ x 10⅝ inches (21.3 x 27 cm)
Signed and dated lower left: *Guy '40*
Dr. and Mrs. Philip L. Brewer Collection, Museum purchase made possible by the Ella E. Kirven Charitable Lead Trust for Acquisitions 2003.1.8
Provenance: Artist's Collection, to early 1980s; Martin Diamond Fine Art, New York; Hirschl & Adler Galleries, New York; Dr. and Mrs. Philip L. Brewer
Exhibited: *Realism and Abstraction: Counterpoints in American Drawing, 1900–1940*, Hirschl & Adler Galleries, New York, November 12 – December 30, 1983, cat. no. 59, illus.; *Celebration*

Fig. 12
Thomas Hart Benton
b. Neosho, Missouri 1889 –
d. Kansas City, Missouri 1975
Sugar Mill ca. 1920s
Pen, ink, and pencil on wove paper
11 x 15 inches (27.9 x 38.1 cm)
Signed lower right: *Benton*
Museum purchase made possible by the Crowley Foundation Art Acquisition Fund 93.7
Provenance: Christie's Auction House, New York
Exhibited: *American Regionalism from Georgia Collections*, Marietta/Cobb Museum of Art, Marietta, Georgia, September 17, 1993 – November 24, 1993; *Making a Mark*; *Celebration*
Literature: *A Collection of Drawings by Thomas Hart Benton* (Columbia, Mo.: University of Missouri Press, 1968), illus.: 72; *Building on a Legacy*, illus.: 198.

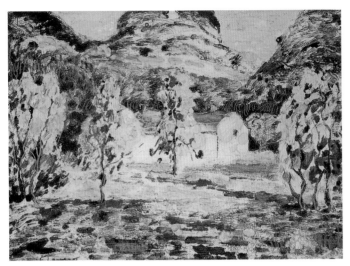

Fig. 10

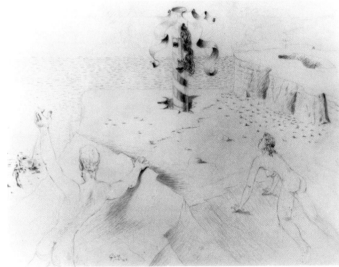

Fig. 11

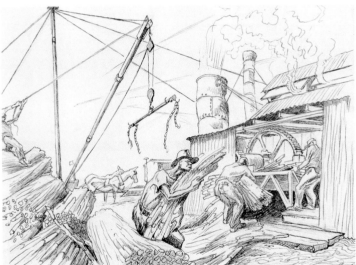

Fig. 12

INTRODUCTION:
THE DISCOVERY OF AMERICAN DRAWINGS

THEODORE E. STEBBINS, JR.
CURATOR OF AMERICAN ART, FOGG ART MUSEUM
HARVARD UNIVERSITY

Though drawings traditionally come first in the artistic process, as preparatory to composing a painting, beginning a sculpture, or planning a building, they were long treated as afterthoughts by scholars, museums, and private collectors. In this country, it was only in the twentieth century that American drawings, watercolors, and pastels began to be treated with respect, and only during the last thirty years have they been accorded the serious scholarly and popular attention they deserve.

One key figure in the early acceptance of works on paper was Alfred Stieglitz, the New York photographer/gallery owner who championed modernism during the first decades of the century. In 1908–1911, Stieglitz introduced Rodin, Picasso, and Matisse to a doubting America, doing so through the drawings and watercolors (rather than the paintings or sculpture) of these masters. During the same years Stieglitz became the first to show many of

the pioneering American modernists, including John Marin, Marsden Hartley, Marius de Zayas, Charles Demuth, Arthur G. Dove and Georgia O'Keeffe, and he typically showed their drawings, watercolors, or in Dove's case, pastels. Thus Stieglitz more than anyone else laid the groundwork for a new appreciation of drawings and watercolors, establishing that these works offer unique insight into the creative process, that they are unrivaled in demonstrating the touch of the artist, and that they have a special accessibility and beauty.

For many years, watercolors were treated far more seriously than drawings, by which we mean works executed on paper with graphite, pen and ink, chalk, or charcoal, typically in black and white. Watercolors had history and precedent on their side. Beginning with the New York Watercolor Society and its one exhibition of 1853, and more resoundingly with the American

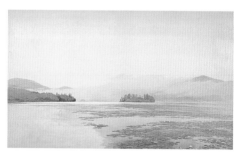

Fig. 13

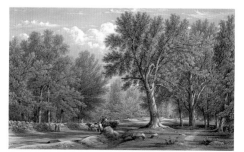

Fig. 14

Fig. 13
John Henry Hill
b. London, England 1839 –
d. Clarksville, New York 1922
Mountain Lake 1870
Watercolor on wove paper
17¼ x 28 inches (43.8 x 71.7 cm)
Dr. and Mrs. Philip L. Brewer Collection, Museum purchase made possible by the Ella E. Kirven Charitable Lead Trust for Acquisitions 2003.1.53
Provenance: Hirschl & Adler Galleries, New York; Private Collection, New York; Hirschl & Adler Galleries, New York; Dr. and Mrs. Philip L. Brewer
Exhibited: *Intimate Expressions*, cat. no. 40, illus.: 79, pl. 21; *A Collector's Pursuit of Drawing; Celebration*

Fig. 14
William Rickarby Miller
b. Staindrop, England 1818 –
d. New York City, 1893
The Elysian Fields, Hoboken, NJ 1874
Watercolor and gouache on gray-colored wove paper
14¾ x 23¾ inches (37.5 x 60.3 cm)
Signed and dated lower left: *W. R. Miller/ 1874*
Promised Gift, Dr. and Mrs. Philip L. Brewer Collection
Provenance: Kennedy Galleries, New York; Private Collection, Darien, Connecticut; Dr. and Mrs. Philip L. Brewer
Exhibited: National Academy of Design, 1874 (as *Road Seen on the Elysian Fields*); Louisiana Purchase Exhibition, 1875; *American Drawings Pastels and Watercolors,*

Part Two, the Nineteenth Century, 1825–1890, Kennedy Galleries, New York, 1968, cat. no. 33, illus.: 32; *Intimate Expressions*, cat. no. 53, illus: 15; *A Collector's Pursuit of Drawing; Celebration*
Literature: John Stevens, *Pioneer in Steam Powered Navigation and his Pleasure Park, Elysian Fields, in Hoboken NJ*, William A. Mann, selected papers of the 1995 Council of Educators in Landscape Architecture Conference, September 1995

Watercolor Society shows starting in 1867–1868, artists had offered for sale good-sized, finished watercolors that were often mounted in heavy gold frames as if they were oil paintings. Watercolors were indeed presented as rivals to paintings and were frequently called "watercolor paintings;" the debate whether they are best considered paintings (given that they can be highly finished, and have color) or drawings (as they may be very sketchy, and are on paper) continues to this day.

Watercolors were widely exhibited and collected in the U.S. during the last third of the nineteenth century, and they came into increased favor during the first half of the twentieth century. One thinks of such highlights as the purchases of major groups of watercolors by John Singer Sargent made by the Worcester Museum, the Brooklyn Museum, the Metropolitan Museum of Art (hereafter MMA), and the MFA between 1909 and 1915, and the publicity surrounding Stieglitz's sale in 1926 of a Marin watercolor to Duncan Phillips for an astounding $6,000—an event that bolstered not only Marin's reputation, but that of watercolor as a medium. Winslow Homer's watercolors, like the watercolors and pastels of James A.M. Whistler, were actively collected in the painters' lifetimes and afterwards; the extensive group of Whistlers collected by Charles L. Freer went to the Freer Gallery in Washington on his death in 1919, while a great number of Homer's best watercolors over the years more gradually entered the collections—largely as gifts—of five or six major museums in the northeast.

The great impact of modernist watercolors by the Stieglitz artists and others fueled a search for American roots for Marin, Demuth, and their colleagues. As Kathleen A. Foster has pointed out, the Brooklyn Museum's large *Exhibition of Water-Color Paintings by American Artists* in 1921 was the first to seek out what the catalogue called the "firm foundation" laid for the moderns by earlier artists, notably Sargent and Homer.[1] Best represented of the moderns in that exhibition were Arthur B. Davies, John Marin, and Dodge MacKnight along with such now-forgotten figures as Mary Rogers and Claggett Wilson. This show heightened interest in the field, as evidenced by such articles as Herbert Seligman's "Some American Watercolorists" and Henry Tyrell's "American Aquarellists, Homer to Marin," both of 1921. In the following year, the modernist painter/collector Albert E. Gallatin published the first book surveying the whole American accomplishment: his *American Water-Colorists* singled out as preeminent the work of three "old masters," Homer, La Farge, and Sargent, and three contemporaries, Marin (see 31a–b), Demuth, and Dodge MacKnight.

Fig. 15

Fig. 16

Fig. 15
Arthur Bowen Davies
b. Utica, New York 1862 –
d. Florence, Italy 1928
Meditation ca. 1905–1910
Chalk and charcoal on gray-colored wove paper
8⅞ x 13 inches (22.5 x 33 cm)
Stamped lower middle right with estate stamp: *Arthur B. Davies*
Museum purchase on the occasion of the Museum's Silver Anniversary 77.20
Provenance: Estate of the Artist; Gallery Clinton Lindley, Ltd.; Image South Gallery, Athens, Georgia

Exhibited: *People, Places, Animals; American Drawings from the Permanent Collection,* Columbus Museum, February 22 – May 28, 1990; *Making a Mark; Celebration*

Fig. 16
Maurice Prendergast
b. St. John's, Newfoundland 1858 –
d. New York City 1924
Girl's Head; verso: *Untitled* (sketch of a boy) ca. 1910–1913
Black chalk on wove paper
7¼ x 4¾ inches (18.4 x 12.1 cm)
Museum purchase made possible by the Edward Swift Shorter Bequest Fund 2003.21
Provenance: Charles Prendergast (from the artist); Mrs. Charles Prendergast; Meyer and Vivian Potamkin; Sotheby's Auction House, New York, Sale 7906, lot 72, May 2003
Exhibited: Davis Galleries, New York, February 5 – March 2, 1963; *Graphic Styles of the American Eight,* Museum of Fine Arts at the University of Utah, Salt Lake City, February 29 – April 11, 1976; *Building on Strength*
Literature: Carol Clark, Nancy Mowll Mathews, and Gwendolyn Owens, *Maurice Brazil Prendergast, Charles Prendergast, A Catalogue Raisonné* (Williamstown, Mass. and Munich, Germany: Williams College Museum of Art and Prestel, 1990), no. 1422: 550

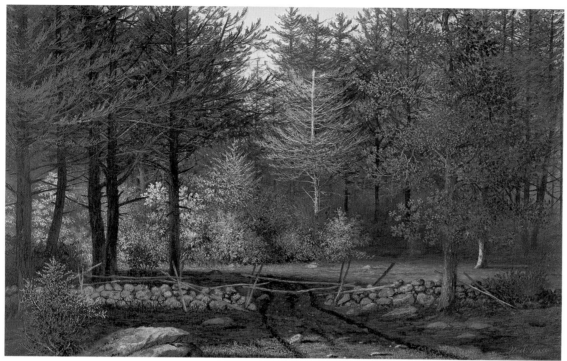

Fig. 17

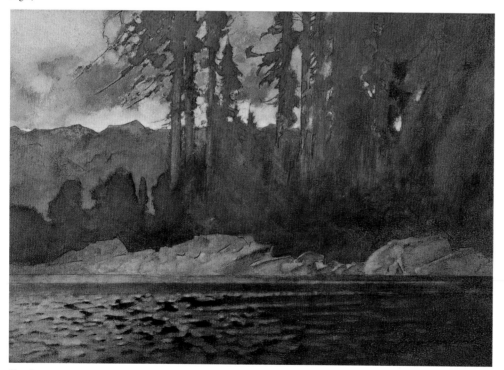

Fig. 18

Fig. 17
William Allen Wall
b. 1801 – d. 1885 New Bedford, New
Hampshire
Clearing in a Pine Forest ca. 1865
Watercolor and gouache on wove
paper
9½ x 14⅞ inches (24.1 x 37.8 cm)
Signed lower right: *W. A. Wall*
Inscribed verso: *Painted by William*
A. Wall (about 1860–70) for Samuel
Leonard, Jr. with the stipulation that
there be no cows in it. Passed on the
[sic] J. Maxim Ryders [sic], Sept. 1933
Promised Gift, Dr. and Mrs. Philip
L. Brewer Collection
Provenance: Samuel Leonard, Jr.; J.
Maxim Ryder; Graham Gallery, New
York; Dr. and Mrs. Philip L. Brewer
Exhibited: *Intimate Expressions*
(Columbus only); *A Collector's*
Pursuit of Drawing; *Celebration*

Fig. 18
George Hallowell
b. 1871 – d. 1926, Boston,
Massachusetts
Afterglow on a Lake 1924
Watercolor on wove paper mounted
on board
9¾ x 13⅝ inches (24.8 x 34.6 cm)
Museum purchase 80.21
Provenance: Child's Gallery, Boston
Exhibited: *Celebration*

This Marin watercolor was included in Gallatin's book. Posterity has agreed with his choices, except in the case of MacKnight, who has never regained his early fame.

Interest in watercolor continued to grow, and the 1940s saw the publication of increasingly useful surveys following Gallatin's model, all of which considered Homer and Sargent together with the modern masters. An unpublished doctoral thesis, "A Critical Survey of American Watercolor Painting" (1941) by Sherman E. Lee (later to become well known as director of the Cleveland Museum), the ambitious, broadly conceived *History of American Watercolor Painting* (1942) by Alan Burroughs of Harvard, and *American Watercolor and Winslow Homer* (1945) by Lloyd Goodrich, the latter two accompanying exhibitions at the Whitney Museum of American Art, New York, all marked important steps in the appreciation of the medium. Burroughs's exhibition was particularly notable in that it established the canon that survives more or less intact to this day: rejecting MacKnight and several other minor figures featured by Gallatin, Burroughs broke new ground with his recognition of both Audubon and Eakins, who joined Homer, Sargent, and Prendergast among the early masters, and in his recognition of Hopper as deserving an equal place with Marin and Demuth among the moderns. In 1947 the MFA published a fully illustrated checklist of its entire holdings in watercolor, both European and American, the first catalogue of its kind. Finally, Donald A. Shelley's articles on Pennsylvania German frakturs and on such early watercolorists as George Harvey, William

Fig. 19
Robert Motherwell
b. Aberdeen, Washington 1915 –
d. Provincetown, Massachusetts 1991
Edgar Allan Poe Series (Poe #1) 1973
Acrylic and paper collage on Upson board
36 x 48 inches (91.4 x 121.9 cm)
Signed and dated upper right:
R. Motherwell 19 Nov 73
Museum purchase made possible by Evelyn Crowley; Kathleen M. Hohlstein; Janet Bowers Hollis, in memory of Howell Hollis; Dora E. Jackson; Polly C. Miller, in honor of her mother, Betty Corn; Mr. and Mrs. Richard I. Norman; Jill Chancey Philips; Maxine R. Schiffman; Kathelen V. Spencer; Teresa Pike Tomlinson, in memory of Hellen Gregory Pike; Mr. and Mrs. Joe Windsor; special assistance from the Ella E. Kirven Charitable Lead Trust for Acquisitions; and a gift of the Dedalus Foundation 2000.13.4
Provenance: Estate of the Artist; Dedalus Foundation, New York
Exhibited: *Robert Motherwell & Black*, William Benton Museum of Art, Storrs, Connecticut, March – May, 1980, listed in catalogue but not illustrated; *Robert Motherwell*, Padiglione d'Arte Contemporanea di Milano, Italy, September – November 1989; *Robert Motherwell*, Fundació Antoni Tapies, Barcelona,

Spain, Madrid, March – April 1997, illus. pl. 46: 172–173; traveled to Museo Nacional Centro de Arte Reina Sofia, Madrid, Spain, March – May, 1997; *Robert Motherwell at the Columbus Museum*, Columbus Museum, March 15 – June 11, 2000, gallery brochure, illus. in color, unpaginated
Literature: Robert Motherwell, Stephanie Terenzio, and Hildegard Cummings, *Robert Motherwell & Black* (Storrs, Conn.: William Benton Museum of Art, 1979), unpaginated

Fig. 20
Richard Pousette-Dart
b. St. Paul, Minnesota 1916 – d. New York City 1992
Au Coeur du Monde 1989–1990
Gouache on d'Arches paper
7¾ x 12 inches (19.7 x 30.5 cm)
Gift of a Friend of the Museum 2005.16
Provenance: Collection of Evelyn Pousette-Dart, New York; Susan Conway Gallery, Washington, DC; Private Collection
Exhibited: *Art Chicago*, May 10 – 13, 2002; *Found Treasures – Richard Pousette-Dart, David Smith, Roy Lichtenstein, William Christenberry, Willem de Looper, Brockie Stevenson*, Susan Conway Gallery, Washington, D.C., July – August, 2002

Fig. 19

Fig. 20

Rickarby Miller, and William Guy Wall, were also important contributions during these years.

Appreciation of drawings generally lagged behind, as the twenties saw only the publication of Theodore Bolton's *Early American Portrait Draughtsmen in Crayons* (1923). This was a useful study of finished portraits made with charcoal, chalk, or crayons, a genre nicely represented in the Columbus Museum collection by Saint-Memin's *Portrait of Thomas Hillen* (1804). However, this book did not lead to any wider appreciation of drawings in general, and it was not until the late 1930s and 1940s that a wider range of drawings began to come into their own in terms of scholarship and popular understanding. A pioneer here was John Davis Hatch, a scholar, collector, and sometime museum director whose fine collection of drawings ranging from Allston and Cole to Hartley and Joseph Stella was exhibited nationally and internationally over five decades beginning with a University of Pittsburgh show in 1938. Hatch also contributed a number of articles over the years devoted to technique, iconography, and attribution with special attention to such favorite artists as John Vanderlyn.

In 1946 Carl W. Drepperd published his still-useful *American Drawing Books*, a bibliographic checklist of over seventy drawing and watercolor instruction manuals published in North America between 1787 and about 1863. Scholars have been mining drawing books ever since, seeking a greater understanding of how both professional and amateur artists learned to draw and paint, how style was spread, and how art became so varied and so popular in this country. A notable outgrowth of Drepperd's research was Peter C. Marzio's *The Art Crusade: An Analysis of American Drawing Manuals, 1820–1860*, an exemplary study of 1976.

Even more important for the field was the handsome, richly illustrated survey entitled *Treasury of American Drawings* published by the distinguished dealers/scholars Charles E. Slatkin and Regina Schoolman in 1947. This book covers the field from Copley and West to Bellows and Sheeler; like the Hatch Collection, it dealt only with drawings and not with watercolors. The volume quickly became popular with collectors, curators, and others, and it served as a basic text in the field for at least twenty years.

It is not surprising that the 1940s and 1950s witnessed renewed exploration of earlier American drawings, for this was the time of Abstract Expressionism, a period that saw the question of drawing widely discussed. Many leading painters including Pollock, Rothko, and Clyfford Still worked out their paintings directly on canvas, and had no use for preliminary sketches. To some observers, drawing seemed to be dead, or at least relegated to the backwater of artists working in conservative modalities. It did not turn out this way, however, for at least two reasons. First, many of the Abstract Expressionists, notably DeKooning, Gorky, Rothko, and Pousette-Dart, executed brilliant drawings or watercolors independent of their paintings, and Robert Motherwell was a master of collage. Secondly, and more important, the large-scale paintings of Pollock, DeKooning, and others took on the personal energy and the unfinished look of traditional sketches: in effect, their paintings became very large drawings. As Bernice Rose explains in her important study of 1976, *Drawing Now*, only with Abstract Expressionism could drawings "function as an alternative major mode of expression."[2]

With drawing playing a new role in contemporary art, older American drawings began to be reconsidered. Until mid-century, there was as little market interest in them as there was scholarly attention. Museums had acquired some significant holdings of American drawings by this time, but these acquisitions generally came about as afterthoughts, with the museum doing various artists' descendants the favor of accepting as gifts large groups of preparatory works that had been left in their studios. This is how a superlative group of some two thousand of Frederic E. Church's drawings and oil sketches were given to the Cooper Union (now the Cooper-Hewitt Museum) in New York by the artist's last surviving son in 1917, and how so many Thomas Eakins drawings and oil sketches were presented to the Philadelphia Museum by his widow in 1929–1930. Similarly, John Singer Sargent's sisters, after the painter's death, donated hundreds of his mural sketches, watercolors, drawings, and sketchbooks to museums including the MFA and to the Fogg Art Museum between 1928 and 1937. As late as 1949, Violet Sargent Ormond was still in possession of a large group of material from the studio. As she wrote the MMA, "I have a quantity of sketches, studies, some watercolors, & some drawings by my brother. I should like to give them all to you, to dispose of as you see fit, to give to art schools, museums, or students, where you think they might be of service. You would have an absolutely free hand, even destroying those you consider of no interest."[3] This speaks eloquently both to Sargent's then-relatively low reputation, and more significantly to the way that drawings and sketches were still regarded at that time. Mrs. Ormond would be quite amazed to see the massive, scholarly catalogue of Sargent's drawings and sketches published by the MMA in 2000. Her gifts, like those of numerous painters' heirs before her, occurred because of the gen-

eral belief that artists' preparatory works had little value, except perhaps for art students.

Soon thereafter, the pendulum began to swing in the other direction. During the 1950s the legendary Russian-born collector, Maxim Karolik, was busy amassing the third and last of his collections of American art, all of which he presented to the MFA. This final collection was devoted to mid-nineteenth-century drawings. Karolik proceeded in a different manner than any collector before him, ignoring the well-known masters such as Homer, Sargent, and Whistler, and instead sweeping up vast numbers of more vernacular works of every kind. Karolik's only criteria were whether the work had a modicum of quality, or said something about life in nineteenth-century America. He bought works by the trained and untrained, by foreign- and native-born practitioners, by men and women working in every region who made drawings for nearly every purpose. He purchased many folk drawings, from portraits made by itinerants in Vermont to Pennsylvania German frakturs, and he also gathered a large number of Civil War drawings executed by combatants and artist-illustrators on the scene. He acquired architectural and topographic studies, renderings of the Gold Rush and the West, caricatures, sketchbooks, and sketchbook pages, and many studies of various kinds by landscape painters and members of the Hudson River School. Karolik didn't avoid watercolors, but it was drawings—from the beautiful to the mundane—that he primarily sought.

Karolik was the godfather of the Columbus Museum collection in several ways. First, his eclectic taste is mirrored in the wide-ranging approach one finds at Columbus. Secondly, Karolik collected drawings with the advice and consent of the MFA, and especially with Henry P. Rossiter, its curator of prints and drawings, just as the Columbus Museum has worked in partnership with Dr. and Mrs. Philip L. Brewer, whose energy as private collectors provided the foundation for the project. And last, Karolik's collection was handsomely published in 1962 in a scholarly, two-volume catalogue produced by the MFA, a book that set a new standard in the American field and that serves as a direct precedent for the present volume.

During the 1950s and 60s there was something of a hiatus in the study of older American watercolors, paralleling the decline of interest in the medium on the part of contemporary painters. In these decades scholarly energy turned to the examination of several important aspects of the drawing tradition. Bartlett Hayes of the Addison Gallery at Andover studied the "American Line" in an exhibition of 1959; William P. Campbell of the National Gallery of Art produced an estimable study of Civil War drawings in 1961; Jo Miller wrote a fine exhibition catalogue devoted to the drawings of the Hudson River School (1969, Brooklyn Museum); and Lois Fink and Joshua Taylor examined the academic figure drawing in an exhibition at the Smithsonian in 1975. Each of these pioneering studies was followed by other scholarly writings that built upon it.

This period also saw greatly renewed interest in drawing on the part of many important artists of the day. Johns, Rauschenberg, Kelly, Lichtenstein, Oldenburg, Ruscha, Serra, Christo, Smithson, Agnes

Fig. 21
John Marin
b. Cape Split, Maine 1870 – d. Rutherford, New Jersey 1953
Sunset ca. 1952
Watercolor and pencil on wove paper
8¼ x 11 inches (21 x 27.9 cm)
Signed lower right: *Marin*
Promised Gift, Dr. and Mrs. Philip L. Brewer Collection
Provenance: Estate of the Artist; Kennedy Galleries, New York; Christie's Auction House, Sale 7318, lot 212, September 26, 1991; Dr. and Mrs. Philip L. Brewer
Exhibited: Cape Split Place, Addison, Maine; *Intimate Expressions*, cat. no. 49, illus.: 70, pl. 9; *Celebration*
Literature: Sheldon Reich, *John Marin, A Stylistic Analysis and*

Catalogue Raisonné (Tucson: University of Arizona Press, 1970), cat. no. 45.31, illus.: 740.

Fig. 22
Henry Farrer
b. London, England 1843 –
d. Brooklyn 1903
Moonrise, New York Harbor ca. 1870s
Watercolor on wove paper
7 x 10¾ inches (17.8 x 27.3 cm)
Signed and dated lower left:
H. Farrer, 1881
Dr. and Mrs. Philip L. Brewer Collection, Museum purchase made possible by the Ella E. Kirven Charitable Lead Trust for Acquisitions 2003.1.45
Provenance: Gerold Wunderlich, New York; Dr. and Mrs. Philip L. Brewer

Exhibited: *Hudson River in Private Collections in Georgia*, Georgia Museum of Art, Athens, Georgia, March 1995, no. 8; *Intimate Expressions* (Columbus only, not in catalogue); *Celebration*

Fig. 21

Fig. 22

Martin, Twombly, and LeWitt all made drawings of great quality and interest, in traditional and non-traditional media for a wide variety of purposes. Cy Twombly and Sol LeWitt were alike in making very large drawings; both are heirs of Abstract Expressionism, and both illustrate that drawings could have the power, importance, and scale of paintings. The two artists, however, made drawings of very different kinds. In Twombly's case, even more than in Pollock's, drawing subsumes painting, and his "finished" works contain elements of automatic writing, calligraphy, and graffiti, all marked on the canvas with apparent unconcern. LeWitt, beginning in 1968, took an opposite approach, conceiving drawings the size of whole walls or larger and consisting of straight lines executed by others. These were conceptual works with their roots in minimalism, and ones which eliminated traditional notions of the artist's touch.

In 1976 with the book *American Master Drawings and Watercolors: A History of Works on Paper from Colonial Times to Present*, I made a first modern attempt to survey the entire field chronologically, and to consider each drawing medium including pastel through a wide range of works from quick sketchbook notations to the finished exhibition pieces of Homer, Prendergast, and Chase, from the productions of untrained "outsider" artists to the work of popular illustrators and satirists. My hope was to bring attention to a growing enthusiasm for drawings and watercolors (which, it turns out, was just beginning), to examine both the continuities and the discontinuities in American style, and to encourage other writers to dig more deeply. It is hard to say whether the book had any effect, but for whatever reason a wide variety of other, more concentrated, studies did follow. In 1976, I wrote that only John Marin's watercolors had become the subject of a catalogue raisonné. Now one enjoys the use of numerous such catalogues devoted to watercolor oeuvres, including excellent volumes devoted to Whistler, Prendergast, and Hopper, among others, while similar studies of Homer, Chase, La Farge, Sargent, and Cassatt are nearing completion. Nor have drawings been neglected by recent scholars: for example, the drawings of George Caleb Bingham were the subject of a catalogue raisonné by Maurice Bloch in 1975; those of Jackson Pollock are included in the important catalogue by Francis V. O'Connor and Eugene V. Thaw (1978), while Whistler's drawings, watercolors, and pastels are examined in Margaret MacDonald's excellent book of 1995.

I also commented in my book that no monographic study existed for the watercolors of Winslow Homer. This lacuna was filled superbly by Helen Cooper's exhibition catalogue of 1986 (Yale University Art Gallery). In that book, Cooper deals with every aspect of Homer's watercolors with great sensitivity. Another great gap in the literature was filled with the publication of another landmark exhibition catalogue, *The New Path: Ruskin and the American Pre-Raphaelites* (1985) by Linda S. Ferber and William H. Gerdts, with major essays by Kathleen A. Foster and Susan Casteras. This book contributed significantly to our understanding of the work of such important but up to then little-known figures as Thomas and Henry Farrer, John W. Hill, Charles Herbert Moore, and Henry Roderick Newman. These are only a few of the many gaps in the literature that have been filled by scholars, dealers, and museums in recent years.

Museum scholars have played by far the major role in recent years in the study of American drawings and watercolors. Stuart P. Feld in 1966 organized an important exhibition, *200 Years of Watercolor Painting in America,* for the MMA; the same year, his colleague Albert TenEyck Gardner wrote the first well-illustrated history of this field. Then in 1972 the Rhode Island School of Design became the first museum to publish its American drawings and watercolors in a thorough, scholarly manner. This was followed by a series of useful collections catalogues, many dealing with a selection of watercolors and drawings, often accompanied by a history of the collection and, occasionally, by a checklist of the whole holding. This was the model followed in the volume produced by the Wadsworth Athenaeum in 1987, and by Henry Adams in his catalogue for the Carnegie Institute, Pittsburgh (1985) and in Adams's ambitious but more eccentrically selected *American Drawings and Watercolors in the Kansas City Region* (1992), which includes works from two museums and several private collectors. The Worcester Museum (1987), the Museum of Fine Arts, Boston (1993), the Brooklyn Museum (1998) — all museums with major watercolor collections — have produced substantial books devoted to works in this medium alone; more recently the more modest holdings of both drawings and watercolors at the Pennsylvania Academy of the Fine Arts (2000) and Princeton University (2004) have also received excellent treatment. The Princeton volume is noteworthy for John Wilmerding's illuminating history of the teaching and collecting of American art at the institution, and for the judicious survey of the literature by Kathleen A. Foster.

As Foster points out in her essay, the American field has been well served by several expert conservators who have taught us a great deal about the materials and the condition of works on

paper. The pioneer volume here was Marjorie Cohn's *Wash and Gouache* (Fogg Art Museum, Harvard University, 1977), which included Craigen Weston Bowen's analysis of pigment samples from a variety of watercolors. Judith Walsh brought special insight to the question of fading in Homer's watercolors in the National Gallery's exhibition catalogue devoted to that painter (1995). Another gifted conservator, Marjorie Shelley, has written perceptively on Sargent's technique and on the craft of drawings and watercolors in the MMA's superb recent catalogues devoted to its massive holdings of Sargent's works on paper and Kevin Avery's catalogue of that institution's American drawings by artists born before 1835, the first two of four planned books. Finally, the MMA has also been a leader in the study of pastels, as evidenced by *American Pastels in the Metropolitan Museum of Art* by Doreen Bolger et al. (1989). However, the field still lacks a thorough survey of American pastels.

Thus, the last thirty years have witnessed a vast outpouring of scholarly exhibitions and publications devoted to older American drawings and especially to watercolors. But what have the artists been doing during this time? What has happened to drawing?

My book of 1976 concludes with a consideration of the drawings of Twombly, LeWitt, and Dorothea Rockburne, and with a mention of Walter de Maria's *Mile Long Drawing* of 1968, which consisted of two parallel chalk lines in the desert. It was clear at that time that the range of drawing materials had expanded radically, and that drawing had entered a period of dramatic experimentation and redefinition.

Bernice Rose, a leading student of this field, confirmed that "the expansion of scale and the isolation and concentration on line as a subject in itself had the effect of catapulting drawing, formerly relegated to a minor supporting role in art, into a major autonomous role." Rose was surely correct in pointing out the increasing importance of drawings as independent works at the same time that drawing "has also become inextricably mixed with other mediums, with painting and painterly devices, with color, and with paint itself." Today there seem to be an increasing number of "pure" drawings being made with an ever-expanding variety of media, and vastly more finished works that make blatant use of drawing inextricably combined with paint, sculpture, photographic techniques, collage, cartoons, popular imagery, computer technology, and a mixture of other media.

Two other important factors should be mentioned. First, the concept of national style today seems as dead as the dodo. Through the sixties, one could more or less distinguish drawings made in the U.S. from those made in Europe, Japan, and elsewhere. But during the 1970s, art became completely internationalized. The American Cy Twombly, for example, has lived all his adult life in Italy, his work is seen to better advantage in Europe than in this country, and he has had more influence there than here. On the other hand, the drawings of the great German artist Joseph Beuys have greatly affected American artists and critics, though Beuys rarely set foot on these shores. Artists born all over the world have moved to New York for shorter or longer periods, while numerous Americans like Twombly have expatriated. Thus the collectors and museums who are determined to buy only "American" drawings will have an increasingly difficult time deciding which works fit their criteria.

Equally important, the traditional concept of drawing as "the probity of art," as Ingres put it, the long-accepted belief in them as revelatory of the artist's deepest self and of the initial moment of inspiration, have all come into question. As Rose writes, current "skepticism about the validity of the authorial role and the relevance of the signatory gesture…strikes at the heart of drawing itself." The criteria for judging drawings have changed dramatically. Instead of valuing quality of touch and economy of means as critics did for so many years, postmodern observers are more likely to rate drawings in terms of their meaning, iconography, or concept, or according to their effectiveness in accomplishing the overall mission of the artist.

Laura Hoptman, curator of an important exhibition at the Museum of Modern Art in 2002, observed a renewal of drawing as a center of creativity during the 1990s and was bold enough to offer eight major categories for the best of the current work.[4] These included studies of nature, for example the big, dashing landscape drawings of Ugo Rondinone, a Swiss who lives in New York; decoration; architecture (drawings not by architects but by such conceptual artists as Julie Mehretu); images of utopian fantasies; highly personalized travel drawings; drawings in the style of vernacular illustrations such as those of the brilliant Kara Walker; "comics," including the very large multi-object *Untitled*, of 1998–2002 by Barry McGee; and a final category of fashion/allegory, which includes the figurative drawings in colored pencil of Elizabeth Peyton and the humorous renderings of John Curren. All of these categories sound as if they could be applied to nineteenth-century drawings, but drawing has changed so much that the words have very different implications today.

It will be noticed how many references there have been to

Fig. 23

Fig. 23
Mary Ellen Doyle
b. Hartford, Connecticut 1938
Loper's Path 1998
Watercolor, litho-pencil, and
gouache on glued, handmade paper
16 x 22⅜ inches (40.6 x 56.8 cm)
Signed lower right: *MEDoyle*
Museum purchase made possible
by the Edward Swift Shorter
Bequest 99.19
Provenance: Susan Conway
Gallery, Washington, D.C.
Exhibited: *Towards the Horizon:
Recent Works on Paper by Mary Ellen
Doyle*, Columbus Museum, June 20
– August 15, 1999, illus.: cover; trav-
eled to Montgomery Museum of
Fine Arts, Montgomery, Alabama;
Susan Conway Gallery,
Washington, D.C.; *Celebration*
Literature: Tom Butler, *Towards the
Horizon: Recent Works on Paper by
Mary Ellen Doyle* (Washington,
D.C.: Susan Conway Gallery and
Columbus Museum, 1999), illus.

New York's Museum of Modern Art in terms of contemporary drawings. MoMA and its curators and donors have made it the international center in this field. One of its trustees, Werner H. Kramarsky, has become the leading drawings collector in the world, and has given extraordinary groups of recent drawings to MoMA and to several other museums. In addition, in May 2005, MoMA received from the Judith Rothschild Foundation a gift of 2,600 drawings ranging in date from the 1930s to 2004 by some 640 artists from over thirty nations.

Thus the Columbus Museum, in making a commitment to American drawings from West and Copley to the present day, joins a venerable tradition, one that lies at the very heart of creativity in the arts today, and one with both major challenges and enormous potential for the future of this museum and its audience.[5]

1. See Kathleen A. Foster, "Writing the History of American Watercolors and Drawings," in John Wilmerding, et al. *American Art in the Princeton University Art Museum. Volume I: Drawings and Watercolors* (New Haven: Yale University Press, 2004): 52.

2. Bernice Rose, *Drawing Now* (New York: Museum of Modern Art, 1976): 14.

3. Violet Sargent Ormond to Francis Henry Taylor, November 21, 1949, as quoted in Stephanie L. Herdrich and H. Barbara Weinberg, *American Drawings and Watercolors in the Metropolitan Museum of Art: John Singer Sargent* (New York and New Haven: Metropolitan Museum of Art and Yale University Press, 2000): 11.

4. Laura Hoptman, *Drawing Now: Eight Propositions* (New York: Museum of Modern Art, 2002).

5. I owe a special thanks to Edward Saywell and Virginia Anderson for their assistance in preparing this essay.

COMMENTARY:
A COLLECTOR'S POINT OF VIEW:
WHY AMERICAN DRAWINGS?

PHILIP L. BREWER, M.D.

Drawings, those direct and frequently intimate forms of pictorial expression, provide documentation of their time, not in a monumental way, but by reflecting concerns that are more personal. How our artists, diverse in their origins and experiences, have recorded through their drawings a social history of America has fascinated me for thirty years. If, as Townsend Wolfe has done, we define a drawing as any unique work of art on paper, then not only are images done in graphite, crayon, charcoal, and metalpoint fair game for the drawing collector, but also included are monotypes and paintings in pastel and watercolor.[1] Together, they present a broad view of American culture: one that complements and enhances the written word.

During our country's first century, we were predominately Protestant, rural and agrarian, with a language and culture largely derived from the British Isles.[2] Consider some illustrative exam-ples from the collection of the Columbus Museum: J.H. Hill's *Haying*, William Marlatt's *Children Playing Mumbly Peg*, and Winslow Homer's lovely drawing of a young woman plucking a water lily from a New England pond, all of which perfectly reflect these rural sensibilities. English affinities are obvious in the academic drawings of expatriates Benjamin West and John Singleton Copley, but can also be seen in the love of the natural world apparent in the reverent studies of trees by Thomas Cole and David Johnson, and in the later work, scrupulously true to nature, by two disciples of John Ruskin, W.T. Richards and Fidelia Bridges. The paintings of Jasper Cropsey and his companions in the American Watercolor Society would be quite at home in a group of Victorian watercolors. These are not idle associations; in great part, America's ideals of domesticity and love of God and country came directly from the Victorians.

Fig. 24

Fig. 25

Fig. 26

Toward the end of the nineteenth century, heralded by such authors as Henry James and the painter William Merritt Chase, and three artists who concerned themselves more with Europe than with America, Mary Cassatt, James Abbott McNeill Whistler, and John Singer Sargent, the country began a long love affair with the art of France. A student of Couture and Millet, William Morris Hunt produced a smudged and mysterious evocation of light and shade that is a world away from the precise crayon drawings of the Hudson River and New Path artists of the previous generation. Munich-trained Chase, in his painterly monotype, replaces the self-effacing crayon portraiture of artists such as Samuel Rowse. The phrase "art for art's sake" was coined and Sargent could choose as a subject bright sunlight, shining on a window in Spain. Later, examples by Childe Hassam, Willard Metcalf, and Ernest Lawson demonstrate the adaptation to their drawings of the broken strokes found in Claude Monet's Impressionism.

The interest of our Impressionists focused on landscape or on tranquil domestic scenes, but at the dawn of the twentieth century, migration of the population to the cities was well underway. There, jostling crowds and a cacophony of sounds intrigued a new breed of artists, the American Realists. Among the Museum's examples of their work are George Luks's liberated young women, William Glackens's shopkeeper and the patrons of Glenn Coleman's Irish bar.

The momentum of the Realist movement soon dissipated, however, as artists such as Arthur Dove, Marsden Hartley, and John Marin returned from Europe where they had, to paraphrase

Charles Demuth, dipped into the modernist well.[3] Immigrants from Europe with names such as Zorach, Walkowitz, Nadelman, Stella, and Bluemner joined them, bringing new concepts of form and color, and, in 1913, the public at large was introduced to these new ways of seeing at the historic Armory Show. Urbanization and immigration had changed the complexion of America and her art changed with it. Modernist ideas are evident in numerous drawings in the collection, including those by the above-mentioned artists.

Of course, in a country as large and disparate as ours, there have been currents and countercurrents. Tom Benton renounced his modernist beginnings to champion art that glorified life away from the cities, as in his carefully studied but quickly executed portrait of a country music singer. Early on, other artists embraced an abstract approach; Morton Schamberg, who died in the 1918 influenza epidemic, is represented by one of his machine pastels; Burgoyne Diller by a typical geometric abstraction; and Arshile Gorky, who drew haunting, sinuous biomorphic forms, by an abstracted figure. Ultimate freedom of expression was achieved by Robert Motherwell and Norman Bluhm. Their explosive abstractions are important as documentation of bursts of emotional creativity, rather like recordings of improvised jazz that captured the anger of a Charles Mingus or the immense sadness of John Coltrane's *Alabama*.

As the twentieth century wore on, our American artists found many ways of expressing themselves in their drawings. Spanish-born Federico Castellon expressed himself in Surrealist terms, as did James Guy and John Wilde. Preston Dickinson, rep-

Fig. 24
William Russell Birch
b. Warwickshire, England, 1755 – d. Philadelphia 1834
Autumn, View from the Lawn, Springland ca. 1808
Watercolor and ink on laid paper
3¼ x 4 inches (8.3 x 10.1 cm)
Signed on the mount: *Autumn Scenery/view from the Lawn / Springland Pa./drawn by William Birch*
Museum purchase made possible by the Endowment Fund in Honor of D.A. Turner 98.34
Provenance: The Artist; John Neagle, ca. 1827; Mrs. E.H. Brodhead, Jr.; Spanierman Gallery, New York
Exhibited: *Celebration*
Note: Springland was the artist's country home outside of Philadelphia.

Fig. 25
William E. Marlatt
active mid-nineteenth century
Children Playing Mumbly Peg ca. 1850–1860
Watercolor on wove paper
13½ x 23¾ inches (34.3 x 60.3 cm)
Signed lower right: *W. Marlatt*
Dr. and Mrs. Philip L. Brewer Collection, Museum purchase made possible by the Ella E. Kirven Charitable Lead Trust for Acquisitions 2003.1.55
Provenance: Kennedy Galleries, New York; Dr. and Mrs. Philip L. Brewer
Exhibited: *Intimate Expressions*, cat. no. 50, illus.: 66, pl. 2; *Celebration*

Fig. 26
Jasper Francis Cropsey
b. Staten Island, New York 1823 – d. Hastings, New York 1900
Greenwood Lake 1891 (previously erroneously entitled *Hudson Highlands*)
Watercolor on wove paper
12¾ x 20¾ inches (32.4 x 52.7 cm)
Signed and dated lower right: *J. F. Cropsey, 1891*
Dr. and Mrs. Philip L. Brewer Collection, Museum purchase made possible by the Ella E. Kirven Charitable Lead Trust for Acquisitions 2003.1.47
Provenance: Bernard Dannenberg Galleries, New York; Mr. Rothschild, Baltimore, Maryland; Achim Moeller Fine Art, New York; Hope Davis Fine Art, New York; Dr. and Mrs. Philip L. Brewer

Exhibited: *Looking at Drawings*, Achim Moeller Fine Art, New York, spring and summer 1988, no. 2; *Hudson River in Private Collections in Georgia*, Georgia Museum of Art, Athens, Georgia, March 1995, cat. no. 5; *Intimate Expressions* (Columbus only, not in catalogue); *Celebration*

resented here by a pastel still life, embraced Cubism. Others, namely John Steuart Curry, in a tragic drawing of a man chased by a lynch mob, and Rico Lebrun, with his cowering, crippled victims, chose to impress upon us their concerns of an unjust world. Sculptor Isamu Noguchi's spare and elegant drawing of a nude suggests his Asian origins. In contrast, David Bates draws with a strong Expressionist influence, and a recent trend back to representational art can be seen in the closely observed subjects of James Valerio and Stephen Assael.

Surprisingly, in this country of Mark Twain, comic strips, and comedy clubs, the presence of American humor in our drawings is infrequently acknowledged. The drawings of John Sloan, Reginald Marsh, Joseph Hirsch, and William Wiley make me smile, while the drawing of Saul Steinberg should cause most fathers a moment of introspection.

With an abundance of examples, the drawing collection of the Columbus Museum reflects the many flavors of American life. The variety of images illustrates an additional point; in contrast to the concept of a melting pot, the art of America is not settling toward some common denominator of uniformity in technique or choice of subject, but rather, the churning of cultures and ethnicities is continuously producing new images. Paul Cummings has

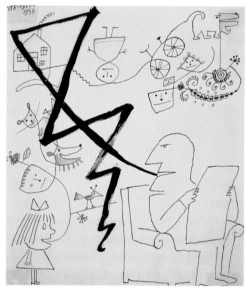

Fig. 27

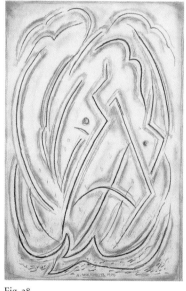

Fig. 28

Fig. 27
Saul Steinberg
b. Râmnicul-Sarat, Romania 1914 –
d. New York City 1999
Untitled 1953
Ink and colored crayon on buff-colored wove paper
14½ x 13 inches (36.8 x 33 cm)
Signed and dated, upper left:
Steinberg, 1953 (most probably executed ca. 1958 and incorrectly dated by artist later)
Promised Gift, Dr. and Mrs. Philip L. Brewer Collection
Provenance: Sotheby's Arcade sale, New York, June 24, 1998, lot 218; Kraushaar Galleries, New York; Dr. and Mrs. Philip L. Brewer

Fig. 28
Abraham Walkowitz
b. Tuieman, Siberia, 1878/80 –
d. Brooklyn, New York 1965
Untitled (Abstract figure study) 1914
Graphite on wove paper
20 x 13 inches (50.8 x 33 cm)
Signed and dated lower middle: *A Walkowitz 1914*
Gift of the artist 59.166
Provenance: Artist
Exhibited: *Making a Mark*
Literature: *Legacy*, illus.: 114

Fig. 29

Fig. 30

Fig. 29
Elie Nadelman
b. Warsaw, Poland 1882 – d. New
York City 1946
Woman's Head Study ca. 1921
Pencil on wove paper
9⅞ x 7⅞ inches (25.1 x 20 cm)
Dr. and Mrs. Philip L. Brewer
Collection, Museum purchase
made possible by the Ella E. Kirven
Charitable Lead Trust for
Acquisitions 2003.1.57
Provenance: Henry Davis Sleeper,
Gloucester, Massachusetts; Charles
and Helena Woolworth McCann,
Gloucester, Massachusetts; The
Society for the Preservation of New
England Antiquities, Boston;
Zabriskie Gallery, New York;
Hirschl & Adler Galleries, New
York; Dr. and Mrs. Philip L. Brewer
Exhibited: *A Sense of Line:
American Modernist Works on Paper*,
Hirschl & Adler Galleries, New
York, November 25, 1989 – January
6, 1990, cat. no. 9, illus.: 9; *Intimate*

Expressions, cat. no. 55, illus.: 29;
Celebration
Literature: Cynthia Nadelman,
"Elie Nadelman's Beauport
Drawings," *Drawing* VII, no. 4:
75–78.

Fig. 30
Oscar F. Bluemner
b. Prenzlau, Germany 1867 –
d. South Braintree, Massachusetts
1938
Newark 1914
Crayon on buff-colored wove paper
5 x 8 inches (12.7 x 20.3 cm)
Inscribed overall surface with artist's
notations for color and shading
Gift of Ira Spanierman in memory
of Norman S. Rothschild 98.59
Provenance: Spanierman Gallery,
New York
Exhibited: *Towards a New Century:
Contemporary Art from the
Permanent Collection*, Columbus
Museum, October 31, 1999 –
January 23, 2000

said, "American drawings…differ in ambition, size, scale, color, imagery and function from anything in the graphic tradition."[4] He might have added that they differ among themselves. Paradoxically, what is most characteristic of American drawings is their diversity, from which they obtain their extraordinary vitality and interest.

Although there is a strong aesthetic appeal to these drawings, my interest here is what they tell us about America. My parents, born early in the twentieth century, met in Manhattan during the Depression years. My mother came from the harsh and rocky center of New England and my father from North Georgia, not yet recovered from Sherman's March, and equally harsh and rocky. As a boy, I swam in the warm waters of the Gulf of Mexico and in cold Vermont lakes, and inherited a confused taste for bagels, biscuits and red-eye gravy, and sweet Yankee cornbread. Later, I had the privilege of training to be a surgeon at two legendary southern institutions, Atlanta's Grady Hospital and the Charity Hospital of Louisiana at New Orleans. In contact with patients and their families in times of grief and of joy, I have been placed (or have placed myself) in a position to encounter the worst and the best of American humanity: foolish, cruel, penurious, and profane, as well as wise, kind, generous, and pious. During my almost seventy years, I have seen much of what this great land and its ever-changing population offers. What more enjoyable way to revisit our past and gain insights into our present than by a study of these exceptional works of art?

1. This definition comes from a lecture given by Townsend Wolfe at the Columbus Museum in December 1988.
2. As late as 1788, an almanac inherited from my grandfather, Edwin Sherman of Danby Four Corners, Vermont, failed to list a single city with a population of over one million.
3. Barbara Haskell, *Charles Demuth* (New York: Whitney Museum of American Art, 1987): 51.
4. Paul Cummings, "A Discipline Aborning: Twentieth Century American Drawing Studies," *Drawing* XIV (September–October 1992): 52–56.

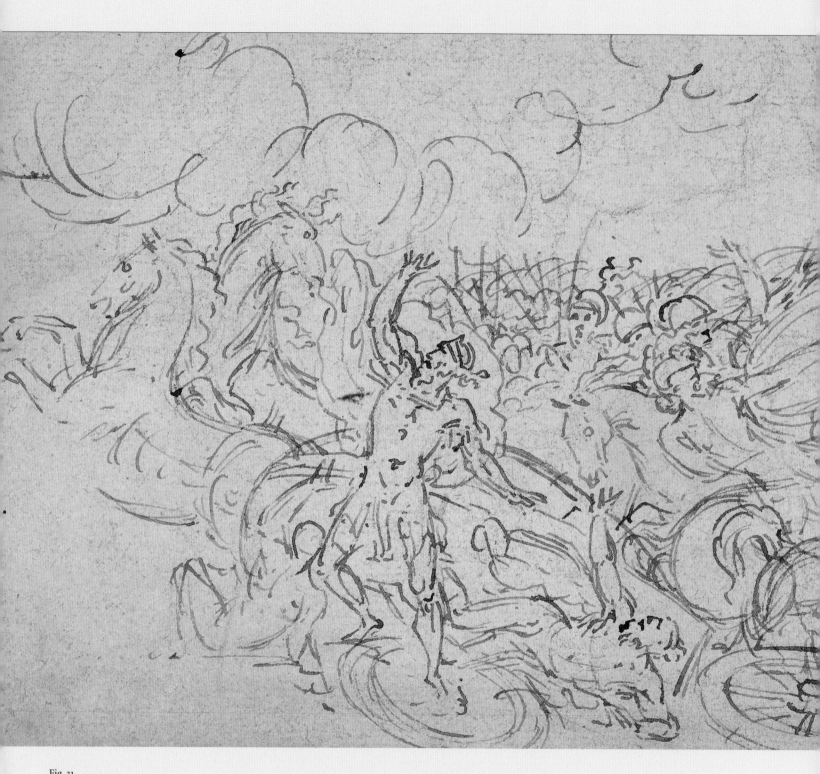

Fig. 31
Benjamin West
b. Springfield, Pennsylvania
1738 – d. London, England 1820
The Destruction of Pharaoh and His Host; verso:
Study for The Destruction of Pharaoh and His Host ca. 1780
Pen and bistre ink on cream-colored laid paper
6½ x 11⅜ inches (16.5 x 28.9 cm)

1.

FROM EUROPEAN TRADITIONS
TO THE EMERGENCE
OF A NEW AND UNITED COUNTRY

1.

John Singleton Copley
b. Boston 1738 – d. London, England 1815
Study of William Murray, Earl of Mansfield ca. 1778–1780
Graphite, black and white chalk on gray-blue wove paper
10½ x 8¾ inches (26.7 x 22.2 cm)

The unrivaled portraitist of the pre-revolutionary North American colonies, John Singleton Copley in 1774 set sail for London, England, where he quickly assumed the mantle of a celebrated history painter. In contrast to his colonial career, in which preparatory drawings for paintings are virtually non-existent, Copley in England developed his draftsmanship in response to the mounting complexity of his monumental and epic paintings of modern, historical events.

As seen here, the loose, fluid handling, use of white heightening, and blocked areas of chiaroscuro, typify Copley's drawing style. This drawing is one of seven sheets that relate to two finished oil paintings: Copley's *The Death of the Earl of Chatham* (1779–1781, Tate Gallery, fig. 32) and *William Murray, 1st Earl of Mansfield* (1783, National Portrait Gallery, London, fig. 33).[1] Both finished works demonstrate Copley's inventive twists on portraiture and history painting, and the artist's enterprising efforts at promoting himself in his new artistic milieu.

In the newly established field of modern history painting, *The Death of the Earl of Chatham* marked the first history painting of a current political rather than the more common military subject. Depicting the moment at which the moderate William Pitt, the Earl of Chatham, collapsed in the House of Lords after arguing for British continuance in the war against the rebellious colonies in 1778, Copley included portraits of the fifty-five Members of Parliament. His ambitious plan was logistically difficult but resulted in his introduction to the most influential members of the aristocracy and led to further individual portrait commissions, such as his portrait of William Mansfield, who appears at left in the narrative painting. In these individual portraits, Copley poses the sitter reenacting, in large part, the role he plays in the larger painting. Both pragmatic and inventive, Copley thus created a higher style of portraiture that imaginatively linked the individual sitter to his role as a public servant in contemporary historical events. EBN

Inscribed verso: *Earl of Chatham*
Promised Gift, Dr. and Mrs. Philip L. Brewer Collection
Provenance: The Artist, until 1815; John Singleton Copley, Jr., Lord Lyndhurst (the artist's son); Lyndhurst Library Sale, Christie's, London, February 26 – 27, 1864 (lot 664 or 670); Sir Edward Basil Jupp, London; Martha Babcock Amory, Boston (the artist's granddaughter); Edward Linzee Amory, Boston (the artist's great-grandson); a servant of Edward Linzee Amory, Boston; Child's Gallery, Boston; Private Collection, Boston; Child's Gallery, Boston; Dr. and Mrs. Philip L. Brewer
Exhibited: *Local Wonders: Treasures of American Art in Columbus Collections*, Columbus Museum, February 6 – May 29, 1994; *Intimate Expressions*, cat. no. 18, illus.: 6; *A Collector's Pursuit of Drawing; Celebration*
Literature: Jules David Prown, *John Singleton Copley*, vol. II (Cambridge, Mass.: Harvard University Press, 1966), cat. no. 433, illus.: 298, 396, and 426

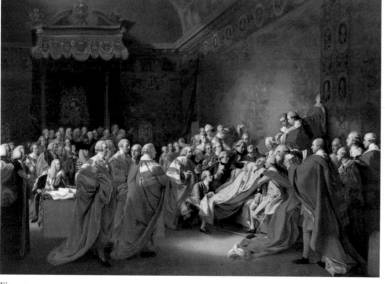

Fig. 32

Fig. 32
John Singleton Copley
The Death of the Earl of Chatham
1779–1781
Oil on canvas
90 x 121 inches (228.6 x 307.3 cm)

Fig. 33
John Singleton Copley
William Murray, 1st Earl of Mansfield 1783
Oil on canvas
88 x 57⅛ inches (223.5 x 145.1 cm)

Fig. 33

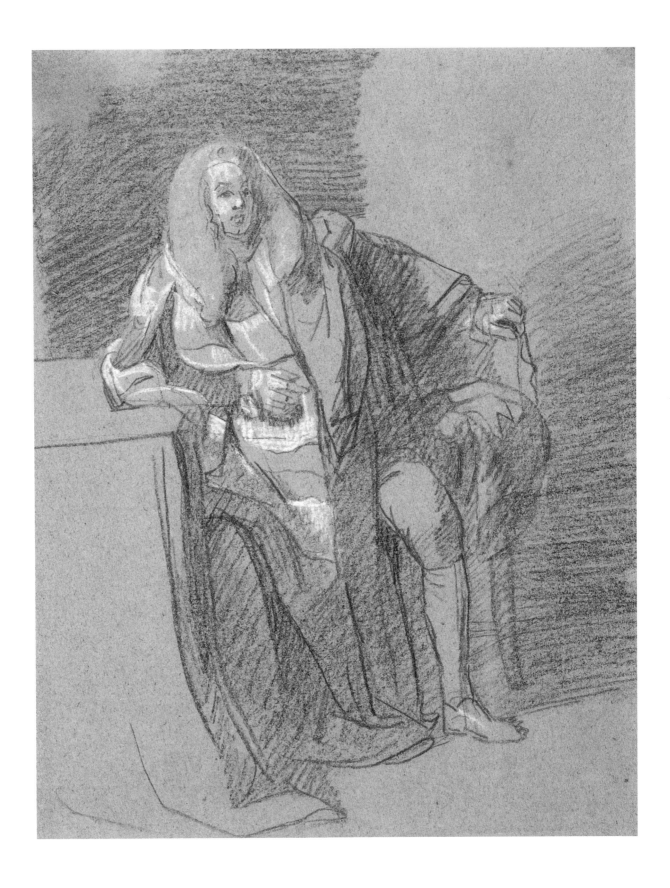

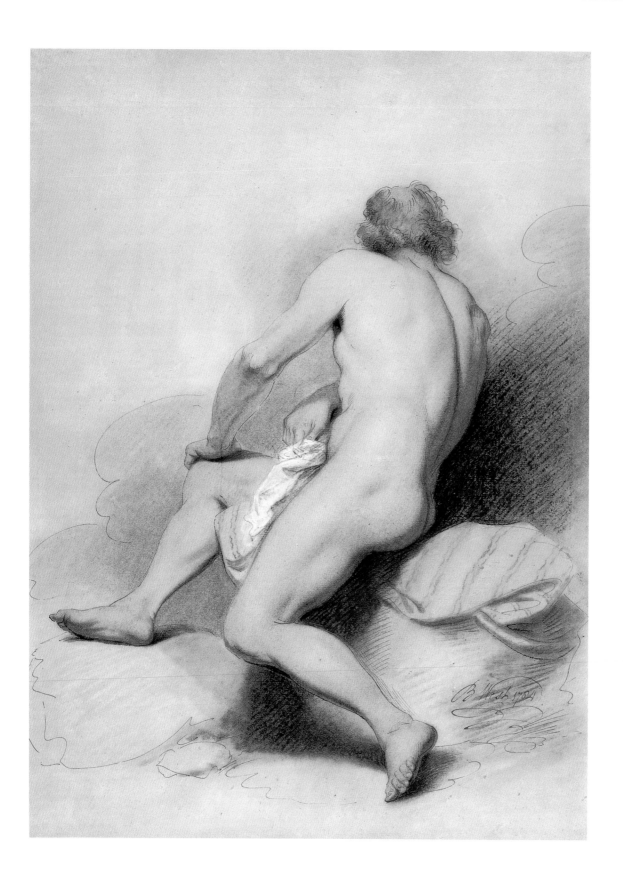

2.

Benjamin West

b. Springfield, Pennsylvania 1738 – d. London, England 1820

Male Nude 1784

Charcoal, chalk and pastel over reed pen and ink on wove paper

24½ x 17⅞ inches (62.2 x 45.4 cm)

From his rural roots in a Quaker town near Philadelphia, Pennsylvania, the aspiring colonial artist Benjamin West departed for Europe in 1760 and eventually became one of the most prominent and influential figures on the international art scene: a founder and president of the Royal Academy in London, England; history painter to King George III; and generous mentor to three generations of American artists.[1]

This exquisite life drawing of an aging, seated male nude, twisting his body away from the viewer to reveal the curve of his spine, and the vigorous musculature of his back, stomach, and legs, descends from a long line of academic poses inspired by statues from ancient Greece and Rome and later Renaissance and Baroque interpretations by Italian Old Masters. West's firm handling and delicacy of line and tone achieves a fine sculptural quality that testifies to his mastery of academic draftsmanship. The study, in fact, may be a demonstration drawing for the many students he taught in his design class at the Royal Academy and the many students who passed through his studio doors, American artists who had no opportunity for academic training at home because it did not, as yet, exist. Further, West scholar Ruth Kraemer has suggested that the drawing may, in fact, have been intended for G. Minasi's *Academical Studies after Great Masters* (London, 1814).[2]

Another West scholar, Allen Staley, suggests the drawing may not relate to any specific painting.[3] It may be worth mentioning, however, that *Male Nude* bears some resemblance to the many studies West produced in preparation for the several commissions for scenes of biblical subjects he received in the 1780s, primarily for King George III's two chapels at Windsor Castle.[4] EBN

Signed in ink lower right: *B West 1784*

Museum purchase made possible by the Endowment Fund in Honor of D.A. Turner 95.1

Provenance: Trevor Reede; Fry Gallery, London; Private Collection, Miami, Florida; Barridoff Galleries Auction, Portland, Maine, August 3, 1994, lot 80

Exhibited: *Sketch, Study and Likeness: Drawings by Benjamin West and his Circle,* Columbus, Georgia, Columbus Museum, September 24, 1995 – January 7, 1996; *Making a Mark; Celebration*

Literature: *Building on a Legacy,* illus.: 113

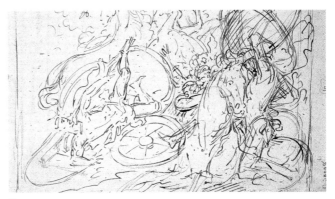

Fig. 34

Fig. 34

Benjamin West

b. Springfield, Pennsylvania 1738 –
d. London, England 1820

Study for The Destruction of Pharaoh and His Host; verso: *The Destruction of Pharaoh and His Host* ca. 1780

Pen and bistre ink on cream-colored laid paper

6½ x 11⅜ inches (16.5 x 28.9 cm)

Promised Gift, Dr. and Mrs. Philip L. Brewer Collection

Provenance: Estate of E. Maurice Bloch; Christie's Auction House, New York, Sale 7206, lot 41, January 9, 1991; Dr. and Mrs. Philip L. Brewer

Exhibited: *Sketch, Study and Likeness: Drawings by Benjamin West and his Circle,* Columbus Museum, September 24, 1995 – January 7, 1996; *Intimate Expressions,* cat. no. 75, illus.: 8; *A Collector's Pursuit of Drawing; Celebration*

Note: This drawing and Fig. 31 are studies for the lost painting, *The Triumph of Moses over Pharaoh and his Host,* intended for the Kings Chapel, Windsor Castle, and exhibited at the Royal Academy in 1792. Related drawings are in the Museum of Fine Arts, Boston and in the Pierpont Morgan Library. Ruth S. Kraemer, *Drawings by Benjamin West and his Son, Raphael Lamar West* (New York: Pierpont Morgan Library, 1975), fig. 23 and fig. 51, pl. 30 respectively.

3.

William Russell Birch

b. Warwickshire, England, 1755 – d. Philadelphia 1834
View above the Upper Ferry Bridge on the Schuylkill River 1796
Watercolor and ink on laid paper
7 x 5½ inches (17.8 x 14 cm)

Shortly after settling in Philadelphia in 1794, the English-born artist William Russell Birch advertised his services as a painter of miniature portraits in enamel.[1] Birch had already been acknowledged in his native England as one of its finest enamel painters; he had studied portraiture with Sir Joshua Reynolds, first president of the Royal Academy, and he came to the United States with the recommendation of the American-born Benjamin West, the Academy's current president.[2]

Although Birch thrived as a portrait miniaturist in America, he quickly saw that there might be other uses for his artistic talents, which included both watercolor and engraving. He was particularly impressed with the architecture and bustle of Philadelphia, the city he had chosen as his residence, which, he wrote, "was less than a century ago, in a state of wild nature; covered with wood, and inhabited by Indians. It has in this short time, been raised, as it were, by magic power, to the eminence of an opulent city, famous for its trade and commerce."[3]

Birch thus conceived of a book – the first of its kind to be published in the United States – that would record, in engraved color plates, those buildings and street scenes "of any consequence" that gave "the true idea of this Metropolis."[4] Although Birch's resulting *City of Philadelphia* would not be published until 1800, he had already set the project in motion by 1796, the year of this watercolor which, though not included among the engravings finally chosen for the book, clearly fits within the artist's larger topographical purpose.[5]

Birch's watercolor style is interesting in its own right, since it combines the generalized, feathery foliage preferred by his teacher Reynolds and Reynolds's contemporary, Thomas Gainsborough, with many features – like asymmetrical composition ("irregularity") and pastoral detail – that were more typical of the "picturesque" aesthetic of such late eighteenth-century British watercolorists as Thomas Girtin and John Robert Cozens. BWC

Inscribed on mount: *Drawn from nature in 1796 by William Birch, enamel painter. Presented to J. Neagle by Thomas Birch 1827*
Museum purchase made possible by the Endowment Fund in Honor of D.A. Turner 98.33
Provenance: The Artist; John Neagle, ca. 1827[6]; Mrs. E.H. Brodhead, Jr.; Sotheby's Arcade Auction, March 25, 1997; Spanierman Gallery, New York
Exhibited: *Celebration*

Fig. 35

Fig. 36

Fig. 35
John Abbot
b. London, England ca. 1751 – d. Bullock County, Georgia 1840
King Bird or Bee-Martin ca. 1790
Watercolor on laid paper
11 x 8½ inches (27.9 x 21.6 cm)
Inscribed lower center: *27*
Museum purchase made possible by the Endowment Fund in Honor of D.A. Turner and Art Acquisition and Restoration Fund 81.9
Provenance: Ibarcord Group S.A. Fine Arts
Exhibited: *Celebration*

Fig. 36
John Abbot
b. London, England ca. 1751 – d. Bullock County, Georgia 1840
Great Annereas Shrike ca. 1790
Watercolor on laid paper
11 x 8½ inches (27.9 x 21.6 cm)
Inscribed lower center: *106 (partially trimmed earlier)*
Museum purchase made possible by the Endowment Fund in Honor of D.A. Turner and Art Acquisition and Restoration Fund 81.10
Provenance: Ibarcord Group S.A. Fine Arts
Exhibited: *Celebration*

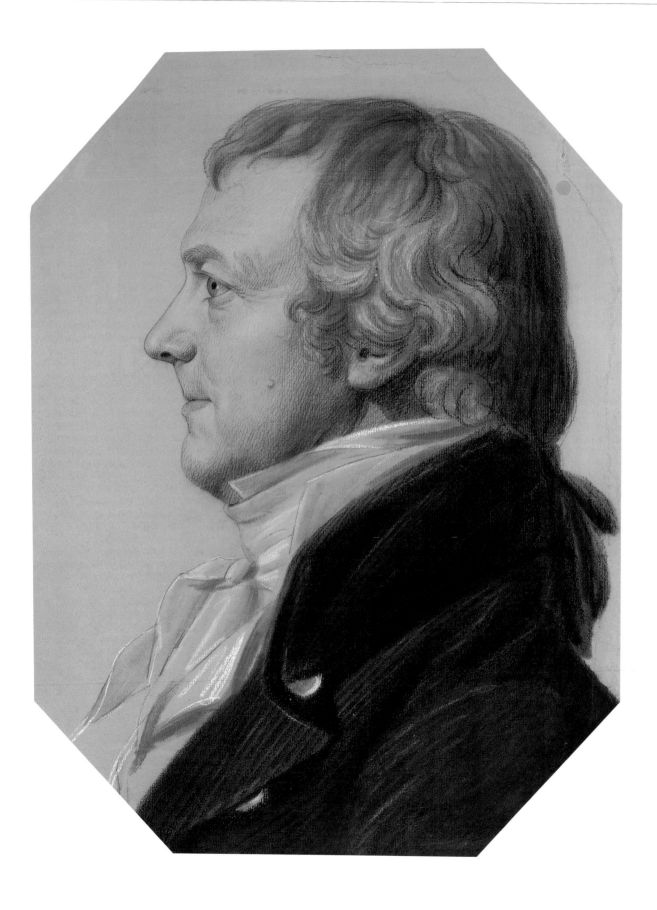

4.

Charles Balthazar Julien Févret de Saint-Memin
b. France 1770 – d. France 1852 (active in U.S. 1793–1814)
Portrait of Thomas Hillen 1804
Pencil, charcoal, and chalk on prepared laid paper
19 x 14 inches (48.3 x 35.6 cm)

Saint-Memin was not a professional artist when he came to the United States as a political refugee from his native France in 1793. He was, however, a talented amateur draftsman and he put this skill to good use during the two decades he resided in America.[1] With another émigré, Thomas Bluget de Valdenuit, he formed a partnership in 1796 to draw portraits in profile using a device called a "physiognotrace," which allowed an artist to make a very precise drawing of a person's profile. Valdenuit returned to France in 1798, but Saint-Memin had a very successful career, here producing likenesses in this distinctive manner of almost everybody who was anybody in federal America. Before beginning a drawing he coated the front of a piece of imported rag paper with a pink wash in order to create a smoother surface on which to draw. With the aid of the physiognotrace he then drew the sitter's profile in black chalk, afterwards adding the person's features in black and white chalks. The result was a very accurate likeness and a much more interesting, detailed, and lively characterization than a mere silhouette.[2]

Saint-Memin traveled from New York City to Charleston, South Carolina, making portraits, and worked in Baltimore at various times between 1803 and 1807. The drawing of Thomas Hillen (1759–1847) was almost certainly done in 1804. He was an important merchant who resided at the punningly named Hillendale in Baltimore County. His portrait, with its strong, vigorous draftsmanship, is an excellent example of Saint-Memin's work and well captures his subject's shrewd character. Hillen paid eight dollars for it. For an additional seventeen dollars Saint-Memin would have engraved it and delivered up not only the drawing but also a copperplate and twelve impressions, but Hillen did not avail himself of this opportunity. The artist had so many sitters—most of whom ordered the copperplate and impressions—that it generally took him several weeks to engrave them all, and Hillen may not have wanted to wait to take possession of his portrait. It is still in its original frame.[3] DM

Inscribed verso: *This picture of Thomas Hillen of Baltimore, Md. was made by St. Memin in 1804*
Gift of Dr. and Mrs. Philip L. Brewer in honor of the Museum's 50th Anniversary 2003.38.7
Provenance: Eleanor Hillen Sanders (Mrs. Beverly C.); Macbeth Galleries, New York; Ginsberg and Levy, New York; Richard Heald, Worcester, Massachusetts; Hirschl & Adler Galleries, New York; Dr. and Mrs. Philip L. Brewer
Exhibited: *American Drawings and Watercolors*, Hirschl & Adler Galleries, New York, October 6 – October 20, 1979, cat. no. 91, illus.; *American Art from the Colonial and Federal Periods*, Hirschl & Adler Galleries, New York, 1982, cat. no. 49, illus.: 64; *American Masterworks on Paper*, Hirschl & Adler Galleries, New York, November 23, 1985 – January 4, 1986, cat. no. 91, illus.: 9; *Local Wonders: Treasures of American Art in Columbus Collections*, Columbus Museum, February 6 – May 29, 1994; *Intimate Expressions*, cat. no. 64, illus.: 10; *A Collector's Pursuit of Drawing; Celebration; Building on Strength*
Literature: Stephen Decatur, "Charles Balthazar Julien Févret de Saint-Memin," *American Collector* (June 1944): 9, cat. no. 13; Ellen G. Miles, *Saint-Memin and the Neoclassical Profile in Portrait in America* (Washington, D.C.: National Portrait Gallery and Smithsonian Press, 1994), cat. no. 416, illus.: 119, 320

Fig. 37
Joseph Wood
b. near Clarkstown, New York ca. 1778 – d. Washington, D.C. 1852
Postmaster General William Joseph Habersham 1811
Ink and wash on laid paper
7 x 5 inches (17.8 x 12.7 cm)
Signed lower right: *Joseph Wood*, and inscribed and dated lower center: *P. Gen. Wm. Joseph Habersham 1811, Savannah, Ga*
Museum purchase 80.49.1
Provenance: Craig & Tarleton, Inc., Raleigh, North Carolina
Exhibited: *People, Places, Animals; Celebration*

Fig. 37

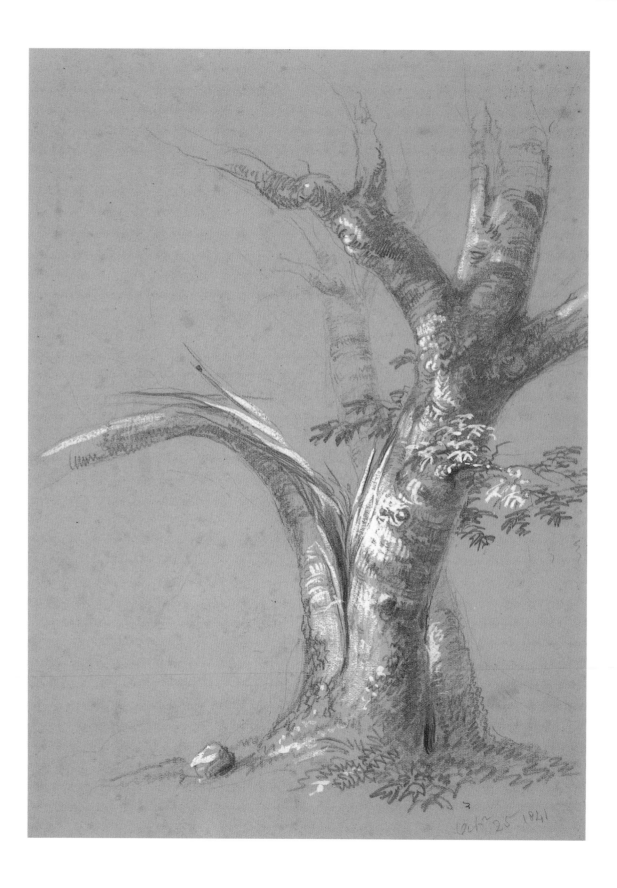

5.

Thomas Cole

b. Bolton-on-Moors, England 1801 – d. Catskill, New York 1848

Study of a Blasted Tree 1841

Pencil and gouache on brown-colored wove paper

14 x 10 inches (35.6 x 25.4 cm)

For Thomas Cole—the "father of Romantic landscape painting in America"—trees played a vital symbolic role in his interpretation of nature. Cole saw the untamed American wilderness—and its trees—as significantly different from civilized European scenery, where "the primitive features have long since been destroyed or modified."[1] "Trees are like men," Cole wrote, "differing widely in character."

In sheltered spots, or under the influence of culture, they show few contrasting points. But in exposed situations, battling with the elements and with one another for the possession of a morsel of soil or a favoring rock—they exhibit striking peculiarities, and sometimes grand originality.[2]

As Cole saw it, ancient trees, the "monarchs of the forest," gnarled, weather-beaten and often split by lightning, posed an especially significant parallel to human experience. In his monumental four-part series, *The Voyage of Life*, the third painting in the series, describing *Manhood*, stands out for its grim, storm-tossed imagery.

Trouble is characteristic of manhood. In childhood and youth there is no despairing thought. It is only when experience has taught us the realities of the world that we lift from our eyes the golden veil of early life. In the picture, the gloomy tone, the conflicting elements, the trees riven by tempest, are the allegory.[3]

Although Cole drew *Study of a Blasted Tree* during a tour of the Swiss Alps in late October 1841, by the artist's own admission the tree was found in a landscape that reminded him more of "our own Catskills, their forms and forests," than of any of his earlier preconceptions of European scenery. The "savage grandeur" of the Alpine landscape, with its "stupendous mountains" and "dark forests" inspired him to paint a second version of *The Voyage of Life*, whose own scene of *Manhood* incorporates this sketch.[4] BWC

Inscribed lower right: *Oct 25, 1841*

Gift of Dr. and Mrs. Philip L. Brewer 2001.16.3

Provenance: Private Collection, New Jersey; Gift to a New York Foundation; Jill Newhouse, New York; Dr. and Mrs. Philip L. Brewer

Exhibited: *Local Wonders: Treasures of American Art in Columbus Collections,* Columbus Museum, , February 6 – May 29, 1994; *Hudson River in Private Collections in Georgia,* Georgia Museum of Art, Athens, Georgia, March 1995, no. 2; *Intimate Expressions,* cat. no. 15, illus.: 10–11; *A Collector's Pursuit of Drawing; Celebration*

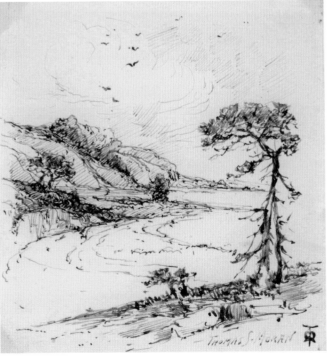

Fig. 38

Fig. 38

Thomas Sydney Moran

b. Bolton, England 1837 – d. Santa Barbara, California 1926

Landscape with River ca. 1866

Pen and ink on wove paper

3¾ x 3¼ inches (9.5 x 8.3 cm)

Signed in ink lower right: *THOMAS S. MORAN* followed by his monogram in ink

Gift of Lt. Col. and Mrs. Chester I. Christie 72.35

Provenance: Lt. Col. and Mrs. Chester I. Christie

Exhibited: *American Drawings from the Permanent Collection,* Columbus Museum, February 22 – May 28, 1990; *People, Places, Animals; Making a Mark; Celebration*

6.

George Harvey
b. 1799 – d. 1880, Tottenham, England
Children's Outing on the Cape 1847
Watercolor and gouache on buff-colored wove paper
12¾ x 19 inches (32.4 x 48.3 cm)

George Harvey immigrated to America in 1820 and spent several years in Ohio and Michigan "hunting and trapping, scribbling poetry and prose, drawing and sketching."[1] He also worked as a painter of miniatures, executing hundreds of intricate portraits and flower pictures on ivory using a method of applying pigment in tiny dots.[2] By the 1830s he had settled in Hastings-on-Hudson, just north of Manhattan, where his "exercises in the open air led him particularly to study and notice the ever-varying atmospheric effects of the American climate…and illustrate them with his pencil."[3] Produced between 1835 and 1840, the resulting "Atmospheric Landscapes" represent a milestone as the only series of American drawings devoted to specific regions at different times of day under varying weather conditions.[4] The artist's sensitive eye and miniaturist technique enabled him to render topographical details and meteorological conditions with remarkable clarity and precision.

Childrens Outing on the Cape exhibits the hallmarks of Harvey's empirical approach to documenting broad landscape settings in which elements of civilization are meticulously described, but rendered subordinate to nature. The scene presents a panoramic sweep of coastal life as the sun has begun to redden the low horizon. Using the minute strokes of a miniaturist, he describes in detail a group of fashionably dressed children as they socialize along the edge of a small village—perhaps an English village given the specific architectural details.[5]

Despite Harvey's extensive experience as a portrait painter, the relatively tiny figures appear as little more than props included for a sense of scale and period context. Drawing attention from the comparatively drab world below are luminous veils of cirrus clouds, whose distinctive forms are carefully described in broad hatches of gouache. Harvey's exacting technique would prove influential to the Pre-Raphaelites, and his focus on painting out of doors to capture the fleeting effects of light and atmosphere anticipates in many ways the concerns of the Impressionists. SCW

Signed and dated lower right: *G. Harvey 1847*
Promised Gift, Dr. and Mrs. Philip L. Brewer Collection
Provenance: Kennedy Galleries, New York; Dr. and Mrs. Philip L. Brewer
Exhibited: *Intimate Expressions*, cat. no. 39, illus.: 67, pl. 3; *A Collector's Pursuit of Drawing*; *Celebration*

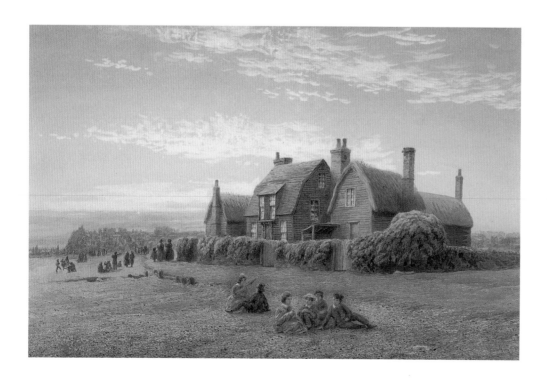

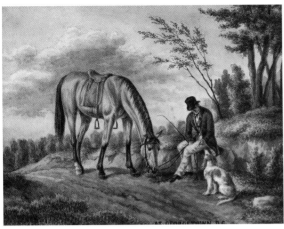

Fig. 39

Fig. 40

Fig. 41

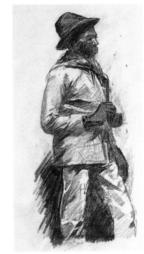

Fig. 42

Fig. 39
Augustus Kollner
b. Düsseldorf, Germany 1812 –
d. Philadelphia 1906
Virginia Horse 1840
Watercolor on wove paper
9⅜ x 12¼ inches (23.8 x 31.1 cm)
Signed lower right: *A. Kollner fecit*
Inscribed lower center: *AT GEORGETOWN, DC* and inscribed verso: *Virginia Horse, Georgetown, Dist. Columbia, US, 1840, A Kollner* [illegible], *Phila 1890*
Promised Gift, Dr. and Mrs. Philip L. Brewer Collection
Provenance: Christie's Auction House, New York, Sale 7253, lot 3, November 11, 1991; Dr. and Mrs. Philip L. Brewer
Exhibited: *Celebration*

Fig. 40
Felix Octavius Carr Darley
b. Philadelphia 1822 – d. Claymont, Delaware 1888
The Fatigued Sportsman 1845
Ink wash on wove paper
8¼ x 6 inches (21 x 15.2 cm)
Signed and dated lower right: *FOC Darley Fecit Aug 11th 1845* and inscribed lower center: "*The Fatigued Sportsman*"
Dr. and Mrs. Philip L. Brewer Collection, Museum purchase made possible by the Ella E. Kirven Charitable Lead Trust for Acquisitions 2003.1.12
Provenance: Dr. William Schreiber, Philadelphia; Dr. and Mrs. Philip L. Brewer
Exhibited: *Celebration*

Fig. 41
James H. Cafferty
b. Ireland 1819 – d. New York City 1869
Mr. Robertson's Boy with a Fishing Pole ca. 1850–1860
Watercolor on wove paper
18 x 14¼ inches (45.7 x 36.2 cm)
Dr. and Mrs. Philip L. Brewer Collection, Museum purchase made possible by the Ella E. Kirven Charitable Lead Trust for Acquisitions 2003.1.6
Provenance: Vose Galleries, Boston; Dr. and Mrs. Philip L. Brewer
Exhibited: *A Collector's Pursuit of Drawing, Intimate Expressions* (Columbus only, not in catalogue); *Celebration*
Literature: David Stewart Hull, *James Henry Cafferty, NA (1819–1869), A Catalogue Raisonné,* (New York: New-York Historical Society, 1986), no. 18: 46

Fig. 42
Gilbert Gaul
b. Jersey City, New Jersey 1855 –
d. New York City 1919
Standing Man with a Long Pipe ca. 1870
Charcoal on buff-colored wove paper
15⅞ x 8½ inches (40.3 x 21.6 cm)
Signed lower middle: *Gilbert Gaul*
Museum purchase 84.55
Provenance: John L. Petty
Exhibited: *Celebration*

7

John William Hill

b. London, England 1812 – d. West Nyack, New York 1879
Haying ca. 1850
Watercolor and gouache on wove paper
5⅜ x 6⅞ inches (13.7 x 17.5 cm)

John William Hill was one of the leaders of the American Pre-Raphaelite movement of the mid-nineteenth century. Following the example and precepts of their hero, John Ruskin, the English writer, watercolorist and aesthetic theorist who inspired several generations of artists and designers, the American Pre-Raphaelites treasured descriptive precision, consummate technique, and a reverence for the divine creativity that infuses every corner of nature.

Long before he "converted" to a Ruskinian perspective in 1855, however, Hill had already achieved a considerable degree of artistic respect. Apprenticed to his father, John Hill, an immigrant engraver from London, by age sixteen Hill was already exhibiting at New York City's National Academy of Design. In the 1830s and 40s he was employed by the New York State Geological Survey as a topographical artist. In 1850 he helped found the New York Water Color Society, the first American art association dedicated to what was then still thought of as an ephemeral and minor art. It could justly be said that, more than any other American artist, J.W. Hill revolutionized the appreciation of watercolor as a fine art medium.

Based on stylistic evidence, *Haying* probably dates to the early 1850s, before Hill had fully adopted the intensified color and almost maniacal attention to every leaf, blade of grass and geological contour that came to characterize his later Pre-Raphaelite watercolors. Nonetheless, the panoramic sweep of *Haying*'s landscape, the prominence of the foreground profusion of wildflowers, the layered sense of distance, and the carefully ordered placement of figures and buildings foreshadow his later work as well as his appreciation of the importance of harvest imagery, in a typically American iconography that emphasizes both the abundance of the land and, at the same time, the inexorable passage of the seasons. BWC

Signed lower left: *J.W. Hill*
Gift of Dr. and Mrs. Philip L. Brewer 2002.47.5
Provenance: Kitty Curry, Stonedene Mansion, Suisun, California; Dr. and Mrs. Philip L. Brewer
Exhibited: *Hudson River Paintings in Private Collections in Georgia*, Georgia Museum of Art, Athens, Georgia, March 1995; *Intimate Expressions* (Columbus only); *Celebration*, illus. gallery guide, unpaginated

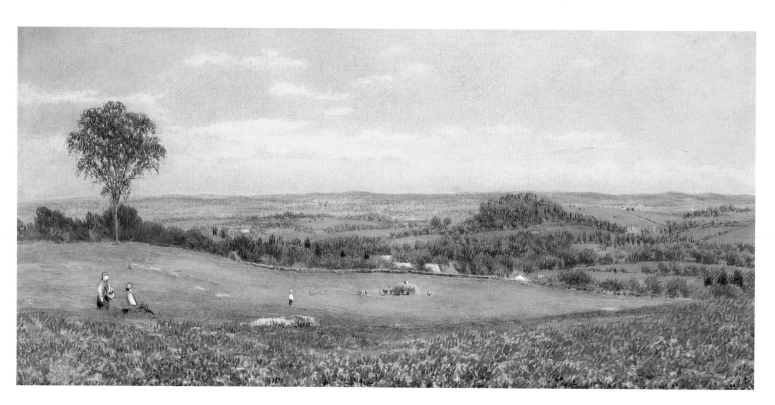

8
John Gadsby Chapman
b. Alexandria, Virginia 1808 – d. Tottenville, New York 1889
Shepherdess, Holding Sheaf of Hay 1852
Pen and ink on buff-colored wove paper
14 x 10¼ inches (35.6 x 26 cm)

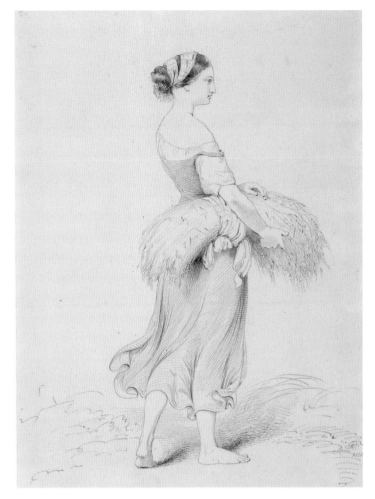

John Gadsby Chapman's greatest professional accomplishment—and disappointment—was his monumental mural for the United States Capitol rotunda, *The Baptism of Pocahontas*, unveiled in 1840. When it was unjustly criticized for its "obscure" subject matter and "flawed" draftsmanship, it brought his aspirations as a history painter to a standstill. As if in reply to his critics, Chapman spent the better part of the next decade producing what is still his proudest achievement, *The American Drawing Book: A Manual for the Amateur, and Basis of Study for the Professional Artist*, which continued in publication from 1847 to 1877 in a number of American and English editions and which remained the premier book of American drawing instruction until the end of the nineteenth century.

Described universally as of a "happy disposition, pleasant self-confidence and humorous charm"[1] and as a multitalented artist constantly at work on some new project, Chapman nonetheless suffered from fragile health, and in 1848 moved to Europe in the hope of improving both his medical and artistic fortunes. Settling in Rome in 1850, he abandoned book illustration, which had been his primary source of income for many years, and began to produce paintings and etchings of the Italian countryside and people that were tailored to the thriving tourist trade. Political revolutions in Italy and the American Civil War brought a halt to that trade, leading to a drastic decline in Chapman's fortunes, and he eventually died a pauper in Tottenville, New York, in 1889.

Chapman's elegantly drawn Italian scenes from the last half of his career have received less notice in recent years than his earlier works, but if *Shepherdess, Holding Sheaf of Hay* of 1852 is any indication, they were of sufficient quality to command the attention of one of America's greatest nineteenth-century collectors, Henry G. Marquand, a prominent New York banker and art patron, and the third president of the Metropolitan Museum of Art.[2] BWC

Signed with monogram and dated lower right: *JGC/Roma/1852*
Promised Gift, Dr. and Mrs. Philip L. Brewer Collection
Provenance: Henry G. Marquand, New York; Dr. and Mrs. Philip L. Brewer
Exhibited: *Intimate Expressions*, cat. no. 13, illus.: 9; *Celebration*

9

John Mackie Falconer

b. Edinburgh, Scotland 1820 – d. Brooklyn, New York 1903
Washing Day Down South in Georgia possibly 1853[1]
Watercolor on brown-colored wove paper
10½ x 15¼ inches (26.7 x 38.7 cm)

Hardware merchant, art collector, organizer, and amateur painter and engraver, John M. Falconer was a key contributor to the greater New York City art community for over half a century, from the 1840s to the 1890s.[2] His professional affiliations ranged from the National Academy of Design to the Artists' Fund Society, the American Water-Color Society, and the Brooklyn Art Association, which he helped to establish. He was a close friend and frequent correspondent with some of the leading painters of the century, from Thomas Cole and William Sidney Mount to Jasper F. Cropsey and Samuel Colman.

Falconer's first love, however, and the dominant subject of his watercolors and prints, was the rapidly disappearing physical evidence of the American past, from Dutch colonial houses on Long Island to Revolutionary-era forts. He traveled widely in search of such historic structures, from Boston to Missouri and Virginia; he sometimes even captured the look of houses at the very moment they were being demolished. "Mr. Falconer has an open eye for the poetry of decay," wrote S.R. Koehler, an early historian of American engraving. "Most of his plates are devoted to the representations of decrepit buildings and similar subjects,

attractive only to the lover of picturesque ruins. …To most of us, the rickety old wooden houses in the side streets, ready to collapse, even if they be historic landmarks, are only conducive to a desire to see them vanish before 'the march of improvement.'"[3]

The same antiquarian impulse led Falconer to explore and document some of the South's most characteristic vernacular structures, the log cabins that could still have been seen from Tidewater Virginia to the Natchez Trace. The houses that appear in *Washing Day Down South in Georgia* are typical "single pen" cabins; the details of their construction suggest a lowland or coastal setting.[4] There is nothing in the scene to indicate that these are part of a larger plantation slave quarters; indeed, the festive communal laundry scene that forms the composition's focus may even indicate an independent black settlement. BWC

Signed lower right: *Falconer*
Museum purchase made possible by the Art Acquisition and Restoration Fund 98.1.1
Provenance: Artist's Estate Sale; Babcock Gallery, New York
Exhibited: *Celebration*
Literature: Anderson Auction Company, *Catalogue of the interesting and valuable collection of oil paintings, water-colors and engravings formed by the late John M. Falconer (Brooklyn, N. Y.), for sale at auction, Thursday and Friday, April 28 and 29, 1904 by the Anderson Auction Company* (New York: Anderson Auction Company, 1904), lot 476, as "'Washing Day down South in Georgia.' Clever water-color of negro huts and negroes actively employed in open-air washing."

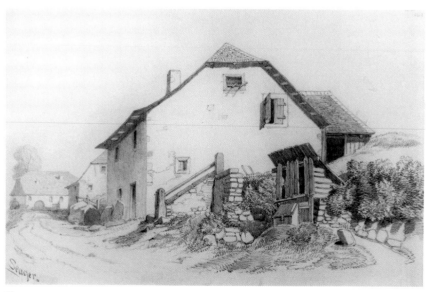

Fig. 43
Edward Seager
b. 1809 – d. 1886, active Rhode Island
The Homestead ca. 1840–1850
Pencil on wove paper
9 x 14 inches (22.9 x 35.6 cm)
Signed lower left: *Seager*
Dr. and Mrs. Philip L. Brewer Collection, Museum purchase made possible by the Ella E. Kirven Charitable Lead Trust for Acquisitions 2003.1.27
Provenance: Christie's East, New York; Dr. and Mrs. Philip L. Brewer
Exhibited: *Celebration*

Fig. 43

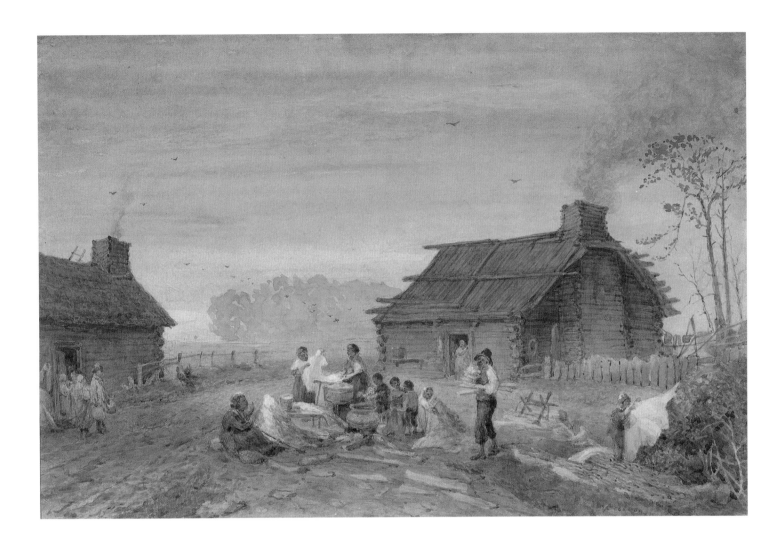

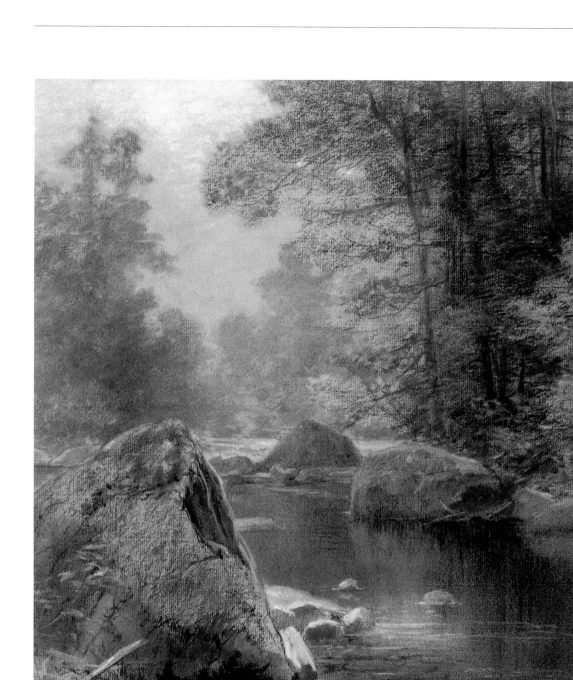

10.
Francis Hopkinson Smith
b. Baltimore, Maryland 1838 – d. New York City 1915
A Quiet Stream ca. 1870
Charcoal and white chalk on buff-colored laid paper
21¼ x 16 inches (54 x 40.6 cm)

Drawing and painting were but two of Francis Hopkinson Smith's many talents. As a mechanical engineer, he was involved in constructing the Statue of Liberty's foundation and the Race Rock Lighthouse.[1] Smith was also a world traveler and storyteller who spun tales from his adventures into popular short stories for which he produced detailed illustrations. By the 1870s, the artist was traveling far and wide in search of scenic locales to serve as the basis of his charcoal drawings and watercolors. Although self-taught, Smith was noted for his ability to create a detailed rendering of a particular setting with great speed and confidence. He joined the New York Tile Club, an artists' association in which he mingled with William Merritt Chase, Elihu Vedder, Edwin Austin Abbey, and other prominent members.[2]

A Quiet Stream represents Smith's talent for conveying picturesque subjects in a manner that is both poetic and highly descriptive.[3] Although its geographical setting is unknown, the work may be one of several he produced on Tile Club boat trips to Lake Champlain and other rustic destinations.[4] This scene depicts a tranquil waterway, punctuated by large boulders, as it meanders through unspoiled woodlands. Using charcoal, the color of the page, and occasional accents of white chalk, he modulates subtle gradations of tone in order to capture the fleeting effects of light and atmosphere.[5] Smith convincingly differentiates rock from foliage and material objects from their reflections through a broad and sophisticated vocabulary of marks. Such differentiation would diminish after 1900 when, under the influence of Impressionism, he began to define the material world in soft, loose strokes.[6] Produced during a time of rapid industrialization, Smith's idyllic compositions provided much-needed refuge for urban audiences increasingly detached from nature. SCW

Signed lower left: *F. Hopkinson Smith*
Promised Gift, Dr. and Mrs. Philip L. Brewer Collection
Provenance: Spanierman Gallery, New York; Dr. and Mrs. Philip L. Brewer
Exhibited: *Intimate Expressions*, cat. no. 69, illus.: 55; *Celebration*

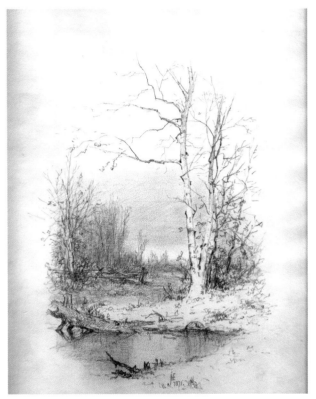

Fig. 44

Fig. 44
Jervis McEntee
b. 1828 – d. 1891, Rondout, New York
Pond with Trees 1871
Pencil on wove paper
14 x 10¼ inches (35.6 x 26 cm)
Signed with conjoined initials and dated lower center: *JmcE, 1871*
Dr. and Mrs. Philip L. Brewer Collection, Museum purchase made possible by the Ella E. Kirven Charitable Lead Trust for Acquisitions 2003.1.23
Provenance: Henry G. Marquand, New York; Dr. and Mrs. Philip L. Brewer
Exhibited: *Intimate Expressions* (Columbus only, not in catalogue); *Celebration*

11.

William Trost Richards
b. Philadelphia 1833 – d. Newport, Rhode Island 1905
Beach Scene, East Gloucester ca. 1871
Watercolor and gouache on light gray-colored wove paper
8⅜ x 13¾ inches (21.3 x 34.9 cm)

It was only after Richards's return from Europe in late 1867 that he began seriously to explore the "combinations of rock and beach and sea" that were to become his stylistic hallmark.[1] Legend has it that the stormy crossing from England so reinforced Richards's respect for the sea's power that he determined thereafter to focus on marine subjects. Richards was equally at home in oil and water-color, although his ability to utilize watercolor's transparency and his aptitude for the fleeting effects of sunlight—enhanced by the use of opaque Chinese white in the highlights—made him one of his generation's master watercolorists.

Slight of build, unassuming, and intensely domestic in his habits, Richards would nonetheless spend hours standing in the surf studying the action of tide, waves, and wind. "I watch it and watch it," he wrote,

[and] try to disentangle its push and leap and recoil, always star-tled out of my self-possession by the thunder and the rush—jump backward up the loose shingle of the beach, sure this time I will be washed away; get soaked with spray, and am ashamed that I had missed getting the real drawing, and this happens 20 times in an hour, and I have never yet got used to it.[2]

This meticulous approach to nature continues to impress with its directness and simplicity. His painstaking approach to the facts, wrote one admirer, "worked a revelation, and it will never again be possible to make the world accept the old-fashioned wave drawing for accurate representation."[3] Yet for Richards it was as much a matter of poetry as of science. His favorite author was William Wordsworth, with whom Richards shared a basic aesthet-ic: "There was to be no more artificiality, no more theatrical appeal. The mellow English speech was to return to the nursery and it was to tell tales of plain life, unvarnished nature, [and] simple reality."[4]

Beach Scene, East Gloucester was painted during the summer either of 1871 or 1872, the only years when Richards is known to have visited that locale. BWC

Inscribed verso: *East Gloucester (about 1871)*
Promised Gift, Dr. and Mrs. Philip L. Brewer Collection
Provenance: Descended in the family of the Artist; Jill Newhouse, New York; Dr. and Mrs. Philip L. Brewer
Exhibited: *Intimate Expressions*, cat. no. 59, illus.: 68, pl. 5; *A Collector's Pursuit of Drawing*; *Celebration*

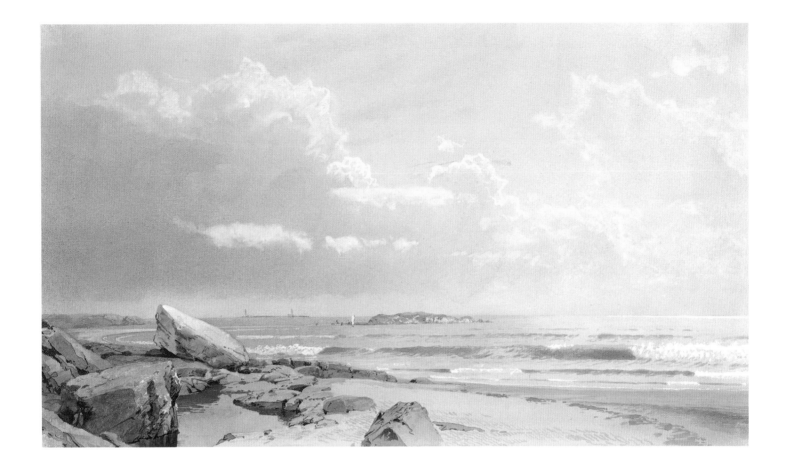

12.

David Johnson

b. New York City 1827 – d. Walden, New York 1908

Pine, Lake George 1871

Pencil on wove paper

12½ x 19 inches (31.8 x 48.3 cm)

While most of his Hudson River School counterparts celebrated America's landscape at its most spectacular, David Johnson depicted nature's ordinary beauty with quiet reverence. His paintings and drawings reflect a Pre-Raphaelite attention to detail and a Hudson River School emphasis on sense of place. By the late 1850s, the largely self-taught artist was venturing out from New York City each summer for sketching trips in the Hudson River Valley, the Catskills and the White Mountains. Rather than attempting to encompass broad expanses of wilderness, he created intimate sketches of rock formations and individual trees as a more direct means of revealing nature's underlying truths.[1]

Rendered near the height of his career at a favorite sketching location in upstate New York, *Pine, Lake George* epitomizes Johnson's draftsmanship in its methodical execution, botanical accuracy, and inclusion of field notes.[2] It is likely a study for *A View on Lake George (Paradise Bay)*, painted in 1876, given the similarity between the distinctive branch patterns of the right-hand tree in the drawing and those of a large pine that dominates the right side of the canvas. Notable are Johnson's masterful adjustments in the speed and weight of line in order to capture the thrust of branches into space and the rhythmic cadence of shadows beneath dense needle clusters. This balance between line and tone places the work in a transitional period between the artist's linear phase in which the contours of a subject are often set against a blank page, and his later tonal phase in which dramatic shadow and washes of pigment define landscape elements within fully realized settings.[3] In its clarity, virtuosity, and monumentality, *Pine, Lake George* represents Johnson at the height of his powers and attests to his unique ability to transform individual studies into eloquent, concise statements of nature's beauty and infinite complexity. SCW

Signed with monogram dated and inscribed lower center: *DJ 1871 Pine, Lake George*

Dr. and Mrs. Philip L. Brewer Collection, Museum purchase made possible by the Ella E. Kirven Charitable Lead Trust for Acquisitions 2003.1.38

Provenance: Graham Gallery, New York; Dr. and Mrs. Philip L. Brewer

Exhibited: *Meditations on Nature: The Drawings of David Johnson*, Hudson River Museum, Yonkers, New York, 1987, cat. no. 32, illus.: 57; *Intimate Expressions*, cat. no. 6a, illus.: 61; *Celebration*

Fig. 45

Henry Farrer

b. London, England 1843 – d. Brooklyn, New York 1903

Tree Study ca. 1860s

Pencil on wove paper

11⅝ x 8¼ inches (29.5 x 21 cm)

Gift of Dr. and Mrs. Theodore E. Stebbins, Jr., in honor of Chris and Kathleen Hohlstein 2003.18

Provenance: Dr. and Mrs. Theodore E. Stebbins, Jr.

Exhibited: *Building on Strength*

Fig. 46

William Trost Richards

b. Philadelphia 1833 – d. Newport, Rhode Island 1905

Study of Tree Bark 1862

Pencil on buff-colored wove paper

8³⁄₁₆ x 5⅛ inches (20.8 x 13 cm)

Dated lower right: *June 1862*

Gift of Dr. and Mrs. Philip L. Brewer in honor of the Museum's 50th Anniversary 2003.38.5

Provenance: By descent in the family of the Artist; Jill Newhouse, New York; Dr. and Mrs. Philip L. Brewer

Exhibited: *Never at Fault, the Drawings of W. T. Richards*, Hudson River Museum, Yonkers, New York, February 2 – May 4, 1986, cat. no. 53, illus.: 70; *Intimate Expressions* (Columbus only); *Celebration*

Literature: Linda S. Ferber, *Never at Fault, the Drawings of W. T. Richards* (Yonkers, N.Y.: Hudson River Museum, 1986), 70, no. 53

Fig. 45 Fig. 46

13.
Alfred Thomson Bricher
b. Portsmouth, New Hampshire 1837 – d. New Dorp, Staten Island,
New York 1908
Narragansett Bay 1874
Watercolor and gouache on wove paper
19¾ x 15½ inches (50.2 x 39.4 cm)

Alfred T. Bricher first exhibited his watercolors in 1873. They were
highly praised at the time for their crisp realism, luminosity, and
sense of repose, and they instantly won him membership of the
American Society of Painters in Water Colors, which had been
founded just seven years earlier by Samuel Colman and William
Trost Richards.[1]

The American watercolor movement of the last third of the
nineteenth century remains one of the defining moments in
American art, attracting as it did some of the premier artists of the
era such as Winslow Homer, Thomas Eakins, Maurice
Prendergast, and John Singer Sargent. Bricher was one of the pio-
neers of this development, translating the coastal landscapes of his
friends Martin J. Heade, John F. Kensett, and William S. Haseltine
into carefully measured trilogies of worn sandstone rocks and
cliffs, cloud-filtered skies, and translucent waves.

Although Bricher had painted a wide range of familiar
American landscapes early in his career, he found his defining sub-
ject on his first visit to Narragansett Bay, in Rhode Island, in 1871.
The isolation of its still uncrowded coasts appealed to his desire for
clarity and order, and for the next seven years its seas and shores
almost became an obsession. Most of Bricher's views of
Narragansett Bay are dramatically horizontal; this watercolor is
unusual in its vertical format, which allows him to experiment with a
series of parallel diagonals that he plays against the rectilinearities of
both horizon and frame. He further achieves a feeling of crystalline
calm by the use of classic mathematical divisions of the picture
plane and the subtle use of repeated highlights. Bricher's precise,
objective vision of nature often set him apart from his contempo-
raries, and forms his greatest appeal to modern viewers. BWC

Signed and dated lower left: *A. T. Bricher 1874*
Gift of Dr. and Mrs. Philip L. Brewer 2002.47.3
Provenance: Richard Bourne Auction, Cape Cod, Massachusetts, lot 84, August 20,
1991; Dr. and Mrs. Philip L. Brewer
Exhibited: *Hudson River in Private Collections in Georgia*, Georgia Museum of Art,
Athens, Georgia, March 1995, no. 1; *Intimate Expressions* (Columbus only, not in
catalogue); *A Collector's Pursuit of Drawing*; *Celebration*

14.

William Morris Hunt

b. Brattleboro, Vermont 1824 – d. Boston, Massachusetts 1879

Child at Water's Edge ca. 1877

Charcoal on buff-colored wove paper

9¾ x 15¾ inches (24.8 x 40 cm)

William Morris Hunt cut an impressive figure as an artist in post-Civil War Boston. His Tennysonian beard, bohemian dress, and Parisian manners charmed the ladies, while his impeccable tact and ethereal nature calmed their husbands and fathers. It did not hurt that his brother, Richard, was everyone's favorite architect.

Hunt favored charcoal above all other drawing media. Pencil and ink still remained the traditional means of American drawing in the 1870s, although watercolor and, more recently, pastel, had also come into vogue, but Hunt, with his French training and admiration for the Barbizon painters, had come to prefer charcoal for its facility, flexibility, and textural richness. "Painting," Hunt once claimed," is vulgar by the side of a fine charcoal drawing. Imagination and suggestion are everything in art. Harmony is the great thing to strive for and one is surer of this in black and white."[1] Above all, Hunt preached simplicity. "You are to draw not reality, but the *appearance* of reality. Look first for the big things. Get the effect of light, and you won't miss color!"[2]

After the destruction of his studio and most of his earlier artworks in the Great Fire of Boston in November 1872, Hunt decided to focus his attention on landscape, and in the ensuing years painted and drew along Boston's North Shore, most notably at Magnolia, near Gloucester. *Child at Water's Edge* was probably executed at Magnolia in 1877. Its technique neatly summarizes Hunt's ease of execution which nonetheless results in memorable effect, a phenomenon perhaps best described by a contemporary, Henry Angell:

He went on with his drawing. There were the dark willows at the edge of the water, the shoreline and the hills far away, the exquisitely tender clouds just over them, and the whole reflected in the water with a success so disproportioned to the apparent labor that it seemed like magic.[3] BWC

Signed with monogrammed initials lower left: *WMH*

Promised Gift, Dr. and Mrs. Philip L. Brewer Collection

Provenance: Family of the Artist; Hope Davis Fine Art, New York; Dr. and Mrs. Philip L. Brewer

Exhibited: *The Return of William Morris Hunt*, Vose Gallery, Boston, September 30 – November 26, 1986, cat. no. H–42, illus.: 12; Joan Whitney Payson Gallery of Art, Portland, Maine, September 1 – October 7, 1987; *Intimate Expressions*, cat. no. 42, illus.: 13; *A Collector's Pursuit of Drawing*; *Celebration*

15.

Winslow Homer

b. Boston, Massachusetts 1836 – d. Prout's Neck, Maine 1910

Pond Lilies 1884

Charcoal, chalk, and gouache on laid paper

17 x 23 inches (43.2 x 58.4 cm)

Winslow Homer's early career was supported largely from commercial book and magazine illustrations. His Civil War work as a pictorial reporter for *Harper's Weekly* reflects his early ability to draw with intense power and emotion. In 1881 he went to England, where he worked mostly in watercolor. Upon his return in late 1882, he was utterly captivated by the fishermen and the raging sea. At this time, he produced *Fisher Girl with Net* (ca. 1882, Sterling and Francine Clark Institute, Williamstown, Massachusetts)—a powerful and liberating drawing.

In *Pond Lilies*, there is no narrative, no sentiment, and no nostalgia. Tone and compositional structure capture the essence of man at peace with nature. Here, without story line, is a glimpse of the souls of Mark Twain and Henry David Thoreau.

His charcoal, chalk, and gouache create a fluidity that is reminiscent of his greatest watercolors. In addition, the bow of the boat's sepia tones curves diagonally upward in the picture plane with such gentle and sure ease. Hold on though—this curving rhythm is halted by the forceful counter angle of the young girl's reaching arm. The contrasting direction of this arm disturbs the tranquility of the space as our eye is led to this intense, youthful face. The figure holds steady on the bow with a taut left arm. Again, this tension is reinforced with the highlighted, white flowing folds of her shirt. Here Homer creates a very interesting and triangular juxtaposition between the peaceful serenity of the water and lily pads and the palatable tension of the foreground figure as the second figure hovers and emerges in wonder from the atmosphere.

In the end, we are left with a masterful, understated drawing that evolves from the sheet in a very mysterious way.[1] Why is the girl reaching? Was something dear lost? Is the figure just picking a lily for someone? Is this a metaphor for how we go through life—searching for some meaning that is always half submerged? Regardless, Homer takes us out in the quiet morning to taste the humanity of two companions. TWolfe

Signed in charcoal lower right corner: *Homer 1884*

Museum purchase made possible by the Art Acquisition and Restoration Fund, the Endowment Fund in Honor of D.A. Turner, and the Edward Swift Shorter Bequest Fund 89.2

Provenance: Doll & Richards Gallery, Boston; Thomas Wigglesworth; Mrs. Henry S. Grew, Manchester, Massachusetts (his sister); Edward Wigglesworth Grew, Dover, Massachusetts (her son); Hirschl & Adler Galleries, New York; Dr. Irving Levitt, Detroit; Kennedy Galleries, New York ; Sotheby's Auction House, New York

Exhibited: *Studies in Black and White*, Doll & Richards Gallery, Boston, November 29 – December 6, 1884; *Winslow Homer in Monochrome*, Knoedler-Modarco Gallery, New York, December 1986 – January 1987, cat. no. 80; *American Drawings from the Permanent Collection*, Columbus Museum, February 22 – May 28, 1990; *Works on Paper from the Permanent Collection*, Columbus Museum, February 16 – May 17, 1992; *People, Places, Animals*; *Making a Mark*; *Celebration*, illus. (detail), gallery guide, unpaginated

Literature: James F. Cooper, "Winslow Homer Exhibit in Vivid Black and White," *New York City Tribune* (December 26, 1986), illus.; *Sotheby's Auction Catalogue*, December 1, 1988, lot 66, illus.; *Building on a Legacy*, illus.: 177; Charles T. Butler, et al. *American Art in the Columbus Museum* (Seattle and Columbus, Georgia: Marquand, Inc. and Columbus Museum, 2003), illus.: 11

16.

Samuel Colman

b. Portland, Maine 1832 – d. New York City 1920
Mount Sir Donald ca. 1895
Watercolor and gouache on wove paper
11¾ x 17½ inches (29.8 x 44.5 cm)

Although still among the least well known of America's nineteenth-century landscape painters, Samuel Colman was one of the most successful and influential artists of his day. Among his other major accomplishments, he was a founder of the American Society of Painters in Water Color, in 1867, and of the Society of American Artists a decade later. Unusual among American landscape artists of his day, Colman viewed watercolors as having equal importance to oils. In this he consciously emulated the English painter J.M.W. Turner, whose dramatic, light-filled watercolor views had revolutionized the medium.

An inveterate world traveler, over the course of a long career Colman painted scenes from Italy to Mexico and from Egypt to Japan. Among his most powerfully realized watercolor subjects, however, are those that he discovered in the Canadian Rockies between 1892 and 1906, when he was already in his sixties and seventies.

After many years of planning and construction, and much controversy, the Canadian Pacific Railway, which stretched from Montreal to Vancouver, was finally completed in 1885. Its route across southern Canada offered many spectacular views of heretofore unseen geological wonders, not least among which were the Selkirk Mountains in eastern British Columbia, just north of Montana's Glacier National Park. There, the sharp pyramidal cone of Mount Sir Donald and its glacier hovers over Rogers Pass, perhaps the most challenging of all the railroad's obstacles. Snow-capped year round, Mount Sir Donald dominates an otherwise sere and rocky landscape, whose contrasts of cold and warmth Colman captures perfectly. The cloud-wrapped peak also allows the artist to explore "Turneresque" effects of light and shadow and, although he is working on a small, sketchbook scale, he nonetheless manages to achieve a monumentality of expression that is fully comparable to the works of Albert Bierstadt and Thomas Moran. BWC

Signed (lower right): *SAM'L COLMAN* and inscribed (verso): "*Mount Sir MacDonald* [sic], *Canadian Pacific Railroad, Sam'l Colman, $150.00*"
Gift of Dr. and Mrs. Philip L. Brewer in honor of the Museum's 50th Anniversary
2003.38.1
Provenance: Kennedy Galleries, New York; Dr. and Mrs. Philip L. Brewer
Exhibited: *Georgia Collects*, High Museum of Art, Atlanta, January 24 – March 6, 1989, illus.: 98; *Hudson River in Private Collections in Georgia*, Georgia Museum of Art, Athens, Georgia, March 1995, no. 3; *Intimate Expressions*, cat. no. 16, illus.: 66, pl. 1; *A Collector's Pursuit of Drawing; Celebration; Building on Strength*

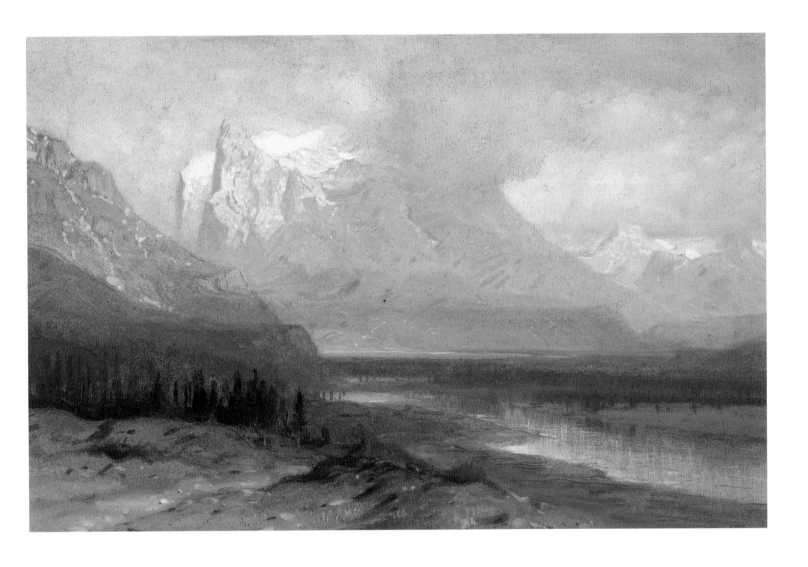

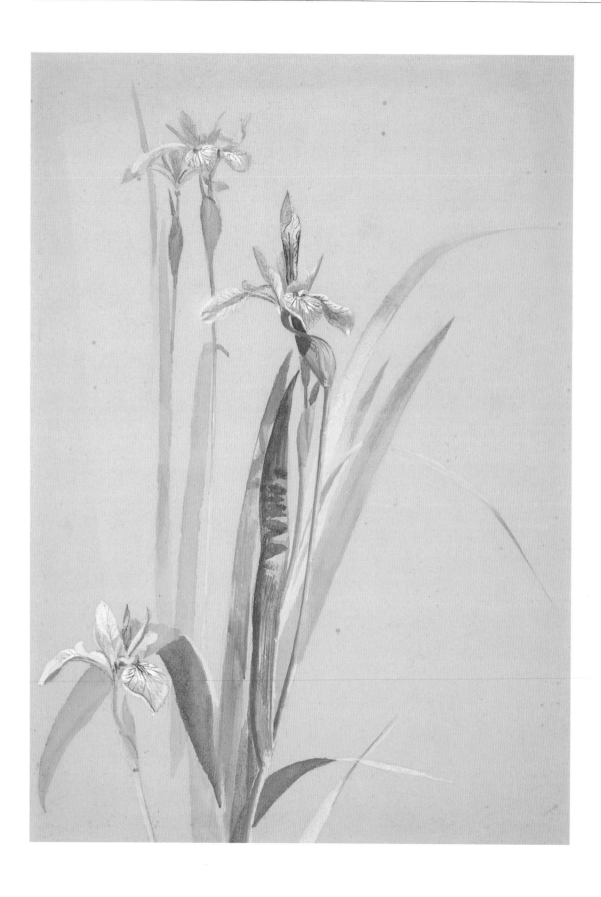

17.
Fidelia Bridges
b. 1835 – d. 1923, Salem, Massachusetts
Iris 1890s
Watercolor and gouache on cream-colored wove paper
14 x 10 inches (35.6 x 25.4 cm)

Fidelia Bridges was one of America's leading exponents of the English writer John Ruskin's belief that God was as much to be found in the humble details of nature as He was in towering mountain ranges and spectacular sunsets. The meticulously rendered, botanically correct studies of plant life that such painters as Asher B. Durand and William Trost Richards executed in the 1850s and 1860s inspired an American "Pre-Raphaelite" movement whose Ruskinian reverence for natural truth continued to inform American landscape painting until the end of the century.[1]

Tall, stately, but of a frail constitution, Bridges first took up drawing as a pastime. In 1860 she was persuaded by her friend, the sculptor Anne Whitney, to take professional art lessons in Philadelphia with Richards. Those lessons led not only to a lifelong friendship with Richards and his family, but also to a long and successful artistic career specializing in watercolors of bird and plant life.[2] Bridges's earliest watercolors vividly capture both detail and the nuances of light and shadow. As her biographer, May Brawley Hill, has noted, "they are not so much nature drawings as microcosms of Nature, embodying the Transcendental idea that divinity is manifest in the smallest part of the created world."[3]

By the mid-1870s Bridges's style had softened and become more informal, in part because of her growing admiration for Chinese Sung Dynasty painting, with its dual emphasis on poetic imagination and effortless skill with the brush. *Iris* is a perfect embodiment of Bridges's late style; the flowers are freely rendered against a neutral background, yet they seem to come alive on the page. The iris she depicts is not an imported garden species, but Blue Flags, a native plant often seen growing in profusion in New England marshes.[4] BWC

Promised Gift, Dr. and Mrs. Philip L. Brewer Collection
Provenance: The Oliver Ingraham Lay family; George C. Lay; Jeffrey Brown Fine Arts, North Amherst, Massachusetts; Dr. and Mrs. Philip L. Brewer
Exhibited: *Fidelia Bridges, American Pre-Raphaelite*, New Britain Museum of American Art, New Britain, Connecticut, November 15 – January 3, 1982, no. 111: 46; *Intimate Expressions*, cat. no. 9, illus.: 68, pl. 6; *Celebration*
Literature: Jill Newhouse and Eric Carlson, *Drawings and Watercolors, Catalogue II* (fall 1982, no. 40), illus.

NOTES TO THIS SECTION

1.
John Singleton Copley

1. See Jules Prown, *John Singleton Copley*, vol. II (Cambridge, Mass.: Harvard University Press, 1966): 275–291 and 297–298, cat. nos. 406 and 430–435; Emily Ballew Neff, with an essay by William L. Pressly, *John Singleton Copley in England* (Houston, Tex.: Museum of Fine Arts, Houston, in association with Merrell Holberton Publishers, London, 1995): 36–38; 50–52; 66–67; 70–74; 83; 164–166.

2.
Benjamin West

1. Key texts on the art of Benjamin West include Helmut von Erffa and Allen Staley's *The Paintings of Benjamin West* (New Haven and London: Yale University Press, 1986) and Ruth S. Kraemer's *Drawings by Benjamin West and his Son, Raphael Lamar West* (New York: Pierpont Morgan Library, 1975). Also helpful is Stanley Weintraub and Randy Ploog's *Benjamin West Drawings from the Historical Society of Pennsylvania* (University Park, Pa.: Palmer Museum of Art, 1987).
2. See Kraemer: 61–62, and curatorial file correspondence dated September 7, 1994. Unusual in West's studio practice, this life drawing includes pastel.
3. See curatorial file correspondence dated September 6, 1994.
4. The pose of the figure and his distinguishing striped drapery, indicating biblical dress, suggests studies West created for the unrealized Royal Chapel at Windsor, which West diligently pursued until the king canceled the project in 1801. See von Erffa and Staley: 577–581, and, specifically, West's study of a slightly similar figure of a seated male nude with exposed back and draped by a similar striped cloth in *Christ Healing the Sick*, second from the left in *Design for a Side Wall of the Royal Chapel, Windsor Castle*, ca. 1780: 577.

3.
William Russell Birch

1. William Russell Birch, advertisement, *Pennsylvania Packet* (October 28, 1794), in Alfred Cox Prime, comp., *The Arts and Crafts in Philadelphia, Maryland, and South Carolina, 1786–1800. Series Two: Gleanings from Newspapers* (Topsfield, Mass.: Walpole Society, 1933): 4. Birch would continue to identify himself as an enamel painter for the rest of his life.
2. See William Russell Birch. "The life of William Russell Birch, enamel painter, written by himself: with a list of his copies in enamel (by desire) from the pencil of Sir Joshua Reynolds, the master he studied under; with a short pencil upon enamel painting," Collections of the Historical Society of Pennsylvania.
3. From Birch's preface to William Russell Birch, *The City of Philadelphia, in the State of Pennsylvania, North America, as it Appeared in the Year 1800* (Drawn and Engraved by W. Birch & Son; Published by W. Birch, Springland Cot, near Neshaminy Bridge on the Bristol Road, Pennsylvania,

December 31st 1800).
4. William Russell Birch, prospectus for "Birch's Views of Philadelphia," *Federal Gazette* [Philadelphia], (January 29, 1799), in Prime: 66.
5. See Martin P. Snyder, "William Birch: His Philadelphia Views," *Pennsylvania Magazine of History and Biography* 73, no. 3 (July 1949): 270–315, for a full account of Birch's many changes to, and editions of, *The City of Philadelphia*.
6. In 1827 the Philadelphia artist John Neagle (1796–1865) set out to compile materials for a book prospectively titled "Lessons on Landscape Painting." The bound and dated manuscript for this book, which Neagle gave to his daughter Elizabeth in 1842 and which now is part of the John Neagle Papers at the American Philosophical Society Library in Philadelphia, focuses on watercolor techniques. The date inscribed by Thomas Birch on the watercolor's mount as the date he gave the painting to Neagle strongly suggests that either Thomas Birch or Neagle may originally have wished to see it included in Neagle's book project.

4.
Charles Balthazar Julien Févret de Saint-Memin

1. Ellen G. Miles, *Saint-Memin and the Neoclassical Profile Portrait in America* (Washington: National Portrait Gallery and Smithsonian Press, 1994) is the definitive study of his life and work.
2. Miles: 44–45, 69, 72.
3. Miles: 92, 94, 117, 119, 320. Saint-Memin kept for himself examples of each of his engravings, which he later assembled into two collections, now owned by, respectively, the Corcoran Gallery of Art and the National Portrait Gallery in Washington. Neither contains an engraving of Hillen.

5.
Thomas Cole

1. Key sources on Cole's life and oeuvre include Louis Legrand Noble, *The Life and Works of Thomas Cole, N.A.* Cambridge, Mass.: Harvard University Press and Belnap Press, 1964; new edition ed. by Elliot S. Vesell, Hensonville, N.Y.: Black Dome Press, 1997; Ellwood C. Parry, III, *The Art of Thomas Cole: Ambition and Imagination* (Newark, Del. and London: University of Delaware Press and Associated University Presses, 1988); Earl A. Powell, *Thomas Cole* (New York: Harry N. Abrams,, 1990); and William H. Truettner and Alan Wallach, *Thomas Cole: Landscape into History* (Exhibition catalogue, New Haven: Yale University Press in association with the National Museum of American Art, 1994). The Cole quote is taken from Thomas Cole, "Essay on American Scenery," *American Monthly Magazine* 1 (January 1836), as reprinted in Thomas Cole, *The Collected Essays and Prose Sketches*, ed. Marshall Tymn (St. Paul, Minn.: John Colet Press, 1980): 8.
2. Cole, "Essay on American Scenery": 14.
3. Noble: 216. Cole painted two separate versions of *The Voyage of Life*, the first in 1840 (Museum of Art, Munson-Williams-Proctor Institute, Utica, N.Y.) before he went on his second trip to Europe, and the second (National Gallery

of Art, Washington, D.C.) while living in Rome in 1841–1842.
4. Louis Legrand Noble, *The Course of Empire, Voyage of Life, and Other Pictures by Thomas Cole, N.A.* (New York: Cornish, Lamport & Company, 1853): 307. For reproductions of the relevant painting details and the similarities of the sketch to one of the storm-blasted trees in the second version of the allegory, see *The Voyage of Life by Thomas Cole: Paintings, Drawings and Prints* (Utica, N.Y.: Museum of Art, Munson-Williams-Proctor Institute, 1985): 33. It is also important to note, with Howard S. Merritt, that Cole signed and inscribed only the most memorable of his tree studies: see introductory essay, *To Walk with Nature: The Drawings of Thomas Cole* (Yonkers, N.Y.: Hudson River Museum, 1982), unpaginated.

6.
George Harvey

1. George Harvey, *Harvey's Royal Gallery of Illustration…A Descriptive Pamphlet of the Original Drawings of American Scenery…* (London: W. J. Golbourn, 1850): 3. The author wishes to acknowledge the assistance of Stephen Edidin, Linda Ferber, Roberta Olson, and Catherine Huber in providing key information related to Harvey.
2. Kevin J. Avery, *American Drawings and Watercolors in the Metropolitan Museum of Art* (New York: Metropolitan Museum of Art, 2002): 160. Avery notes that, if Harvey received art training, he never admitted it.
3. George Harvey, preface to Harvey's *Scenes in the Primeval Forests of America…* (London, 1841): 4.
4. Avery: 160. Harvey is listed as having produced forty "Atmospheric Landscapes" in total, of which twenty-two are known.
5. Harvey spent the early part of 1847 in America and then moved to England later in the year, according to Harvey scholar Christine Huber. Curatorial correspondence, May 3, 2005.

8
John Gadsby Chapman

1. Georgia Stamm Chamberlain. *Studies on John Gadsby Chapman, American Artist, 1808–1889* (Annandale, Va.: Turnpike Press, 1963): 4.
2. In addition to Chamberlain, among the more important sources of information on John Gadsby Chapman's life and art are *John Gadsby Chapman, Painter and Illustrator* (Washington, D.C.: National Gallery of Art, 1962), and Ben L. Bassham, *Conrad Wise Chapman: Artist & Soldier of the Confederacy* (Kent, Ohio and London: Kent State University Press, 1998).

9
John Mackie Falconer

1. Dating Falconer's works is difficult, since in many cases he went back to earlier watercolors as subjects for his later engravings. A print that Falconer made from this watercolor is dated 1882, but for the reasons just stated

that date provides no lead as to the watercolor's original date. Babcock Galleries stated to the present owner that the watercolor dates to 1853. Based on the date of the exhibited oil, Falconer may have visited Virginia in 1853, but there is no documentary evidence that Falconer traveled further south that same year. There is, however, a dated Georgia watercolor in the 1904 sales catalogue of Falconer's art collection that clearly indicates he visited Georgia twenty years later, in 1873: "No. 501. GEORGIA. 'Moonlit Frosty Morning.' Cottage on the banks of a stream. Water-color drawing, by J.M. Falconer. 1873." Anderson Auction Company, *Catalogue of the interesting and valuable collection of oil paintings, water-colors and engravings formed by the late John M. Falconer (Brooklyn, N.Y.), for sale at auction, Thursday and Friday, April 28 and 29, 1904 by the Anderson Auction Company* (New York, N.Y.: Anderson Auction Company, 1904).

2. Despite Falconer's importance to nineteenth-century American art, there is as yet only one extended biography of Falconer: Linda S. Ferber "Our Mr. John M. Falconer," in *Brooklyn Before the Bridge: American Paintings from the Long Island Historical Society* (Brooklyn, N.Y.: Brooklyn Museum, 1982).

3. S.R. Koehler. *American Etchings; American Art*. New York and London: Garland Publishing, Inc., 1978, unpaginated. Koehler was obviously no fan of historic preservation, a movement that would wait until the 1890s to gain its first serious momentum in America.

4. The cabins depicted in the watercolor are "English-style" or "single-pen" one-room structures that occurred throughout the Eastern and Midwestern states. The pair of centrally located doors, one on each long side, the planked rook and log gable-end chimney, the cedar shake roof, and the round-end saddle-notch horizontal log construction help indicate the location. For the history and physical variations of American log cabin construction, see C. A. Weslager, *The Log Cabin in America, from Pioneer Days to the Present*. New Brunswick, N.J.: Rutgers University Press, 1969, and Terry G. Jordan-Bychkov, *The Upland South: The Making of an American Folk Region and Landscape* (Santa Fe, N.M. and Harrisonburg, Va.: Center for American Places in association with the University of Virginia Press, 2003), among other sources.

10
Francis Hopkinson Smith
1. Malone Dumas, ed., *Dictionary of American Biography*, vol. XVII (New York: Charles Scribner's Sons, 1935): 265.
2. Ibid: 266.
3. Smith, in fact, produced drawings titled after works by Tennyson and other famous poets, such as *For Men May Come and Men May Go, But I Go on Forever*, a very similar charcoal drawing of the same period illustrated in Barbara T. Ross, *American Drawings in the Art Museum, Princeton University: 130 Selected Examples* (Princeton, N.J.: Princeton University Press, 1976): 121.
4. Lisa N. Peters, "Francis Hopkinson Smith" (New York: Spanierman Gallery, 2004), unpaginated.
5. Along with descriptive detail, the prominence of mid-

range tones and blurred extremities give this and other drawings by Smith a loosely photographic quality.
6. Smith's Impressionist-influenced drawing style can be seen in the illustrations for his book, *Charcoals of New and Old New York* (1912).

11.
William Trost Richards
1. This Richards quote appears in Linda S. Ferber, *William Trost Richards: American Landscape & Marine Painter, 1833–1905* (Brooklyn, N.Y.: Brooklyn Museum, 1973): 31. Other important publications on Richards include Harrison S. Morris, *Masterpieces of the Sea: William T. Richards, A Brief Outline of His Life and Art* (Philadelphia: J.B. Lippincott Company, 1912), and Linda S. Ferber, *Tokens of a Friendship: Miniature Watercolors by William T. Richards* (New York: Metropolitan Museum of Art, 1982).
2. As related in Ferber, *William Trost Richards*: 33.
3. Quoting Richards's friend, Alfred C. Lambdin, in Morris: 58.
4. Morris: 49.

12.
David Johnson
1. Margaret C. Conrads, catalogue entry for *Pine Tree*, in John I.H. Baur and Margaret C. Conrads, *Meditations on Nature: The Drawings of David Johnson*, (Yonkers, N.Y.: Hudson River Museum, 1987): 21.
2. John I.H. Baur, "The Drawings of David Johnson," in Baur and Conrads: 10. Baur points out the importance of these notations in helping compensate for a lack of biographical information on the artist by providing some chronology of his movement.
3. Ibid: 11. Baur offers a detailed analysis of the phases of Johnson's drawing style.

13.
Alfred Thomson Bricher
1. The only significant publication to date on Bricher's life and career remains Jeffrey R. Brown, *Alfred Thompson Bricher, 1837–1908* (Indianapolis: Indianapolis Museum of Art, 1973).

14.
William Morris Hunt
1. As quoted in Martha A.S. Shannon, *Boston Days of William Morris Hunt* (Boston: Marshall Jones Company, 1923): 160.
2. Quoted in Marchal E. Landgren, *The Late Landscapes of William Morris Hunt* (College Park, Md.: University of Maryland Art Gallery, 1976): 28.
3. Henry C. Angell, *Records of William M. Hunt* (Boston: James R. Osgood and Co., 1881): 8.

15.
Winslow Homer
1. Homer apparently intended to place two other figures in the opposite side of the boat, as pentimenti reveal. The faint outlines of their shape indicate he originally had planned

for a larger figurative group, but abandoned this concept to preserve the scale and monumentality of the remaining two figures.

17.
Fidelia Bridges
1. Although it is a term commonly used to describe the American followers of Ruskin's principles, American "Pre-Raphaelite" is a bit of a misnomer, since the works of the American artists associated with the movement do not closely resemble the work of any of the English "Pre-Raphaelites," who associated themselves with the Italian Quattrocento, or the art before Raphael. The only thing the two groups had in common was an admiration for Ruskin. The best book to date on the American Pre-Raphaelites is Linda S. Ferber and William H. Gerdts, *The New Path: Ruskin and the American Pre-Raphaelites* (Brooklyn, N.Y.: Brooklyn Museum, 1985).
2. The three key publications on Fidelia Bridges are: Alice Sawtelle Randall, "Connecticut Artists and Their Work: Miss Fidelia Bridges in her Studio at Canaan," *Connecticut Magazine* 7 (1903): 583–588; Frederic Alan Sharf, "Fidelia Bridges," *Essex Institute Historical Collections* 104, no. 3 (July 1968): 217–238; and May Brawley Hill, *Fidelia Bridges: American Pre-Raphaelite* (New Britain, Conn.: New Britain Museum of American Art, 1981).
3. Hill: 15.
4. *Iris versicolor*, which—as its botanical name implies—comes in a wide range of hues, from pale blue, as in this example, to deep purple, pink, and even white.

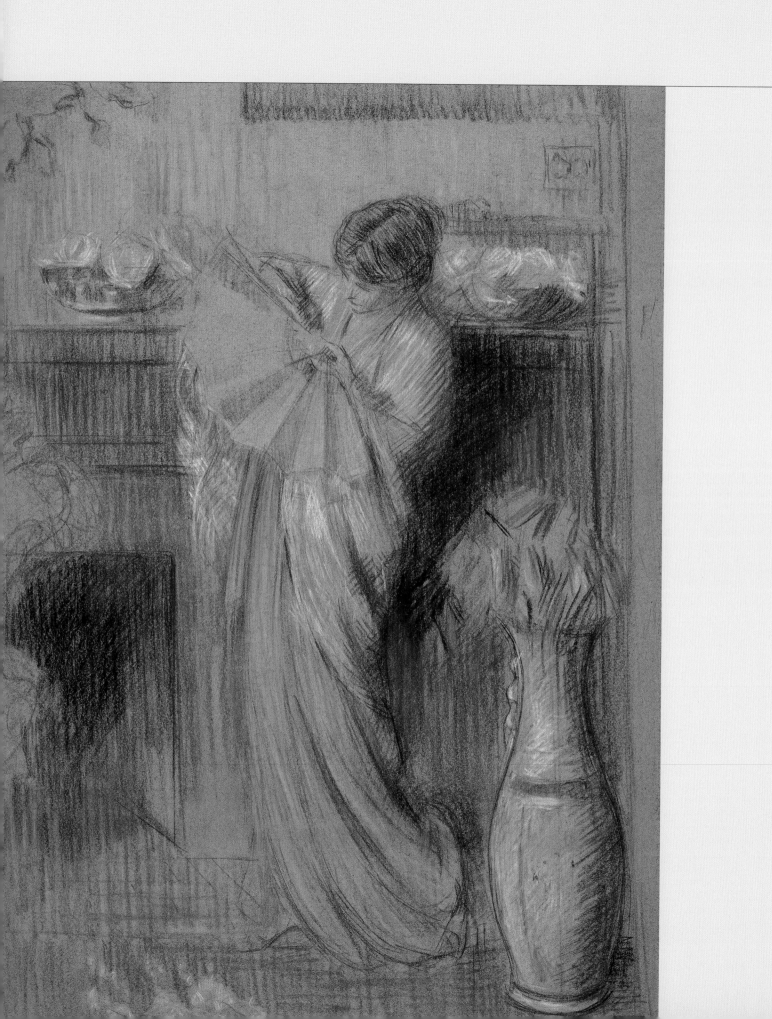

2.

AMERICAN RENAISSANCE
AND COSMOPOLITAN OUTLOOK

Fig. 47
Philip Leslie Hale
b. 1865 – d. 1931, Boston, Massachusetts
Lady with a Fan ca. 1910–1914
Pastel on brown wove paper
24¾ x 17½ inches (62.9 x 44.5 cm)
Museum purchase made possible by the Art Acquisition
and Restoration Fund and the Endowment Fund in
Honor of D.A. Turner 2004.15
Provenance: Florence Taylor Kusher Sherman, Boston
(student of the artist); Estate of Florence Taylor Kusher
Sherman; Mr. M. Kenneth Allen, Hendersonville, North
Carolina; Christie's, New York (lot 88, September 27, 2004)

18.

Abbott Handerson Thayer

b. Boston, Massachusetts 1849 – d. Dublin, New Hampshire 1921
Horse Team ca. 1870–1875
Pencil and wash on wove paper
6⅝ x 9⅝ inches (16.9 x 24.4 cm)

Although Abbott Thayer would later become renowned for his figure painting, portraiture and landscapes, his earliest paintings focused on animal subjects. From childhood he was an avid naturalist who could identify bird species by a single feather. That interest would continue to inform Thayer's work until 1875, when he traveled to Paris to study under the French academic painter Jean-Léon Gérôme.[1]

Eight years earlier, in 1867, Thayer had moved to Brooklyn, New York, where his father maintained a medical practice. The young artist soon rented a studio and received his first professional commissions, for a series of dog portraits. By 1870 he had expanded his repertoire to include rural cattle and the lions and tigers at the Central Park Zoo; at about the same time he moved his studio to Manhattan and enrolled in the National Academy of Design School, where he joined a circle of friends that included John LaFarge, George DeForest Brush, Julian Alden Weir, and Daniel Chester French.

Another academy student at the time was Maria Oakey, who subsequently married the painter Thomas Wilmer Dewing. Fifty years later, she would recall Thayer's contributions to the class:

Thayer did not make very good cast drawings but I think he received a deep impression of the Greek and stowed it away in his mind. He was sometimes away painting animals very cleverly [and] would bring in his drawings and put them on the walls of the schools to solicit praise for he cared enormously for the encouragement of his [friends].[2]

Horse Team may have been one such drawing. It depicts a team of five white horses animatedly pulling a street trolley. Most trolleys would have had two- or three-horse teams; the use of five horses would only have occurred on the steepest grades, and the animals' exertions confirm this.[3] Thayer's adroit handling of washes evokes an early morning fog, while the barking dog attests to his eye for telling detail. Yet the planarity of the composition imitates classical relief sculpture, and the arrangement of horses seems to allude to the ancient four-horse chariot, or *quadriga*, all of which suggests that Thayer had indeed already "stowed away the Greek in his mind."[4] BWC

Signed lower right: *AH Thayer*
Promised Gift, Dr. and Mrs. Philip L. Brewer Collection
Provenance: Drawing in a sketchbook of Mr. Chandler (fellow resident at the Chelsea Hotel, New York); by descent to Mr. Chandler's grandson; Spanierman Gallery, New York; Dr. and Mrs. Philip L. Brewer
Exhibited: *Intimate Expressions*, cat. no. 14a, illus.: 63; *Celebration*

Fig. 48
John Haberle
b. 1856 – d. 1933, New Haven, Connecticut
Mardi Gras ca. 1890–1898
Pencil on wove paper
4¾ x 7⅞ inches (12.1 x 20 cm)
Estate stamp on verso, signed upper right "Vera Haberle Demmer"
Gift of Dr. and Mrs. Theodore E. Stebbins, Jr. 2004.21.1
Provenance: Mrs. Victor Demmer (Vera Haberle Demmer), East Haven, Connecticut, 1970 (daughter of the painter); Dr. and Mrs. Theodore E. Stebbins, Jr.

Fig. 48

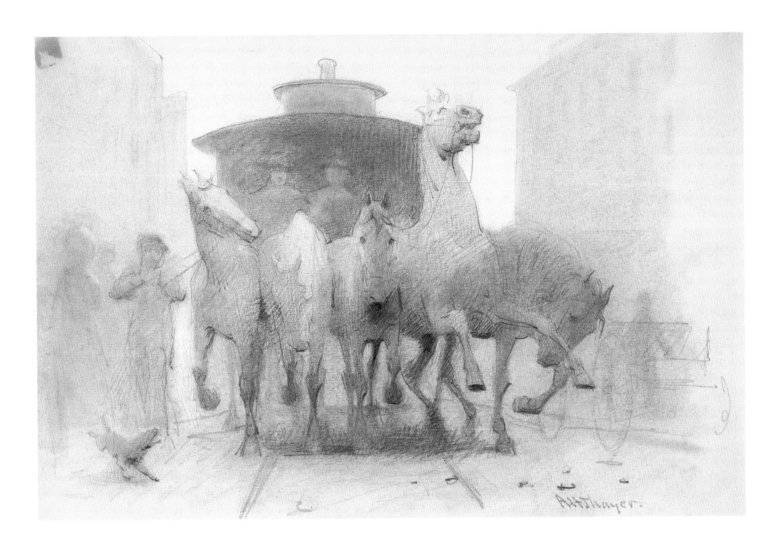

19.
John Henry Twachtman
b. Cincinnati, Ohio 1853 – d. Gloucester, Massachusetts 1902
Bridge across the Ohio River at Cincinnati [recto] *Two Landscapes*
[verso] ca. 1880
Pencil on wove paper
8½ x 11⅛ inches (21.6 x 28.3 cm)

In the fall of 1879, John Twachtman returned to his native
Cincinnati, after a period of study in Munich and a year each in
Venice and New York. Although he found his hometown to be an
unsympathetic environment, offering "no good art influence," he
created a group of fascinating images depicting the city's hills,
which were being rapidly transformed to suburbs after a number of
rail inclines made them suddenly accessible.[1] Given that he had
painted harbors in Venice and New York, it seems that the industri-
alized waterfront on the Ohio River would also hold his attention,
but only one image of this subject by Twachtman is known, this
pencil drawing depicting a view looking east across the river toward
the suspension bridge connecting Cincinnati and Covington,
Kentucky, designed by John Roebling and completed in 1866.[2]

The artist's son identified this scene as an image showing the
Brooklyn Bridge, designed several years later by Roebling. Indeed,
in about 1887–1888, Twachtman created a painting of the Brooklyn
Bridge, reproduced in *Scribner's Magazine* in July 1888.[3] However,
in this drawing the shape of the towers and the decorative turrets
that rise from them, as well as the undeveloped landscape beneath the
bridge, associate it clearly with his hometown. Moreover, the two
small landscape studies on the work's verso correspond closely to

images in Twachtman's only extant sketchbook (private collection),
inscribed with a date of 25 August 1880.[4]

Twachtman's handling in his depiction of the Ohio River
waterfront is consistent with his direct realist approach of about
1880. He recorded the curves of the shore, the angles of barges on
the water, the tiny forms of figures walking on the riverbank,
industrial warehouses in the left distance, and the bridge pilings,
tower, and cable with minimal outlines, conveying the character of
his forms through the energy, force, and intensity of his lines and
shading. Thus, Twachtman used his graphite medium to a suggestive
rather than a descriptive end, and the liveliness of his drawing style is
a perfect complement to this freshly observed view of modern
Cincinnati life. LNP

Inscribed by J. Alden Twachtman, the artist's son, on a separate sheet attached to
the backing: *"Brooklyn Bridge." From the sketch book of J. H. Twachtman – 1888. J.
Alden Twachtman*
Promised Gift, Dr. and Mrs. Philip L. Brewer Collection
Provenance: Jo Mielziner, New York, as of 1958; E. Maurice Bloch; Estate of E.
Maurice Bloch (Christie's Auction House, New York, Sale 7102, lot 78, June 29,
1990, as *Brooklyn Bridge*); Dr. and Mrs. Philip L. Brewer
Exhibited: *Brooklyn Bridge: 75th Anniversary Exhibition*, Brooklyn Museum, New
York, April 29 – June 27, 1958, as *Brooklyn Bridge*, 1888, lent by Jo Mielziner, New
York; *Intimate Expressions*, cat. no. 73, illus.: 14; *A Collector's Pursuit of Drawing*;
Celebration
Literature: Lisa N. Peters. "John Twachtman (1853–1902) and the American Scene
in the Late Nineteenth Century: The Frontier within the Terrain of the Familiar," 2
vols. Ph.D. dissertation, City University of New York, 1995. Ann Arbor, Mich.:
University Microfilms International, 1996: xxvi, 239, illus.: 756

Fig. 49

Fig. 49
American, unknown artist
active second half of nineteenth
century
*Eagle and Phenix Mills, Columbus,
Georgia* ca. 1870s
Watercolor on wove paper
9½ x 13 inches (24.1 x 33 cm)
Gift of G. Gunby Jordan for the
Museum's Silver Anniversary 77.43
Provenance: Musgrove Mill
Antiques & Prints, Spartanburg,
South Carolina; G. Gunby Jordan,
Columbus, Georgia
Exhibited: *Celebration*
Illustrated: *Legacy*: 139

20.

William Merritt Chase
b. Franklin, Indiana 1849 – d. New York City 1916
Portrait of Alice Gerson, Mrs. Chase ca. 1880s
Monotype on wove paper
9 x 6⅝ inches (22.9 x 16.8 cm)

William Merritt Chase's wife, Alice Gerson Chase, was one of his favorite models from the time he married her in 1886. Few of his portraits of her are as intimate as this small monotype in which her face emerges from the surrounding shadows. Her eyes look straight at him, and she seems to be sitting quite close to her husband. When Chase traveled without Alice, he often sent her monotype portraits of himself. It is possible that he took a portrait such as this with him as a reminder of his beloved wife.

Composed strictly in terms of light and dark, the image has the feeling of a sketch. Chase was trained at the Munich academy, where he learned to value directness and spontaneity in the execution of his paintings. The monotype medium required that he finish drawing the composition on the plate before the ink dried, so that he could transfer the image to paper by placing it on top of the image and applying pressure. To make the image, he brushed ink onto the smooth surface of the plate as if he were painting it. He then removed ink from the surface with a cloth or swab, or perhaps even his fingertips, to create highlights on the face and head. The darker areas in Alice's hair and on her collar suggest that he added more ink to the surface to reinforce the dark tonalities. By making a "printed drawing," Chase was able to work from light to dark as well as dark to light in the same composition. It is impossible to tell for certain whether he painted the image on a metal or a glass plate, but the horizontal line to the right of the sitter's head suggests that he was working on a glass plate with a crack in it. JM

Gift of Dr. and Mrs. Philip L. Brewer in honor of Dr. and Mrs. Sidney H. Yarbrough III for their generosity and long years of service to the Columbus Museum 2004.17.2
Provenance: Helen Chase Storm (the artist's daughter); Jackson Storm (her son); Chapellier Galleries, New York; Private Collection since 1970; Jill Newhouse, New York; Dr. and Mrs. Philip L. Brewer
Exhibited: *American Monotypes: 100 Years*, Marilyn Pearl Gallery, New York, 1979, no. 4, illus.; *William Merritt Chase and Robert Henri, American Master Painters*, Vero Beach, Florida, 1986; *Local Wonders: Treasures of American Art in Columbus Collections*, Columbus Museum, February 6 – May 29, 1994; *Intimate Expressions*, cat. no. 14, illus.: 45; *A Collector's Pursuit of Drawing; Celebration*
Literature: Francine Tyler, *American Etching of the 19th Century* (New York: Dover Press, 1984), illus.

Fig. 50
Daniel Huntington
b. 1816 – d. 1906, New York City
Portrait of a Young Girl ca. 1870s
Crayon and white chalk on brown-colored wove paper
13½ x 16½ inches (34.3 x 41.9 cm), oval format
Signed with monogram, lower right: *DH*
Dr. and Mrs. Philip L. Brewer Collection, Museum purchase made possible by the Ella E. Kirven Charitable Lead Trust for Acquisitions 2003.1.16
Provenance: Mystic Fine Arts, Groton, Connecticut, lot 125, May 30, 1991; Dr. and Mrs. Philip L. Brewer
Exhibited: *Celebration*

Fig. 51
Samuel Worcester Rowse
b. Bath, Maine 1822 –
d. Morristown, New Jersey 1901
Mr. Charles H. Russell 1797–1884 ca. 1880s
Charcoal with white chalk highlights on buff-colored wove paper
24 x 18 inches (61 x 45.7 cm)
Promised Gift, Dr. and Mrs. Philip L. Brewer Collection
Provenance: Kennedy Galleries, New York; Dr. and Mrs. Philip L. Brewer.
Exhibited: *Watercolors and Drawings of the Nineteenth Century*, Kennedy Galleries, New York, February 18 – March 30, 1981, cat. no. 29, illus.; *Intimate Expressions*, cat. no. 12a, illus.: 29; *Celebration*
Literature: Patricia Hills, "Gentle Portraits of the Longfellow Era: Drawings of Samuel Worcester Rowse," *Drawing* II, no. 6 (March–April 1981): 121–126, fig. 9, illus.

Fig. 52
Samuel Worcester Rowse
b. Bath, Maine 1822 – d. Morristown, New Jersey 1901
Mrs. Charles H. Russell ca. 1880s
Charcoal on buff-colored wove paper
24 x 18 inches (61 x 45.7 cm)
Signed lower right: *Sam W. Rowse*
Promised Gift, Dr. and Mrs. Philip L. Brewer Collection
Provenance: Kennedy Galleries, New York; Dr. and Mrs. Philip L. Brewer
Exhibited: *Watercolors and Drawings of the Nineteenth Century*, Kennedy Galleries, New York, February 18 – March 30, 1981, cat. no. 28, illus.; *Intimate Expressions*, cat. no. 11a, illus.: 29; *Celebration*

Fig. 50

Fig. 51 Fig. 52

Torso of Hope – Hope & Memory

picture belonging to J. D. Cox – Cleveland

21.
Kenyon Cox
b. Warren, Ohio 1856 – d. New York City 1918
Torso of Hope ca. 1890
Pencil on buff-colored laid paper
16 x 14 inches (40.6 x 35.6 cm)

In the aftermath of the 1913 Armory Show, America's wake-up call to European avant-garde art, Kenyon Cox probably felt more like a dinosaur than the doyen of academic painting which he had been up until then. The new art unsettled him; to his eyes it appeared chaotic and solipsistic. Even the human figure, sacrosanct to his generation of Beaux-Arts-trained associates, was now vulnerable to violation through abstraction. Threatened by modern art, Cox preached a return to order. His artistic philosophy, incarnate in what he referred to as the "Classical Spirit" or the "Classical Point of View," stressed traditional values of perfection, self-control, and continuity.

For an earlier generation of academicians, sound draftsmanship was essential. So was the mastery of anatomy. They believed that drawing was fundamental to every artistic discipline, be it painting, sculpture, or architecture, and that inviolable rules governed its conception. *Torso of Hope* can be seen as the equivalent for a utopian mindset. The graphite drawing of a frontal nude, probably executed in the 1890s and inscribed by the artist with the words "torso of hope—hope and memory," may have been the study for a painting of the same title, originally owned by Cox's father Jacob D. Cox, a prominent Ohio attorney, university president, and governor.

Cox's idealized female torso personified multiple things: purity and virtue, order and stability, even hope and memory. As an allegorical trope, it celebrated the perfectibility of humankind through time-honored symbols. As was the usual practice when transposing an image from one medium to another, Hope's torso wears a grid, a conceptual overlay that ensures anatomical correctness by ruling out subjective impulses. The words "hope" and "memory" no doubt resonated with the artist, who clung tenaciously to tradition in the face of change. DD

Signed lower right: *K Cox*; inscribed lower center: *Torso of Hope-Hope and Memory/picture belonging to J.D. Cox-Cleveland*
Promised Gift, Dr. and Mrs. Philip L. Brewer Collection
Provenance: J.D. Cox, Cleveland; Estate of E. Maurice Bloch; Christie's Auction House, New York, Sale 7206, lot 206.5, January 9, 1991; Dr. and Mrs. Philip L. Brewer
Exhibited: *Faces and Figures in American Drawings*, Huntington Library and Art Gallery, San Marino, California, January – April 1989, no. 5, illus.: 18; *Intimate Expressions*, cat. no. 19, illus.: 39; *Celebration*

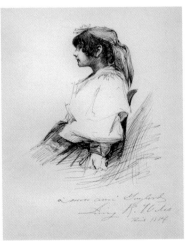

Fig. 53

Fig. 54

Fig. 53
John Haberle
b. 1856 – d. 1933, New Haven, Connecticut
Miss Almand (Lady with a Fan) 1884
Pencil on green-colored wove paper
8½ x 4½ inches (21.6 x 11.4 cm)
Signed and dated lower right, *HABERLE/26ᵗʰ 1884/No. 4/N.Y. Acad'y of Design/Sketch Class/J.H.*
Gift of Spanierman Gallery in honor of Dr. Philip Brewer
2003.43.1
Provenance: Estate of the Artist; Private Collection; Spanierman Gallery, New York

Fig. 54
Irving Ramsey Wiles
b. Utica, New York 1861 – d. Peconic, New York 1948
Young Woman 1914
Pen and ink on wove paper
9 x 7 inches (22.9 x 17.8 cm)
Signed and dated lower right: *Irving R. Wiles 1914 Paris*; inscribed lower right: *à mon ami Gaylord*
Museum purchase made possible by the Art Acquisition and Restoration Fund 2002.67
Provenance: Thomas Colville Fine Art, New York
Exhibited: *Celebration*

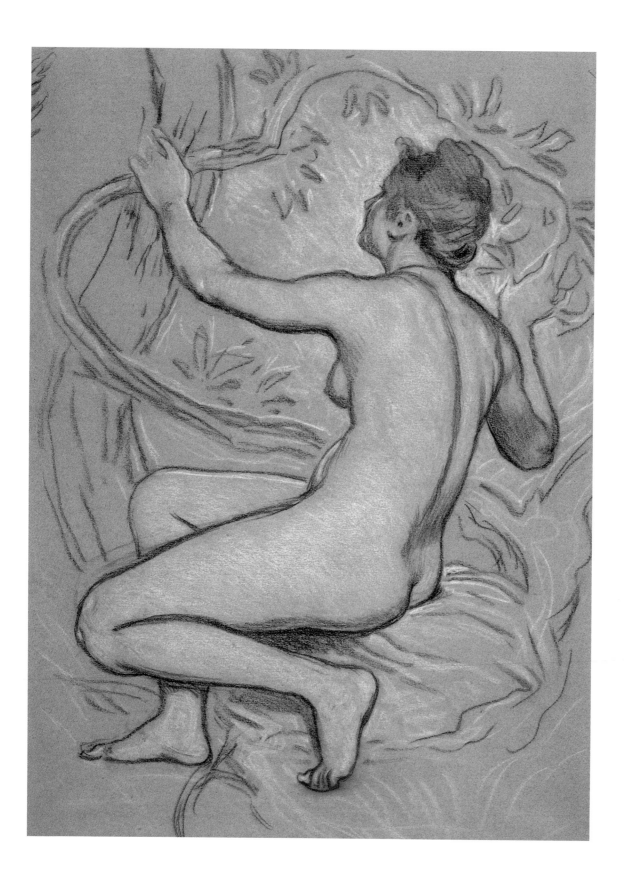

22.
Elihu Vedder
b. New York City 1836 – d. Rome, Italy 1923
Susanna ca. 1885–1895
Charcoal and chalk on gray-colored wove paper
17 x 12½ inches (43.2 x 31.8 cm)

Elihu Vedder's art was an eclectic merging of the enigmatic and sensual visions of the Symbolist poet and the familiar and reassuring visualizations of a keen observer of the natural world. During his career, much of which was spent as an expatriate in Rome, he created paintings, murals, book illustrations, graphic design, and decorative art objects, including stained glass. Inspired by mythology, literature, religion, and philosophy, Vedder made hundreds of drawings, many of which were preparatory for specific works; others suggested his fascination with certain themes and compositions.

Vedder drew upon the Old Testament for several of his projects selecting subjects that had to do "either with death and mourning or treachery and heroism."[1] Treachery is indeed at the heart of the Susanna story. The theme of Susanna from the Old Testament had been popular since the late Renaissance, though Vedder appeared to have used it only in this instance in which he revealed the virtuous woman seated in a pastoral setting with her back to the viewer. Because the image does not include a visible reference to her bathing or to the harassing elders, questions have been raised as to whether this is actually an image of *Susanna*.[2] There are no notations on the drawing verifying the subject but one can readily imagine how intriguing it might be to place the viewer in the questionable role of the licentious peeping elders. Once the viewer realizes that the beautifully rendered figure is Susanna, the circumstances of observing her are altered into a very different context of voyeurism.[3]

Though the figure in this drawing is similar in pose and style to other known compositions by the artist, there is, to date, no direct link between *Susanna* and any other work by Vedder, which leads one to assume that this was a finished drawing for its own sake.[4] ML

Promised Gift, Dr. and Mrs. Philip L. Brewer Collection
Provenance: Kennedy Galleries, New York; Dr. and Mrs. Philip L. Brewer
Exhibited: *Drawings by Elihu Vedder*, Kennedy Galleries, New York, September 12 – October 6, 1979, cat. no. 14, illus.; *Intimate Expressions*, cat. no. 74, illus.: 36; *Celebration*

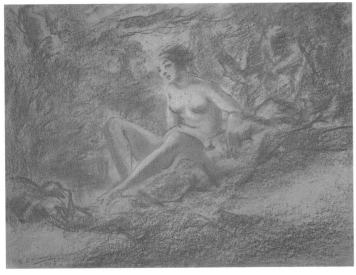
Fig. 55

Fig. 55
Everett Shinn
b. Woodstown, New Jersey 1876 – d. New York City 1953
Nude Seated in a Forest 1908
Red conté crayon on buff-colored wove paper
13 x 16¾ inches (33 x 42.5 cm)
Signed and dated lower left: *E. Shinn 1908*
Promised Gift, Dr. and Mrs. Philip L. Brewer Collection
Provenance: Chapellier Galleries, New York; Dr. and Mrs. Philip L. Brewer
Exhibited: *Collectors Choice*, Mississippi Museum of Art, Jackson, Mississippi, November 10, 1978 – January 14, 1979; *Celebration*
Literature: *American Art Selections, Volume VI*, Chapellier Galleries, cat. no. 33, illus.

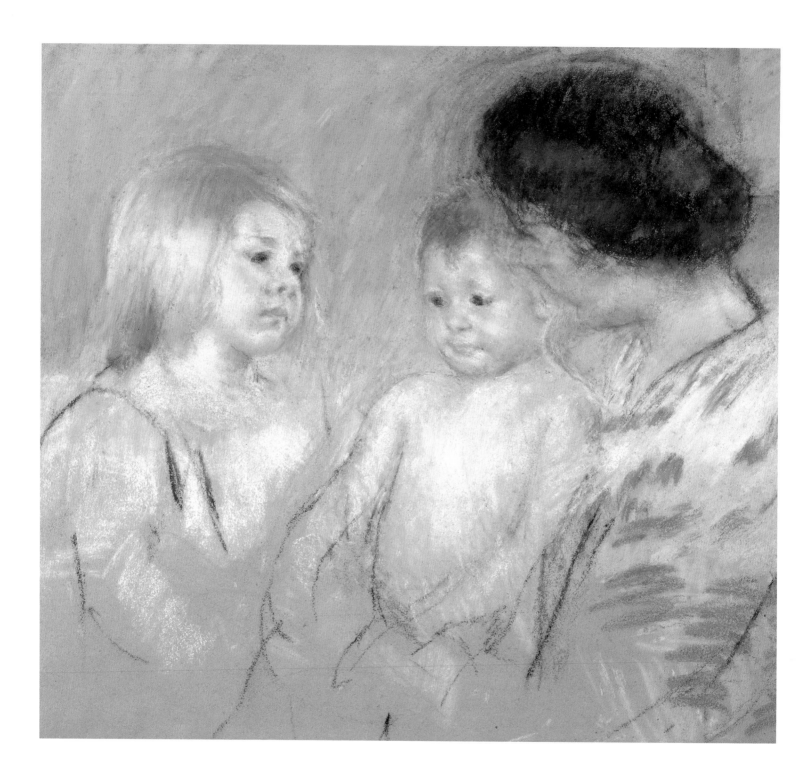

23.
Mary Cassatt
b. Allegheny City, Pennsylvania 1844 – d. Château de Beaufresne,
France, 1926
Sara and Her Mother with the Baby (no. 1) ca. 1901
Pastel on wove paper
22¾ x 23⅝ inches (57.8 x 60 cm)

Mary Cassatt gained an enduring reputation as an international
modern painter through her early association with the
Impressionist group, beginning in 1879. Her youthful academic
training at the Pennsylvania Academy of Fine Arts and subsequent
study in Paris as well as her close examination of Old Master paint-
ing during travels in Holland, Italy, and Spain convinced her of her
calling as a figural artist. She brought to her art a dedicated and
unrelenting focus on the figure, seen individually or in small
groups, and involved in the ordinary affairs of daily life.

Compositions such as *Sara and Her Mother with the Baby* dis-
play a liveliness and vitality, despite the narrow range of subject that
characterized Cassatt's mature work. Her art is tender without
being sentimental and the very vigor of the strokes of the charcoal
and pastel chalks makes clear her ambition to capture the character
of modernity itself that was found in the transience and mutability
of experience, so distinct from the classical idealism of her early
training. Through the openness of her compositions, which seem
more casual than controlled, she invested her work with a sense of
discovery, carrying the image just far enough to realize fully its
essential meanings. The compositional and color lessons she had

learned from Japanese woodblock prints and her own experimen-
tation with color printing techniques in the last decade of the nine-
teenth century became the background for the newly energized
work she began in the early twentieth century. She was very much
attuned to the innovations of the moment and she viewed her style
and subject afresh, despite the continuity of themes in her art.

Sara and Her Mother with the Baby, in its muted but striking
palette, should be viewed in relation to the exciting experiments of
the Nabis group, the younger generation that included Edouard
Vuillard and Pierre Bonnard, whose intimist canvases and graphic
art are similarly muted and subtle in their pictorial balance. A
quiet reverie confronts the bravura of Post-Impressionist painters
such as Vincent van Gogh and Paul Gauguin, whose slashing ener-
gies would have been anathema to Cassatt, and it is astonishing to
see her now, in her mid-fifties, so closely associated with the most
recent pictorial revolution. JEC

Museum purchase with funds provided by a Friend of the Museum 2005.14
Provenance: Dr. Fritz Nathan and Dr. Peter Nathan, Galerie Nathan, Zurich,
Switzerland; Newhouse Galleries, New York; Mrs. Burton Carter, Forth Worth,
Texas, by 1950; by family descent, Private Collection; Adelson Galleries, New York
Exhibitions: *Paintings by Impressionists and Post Impressionists,* Virginia Museum
of Fine Arts, Richmond, Virginia, 1950 (as *Mother and Two Children*); *Turn-of-the-
Century American Art, 1880–1920,* Richard York Gallery, New York, November 29,
1999 – January 29, 2000, no catalogue.
Literature: "Here and There: Richmond," *Pictures on Exhibit XIII/2* (November
1950), illus.: 41 (as *Mother and Two Children*); Adelyn Dohme Breeskin, *Mary
Cassatt: A Catalogue Raisonné of the Oils, Pastels, Watercolors and Drawings*
(Washington, D.C.: Smithsonian Institution Press, 1970), no. 387, illus.: 159

Fig. 56
Catherine Alice Treanor Roundey
b. 1857 – d. 1923, San Francisco
Still Life ca. 1900
Pastel on gold-colored wove paper
14⅝ x 12 inches (37.1 x 30.5 cm)
Signed lower left: *CA Roundey*
Gift of Paul G. Stein 2004.18
Provenance: Paul G. Stein, New
York

Fig. 56

24.

Arthur Bowen Davies

b. Utica, New York 1862 – d. Florence, Italy 1928

Two Standing Female Nudes ca. 1905–1915

Pastel on brown-colored wove paper

16⅞ x 11½ inches (42.9 x 29.2 cm)

The artist Arthur B. Davies, a major mover in the Armory Show of 1913, is known primarily as a prolific draftsman of expressive figures. He joined the Ashcan Group, which initially had five members—Robert Henri, John Sloan, William Glackens, George Luks, and Maurice Prendergast—but which later expanded to include Ernest Lawson and George Bellows. What united these artists was certainly not subject matter, but rather a common dislike of academic doctrine.

This pastel, *Two Standing Female Nudes,* is a prime example of Davies's most expressive work. The classical, elongated wispy figures dance with abandon. It is as if they have found themselves in an Arcadian garden. Free spirits, they move together to the songs of other-worldly harps, and gesture with their arms, hands, heads, and legs. They move without modesty or care. They are sexy without sex, for they are chaste in their nudity. The blue pastel gives definition to their form and imparts radiance to the pink body tones. A much stronger, curving line emphasizes the female form. Davies was a romantic visionary. With every stroke, he provides us with an offering—an offering of his passion for beauty and grace. By today's standards his figures are a gentle and delicate expression of the female body. His line is steady, pure and lovely in and of itself. The tonal areas give volume to the shapes: these are shapes without drama or expectation. Simply put, they are music on the sheet. TWolfe

Stamped and inscribed lower left: *Arthur B. Davies/V.M.D.*[1]

Gift of Dr. and Mrs. Philip L. Brewer 2005.64

Provenance: Estate of the Artist; Max Safron, New York; Estate of Maurice Bloch; Christie's Auction House, New York, Sale 7102, lot 249.5, June 19, 1990; Dr. and Mrs. Philip L. Brewer

Exhibited: *Faces and Figures in American Drawings,* Huntington Library and Art Gallery, San Marino, California, January – April 1989, 22–23, cat. no. 7, illus.; *Intimate Expressions,* cat. no. 21, illus.: 76, pl. 18; *Celebration*

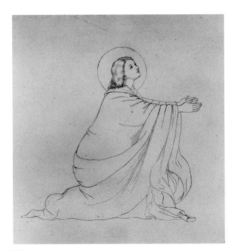

Fig. 57 Fig. 58

Fig. 57

Elliott Daingerfield

b. Harper's Ferry, Virginia 1859 – d. New York City 1932

Priest: Drapery Study for Lady of St. Mary the Virgin Chapel

ca. 1890–1900

Pencil and watercolor on laid paper

19½ x 10 inches (49.5 x 25.4 cm)

Museum purchase 83.1

Provenance: Estate of the Artist; Mint Museum of Art, Charlotte, North Carolina, by deaccession; Robert P. Coggins Collection of American Art, Marietta, Georgia

Exhibited: *Elliot Daingerfield,* North Carolina Museum of Art, Raleigh, May 26 – June 20, 1977; *People, Places, Animals; Celebration*

Fig. 58

Francesca Alexander

b. Boston, Massachusetts 1837 – d. Florence, Italy 1917

Mary Magdalene in the Garden

ca. 1875–1880

Pencil on buff-colored wove paper

10⅛ x 13¼ inches (25.7 x 33.7 cm)

Inscribed lower left: *Mary Magdalene in the garden, from the fresco by Giotto in the Chapel of the Bargello*

Promised Gift, Dr. and Mrs. Philip L. Brewer Collection

Provenance: Child's Gallery, Boston; Dr. and Mrs. Philip L. Brewer

Exhibited: *Celebration*

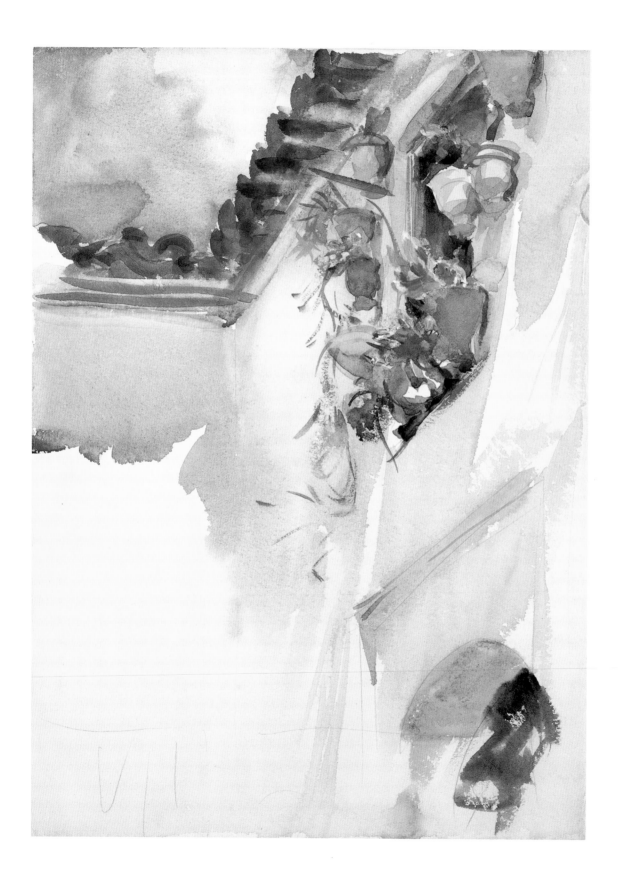

25.
John Singer Sargent
b. Florence, Italy 1856 – d. London, England 1925
Spanish Window ca. 1903
Watercolor on wove paper
13⅞ x 10 inches (35.2 x 25.4 cm)

By 1900, Sargent was becoming disenchanted with formal portraiture. He was turning increasingly to the more spontaneous medium of watercolor, both for artistic inspiration and as a means of financial support. Over the next twenty-five years, he would produce some 1,500 watercolors, which he exhibited and sold to critical acclaim.[1]

Throughout his life Sargent remained an inveterate traveler—a "perpetual tourist," as one scholar described him. During the early twentieth century, he favored locales that he had visited as a child—the Alps, Venice, and Spain. He made at least three extended trips to Spain, in 1902, 1903, and 1912, visiting Granada, Madrid, Seville, and Toledo, among other familiar locations.[2]

Spanish Window, which probably dates to his 1903 trip to Spain, epitomizes the sensual attractions of Sargent's watercolor style. Like many of his other works in the medium, it incorporates—without imitating—the qualities of a "snapshot" in its appearance of immediacy. But there is nothing haphazard about the results, as witnesses of Sargent's watercolor technique observed at the time. Sargent utilized every tool in the watercolorist's armory, while still relying on a simple folding box of colors.[3]

In *Spanish Window*, he begins with cursory pencil notations, and then fills in, in broad, wet washes, the violet, heat-struck sky and its paler shadows on the walls. With short, dabbing strokes of intense blue, he not only indicates the underside of the roof tiles, but also provides a relief of cooling shade. In the steep upward perspective of his view, we know we are in a courtyard, barely traced in our vision, but then are immediately focused on its centerpiece, a window, surrounded by clay pots from which flowering plants descend, delineated in feathery strokes of red and green.

It was Sargent's first biographer, Evan Charteris, who may have best captured the magic of Sargent's watercolor style: "To live with Sargent's watercolors is to live with sunshine captured and held."[4] *Spanish Window* embodies those effects, and the sense of a swiftly rendered summer idyll. BWC

Gift of Dr. and Mrs. Louis Hazouri 80.50
Provenance: D. Croal Thomson; M. Knoedler & Co., New York; Mrs. Lucy Worth James; Parke Bernet Galleries, New York, lot 254; Feragil Gallery, New York; Private Collection; John L. Petty; Dr. and Mrs. Louis Hazouri
Exhibited: *Paintings and Watercolors by John Singer Sargent, RA*, Knoedler & Co., Newport, Rhode Island, August 19 – September 3, 1933, cat. no. 31; *Watercolors by John Singer Sargent*, Berkshires Museum, Pittsfield, Massachusetts, February 1944, cat. no. 27; *American Drawings from the Permanent Collection*, Columbus Museum, February 22 – May 28, 1990; *A Select View*, cat. no. 39, illus.; *Works on Paper from the Permanent Collection*, Columbus Museum, February 16 – May 17, 1992; *People, Places, Animals*; *Making a Mark*; *Celebration*
Literature: *Building on a Legacy*, illus.: 173

Fig. 59

Fig. 59
Joseph Pennell
b. Philadelphia 1860 – d. Brooklyn, New York 1926
Norman Stairway in the Close 1885
Pen and ink on wove paper
8½ x 10½ inches (21.6 x 26.7 cm)
Signed and dated lower right: *Joseph Pennell, Canterbury, 1885*
Dr. and Mrs. Philip L. Brewer Collection, Museum purchase made possible by the Ella E. Kirven Charitable Lead Trust for Acquisitions 2003.1.3

Provenance: N. Bartfield Galleries, New York; Dr. and Mrs. Philip L. Brewer
Exhibited: *Intimate Expressions* (Columbus only, not in catalogue); *Celebration*
Literature: Mrs. Schuyler Van Rensselear, *English Cathedrals*, with illustrations by Joseph Pennell, vol. 1, (New York: Century Co., 1892): 49

26.
Childe Hassam
b. Dorchester, Massachusetts 1859 – d. East Hampton, New York
1935
Babb's Cove 1912
Watercolor on wove paper
13¾ x 19¼ inches (34.9 x 48.9 cm)

In 1886 Childe Hassam made his first trip to Appledore, one of the nine Isles of Shoals off the coast of Portsmouth, New Hampshire. For the next decade he would return there almost every year, drawn by the hospitality of his friend, the poet Celia Thaxter, whose family ran the island's hotel. Although Hassam enjoyed the island's invigorating climate, his artistic attention was focused primarily on Thaxter's own cottage, whose parlor served as a gathering place for the writers, musicians, and artists who had come as summer visitors, and whose wind-blown "island garden" became the subject of many of Hassam's finest oils and watercolors.

After Thaxter's death in August 1894, Hassam's visits to Appledore became more sporadic. When he returned, his focus shifted towards the island's cliffs and tidal pools. The rugged geological formations, pounding surf and distant, sea-girt horizons encouraged Hassam to experiment with livelier color schemes, while the staccato brushwork that he habitually employed gave perfect expression to both storm-worn rocks and flickering whitecaps.

When Hassam came to Appledore in 1912, however, it was to work almost exclusively in watercolor. Again he painted the island's ledges and coves, but his watercolors, which had previously been "bright and breezy," now became far more daring in their use of brushwork and color.

Babb's Cove is a leeward inlet then often used as a swimming hole. Hassam catches the cove at low tide, with the rounded form of Babb's Rock as his background. Working quickly in choppy strokes, he summarizes the weathered mass of the rock, the scree of stones at its base, even the seaweed and other tidal debris littering the shore. The cropped picture space is relieved only by the line of vegetation on the top of Babb's Rock and the cloud-swept sky beyond. With its limited yet intense palette and insistent flatness, Hassam's cove, instead of being a place of casual recreation, now personifies something far more elemental, as ancient as the rocks and sea themselves.[1] BWC

Signed in watercolor upper middle right: *Childe Hassam/1912*; *Babb's Cove on Appledore, Isles of Shoals*; and *11/12* on back
Gift of Hirschl & Adler Galleries, Inc., New York 74.32
Provenance: By bequest, American Academy of Arts and Letters, New York; Ambassador and Mrs. J. Williams Middendorf II, Greenwich, Connecticut; Hirschl & Adler Galleries, New York; Mr. and Mrs. Norman S. Hirschl, New York
Exhibited: *Paintings, Pastels and Etchings by Childe Hassam*, St. Botolph Club, Boston, February 14 – 25, 1914, cat. no. 15; *Exhibition of Pictures by Childe Hassam*, Montross Gallery, New York, November 27 – December 11, 1915, cat. no. 98; *Catalogue of an Exhibition of Paintings, Watercolors, Pastels and Etchings by Childe Hassam, N.A.*, Buffalo Fine Arts Academy, Albright Art Gallery, New York, April 15 – May 7, 1916, cat. no. 39; *Catalogue of the 14th Annual Philadelphia Watercolor Exhibition and the 15th Annual Exhibition of Miniatures*, Pennsylvania Academy of the Fine Arts, November 11 – December 7, 1916, cat. no. 406; *Exhibition of Paintings, Watercolors, Pastels and Etchings by Childe Hassam*, Art Institute of Chicago, Chicago, Illinois, January 5 – January 28, 1917, cat. no. 55; *Paintings, Watercolors, Pastels and Etchings by Childe Hassam*, City Museum of St. Louis, St. Louis, Missouri, May 1917, cat. no. 58; *Third International Watercolor Exhibition*, Art Institute of Chicago, Chicago, Illinois, March 20 – April 22, 1923, cat. no. 128 (listed erroneously as *Bab's Cove*); *A Select View*, no. 16, illus.: 24; *American Drawings from the Permanent Collection*, Columbus Museum, February 22 – May 28, 1990; *Works on Paper from the Permanent Collection*, Columbus Museum, February 16 – May 17, 1992; *People, Places, Animals*; *Celebration*
Literature: *Building on a Legacy*, illus.: 174

Fig. 60
Mina F. Ochtman
b. Cos Cob, Connecticut 1862 – d. Laconia, New Hampshire 1924
Girl in the Garden ca. 1890–1900
Watercolor on wove paper
23¾ x 19⅜ inches (60.3 x 49.2 cm)
Signed lower left: *MF Ochtman*
Gift of the Callaway Chemicals Company, on the occasion of the Museum's Silver Anniversary 77.48
Provenance: Pierce Galleries, Hingham, Massachusetts

Fig. 60

27.
Willard Metcalf
b. Lowell, Massachusetts 1858 – d. New York City 1925
Sketch for Benediction 1920
Pencil and chalk on dark gray-colored wove paper
11⅞ x 10⅞ inches (30.2 x 27.6 cm)

In the spring of 1920, the novelist and playwright Booth
Tarkington suggested to Willard Metcalf that Metcalf and his fam-
ily might like to spend some time that summer in Kennebunkport,
Maine, where "Tark" (as his friend "Metty" called him) had
recently built a summer home.[1]

Metcalf was then at a pivotal point in his career. The Ten
American Painters, the pioneer group of American Impressionists
that he had helped establish in 1898, had held its final exhibition
the previous year, and Metcalf was looking for fresh inspiration.
Kennebunkport, which had become a flourishing seaside resort,
not only offered a physically invigorating environment but also a
wealth of Colonial architecture, which had become one of the
artist's favorite themes over the preceding decade.

Kennebunkport's First Congregational Church, which had
been built in 1815 in the style of the English architect Christopher
Wren, appears in two of Metcalf's Kennebunkport paintings,
Buttercup Time (1920, Telfair Academy and Museum of Art,
Savannah, Georgia) where it appears as a distant white spire under a
sunny sky, and *Benediction* (1920, private collection), where it is seen
in close-up, looming tall under the light of a full moon, and sur-
rounded by a white rail fence and stately elms.[2] Metcalf preferred to
call such paintings "nocturnes," in the manner of James A.M.
Whistler, and they had played an important role in his success.[3]

Metcalf intended *Benediction* and its study (which is one of
only a handful of the artist's complete preparatory studies for paint-
ings to have survived) to be icons of the Colonial Revival, perpetuat-
ing a unique American historic tradition that combined a belief in
democracy with a spirit of optimistic realism. The title of the paint-
ing and its study was furnished by Metcalf's wife, Henriette, yet it
also clearly reflects the artist's own deeply felt principles.[4] BWC

Signed and dated lower right: *W. L. Metcalf/1920*; inscribed, verso, by the Milch
Gallery, *Study for painting*
Promised Gift, Dr. and Mrs. Philip L. Brewer Collection
Provenance: Estate of the Artist; Milch Gallery, New York; Addison M. Metcalf
(the artist's son), ca. 1940; by gift to the Rev. Edwin H. Fountain; Berry-Hill
Galleries, New York, 1990; Dr. and Mrs. Philip L. Brewer
Exhibited: *Intimate Expressions*, cat. no. 52, illus.: 15; *A Collector's Pursuit of
Drawing*; *Celebration*

NOTES TO THIS SECTION

18.

Abbott Handerson Thayer

1. Although Thayer abandoned birds and animals as painting subjects after 1879, his continuing interest in natural concealment would eventually make him a pioneer in military camouflage.

2. Maria Oakey Dewing, "Abbott Thayer, a Portrait and an Appreciation," *International Studio* (August 1921), as quoted in Nelson C. White. *Abbott H. Thayer, Painter and Naturalist* (Hartford: Connecticut Printers, Inc., 1951): 15.

3. Street trolleys were the primary form of public transportation in New York before the advent of the elevated railway in the mid-1870s. The presence of steep grades suggests a Brooklyn rather than Manhattan setting.

4. In both classical and neo-classical sculpture, *quadrigae* are usually steered by Victory or her allegorical equivalent. One of the intriguing aspects of this drawing is that Thayer's "chariot driver" is instead a symbol of industrialization and commerce.

19.

John Henry Twachtman

1. Twachtman, Avondale, to Weir, [New York], March 5, 1882. Weir Family Papers, MSS 41, Harold B. Lee Library, Archives and Manuscripts, Brigham Young University, Provo, Utah.

2. This single span of more than a thousand feet long is still in use today.

3. John Bogart, "Feats of Railway Engineering," *Scribner's Magazine* (July 4, 1888): 2 (Twachtman's image of the Brooklyn Bridge is the frontispiece to the article).

4. This sketchbook includes Twachtman's observations of urban Cincinnati as well as of the city's hills, marked by a few homes and occasional figures or paths. In several drawings in the book, Twachtman outlined trees and rooflines, as in one of the images on the verso of this drawing. A copy of the sketchbook belongs to the John H. Twachtman Catalogue Raisonné Project, Spanierman Gallery, LLC, New York.

22.

Elihu Vedder

1. Jane Dillenberger, *Between Faith and Doubt: Subjects for Meditation, Perceptions and Evocations: The Art of Elihu Vedder* (Washington, D.C.: Smithsonian Institution Press, 1979): 152.

2. However, there is no evidence that contradicts the title *Susanna*. Acquisition records from the Vedder estate through the Kennedy Galleries to the collector have consistently referred to this image as *Susanna*.

3. So much has been written in recent years concerning the "power of the gaze" that we have to acknowledge the artist's role in making someone look. See Michael Ann Holty, "Past Looking," *Critical Inquiry* 16 (winter 1990): 395.

4. Her pose is similar to that of the figure in the painting *Morning Glory* from the Museum of Fine Arts, Boston. The Susanna figure differs only in that she has raised her right arm above her head and more of the right side of her face is visible. I am indebted to the noted Vedder scholar, Regina Soria, for her gracious consideration as to the origins of this drawing as well as to Martha Fleischman of the Kennedy Galleries. Special thanks to Eleanor Harvey and Richard Murray of the Smithsonian American Art Museum, Laura Vookles of the Hudson River Museum and Katy Kline at the Bowdoin College Museum of Art who offered their kind assistance.

24.

Arthur Bowen Davies

1. "V.W.D." – Dr. Virginia Meriwether Davies was the artist's widow.

25.

John Singer Sargent

1. Stephanie L. Herdrich and H. Barbara Weinberg, *American Drawings and Watercolors in the Metropolitan Museum of Art: John Singer Sargent* (New York and New Haven: Metropolitan Museum of Art and Yale University Press, 2000): 271. See also Elizabeth Prettejohn, *Interpreting Sargent* (London: Tate Gallery, 1998): 66–67.

2. Carl Little, *The Watercolors of John Singer Sargent* (Berkeley: University of California Press, 1998): 16–17; Herdrich and Weinberg, chronology of Sargent's life: 371–372.

3. See the extensive description of Sargent's working methods provided by his friend Adrian Stokes, as reported in Little: 17. For a comparison of the visual effects of Sargent's watercolors with informal photography, see Herdrich and Weinberg: 269, and Little: 17.

4. Quoted in Little: 110.

26.

Childe Hassam

1. The literature on Childe Hassam is quite extensive. The most recent essay dealing with Hassam, Appledore, and Celia Thaxter is Susan G. Larkin, "Hassam in New England, 1889–1918," in H. Barbara Weinberg et al., *Childe Hassam: American Impressionist* (New York, New Haven, and London: Metropolitan Museum of Art and Yale University Press, 2004): 119–178. Carol Troyen's essay on Hassam's watercolors in the same publication (pp. 253–266) does an excellent job of placing Hassam's 1912 watercolors of Appledore in their historical and stylistic contexts. Access to Appledore is now restricted, since it serves as a State of Maine Critical Natural Area and the site of the Shoals Marine Laboratory. Babb's Cove is named after Philip Babb, who settled the island in the mid-seventeenth century; his ghost is said to still haunt the cove.

27.

Willard Metcalf

1. Metcalf and Tarkington had first met at the Players Club in New York City in the late 1890s. They shared interests in both American theatre and in art. For more extended discussions of Metcalf's life and art, see Elizabeth DeVeer and Richard Boyle, *Sunlight and Shadow: The Life and Art of Willard L. Metcalf* (New York: Abbeville Press in conjunction with Boston University, 1987), and Bruce W. Chambers, Richard J. Boyle, and William H. Gerdts, *Willard Metcalf* (1858–1925), *Yankee Impressionist* (New York: Spanierman Gallery, 2003). Specific information about Tarkington's friendship with Metcalf and about Tarkington's home in Kennebunkport can be found in DeVeer and Boyle: 132, and in Susanah Mayberry, *My Amiable Uncle: Recollections about Booth Tarkington* (West Lafayette, Ind.: Purdue University Press, 1983): 92–93.

2. According to the artist's son, Addison, Metcalf asked Kennebunkport's town fathers to "turn off the street lamps so that he could sketch and paint in the moonlight. They obliged": Elizabeth DeVeer, handwritten notes of telephone conversations with Addison M. Metcalf, DeVeer Metcalf Archives, Hamden, Connecticut.

3. The most important of Metcalf's nocturnes to that date had been his *May Night* of 1906 (Corcoran Gallery of Art), with which he won his first major competitive prize in 1907, together with a purse of $3,000. Along with scenes of spring, fall and winter, Metcalf considered nocturnes to be one of his four most important types of landscape paintings.

4. For explorations of the importance of the Colonial Revival to American Impressionist painters, see William H. Truettner and Roger B. Stein, eds., *Picturing Old New England: Image and Memory* (New Haven and London: Yale University Press, 1999): passim, and Erica E. Hirshler, "Hassam and American Architecture," in H. Barbara Weinberg et al., *Childe Hassam: American Impressionist* (New York, New Haven, and London: Metropolitan Museum of Art and Yale University Press, 2004): 295–304. Both Tarkington and Metcalf were committed to the realistic portrayal of the world, and were complementarily hostile to the inroads of modernism, which for both artist and writer reflected the radical social and political upheavals that had followed World War I. When the painted version of *Benediction* was shown at the Corcoran Gallery in Washington, D.C., in December 1921, Metcalf exclaimed, "It is my protest against Bolshevism in art!": (DeVeer and Boyle: 132). For Tarkington's aesthetic philosophy and political views, see James Woodress, *Booth Tarkington: Gentleman from Indiana* (Philadelphia and New York: J.B. Lippincott Company, 1955), especially on p. 183ff.

3.

PROGRESSIVE AND AVANT-GARDE ARTISTS

Fig. 61
Jan Matulka
b. Prague, Czechoslovakia 1890 – d. Queens,
New York 1972
Jazz ca. 1930s
Ink on wove paper
11 x 8½ inches (27.9 x 21.6 cm)
Museum purchase made possible through the Art
Acquisition and Restoration Fund 95.13
Provenance: Robert Schoelkopf Gallery, New York;
James Graham & Sons, New York
Exhibited: *Making a Mark*; *Celebration*

28.

John Sloan

b. Lock Haven, Pennsylvania 1871 –
d. Hanover, New Hampshire 1951
Cheering ca. 1903
Crayon on buff-colored paper
19 x 17 inches (48.3 x 43.2 cm)

By 1903, John Sloan was seeking a career breakthrough. Since 1895 he had been employed as an artist by the *Philadelphia Press*, and had filled their Sunday newspaper editions with elegant Art Nouveau illustrations and pictorial puzzles. During the previous year, however, his close friend, the artist William Glackens, had asked Sloan and their Philadelphia colleague, George Luks, to collaborate on the etchings for a deluxe edition of the writings of the popular author Paul de Kock.

It was Sloan's first major illustration commission outside of his work for the *Press*. De Kock's fictional histories of French life in the 1840s were filled with sex, wine, and ambiguity, and Sloan responded enthusiastically to the challenge. His etchings for de Kock were immediately recognized for their fresh, invigorating realism, compositional daring, and "clumsiness"—the critics' term at the time for bold graphic realization, or "rude vigor"—and gained him a reputation as "among the most original draughtsmen in the country," and a leading proponent of the "dash and virility of life."[1]

That reputation was only enhanced by his illustrations for John Kendrick Bangs's *The Genial Idiot*, which was serialized in the *Press* in the fall of 1903.[2] According to Rowland Elzea, one of the leading scholars of Sloan's career, the story is a comedy of manners —arcically based on Oliver Wendell Holmes's novel, *The Autocrat of the Breakfast Table*—and tells the story of bachelor who provides eccentric advice on a variety of subjects.[3] *Cheering* depicts the tale's hero at a football game, his arms and knees flailing about enthusiastically, to the discomfort of the other spectators, while his girlfriend looks on adoringly.

Shortly after Sloan had completed his illustrations for "The Genial Idiot," the *Press* informed him that his artistic services were no longer needed. Like his friends Glackens, Luks, and Robert Henri, Sloan then moved to New York, where he became one of the key founders of the "Ashcan School" of urban realism. BWC

Signed lower left: *SLOAN*
Dr. and Mrs. Philip L. Brewer Collection, Museum purchase made possible by the Ella E. Kirven Charitable Lead Trust for Acquisitions 2003.1.46
Provenance: Kraushaar Galleries, New York; Dr. and Mrs. Philip L. Brewer
Exhibited: *Intimate Expressions*, cat. no. 66, illus.:19; *A Collector's Pursuit of Drawing*; *Celebration*

29.
Glenn O. Coleman
b. Springfield, Ohio 1887 – d. Long Beach, New York 1932
Untitled 1907
Charcoal on wove paper
17 x 21¾ inches (43.2 x 55.2 cm)

Arriving in New York in 1905 from Indianapolis where he had received some art training, Coleman immediately found mentors in Robert Henri and Everett Shinn. The spirit, which led them to record the everyday world they knew, became Coleman's inspiration as well. Though the artist traveled to Havana and Quebec for short periods, the themes of New York's street life dominated his art. As John Sloan noted, "His pictures were love letters to the great lady of his heart—Manhattan. They reveal his love and his understanding of his mighty mistress—no sentimentality, no blind devotion—but the deep quiet love that loves the faults and weaknesses…"[1]

Coleman's untitled scene is a gas-lit tavern. A brazen young woman who, stirred by drink and the music drifting in from the dancehall beyond, impulsively and artlessly performs her version of a French can-can which enlivens this bastion of male camaraderie. Drink has affected this crowd in a myriad of ways, from the uninhibited fling of the dancer appreciated by the leering uniformed figure at the bar, to the man at the left foreground who has passed out, spilling his glass. Coleman's perspective is always as witness and not as commentator and he misses nothing including the dog tethered just out of reach of some delicious morsels that have fallen. Delighted in capturing the actions and reactions of this bawdy scene of urban nightlife, the artist has personally inscribed the image, suggesting his willingness to share his impression only with a friend who might appreciate the capricious nature of the scene without being too judgmental. Though more anecdotal than provocative today, in 1907 such an image brimming with sexual tension probably would have been deemed lewd even by the liberal standards of the members of the Ashcan School. ML

Signed lower right: *Glenn O. Coleman 07* and inscribed lower right: *To my friend Ted Ireland*
Promised Gift, Dr. and Mrs. Philip L. Brewer Collection
Provenance: Ted Ireland; Private Collection; N.W. Lott, Westport, Connecticut; Dr. and Mrs. Philip L. Brewer
Exhibited: *Intimate Expressions*, cat. no. 16, illus.: 48; *A Collector's Pursuit of Drawing*; *Celebration*

Fig. 62

Fig. 62
George Benjamin Luks
b. Williamsport, Pennsylvania 1867 – d. New York City 1933
Celebrating the Completion of the Third Avenue El ca. 1905
Watercolor and ink on buff-colored wove paper
19½ x 31¼ inches (49.5 x 79.4 cm)
Signed lower right: *Geo B Luks*
Gift of Herbert Waide Hemphill, Jr., in memory of his grandparents Mr. and Mrs. Dan Bradley 68.250
Provenance: Herbert Wade Hemphill
Exhibited: *Made with Passion: The Hemphill Folk Art Collection*, National Museum of American Art, Washington, D.C., 1990, cat. no. 9, illus.: 8; *Making a Mark*
Literature: Lynda Roscoe, *Made with Passion: The Hemphill Folk Art Collection* (Washington, D.C.: National Museum of American Art, 1990), no. 9

30.

William Glackens

b. Philadelphia 1870 – d. Westport, Connecticut 1938
Mulberry Street ca. 1905
Pencil and charcoal on wove paper
10¾ x 14½ inches (27.3 x 36.8 cm)

"I have never met an artist who so consistently fails to indulge in blah," wrote Glackens's friend, the art critic Forbes Watson.[1] Although Glackens always wanted to succeed first as a painter, he was also one of the finest illustrators of his generation. As an artist for the Philadelphia and New York newspapers and many illustrated magazines, he trained himself not only to make rapid on-the-spot sketches, but also to memorize entire scenes that he would then realize in detail once he had returned to his drawing board. Unlike many other illustrators of his generation, however, Glackens was fascinated by the gritty hubbub of city life and by its many human stories, whether debonair or sordid, comic or tragic. Some readers complained that his pictures weren't "sweet enough." Albert Sterner, a colleague at *McClure's Magazine*, observed that Glackens's images were often "too real, too original, too fresh and amusing" for a public accustomed to Gibson Girls.[2]

In the early twentieth century, Mulberry Street—which today is still a key artery for New York's Little Italy and Chinatown districts—was already a haven for immigrants. The street was crowded with vehicles of every description, shops of all kinds spilled out onto the sidewalks, and every type and nationality could be found among its human throngs. Working quickly in pencil and then reinforcing his image with staccato strokes of charcoal, Glackens perfectly captures the fleeting vignette of an overburdened mother with a clinging child at her side as she passes a storefront where a satisfied salesman gazes fondly at the bridal mannequin he has so carefully assembled for display. Although filled with all the detail of a specific time and place, Glackens's witty drawing still prompts a quiet smile of universal recognition. BWC

Gift of Dr. and Mrs. Philip L. Brewer 2002.47.4
Provenance: Sid Deutsch Gallery, New York; Dr. and Mrs. Philip L. Brewer Collection
Exhibited: *Art on Paper, 1980*, Weatherspoon Art Gallery, University of North Carolina at Greensboro; *Romantic Visions and Urban Realities*, Museum of the Borough of Brooklyn, New York, October 7 – December 2, 1986, cat. no. 25; *Intimate Expressions*, cat. no. 4a, illus.: 59; *A Collector's Pursuit of Drawing; Celebration*

Fig. 63
William Glackens
b. Philadelphia 1870 – d. Westport, Connecticut 1938
Study for Woman and Umbrella ca. 1910
Crayon on brown-colored wove paper
14¾ x 11¾ inches (37.5 x 29.8 cm)
Gift of Kraushaar Gallery in honor of the Columbus Museum's 50th Anniversary 2003.2
Provenance: Estate of the Artist; Kraushaar Gallery, New York
Exhibited: *Collectors' Show*, Arkansas Arts Center, Little Rock, Arkansas, 1986; *Celebration; Building on Strength*

Fig. 63

31a–b.

John Marin

b. Cape Split, Maine 1870 – d. Rutherford, New Jersey 1953
a. *Untitled (View of Bay)*; verso: b. *Casco Bay* 1914
Watercolor on wove paper
13¼ x 15¾ inches (33.7 x 40 cm)(both)

This double-sided watercolor depicting Maine's Casco Bay region dates to John Marin's August–September 1914 visit, his first, to the state with which his name remains inextricably associated. With few exceptions he painted the Maine landscape for part of each year for the rest of his life, often stopping in this region until he acquired a home at Cape Split in 1934. In an August 7, 1914 letter to Alfred Stieglitz, Marin, in his colorful way, described having recently arrived at this "fierce, relentless, cruel, beautiful, fascinating, hellish, and all the other ish'es place….At high tide…our little shack is 15 feet from the water on a ledge of rock running down into the water. In fact all ledges run down into the water here, and it is all ledges."

Marin's initial experience of this powerful landscape was successful in both quantity and quality: more than eighty experimental watercolors and possibly a few oils date to these months in Maine. The watercolors range from close-in views of ledges, trees, and sea such as the *Untitled (View of Bay)* reproduced here in color for the first time, to distant vistas from an elevated vantage point, such as *Casco Bay*, the watercolor from this sheet that has previously been given pride of place. Marin transformed hidden coves, watery expanses, distant hills, small rocky islands, high cliffs, and banks of trees into a distinctively articulated world—pointed evergreens, massive shrubs, choppy sea, grasses distributed among the jagged hills as well as the dramatic skies that would become a hallmark of his art regardless of place.

Marin juxtaposed broad areas of wash with saturated dry brush touches (most evident in *Casco Bay*), and delicate lines made either with a tiny brush or from paint forming in pools within grooves in the sheet Marin had incised with the tip of a brush handle. These dis-

tinctive markings are visible, for example, in the green bushes along the right edge of *Untitled (View of Bay)*.

Although impossible to demonstrate, Marin's practice each year may have been to move from a representational approach to one of a more symbolic and abstract nature, a trajectory in which early in the season he sought to learn the organization of a place, the details and rhythms within its particular gathering of nature, the changing effects of light and wind, depicting the site fairly specifically but never attempting realism as it would have been understood at that time. Feeling more familiar with his surroundings, in later works he would move away from a location's specificity.

Using that hypothesis, it is proposed that Marin painted *Casco Bay* within the early weeks of his 1914 trip. Although considerably abstracted, it is the more highly detailed of these two images, and the more conventional of the two compositions when compared with other works from this year. *Untitled (View of Bay)*, then, would have been painted toward the end of Marin's visit, on the reverse of the earlier work by necessity, because he would have used all of the paper he brought with him. More schematic overall, the extensive use of broad gestural strokes, and the surprising diagonal that cuts across the water at the upper right, *Untitled (View of Bay)* reveals Marin's educated ease with his subject and foretells broadly worked sheets of subsequent years. RF

Signed lower right, verso: *Marin /14*
Museum purchase made possible by the Art Acquisition and Restoration Fund and the Endowment Fund in Honor of D.A. Turner 82.1
Provenance: A.E. Gallatin Collection; Marlborough Gallery, New York
Exhibited: *16th Annual Philadelphia Watercolor Club*, Pennsylvania Academy of the Fine Arts, 1918; *A Select View*, cat. no. 27a. and 27b., illus.: 27; *American Drawings from the Permanent Collection*, Columbus Museum, February 22 – May 28, 1990; *Works on Paper from the Permanent Collection*, Columbus Museum, February 16 – May 17, 1992; *People, Places, Animals*; *Making a Mark*; *Celebration*
Literature: A.E. Gallatin, *American Water-colourists* (New York: E.P. Dutton & Co., 1922), pl. 20 (as *Casco Bay, Maine*), unpaginated

31a

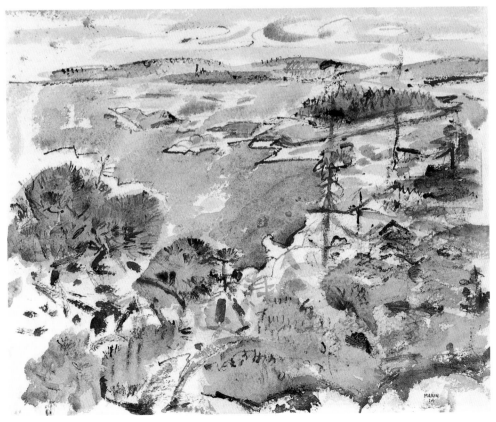

31b

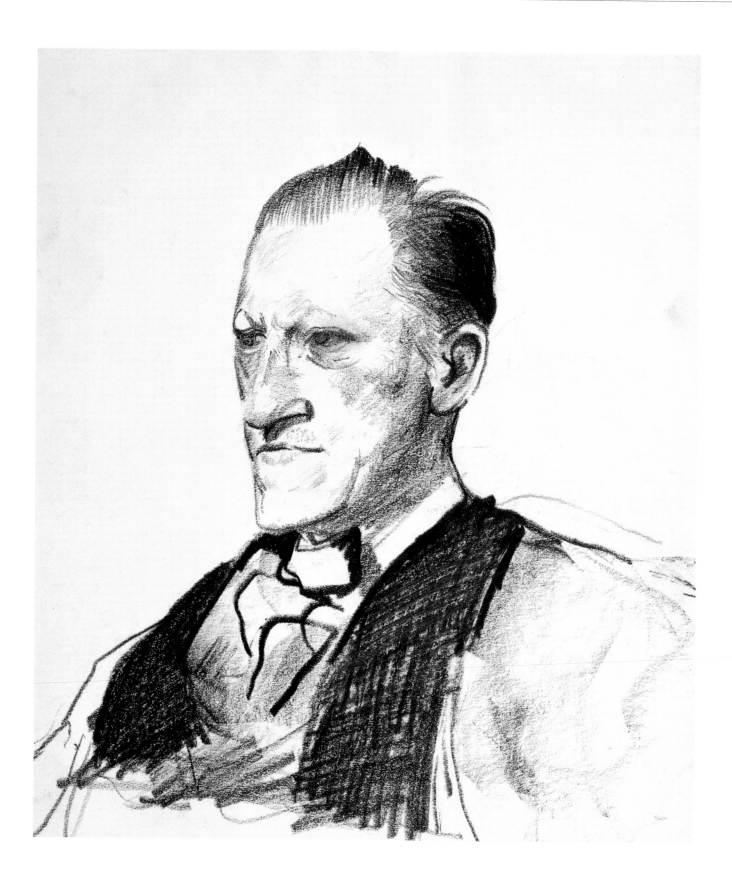

32.

George Wesley Bellows

b. Columbus, Ohio 1882 – d. New York City 1925
Study of Leon Kroll 1915–1916
Crayon on wove paper
10½ x 8¾ inches (26.7 x 22.2 cm)

George Bellows was a quintessentially American artist. He never went to Europe, and he painted uniquely American subjects: boxing matches, revival meetings, rural landscapes, and cityscapes. He loved sports and when he was not painting he could be found playing tennis or baseball, before complications from a burst appendix put an end to his vigorous life at age forty-three. This energetic artist enjoyed the company of a group of close friends who shared his traditionally masculine values and who, like Bellows, painted their surroundings in a dynamic, realist style.

Bellows and Leon Kroll met in 1911 through Bellows's admiration for one of Kroll's paintings. From then on Kroll was part of Bellows's circle, and the two spent time together socializing and critiquing each other's paintings (Kroll said of Bellows, "He loved to have people give their opinion of his work, and sometimes he'd change it and sometimes he wouldn't.").[1]

Bellows made several lithographs depicting Kroll in the company of artists Robert Henri, Eugene Speicher and himself, caricaturing them all.[2] He emphasized Kroll's diminutive stature, as well as his big nose and thinning hair. However, in the drawing in the Columbus Museum's collection he imbues his friend with the dignity and gravitas of a serious artist. Kroll's head is seen in three-quarter view, led up to by the dark vest which Bellows rendered with vigorous crosshatching that is the charcoal equivalent of the gestural paint handling that makes his paintings so celebrated.

Kroll's hair, silhouetted against the white page, forms irregular and unpredictable contours that suggest the creative temperament housed behind his expansive forehead. His nose is large, but not outlandish as in the lithographs, and his tensed lips and the focused glance of his eyes create the image of a determined artist. Kroll would have little to criticize about this drawing, which he described as "…Bellows's vision of me." TWolf

Inscribed verso: *This is Geo Bellows vision of me—Leon Kroll*
Gift of Dr. and Mrs. Philip L. Brewer 2002.47.1
Provenance: H.V. Allison and Company, New York; Dr. and Mrs. Philip L. Brewer
Exhibited: *Intimate Expressions*, cat. no. 4, illus.: 15; *Celebration*
Literature: C.H. Morgan, *Drawings of George Bellows* (Alhambra, Calif.: Borden Pub. Company, 1973), illus.

Fig. 64

Fig. 64
Boardman Robinson
b. Somerset, Nova Scotia 1876 –
d. New York City 1952
Waiting for the Spoils (Getting Ready)
1913
Crayon, ink, and gouache on wove paper
18⅞ x 14¼ inches (47.9 x 36.2 cm)
Signed lower right: *Boardman Robinson* and dated upper center: *1913*
Dr. and Mrs. Philip L. Brewer Collection, Museum purchase made possible by the Ella E. Kirven Charitable Lead Trust for Acquisitions 2003.1.56
Provenance: Kraushaar Galleries, New York; Dr. and Mrs. Philip L. Brewer
Exhibited: *Boardman Robinson, American Muralist and Illustrator, 1876–1952*, Colorado Springs Fine Art Center, September 21, 1996 – January 12, 1997, text by Henry Adams, 6, cat. no. 4, illus.; *Intimate Expressions*, cat. no. 60, illus.: 22; *A Collector's Pursuit of Drawing*; *Celebration*
Note: This cartoon appeared in the *New York Tribune*, July 8, 1913: 8

33.
Morton Schamberg
b. 1881 – d. 1918, Philadelphia
Composition 1916
Pastel on cream-colored laid paper
9 x 6¾ inches (22.9 x 17.1 cm)

The discovery, in 1982–1983, of thirty pastels attributed to Morton Livingston Schamberg altered our perception of this artist and his symbolic reference to the machine as a modernist expression.[1] Schamberg's machine aesthetic has been linked to the work of Francis Picabia and Marcel Duchamp though it has also been noted that his work in this vein may have paralleled or slightly preceded theirs.[2] According to Schamberg's family, his inspiration also may have come directly from his knowledge of the equipment and mechanical catalogues that his brother-in-law used in his manufacturing of ladies' cotton stockings.[3] Schamberg's 1916 paintings of machines relate to the sleek, simplified commercial graphics of the time but his pastels, including this image, do not.

One reason is the artist's expressive handling and affirmation of brilliant color through the pastel medium. His use of pastel was part of a revived interest in the process that Schamberg experienced first as a student of William Merritt Chase. Schamberg and others later recognized that the immediacy of pastel and its intense color was compatible with the modernist sensibility.[4]

The strong color and centralized composition of circular elements is an important characteristic of Schamberg's work from this period, bearing similarities to Orphism and Synchromism. However, what sets this image apart from the other pastels he produced at this time is the suggestion of illusionistic space. Schamberg has us peer through an octagonal machine part suspended by a strong diagonal in the foreground. Beyond is a system of two rotating wheels and vibrating belts or bolts of cloth. Schamberg's use of turquoise, lavender, yellow, and white with tinges of red and pale pink are with colors not normally associated with machinery. Instead, the connection is to a feminine entity recalling what Paul Havilland wrote in the 1915 September–October issue of *291*, "Man has made the machine in his own image. She has limbs which act; ….and a nervous system through which runs electricity."[5] Schamberg has blurred the pastel surface to achieve the idea of motion—a dynamic physical energy. Unlike his paintings of this time, which are sleek and static, these machines are enlivened with a sensual power of perpetual force. ML

Promised Gift, Dr. and Mrs. Philip L. Brewer Collection
Provenance: Natalie Morris; Estate of Natalie Morris; Private Collection; Hirschl & Adler Galleries, New York; Christie's Auction House, New York, Sale 7458, lot 252, May 28, 1992; Dr. and Mrs. Philip L. Brewer
Exhibited: *Morton Livingston Schamberg*, Salander-O'Reilly Galleries, New York, November 3 – December 31, 1982, cat. no. 49, illus.; traveled to Columbus Museum of Art, Columbus, Ohio; Pennsylvania Academy of the Fine Arts, Philadelphia; Milwaukee Art Museum, Wisconsin; *Realism and Abstraction: Counterpoints of American Drawing, 1900–1940*, Hirschl & Adler Galleries, New York, November 12 – December 30, 1983, 101, cat. no. 121, illus.; *American Masterworks on Paper*, Hirschl & Adler Galleries, New York, November 23, 1985 – January 4, 1986, cat. no. 42, illus.; *Morton Livingston Schamberg*, Salander-O'Reilly Galleries, New York, January 4 – February 1, 1986, cat. no. 8, illus.; *Modern Times: Aspects of American Art 1907–1956*, Hirschl & Adler Galleries, New York, November 1 – December 6, 1986, cat. no. 92, illus.: 101; *Painters in Pastel: A Survey of American Works*, Hirschl & Adler Galleries, New York, April 25 – June 5, 1987, cat. no. 76, illus.: 75; *A Sense of Line, American Modernist Works on Paper*, Hirschl & Adler Galleries, New York, November 25, 1989 – January 6, 1990, cat. no. 75, illus.; *Intimate Expressions*, cat. no. 65, illus.: 75, pl. 17; *Celebration*
Literature: William C. Agee, *Morton Livingston Schamberg* (New York: Salander-O'Reilly Galleries, 1982), no. 49; William C. Agee, *Morton Livingston Schamberg, The Machine Pastels* (New York: Salander-O'Reilly Galleries, 1986), no. 8, unpaginated; Dianne Pilgrim, *Painters in Pastel: A Survey of American Works* (New York: Hirschl & Adler Galleries, 1987), no. 76.

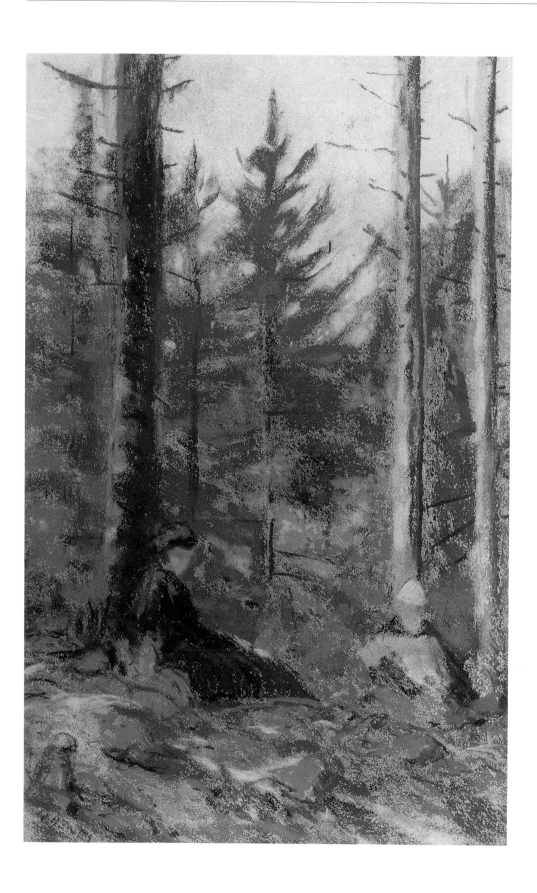

34.
Robert Henri
b. 1865 – d. 1929, Cincinnati, Ohio
A Place in the Woods 1918
Pastel on tan wove paper
18¾ x 11¾ inches (47.6 x 29.8 cm)

In 1903, Robert Henri finally arrived at Monhegan Island after spending a few desultory weeks at what he found to be a disappointingly placid Boothbay Harbor, at the sea end of the Damariscotta Peninsula. Henri had been searching for something more closely resembling Winslow Homer's vision of the Maine coast, with rugged cliffs and pounding sea, and he found it perfectly expressed at Monhegan, seventeen miles out at sea, whose 200-foot precipices and virgin forests perfectly matched the "vastness, order and grand formation" of his preconceptions.[1]

Henri returned to Monhegan Island at least three more times, in 1911, 1912, and 1918. His enthusiasm for the island and inspirational example as a teacher encouraged such younger artists as George Bellows, Rockwell Kent, and Edward Hopper to visit Monhegan, where they were inspired to paint scenes of the New England coast and its fishermen that were at least as muscular and dramatic as those in Homer's Maine shorescapes of the 1890s.[2]

Henri's last visit to Monhegan took place in 1918, at the end of World War I. Naval restrictions prevented him from spending much time boating around the island or walking along the cliffs. As a result, he focused his attention on the Cathedral Woods, near his own property in the center of the island. At the time Henri had also begun experimenting extensively with pastel, and over the summer produced many views of his wife, Marjorie, and two of his students, Lucy Blaesus and Ruth Jacobi, reading and relaxing amid the woods' tall pines and cedars. *A Place in the Woods* is typical of these pastels, which, with their bright palette, atmospheric effects and sunny mood, reveal Henri at his most "impressionistic" and lyrical.[3] BWC

Signed in pastel lower left corner: *R. Henri* and inscribed recto: *Robert Henri/A Place in the Woods/Monhegan Island, Maine/1918*
Museum purchase made possible by an anonymous donor 83.7
Provenance: Estate of the Artist; Mr. Julian Foss; Hirschl & Adler Galleries, New York
Exhibited: *Robert Henri: Painter, Teacher, Prophet*, New York Cultural Center, New York, 1969, cat. no. 82: 106; *Robert Henri (1865–1929)*, Harbor Gallery, Cold Harbor, New York, 1973, cat. no. 42, illus.; *The Eight*, Janet Fleisher Gallery, Philadelphia, 1974; *100 American Drawings and Watercolors from 200 Years*, Hirschl & Adler Galleries, New York, 1976; *American Drawings from the Permanent Collection*, Columbus Museum, February 22 – May 28, 1990; *Works on Paper from the Permanent Collection*, Columbus Museum, February 16 – May 17, 1992; *People, Places, Animals*; *Making a Mark*; *Celebration*

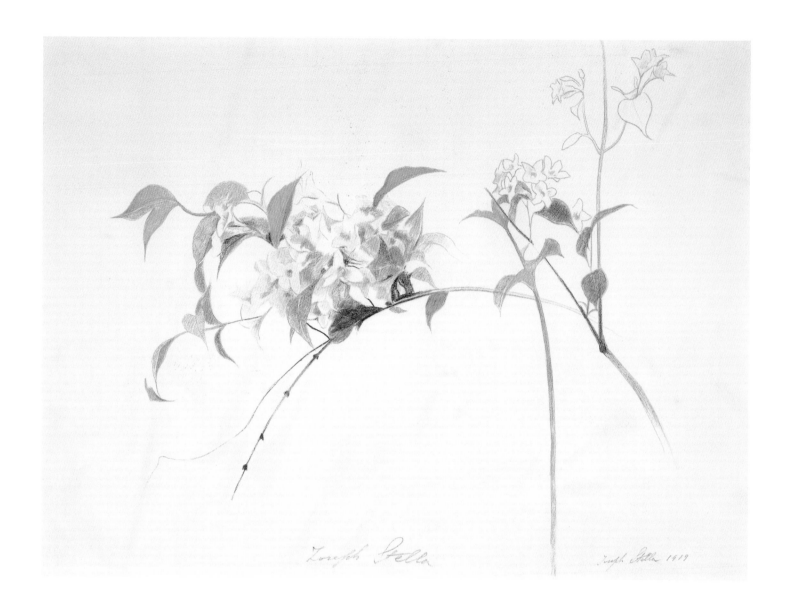

35.

Joseph Stella
b. Muro Locano, Italy 1877 – d. New York City 1946
Flowering Branch of Wigelia 1919
Silverpoint and crayon on prepared wove paper
10¼ x 14½ inches (26 x 36.8 cm)

Known especially for his Futurist-inspired paintings of the
Brooklyn Bridge and Coney Island, Joseph Stella also made exqui-
site drawings of flowers. In contrast to the kaleidoscopic patterns of
light and color that animate the canvases, his silverpoint and cray-
on plant studies seem timeless: nature in a suspended state of grace.

A modernist disposed toward abstraction, Stella never relin-
quished his identification with Italy and deep respect for the tradi-
tion of Italian art. This is especially true of his work in silverpoint.
"In order to avoid careless facility," he wrote, "I dig my roots obsti-
nately, stubbornly in the crude untaught line buried in the living
flesh of the primitives, a line whose purity pours out and flows so
surely in the transparency of its sunny clarity. I dedicate my ardent
wish to draw with all the precision possible, using the inflexible
media of silverpoint and goldpoint that reveal instantly the clearest
graphic eloquence."[1] Silverpoint was to Stella what the practicing of

scales is to a seasoned musician: a way of limbering up and perfect-
ing technique. The medium, unforgiving because there is no way
to erase it, thrived in his hands. *Flowering Branch of Wigelia* is
dated 1919, the same year Stella painted *Tree of My Life*, a horticul-
tural index to the many flower drawings that came before and
after. Each drawing is distinct, not unlike the many portraits of
artists, musicians, and friends he produced concurrently in silver-
point and pencil. The flower had multiple meanings for him; it was
a thing of great beauty, a symbol of hope and regeneration, an
affirmation of life. That his persistent interest in the motif extend-
ed beyond mere exercise can be gleaned from his insightful com-
ment, "that all our days may glide by serene, sunny, each must
begin with the study of a flower."[2] DD

Signed lower center: *Joseph Stella*; also, signed and dated lower right:
Joseph Stella 1919
Dr. and Mrs. Philip L. Brewer Collection, Museum purchase made possible by the
Ella E. Kirven Charitable Lead Trust for Acquisitions 2003.1.44
Provenance: Richard York Gallery, New York; Dr. and Mrs. Philip L. Brewer
Exhibited: *Intimate Expressions*, cat. no. 70, illus.: 71, pl. 10; *Celebration*

Fig. 65
Malvina Cornell Hoffman
b. 1887 – d. 1966, New York City
Pavlova (study for a Red Cross
benefit poster) 1914
Colored pencil, watercolor, and
graphite on tan-colored wove paper
13½ x 9¼ inches (34.3 x 23.5 cm)
Museum purchase made possible
by the Endowment Fund in Honor
of D.A. Turner 81.53
Provenance: Berry-Hill Galleries,
Inc., New York
Exhibited: *American Drawings from
the Permanent Collection*, Columbus
Museum, February 22 – May 28,
1990; *Works on Paper from the*

Permanent Collection, Columbus
Museum, February 16 – May 17,
1992; *People, Places, Animals*;
Celebration

Fig. 66
Malvina Cornell Hoffman
b. 1887 – d. 1966, New York City
*Pavlova, Dancing the Autumn
Bacchanal* ca. 1914–1915
Pencil, gouache, and watercolor on
light green-colored wove paper
5½ x 12⅜ inches (14 x 31.4 cm)
Signed with estate stamp lower left
Promised Gift, Dr. and Mrs. Philip
L. Brewer Collection
Provenance: Estate of the Artist;
Berry-Hill Galleries, New York; Dr.
and Mrs. Philip L. Brewer
Exhibited: *Intimate Expressions*
(Columbus only, not in catalogue);
Celebration

Fig. 65

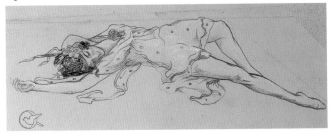

Fig. 66

36.

Charles Burchfield

b. Ashtabula, Ohio 1893 – d. Buffalo, New York 1967
Daybreak ca. 1920
Gouache, watercolor, and pencil on wove paper
17⅝ x 26½ inches (44.8 x 67.3 cm)

Charles Burchfield was one of those great American loners, like Henry David Thoreau and John Muir, for whom long, solitary walks in the woods and fields near his home provided intense intellectual, emotional, and aesthetic stimulation. In the spring of 1920, after a disheartening year of service with the Army, and yet with his first successful one-man exhibition in New York fresh in his memory, Burchfield took a three-month leave of absence from his accounting job at Cleveland's Mullins Company in order to pursue a summer of full-time painting.[1]

Burchfield had already set out on the highly individual path he would follow for the rest of his artistic career, a path that, as he put it, might communicate his yearning "for some strange land of poetry and imagination, which is always beyond my reach."[2] Since 1915 he had been experimenting with a vocabulary of pictorial symbols that could convey both moods and sounds. Not every experience was upbeat; he was as moved by intimations of darkness and evil as he was by romantic expressions of joy. Shapes strangely altered by the passage of light, the ambient sounds of

insect and bird life, or the blank, dark windows of a house could all produce emotional responses which Burchfield would then translate into his own invented pictorial equivalents.

Among the watercolors that Burchfield produced in the summer of 1920 was a series of broad, panoramic, low-horizon landscapes featuring dramatic skies filled with clouds that were often backlit by the sun as though players on a cosmic stage. Like John Constable before him, Burchfield loved the ever-changing forms of clouds in passage, at one moment serene, at another violent, and often, as in *Daybreak*, taking the shapes of fantastic, evanescent beasts, soon whisked away by the wind. BWC

Stamped lower right corner with estate stamp: *C. E. BURCHFIELD /B 240 [in pencil] FOUNDATION*
Gift of the Royal Crown Cola Company on the occasion of the Museum's Silver Anniversary 77.37
Provenance: Charles E. Burchfield Foundation; Kennedy Galleries, New York
Exhibited: *Charles E. Burchfield at Kennedy Galleries, The Early Years, 1915–1929*, Kennedy Galleries, New York, October 13 – November 14, 1977, no. 41; *Drawings from Georgia Collections, 19th and 20th Centuries*, High Museum of Art, Atlanta, 1981; cat. no. 73, illus.; *A Select View*, cat. no. 4, illus.: 20; *Making a Mark*; *Celebration*
Literature: John I.H. Baur, *Charles E. Burchfield at Kennedy Galleries, The Early Years, 1915–1929* (New York: Kennedy Galleries, 1977), unpaginated; Peter Morrin and Eric Zafran, *Drawings from Georgia Collections, 19th and 20th Centuries* (Atlanta: High Museum of Art, 1981), illus.: 150; *Building on a Legacy*, illus.: 189

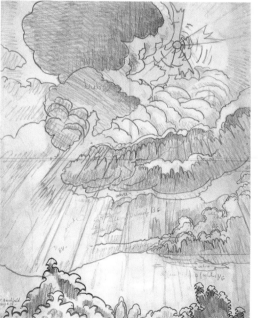

Fig. 67
Charles Burchfield
b. Ashtabula, Ohio 1893 –
d. Buffalo, New York 1967
Sunburst and Clouds 1915
Pencil and ink wash on assembled wove paper
21¼ x 16⅝ inches (54 x 42.2 cm)
Signed in pencil lower left corner: *C. Burchfield /7/22/1915*; inscribed throughout in pencil with notes on color placement
Gift of the Callaway Chemicals Company on the occasion of the Museum's Silver Anniversary 77.38
Provenance: Charles E. Burchfield Foundation; Kennedy Galleries, New York
Exhibited: *Making a Mark; Celebration*

Fig. 67

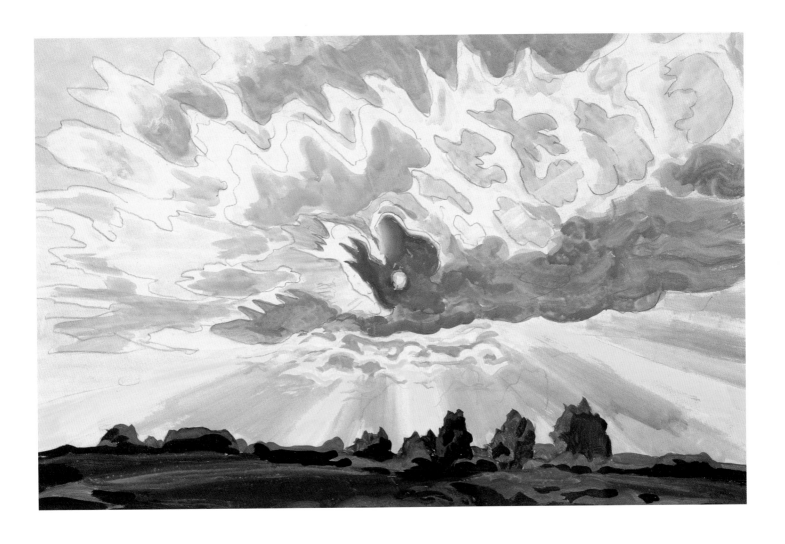

37.

Marguerite Thompson Zorach
b. Santa Rosa, California 1887 – d. New York City 1968
Baby (Dahlov, the Artist's Daughter) ca. 1919
Pencil on wove paper
21 x 14 inches (53.3 x 35.6 cm)

This pencil drawing probably dates from 1919, when Dahlov was a toddler, and shows a departure from the simplification of form found in her mother's earlier drawings and paintings.

Marguerite Thompson studied in Paris beginning in 1908, and saw the works of Henri Matisse and Pablo Picasso there. She was exposed to modern art in France, Spain, Germany, and England and her early works featured bold strokes of unmodulated color.[1] Her paintings were included in the *Salon des Indépendants* of 1911. Having returned to the United States, she became active with a group of American modernists after her marriage to William Zorach in 1912. By 1913, she began making portraits that featured bold outlines, expressive color, and simplified forms, seemingly indebted to Matisse. Dahlov, the second child of the Zorachs, was born on November 12, 1917 in Windsor, Vermont, and was two years younger than her brother Tessim. Both children served as a proud source of inspiration for their parents' art from infancy through their childhood. The children appear in drawings, paintings, and sculptures by both William and Marguerite Zorach. At the same time Marguerite Zorach sketched this image of her young daughter, she created a number of portraits of friends and associates. For example in 1919, she painted *Marianne Moore and Her Mother*. Moore, a celebrated American poet, was also the subject of a pencil sketch similar in style and execution to this portrait of Dahlov. Zorach's other portrait studies, however, do not include the hands of her sitters. The sketch of Dahlov emphasizes the child's expressive fingers that are presented as disconnected from the body, and convey her inner vitality. Soft curls frame the child's face and create a credible likeness, different from the stylized details of Zorach's other portraits of these years.[2] JMM

Signed lower right: *Marguerite Zorach*
Dr. and Mrs. Philip L. Brewer Collection, Museum purchase made possible by the Ella E. Kirven Charitable Lead Trust for Acquisitions 2003.1.15
Provenance: Estate of the Artist; Kraushaar Galleries, New York; Dr. and Mrs. Philip L. Brewer
Exhibited: *Intimate Expressions*, cat. no. 78, illus.: 43; *Celebration*

Fig. 68
Emil Ganso
b. 1895 Woodstock, New York –
d. 1941 Halberstadt, Germany
Nude on a Printed Bedcover ca.
1918–1920
Charcoal and crayon on wove paper
20 x 16¼ inches (50.8 x 41.3 cm)
Signed lower right: *Ganso*
Promised Gift, Dr. and Mrs. Philip
L. Brewer Collection
Provenance: Catherine E. Burns,
Oakland, California; Janet
Marqusee Fine Arts, New York; Dr.
and Mrs. Philip L. Brewer
Exhibited: *Intimate Expressions*, cat.
no. 30, illus.: 50; *Celebration*

Literature: *American Master Prints
and Drawings* (Oakland, Calif.:
Catherine E. Burns, 1989), cat. no. 4,
illus.: 29; *American Art Notes* (New
York: Janet Marqusee Fine Arts,
New York, spring 1990), cat. no. 30,
illus.: 30

Fig. 68

38.

Morgan Russell

b. New York City 1886 – d. Broomall, Pennsylvania 1953

Job's God ca. 1920

Charcoal on Montgolfier wove paper

18 x 19 inches (45.7 x 48.3 cm)

Some scholars have based Morgan Russell's reputation as an early American modernist only on his abstract Synchromies, which explored the possibilities of light and color upon abstract form. However, further investigations have discovered that even while the artist was developing these images based on color theories, he continued to draw figures indicating that they were equally important. The prominent S-curve, which is the basis for many of the early Synchromies, is also the S-curve of the twisting heroic figures based on Michelangelo, Pablo Picasso and others that filled the pages of Russell's notebooks.[1]

During and after World War I, Russell chose to remain in France, where he produced abstractions, still lifes, landscapes, and figures. As he wrote to his close friend Stanton MacDonald Wright:

There are a very few who seem to appreciate at least that
my figures are serious work of a superior and hidden character…
I should say they are my real expression….The rest is but
play beside them.[2]

His growing fascination with Asian and Western mythology became an important inspiration, as did images from the Bible. This is evident from a photograph in the Russell Archives of an unidentified triptych, which depicts Giants and Gods that hold sway over mere mortals.[3] The drawing of *Job's God* is doubtless a study for the entire right panel of this work. In the drawing, the perspective is looking down upon a muscular nude male whose hands extend above his head, palms up, as if to fend off or push something away. His foreshortened torso and legs, bent under the weight of his struggle, exist in a very compressed space. Is this Job himself, almost crushed beneath the difficult trials and hardships thrust upon him? Alternatively, is it the artist's idea of Job's God who sends ordeal after tribulation to test the mortal's fidelity? Russell made notational references to *Le Dieu de Job* (Job's God) or *Jobe* in his notebooks, suggesting that the story of enduring faith despite extreme adversity greatly intrigued him and was perhaps something he identified with in his own struggle as an artist.[4] ML

Inscribed verso: *Job's God, one of a series of drawings and paintings made by Russell about 1926–1935/ on this subject/ S Macdonald-Wright*

Gift of Dr. and Mrs. Philip L. Brewer in honor of the Museum's 50th Anniversary 2003.38.6

Provenance: Hirschl & Adler Galleries, New York; Dr. and Mrs. Philip L. Brewer

Exhibited: *Realism and Abstraction: Counterpoints of American Drawing, 1900–1940,* Hirschl & Adler Galleries, New York, November 12 – December 30, 1983, 30, cat. no. 24, illus.; *A Sense of Line, American Modernist Works on Paper,* Hirschl & Adler Galleries, New York, November 25, 1989 – January 6, 1990, cat. no. 3, illus.: 12; *Intimate Expressions,* cat. no. 63, illus.: 28; *Celebration*

Fig. 69

Fig. 69

Jules Pascin

(Julius Mordecai Pincas)

b. Widden, Bulgaria 1885 – d. Paris, France 1930

Seated Nude with Hat (Reclining Nude) ca. 1918–1925

Pencil and sepia ink, wash, and pencil on wove paper

19¾ x 14½ inches (50.2 x 36.8 cm)

Signed lower right: *Pascin* and inscribed upper left: *#41*

Promised Gift, Dr. and Mrs. Philip L. Brewer Collection

Provenance: Stefan Hirsch, New York; Family of Stefan Hirsch, New York; Conner-Rosenkranz Gallery, New York; Dr. and Mrs. Philip L. Brewer

Exhibited: *Intimate Expressions,* cat. no. 57, illus.: 47; *Celebration*

Note: This drawing is a study for *Nude with Green Hat* in the Cincinnati Art Museum

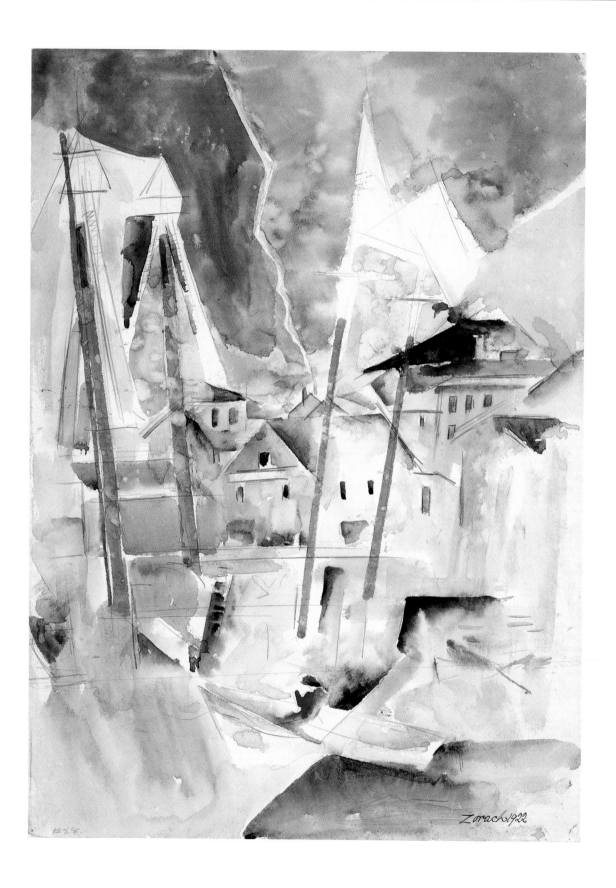

39.
William Zorach
b. Eurburick-Kovno, Lithuania 1887 – d. Bath, Maine 1966
Lightning Storm, Provincetown 1922
Watercolor on wove paper
17½ x 12¼ inches (44.5 x 31.1 cm)

This depiction of a storm along the waterfront in Provincetown, Massachusetts, is an example of Zorach's fusion of his direct experience of nature with the most progressive style in American art of the period. The watercolor features faceted forms, an emphasis on angularity, and muted colors, all of which can be related to Cubism. Although many American modernists incorporated the cubist vocabulary into their paintings after 1915, Zorach's approach to abstraction was to combine the facture of analytical Cubism with his earlier interest in impressionism. The specifics of time of day and the spontaneous representation of certain weather conditions remained essential to Zorach's vision. Although he was studying in Paris in 1911, during the heyday of analytical Cubism, Zorach's paintings of that time were expressive landscapes in a Post-Impressionist style. By 1915 Cubist facets appear in his paintings. Zorach recalled:

In Paris I had not understood or been interested in the Cubists, but after the Armory Show I began making my visual observation of nature into Cubist patterns. It was another revelation: that one was not confined to the small section of nature framed in the space of a canvas and seen from only one point of view.[1]

A summer storm was the inspiration for this watercolor, which demonstrates Zorach's skill with the medium as well as his mastery of the varying moods of nature. Marguerite and William Zorach first enjoyed summer in the artists' colony of Provincetown in 1916. Marine life and scenes along the waterfront appear in Zorach's work from that time. The couple returned to Provincetown in 1921 and spent the following two summers there. By 1922, Zorach had abandoned oil painting entirely for sculpture, although he continued to make watercolors until his death.[2] JMM

Signed lower right: *Zorach 1922* and inscribed lower left: *#28*
Dr. and Mrs. Philip L. Brewer Collection, Museum purchase made possible by the Ella E. Kirven Charitable Lead Trust for Acquisitions 2003.1.52
Provenance: Private Collection; Kraushaar Galleries, New York; Dr. and Mrs. Philip L. Brewer
Exhibited: *Intimate Expressions*, cat. no. 79, illus.: 72, pl. 11; *A Collector's Pursuit of Drawing; Celebration*

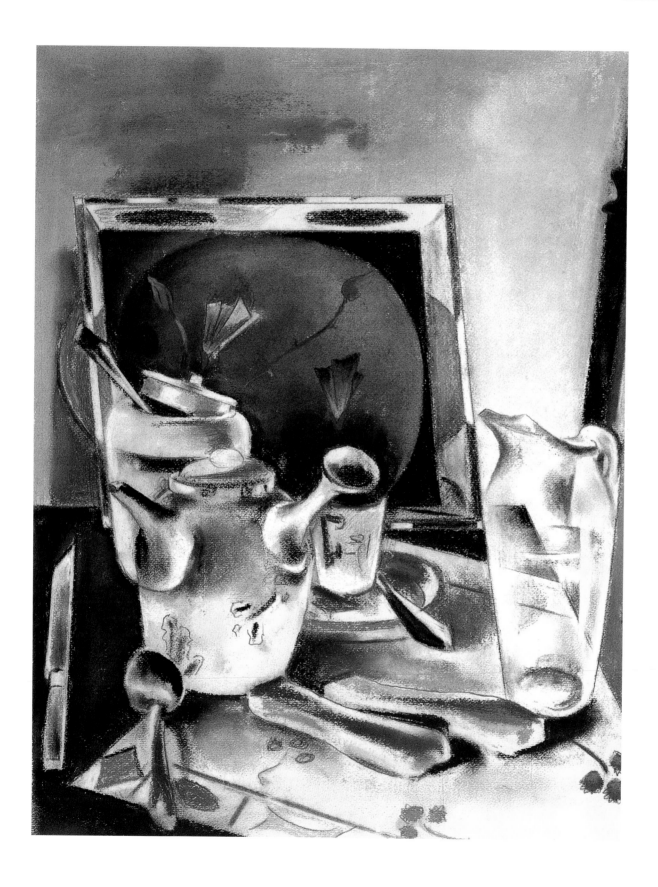

40.
Preston Dickinson
b. New York City 1889 – d. Irun, Spain 1930
Still Life: Tea Table before 1927
Pastel on wove paper
18¼ x 13¼ inches (46.4 x 33.7 cm)

Curator Ruth Cloudman noted that Preston Dickinson was "…among the earliest in American art to express the inherent geometric beauty of the city and…" and that his "…were among the first Precisionist works…," establishing him "firmly as a founder and a leader of the movement."[1] *Still Life: Tea Table* presented a simplification of design that fused abstract and realist strategies, which was an essential undercurrent of Precisionism even as it eschewed the usual subject of urban environs or the machine aesthetic. However, Dickinson approached this well-ordered composition of domesticity with the same meticulousness that defined the underlying structural dynamic of his Harlem River industrial scenes or his images of grain elevators in Nebraska. Perhaps it was this exactitude, regardless of subject, that caused collector Duncan Phillips to write that though the artist's still life images were masterful, "…they lack vitality…" and "…are too obviously arranged."[2] During the course of the artist's brief career which ended with his death from pneumonia at age forty-one, there were those who agreed with Phillips, while others contended that, "…as a painter of 'still-life' Dickinson is a master… These are living designs modeled and luxuriously rich in form and magnificent in color."[3]

In this pastel, Dickinson experimented with the depiction of space using shifting perspectives and overlapping forms. This is evident in the manner in which he revealed planes and angles behind and beneath the transparent glass pitcher at right and the seeming levitation of the knife at left. Though this work evokes the Cubist still life compositions of Picasso and Braque, Dickinson's work is primarily realistic (even though one must concede the artificial elegance of this purposeful arrangement). The style and modern grace of the work was enhanced by his use of jewel-like color, which artist Louis Bouché noted as having the "tones of silk dyes," and by his proficiency with pastels that his friend and author Moritz Jagendorf said he preferred because he could play with them much more than watercolors.[4] The commitment to explore the possibilities of color, form, and space as evidenced in this piece secures Dickinson's work among the best in American modernism. ML

Gift of Dr. and Mrs. Philip L. Brewer 2001.16.4
Provenance: Daniel Gallery, New York; Mrs. Alexander Lieberman, Philadelphia; Private Collection, New York; Hirschl & Adler Galleries, New York; Dr. and Mrs. Philip L. Brewer
Exhibited: *Recent Pastels by Preston Dickinson*, Daniel Gallery, New York, 1927; *American Masterworks on Paper*, Hirschl & Adler Galleries, New York, November 23, 1985 – January 4, 1986, cat. no. 55: 53; *Modern Times: Aspects of American Art, 1907–1956*, Hirschl & Adler Galleries, New York, November 1 – December 6, 1986, cat. no. 26: 33; *Painters in Pastel: A Survey of American Works*, Hirschl & Adler Galleries, New York, April 25 – June 5, 1987, cat. no. 102: 95; *Intimate Expressions*, cat. no. 23, illus.: 77, pl. 19; *A Collector's Pursuit of Drawing; Celebration*

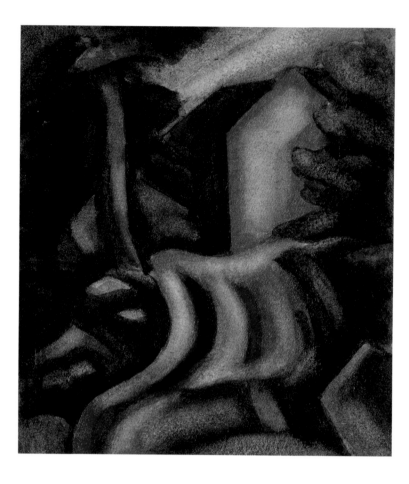

41.
Oscar F. Bluemner
b. Prenzlau, Germany 1867 – d. South Braintree, Massachusetts
1938
Red House by a Stream 1927
Watercolor and gouache on wove paper
4⅝ x 3¾ inches (11.7 x 9.5 cm)

Trained as an architect in his native Germany, Oscar Bluemner
immigrated to America in 1892 and soon launched an architecture
firm in New York. Disillusioned with his practice by 1910, he was
drawing and painting full-time and producing moody landscapes
inspired by the vanguard pictures in Alfred Stieglitz's gallery *291*,
especially those by O'Keeffe and Hartley. In 1912 he traveled to
Europe, where he was deeply affected by Kandinsky's spiritually
based work and the emotive color used by van Gogh and Gauguin.
Upon returning to New York, Bluemner formulated a distinctive
style comprised of architectonic forms and expressive hues.[1]

 Red House by a Stream was produced in 1927, a year after
Bluemner moved to South Braintree, Massachusetts, during a time
of artistic growth and great personal turmoil.[2] Destitute, and reel-
ing from his wife's death the previous year, he channeled his
despair into this and other works—many of them watercolors—
featuring boldly simplified domestic structures nestled within

melancholy landscape settings.[3] Visible over the roofline is a pale
orange sliver—perhaps the edge of a setting sun or rising moon.[4]
Echoing the artist's personal loss, the eerily lit composition
appears devoid of life. Considerable movement, however, is gener-
ated by rippling contours and vibrant, contrasting hues. Rendered
in densely applied pigment, a vermilion dwelling and fiery cascade
glow like shards of stained glass amid jade foliage.[5] According to
Bluemner's color system, which assigned physical and emotional
properties to specific hues, red was of primary importance as rep-
resenting "power, vitality, energy, life…passion, struggle."[6] He
regarded color as a universal language akin to music that, properly
orchestrated, stirs all regions of the psyche. As a striking synthesis
of iconic form and emotive color, and a telling reflection of his
own state of mind, *Red House by a Stream* embodies the full real-
ization of Bluemner's lofty artistic ambitions. SCW

Inscribed: *Jy12–27/w rose verm old and old veils/on gy and turk sky/gn ble
shds and d gy fol/s28–27 2x*[illegible] *1:3then 1xinches1:4*[illegible] Dr. and Mrs. Philip
L. Brewer Collection, Museum purchase made possible by the Ella E. Kirven
Charitable Lead Trust for Acquisitions 2003.1.42
Provenance: Estate of the Artist; Private Collection, New York; Richard York
Gallery, New York; Dr. and Mrs. Philip L. Brewer
Exhibited: *Intimate Expressions*, cat. no. 7, illus.: 69, pl. 7; *Celebration*

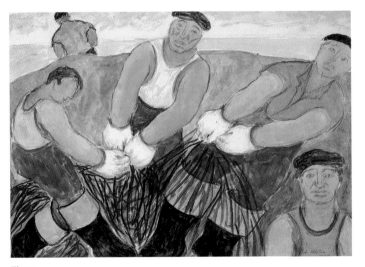

Fig. 70

Fig. 70
Abraham Walkowitz
b. Tuieman, Siberia, 1878/80 –
d. Brooklyn, New York 1965
Untitled (Men with Nets) 1929
Watercolor on buff-colored wove
paper
22⅛ x 30¾ inches (56.2 x 78.1 cm)
Signed and dated lower right: *A
Walkowitz 1929*
Gift of the artist 59.148
Provenance: Artist
Exhibited: *Celebration*

42.

Isamu Noguchi
b. Los Angeles 1904 – d. New York City 1988
Female Nude 1928–1929
Charcoal on buff-colored wove paper
17⅛ x 11 inches (43.5 x 27.9 cm)

Celebrated primarily as a sculptor, Isamu Noguchi was a multifac-
eted artist whose work ranged across numerous forms of creative
production, including garden and stage design and the fabrication
of useful objects for the home. But Noguchi focused much effort
on creating traditional kinds of artworks, both the abstract sculp-
tures for which he is best known and, in two dimensions, large
numbers of drawings.

Apart from sketches made to capture sculptural ideas or
done while traveling, Noguchi created four cohesive bodies of
drawings: images of the figure drawn from life while working in
Paris during the late 1920s, geometric and biomorphic abstractions
in black and white gouache from the same period, large figurative
ink-brush drawings created in Beijing in 1930–1931, and works
using graph paper and black construction paper that show the ele-
ments of his interlocking sculptures of the 1940s. *Female Nude*
belongs to the first group, done as Noguchi was developing his first
abstract sculptures under the inspiration of Constantin Brancusi,

for whom he had worked as a studio assistant soon after arriving in
Paris. But as indicated by the conjunction of this drawing with his
innovative abstractions of the period, Noguchi moved readily
between abstraction and figuration, and references to the body
never would disappear entirely from his work.

For the most part done while working alongside other
American and foreign artists in the independent academies of Paris,
Noguchi's late-twenties figure drawings range from rough sketches
to highly finished pieces, of which *Female Nude* is a noteworthy
example. Completing the image with subtle shading, Noguchi went
on to sign *Female Nude*, a significant feature of the work as he often
did not autograph his drawings. Perhaps signed on the way to an
exhibition or for possible sale, the signature represents the artist's
satisfaction with this sensuous rendering of a lovely Parisian model,
hair bobbed in twenties style and suggesting the pleasures of the city
where Isamu Noguchi became a modern artist. BA

Signed lower right: *Isamu Noguchi*
Dr. and Mrs. Philip L. Brewer Collection, Museum purchase made possible by the
Ella E. Kirven Charitable Lead Trust for Acquisitions 2003.1.43
Provenance: Private Collection, New York; Jill Newhouse, New York; Dr. and Mrs.
Philip L. Brewer
Exhibited: *Intimate Expressions*, cat. no. 16, illus.: 54; *Celebration*

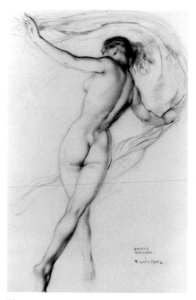

Fig. 71

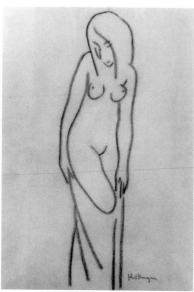

Fig. 72

Fig. 71
Francis Luis Mora
b. Montevideo, Uruguay 1874 – d.
Gaylordsville, Connecticut 1940
Dance Rhythm ca. 1929
Pencil on wove paper
13⅜ x 9 inches (34 x 22.9 cm)
Signed lower right: *F. Luis Mora* and
inscribed lower right:
Dance/Rhythm
Dr. and Mrs. Philip L. Brewer
Collection, Museum purchase
made possible by the Ella E. Kirven
Charitable Lead Trust for
Acquisitions 2003.1.18
Provenance: Private Collection;
Hope Davis Fine Art, New York; Dr.
and Mrs. Philip L. Brewer
Exhibited: *Intimate Expressions*, cat.
no. 54, illus.: frontispiece; *Celebration*,
illus. gallery guide, unpaginated

Fig. 72
John B. Flannagan
b. Fargo, North Dakota 1895 –
d. New York City 1942
Nude ca. 1933–1935
Black crayon on buff-colored wove
paper
11 x 7½ inches (27.9 x 19.1 cm)
Signed lower right: *John B*
Flannagan
Dr. and Mrs. Philip L. Brewer
Collection, Museum purchase
made possible by the Ella E. Kirven
Charitable Lead Trust for
Acquisitions 2003.1.2
Provenance: Private Collection,
Connecticut; Hirschl & Adler
Galleries, New York; Dr. and Mrs.
Philip L. Brewer
Exhibited: *Realism and Abstraction:*
Counterpoints in American
Drawing, 1900–1940, Hirschl &
Adler Galleries, New York,
November 12 – December 30, 1983,
cat. no. 34, illus.: 38; *Intimate*
Expressions, cat. no. 28, illus.: 29;
Celebration

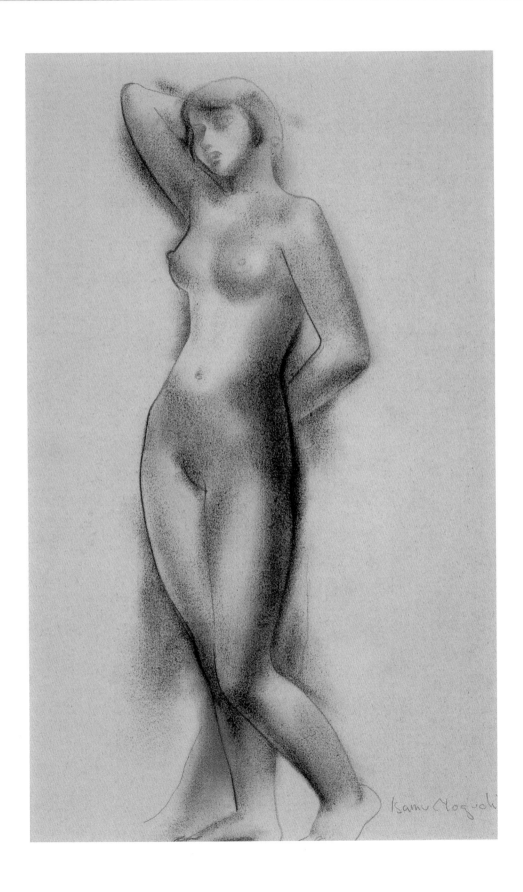

43.

Jan Matulka

Prague, Czechoslovakia 1890 – d. Queens, New York 1972
Interior ca. 1930
Watercolor on wove paper
22 x 17 inches (55.9 x 43.2 cm)

Jan Matulka's legacy lived on memorably through his students. During the late twenties, his classes at the Art Students League attracted a diverse group of creative individuals that included David Smith, Dorothy Dehner, George McNeil, Irene Rice Pereira, and Burgoyne Diller. Matulka's prescient approach to teaching the basics of modern art profoundly influenced his protégés, many of whom went on to have impressive careers.

Worldly and well informed about contemporary European art, Matulka combined traditional precepts of drawing and composition with a disposition toward abstraction. Cubism figures large in the many landscapes, seaport scenes, cityscapes, still lifes, and abstractions he painted and drew. He was particularly drawn to still lifes, both as a teaching tool and a favored subject in his own art. In many of these, including *Interior*, selected motifs—an armchair, an array of musical instruments, a wind-up record player, conch shell, lamp, pipe, and pitcher—are recycled in varying contexts. An interior space, it seemed, with a table populated by sundry objects, became the arena for an ongoing series of autobiographical arrangements.

Interior combines an interior domestic view with a distant view of the metropolis seen through a window. In other interior scenes Matulka painted with windows, a half moon floats among scattered clouds. Conceived in pencil and watercolor as a work in progress, *Interior* is distinctive in that the objects represented—a banjo and a wind-up record player—suggest the same progressive forces, in this case jazz music and technology, that thrive in the metropolis outside.

Matulka embraced jazz (the word prominently appears on a placard in another drawing [see Fig. 61] executed around the same time as *Interior*) in the same spirit that he adapted Cubism: as a progressive art that appealed to his sense of experimentation. Jazz was unabashedly American; it thrived on spontaneity and improvisation; and its syncopated rhythms were born of the city's frenetic pulse. Not surprisingly, jazz instruments found a prominent place in his art, where they came to represent a few of the artist's favorite things. DD

Gift of Dr. and Mrs. Philip L. Brewer in honor of the Museum's 50th Anniversary 2003.38.4
Provenance: Estate of the Artist; Robert Schoelkopf Gallery, New York; Graham Gallery, New York; Dr. and Mrs. Philip L. Brewer
Exhibited: *Intimate Expressions*, cat. no. 51, illus.: 72, pl. 12; *A Collector's Pursuit of Drawing; Celebration*

Fig. 73
Louis Bouché
b. 1896 – d. 1969, New York City
Sisters ca. 1930s
Watercolor on wove paper
9½ x 6½ inches (24.1 x 16.5 cm)
Signed lower right: *L. BOUCHÉ*
Dr. and Mrs. Philip L. Brewer Collection, Museum purchase made possible by the Ella E. Kirven Charitable Lead Trust for Acquisitions 2003.1.21
Provenance: Kraushaar Galleries, New York; Dr. and Mrs. Philip L. Brewer
Exhibited: *Celebration*

Fig. 73

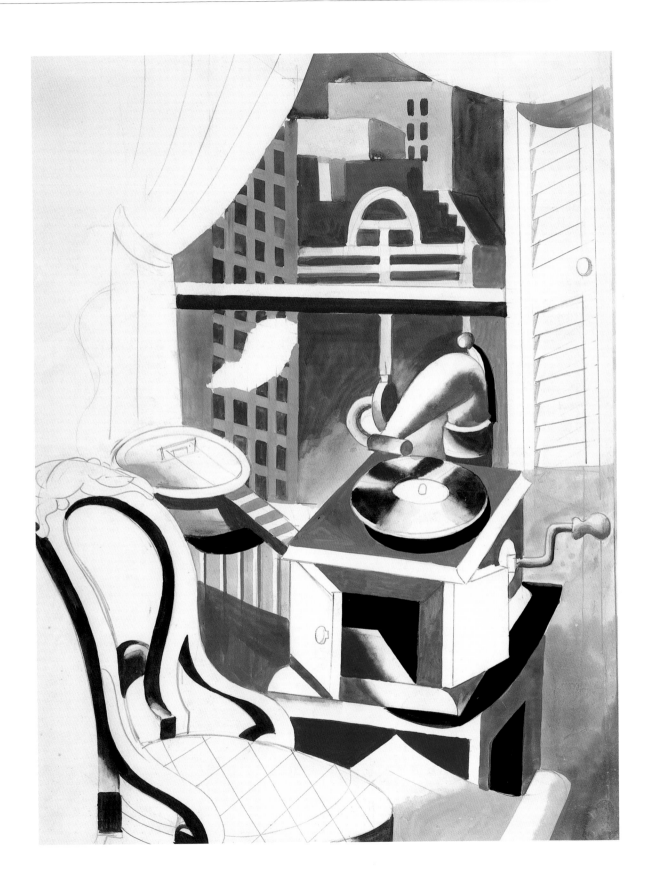

44.

Arshile Gorky
b. Dzov, Turkish Armenia 1904 – d. Sherman, Connecticut 1948
Abstract Figure ca. 1930
Pen and ink on wove paper
12⅝ x 9¼ inches (32.1 x 23.5 cm)

During the early 1930s drawing preempted painting in Arshile Gorky's production, including small studies such as *Abstract Figure* and highly finished works in the well-known *Nighttime, Enigma, and Nostalgia* series, for all of which Picasso was his essential guide. "Drawing is the basis of art," Gorky wrote to his sister Vartoosh in 1942. "A bad painter cannot draw. But a good drawer can always paint. Drawing gives the artist the ability to control his line and hand.…This is the path toward masterwork."

Abstract Figure is from a sketchbook with which other studies are associated, primarily classical figures that are more traditional in style than this sensuously draped and suggestively erotic standing female. They were once owned by Gorky's dealer, Julien Levy, and were first reproduced in his 1966 monograph, *Arshile Gorky.*[1]

Above the drapery enclosing the legs, *Abstract Figure* looks forward to Gorky's *Cubist Standing Figure* drawings of ca. 1929–1933, especially one dated ca. 1930–1931 (in *Arshile Gorky and the Genesis of Abstraction: Drawings from the 1930s*). This suggests *Abstract Figure* might be dated earlier than previously, to ca. 1930.

Marked by a small circular navel, the drooping stomach is a step toward the heart/kidney/pallet shape in the later series. The sideways buttocks in the Cubist figures propose the overlapping vertical ovals divided by crosshatching left of the stomach in *Abstract Figure* as an early articulation of buttocks, brought to the figure's front in a true Cubist moment. Additional relationships may be drawn between this figure and the later series, including curvilinear forms throughout and key vertical and horizontal lines.

Pen and ink was a prime technique for Gorky, often densely developed using the hatching seen here in touches of dramatic darkness. As one of his first works to incorporate surrealist strategies with the layered geometry he previously had adopted from Cubism, *Abstract Figure* marks an important moment for him. The intellectual concerns central to this compelling study wedded to Gorky's keen observations from nature led to the distinctive lyrical abstractions that followed. RF

Promised Gift, Dr. and Mrs. Philip L. Brewer Collection
Provenance: Acquired from the Artist; Private Collection, New York; Spanierman Gallery, New York; Dr. and Mrs. Philip L. Brewer
Exhibited: *Intimate Expressions*, cat. no. 31, illus.: 40; *Celebration*
Literature: *Works on Paper*, winter 1989, Spanierman Drawings, New York, no. 24, illus.

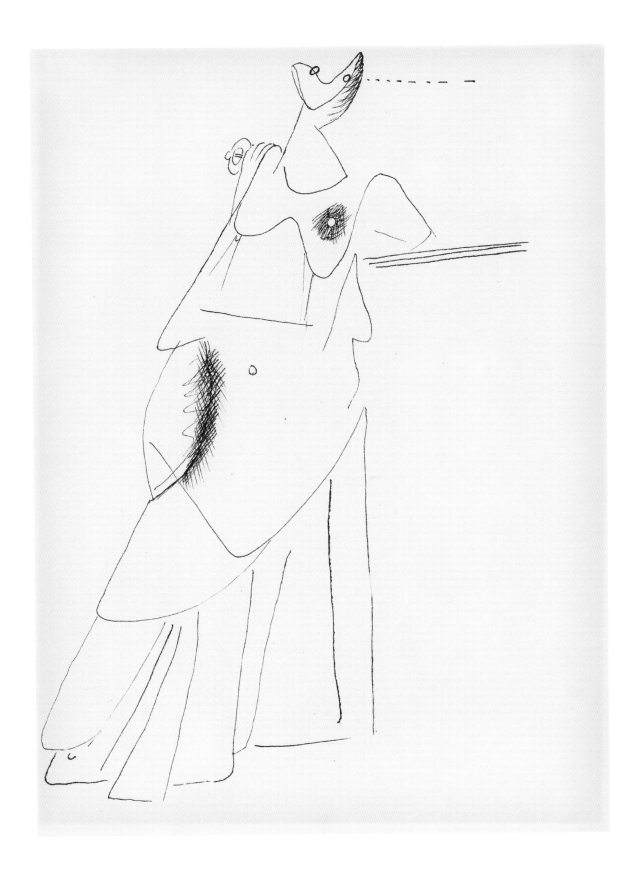

45.

Blanche Lazzell
b. Maidsville, West Virginia 1878 – d. Morgantown, West Virginia 1956
Calendulas 1932
Monotype in oil on wove paper
7⅞ x 10 inches (20 x 25.4 cm)

Blanche Lazzell delighted in the profusion of flowers that grew in her garden in Provincetown, Massachusetts. Flowers appear in many of her paintings, drawings, and prints, and they were the sole subject of her many monotypes. Calendulas, also called pot marigolds, must have been especially appealing to her because of their bright yellow-orange color and circular shape, both characteristics that lent themselves to modernist abstraction.

Lazzell traveled extensively in Europe and lived in Paris during 1912–1913. She became familiar with the latest European modern art movements and adapted several aspects of modernist expression in her own work. Immediately after returning to the United States from this trip, she painted with brighter, more intense colors, reminiscent of the Fauve palette. After a second trip to Paris in 1923 and study with Fernand Léger, Andre Lhote, and Albert Gleizes, she adopted a form of cubist abstraction for her compositions.

As one of the Provincetown artists who developed the white line woodcut as a means of making color prints in a single run through the press, Lazzell made monotypes as unique prints that allowed her to work freely with color. In contrast to some of her more naturalistic renderings of flowers, *Calendulas* reveals the strong impact of Cubism and its immediate predecessor, Paul Cézanne, on her work. Simultaneous top and side views of the bowl of flowers, abstraction of the flowers, leaves, and bowl, as well as bold, repeated brushstrokes emphasize that the image is a composition of two-dimensional shapes and colors rather than a representation of reality. Outlines around the bowl and the perimeter of the composition call attention to the flatness of the forms, while the brilliant yellow-orange calendulas seem to jump forward off the sheet. JM

Signed lower right: *Blanche Lazzell–1932* and inscribed lower left: *Calendula*;
inscribed on reverse: *M–33 Blanche Lazzell, Provincetown, MA 1932*
Promised Gift, Dr. and Mrs. Philip L. Brewer Collection
Provenance: Private Collection; Wendy Shankel Hoff, New York; Dr. and Mrs. Philip L. Brewer
Exhibited: *Intimate Expressions*, cat. no. 46, illus.: 74, pl. 14; *Celebration*

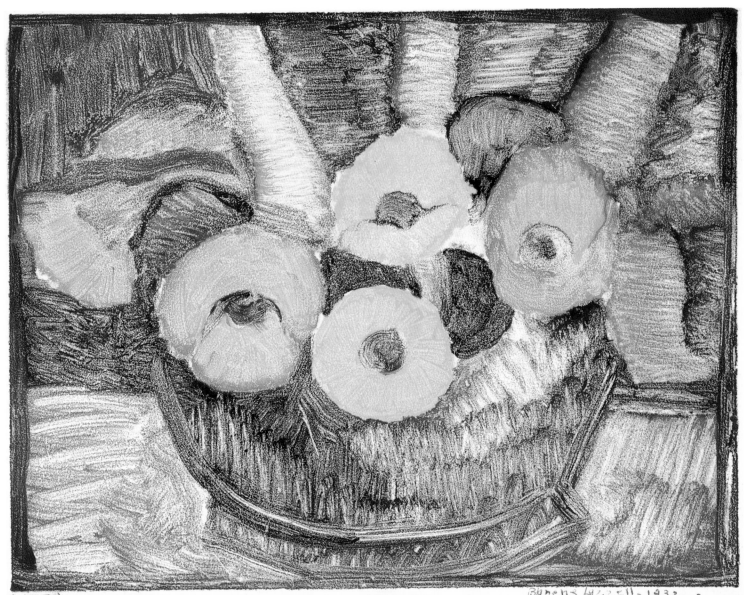

Calendula Blanche Lazzell - 1932 -

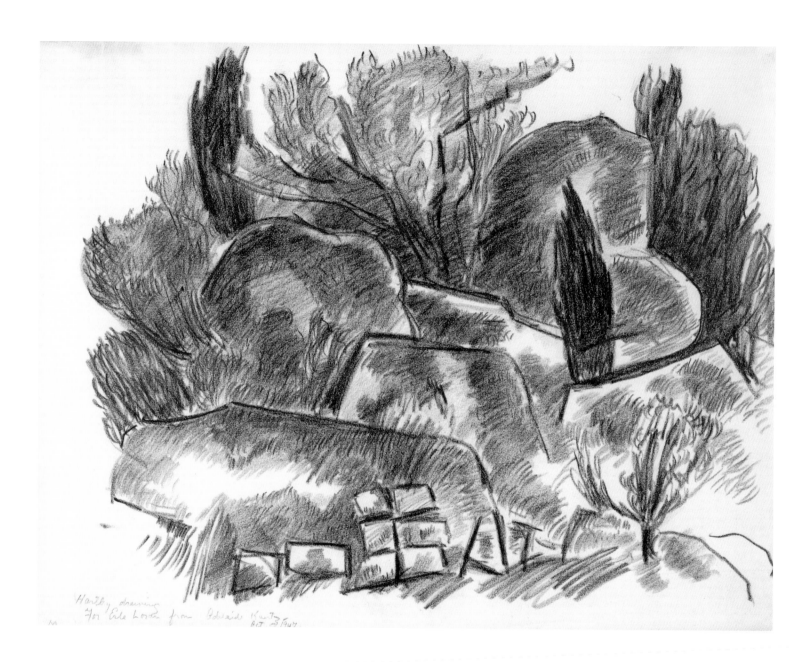

46.

Marsden Hartley

b. Lewiston, Maine 1877 – d. Ellsworth, Maine 1943
Granite Rocks, Dogtown ca. 1934
Crayon on wove paper
12⅝ x 16⅛ inches (32.1 x 41 cm)

Marsden Hartley was one of America's most adventurous and versatile modernists of the early twentieth century. Trained at the National Academy of Design, he quickly shook off academic conventions in pursuit of a visual language that he could call his own. In 1909, the artist became affiliated with Alfred Stieglitz's gallery *291*, the most influential avant-garde gallery in New York, where he encountered the work of Cézanne, Picasso, and other leading European modernists. Traveling to Europe, Hartley became involved in progressive art circles in Paris and Berlin, and produced vibrant abstractions that blended elements of Cézanne, Cubism and German Expressionism in a distinctly individual manner. He also absorbed the transcendentalist writings of Emerson, Thoreau, and Whitman, and became increasingly interested in landscapes as a means of expressing nature's spiritual essence.

Granite Rocks, Dogtown is one of several drawings Hartley produced during the 1930s depicting an abandoned glacial moraine near Gloucester, Massachusetts. Following a near-fatal bout of bronchitis, he visited Dogtown in 1931 to regain his health and renew his artistic focus.[1] The site's primeval, boulder-strewn terrain struck a deep spiritual chord within the artist, inspiring him to return in the summer of 1934 for a second series of works and to produce a third from memory while in Nova Scotia in 1936.[2] Drawing upon Cézanne and Cubism, Hartley interprets the scene as a dense network of flattened, overlapping shapes modeled by groups of parallel lines.[3] Serpentine contours suggest animated tufts of foliage while bold, staccato marks give form to massive, angular stones. Through such nuances in line and the elimination of extraneous detail, Hartley captures the rugged monumentality of the site and penetrates its surface to unlock rhythms and movements within the very land itself. In *Granite Rocks*, Hartley achieves a structural purity, expressive force, and equilibrium between imagination and description that signal a new level of artistic maturity. SCW

Inscribed lower left: *Hartley drawing for Erle Loran from Adelaide Kuntz/Oct. 1947*
Promised Gift, Dr. and Mrs. Philip L. Brewer Collection
Provenance: Adelaide Kuntz, New York; Erle Loran, Berkeley, California; R.E. Lewis, San Rafael, California; Estate of E. Maurice Bloch; Christie's Auction House, New York, Sale 7102, lot 252, June 19, 1990; Dr. and Mrs. Philip L. Brewer
Exhibited: *Local Wonders: Treasures of American Art in Columbus Collections*, Columbus Museum, February 6 – May 29, 1994; *Intimate Expressions*, cat. no. 38, illus.: 33; *A Collector's Pursuit of Drawing, Celebration*, illus. gallery guide, unpaginated

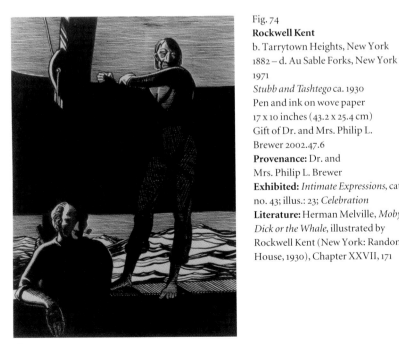

Fig. 74
Rockwell Kent
b. Tarrytown Heights, New York 1882 – d. Au Sable Forks, New York 1971
Stubb and Tashtego ca. 1930
Pen and ink on wove paper
17 x 10 inches (43.2 x 25.4 cm)
Gift of Dr. and Mrs. Philip L. Brewer 2002.47.6
Provenance: Dr. and Mrs. Philip L. Brewer
Exhibited: *Intimate Expressions*, cat. no. 43; illus.: 23; *Celebration*
Literature: Herman Melville, *Moby Dick or the Whale*, illustrated by Rockwell Kent (New York: Random House, 1930), Chapter XXVII, 171

Fig. 74

47.

Hans Hofmann

b. Weissenburg, Bavaria, Germany 1880 – d. New York City 1966
Untitled 1935
India ink on wove paper
11 x 8½ inches (27.9 x 21.6 cm)

Hans Hofmann was a painter and teacher. Utilizing brush and ink, his drawings were like his teaching—*liberating*. What made him such a wonderful teacher was his great ability to instill in each student the confidence to pursue his or her own vision and to express his or her own feelings and personal uniqueness. Helen Frankenthaler, Larry Rivers, Mary Frank, and Richard Stankiewicz were among his pupils, and all became very liberated and individual thinkers.

As a painter, the flat two-dimensional surface was his challenge. He attacked the surface with a mark and then a counter-mark. That is how he activated space—in what he calls his "pushes and pulls."

Untitled is an incredible ink drawing of a figure. Make no mistake: Hofmann is not describing this figure or image but rather energizing the composition with flat forms and shapes. For example, a leg or arm is no longer a volume; it is a two-dimensional element that occupies space; in short, it is one form working against another form. White and dark areas appear to move forward and then recede. The figure is not an analytical interpretation; it pulsates the surface with varying weights and rhythms that can be felt as well as seen. Hofmann departs from the pictorial elements. He expressively explores forms fighting on the surface for their rightful place. This fight for a *right to be* creates palpable energy in a compositional work of art. TWolfe

Museum purchase made possible by the Edward Swift Shorter Bequest Fund
2002.53
Provenance: Estate of the Artist; Ameringer-Yohe Gallery, New York
Exhibited: *Celebration*

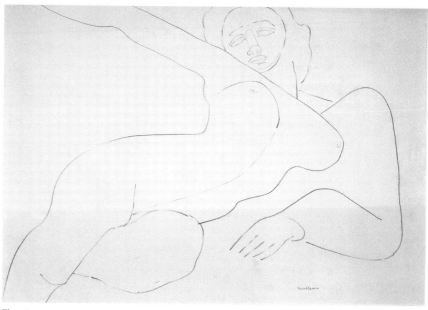

Fig. 76

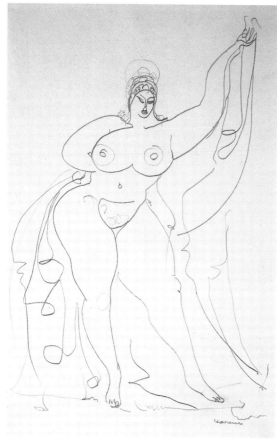

Fig. 75

Fig. 75
Gaston Lachaise
b. Paris, France 1882 – d. New York
City 1953
Female Nude ca. 1933–1934
Pencil on wove paper
19 x 12 inches (48.3 x 30.5 cm)
Signed lower right: *Lachaise*
Museum purchase made possible
through the Edward Swift Shorter
Bequest 2004.9
Provenance: Solomon Estate, New
York; Private Collection, New York;
Sotheby's Auction House, New
York, Sale 1734, lot 1050, December
19, 2003
Exhibited: *Building on Strength*

Fig. 76
Louise Nevelson
b. Kiev, Russia 1899 – d. New York
City 1988
Untitled (Reclining Female Nude)
ca. 1935
Graphite on buff-colored wove
paper
13½ x 18¾ inches (34.3 x 47.6 cm)
Signed lower right: *Nevelson*
Museum purchase made possible
by the Edward Swift Shorter
Bequest Fund 2002.2
Provenance: Estate of the Artist;
Fay Gold Gallery, Atlanta
Exhibited: *Celebration*

48.

Carl Holty

b. Freiburg, Germany 1900 – d. New York City 1973
Abstraction 1936
Brush and ink on wove paper
7 x 9½ inches (17.8 x 24.1 cm)

Though Carl Holty was aware of modernism while an art student in the Midwest (and later in New York City), his strong German heritage led him to Munich in 1926 where he began his modernist studies in earnest.[1] In 1930, Holty moved to Paris where he became involved in *Abstraction – Création,* a loose association of abstract artists that included Piet Mondrian. Upon returning to America four years later, he soon became a member of the American Abstract Artists. Although much of America at this time had little appreciation for abstract art, this group worked diligently through publications and lectures to change what they deemed to be the provincial attitude of the American art world. They were somewhat successful in this, producing touring exhibitions to major American cities and publishing a portfolio of thirty lithographs by the members.

In 1936, the date of this drawing, the Museum of Modern Art organized the exhibition *Cubism and Abstract Art,* which to Holty's and his fellow abstractionists' dismay had only included one American artist. In *Abstraction* his use of simple linear forms and organic shapes suggests Joan Miró's abstract landscapes.[2] However, Holty's use of lines on a white field, a feature of both his paintings and drawings of this time, was influenced by Piet Mondrian, who dictated that the two-dimensional surface of the image be preserved.[3] Appearing at first as uncomplicated marks on an open field, Holty is able to create a tension that suggests and denies spatial depth by simply thickening the outline of his floating organic forms or filling them in entirely. The artist's fluent use of brush and ink evident in *Abstraction* reveals a control and sureness evident in much of his earlier art, and which provided the fundamental underpinnings for much of his subsequent work. ML

Signed and dated lower right: *Holty 36*
Gift of Spanierman Gallery in Memory of Donald F. Broda, Jr. 2003.43.2
Provenance: Private Collection; Spanierman Gallery, New York
Exhibited: *Building on Strength*

49.

Federico Castellon

b. Almeira, Spain 1914 – d. Brooklyn Heights, New York 1971
The Bride ca. 1938
Pencil on wove paper
11 x 15 inches (27.9 x 38.1 cm)

Federico Castellon's drawing of *The Bride* at first glance appears mysterious and enigmatic. Populated by strange figures, architectural fragments, and fetish objects—symbolic props in a surreal narrative—the image seems to have sprung fully formed from the recesses of the artist's subconscious.

Castellon was born with a fertile imagination and a propensity for psychologically charged subject matter. That he gravitated to dreams as the basis for his art isn't surprising in light of his Spanish heritage and his deep respect for another Spaniard, the Surrealist avatar Salvador Dali, whose disfigured anatomies, vertiginous perspectives, and fetishistic proclivities he emulated. Like Dali, Castellon free-associated his own, highly subjective realities and rendered these with a tight-fisted realism.

Simultaneous realities exist in *The Bride*, which could easily function as a theatrical set. If marriage implies the auspicious beginning of a new life, then the bride wearing her virginal headdress and seated on a classical plinth with a bouquet of flowers,

embodies this notion. But the prospect of marriage is shadowed by unknowns—a darkened doorway behind the bride—and by the burden of history, incarnate in the bizarre arrangement of figures and objects that rise up like a mirage out of the barren landscape on the opposite side of a vast ravine. The egg on the ledge to the right of the bride reinforces the potential for life. But what are we to make of the two figures observing the scene from the top of a dilapidated wall? Do they represent the bride's ancestors? Oracles? Specters from the past? Premonitions of the future? Two high-heeled shoes and an exfoliating female statue conflate fetish with the unrelenting progression of time. The scene remains ambiguous, but it could be that in Castellon's fertile mind, marriage mediated between two discrete worlds—the sacred and the profane. DD

Signed lower left: *Federico/Castellon*
Dr. and Mrs. Philip L. Brewer Collection, Museum purchase made possible by the Ella E. Kirven Charitable Lead Trust for Acquisitions 2003.1.36
Provenance: Estate of the Artist; Michael Rosenfeld Gallery, New York; Dr. and Mrs. Philip L. Brewer
Exhibited: *Federico Castellon: Surrealist Drawings, 1933–1939*, Michael Rosenfeld Gallery, New York, November 14, 1996 – January 18, 1997, illus.: 10; *Intimate Expressions*, cat. no. 12, illus.: 37; *A Collector's Pursuit of Drawing*; *Celebration*
Literature: Michael Rosenfeld, *Federico Castellon: Surrealist Drawings, 1933–1939* (New York: Michael Rosenfeld Gallery, 1996), illus.: 10

Fig. 77

Fig. 78

Fig. 77
Lamar Baker
b. Atlanta, Georgia 1908 –
d. Talbotton, Georgia 1994
Love of Money is the Root of All Evil
1936
Pen on wove paper
10¾ x 8½ inches (27.3 x 21.6 cm)
Bequest of Lamar Baker
95.23.54
Provenance: Estate of the Artist
Exhibited: *Celebration*

Fig. 78
Pavel Tchelitchew
b. Kaluga, Russia 1898 –
d. Grottaferrata, Italy 1957
Study for Blue Clown 1929
Ink on wove paper
16⅞ x 10⅞ inches (42.9 x 27.6 cm)
Signed lower right: *P. Tchelitchew '29*
Dr. and Mrs. Philip L. Brewer Collection, Museum purchase made possible by the Ella E. Kirven Charitable Lead Trust for Acquisitions 2003.1.50
Provenance: Julien Levy Gallery, New York; John Atherton; Maxine Atherton; Mary Varchver; Jill Newhouse, New York; Dr. and Mrs. Philip L. Brewer
Exhibited: *Intimate Expressions*, cat. no. 71, illus.: 42; *Celebration*

50.

Jacques Lipchitz
b. Druskieniki, Lithuania 1891 – d. Capri, Italy 1973
Theseus and the Minotaur ca. 1942
Charcoal, India ink, and gouache on cream-colored wove paper
11⅞ x 18 inches (30.2 x 45.7 cm)

A Jewish immigrant from Lithuania, Jacques Lipchitz moved to
Paris in 1909 and became closely associated with Picasso and other
Cubists by 1913. He was able to translate the angular, flattened
forms of Picasso's revolutionary style into distinctive sculptural
figures, and by the early 1920s was internationally recognized as
the preeminent sculptor of the Cubist movement. Around 1925,
however, his forms became increasingly rounded, abstract, and
robust. In response to the volatile European political climate of the
1930s, he began using Old Testament and mythological themes of
conflict to symbolize the eternal struggle between opposing forces
and comment on the growing specter of Hitler's Nazi Germany.[1]
Upon the German army's invasion of France in 1940, the artist fled
to New York and soon reestablished his sculptural production
with renewed intensity.[2]

Produced at the height of World War II, *Theseus and the
Minotaur* is related to several sculptures and works on paper of the
same title executed by Lipchitz during 1942–1943.[3] A prolific drafts-
man, the artist developed a bold drawing technique that allowed
him to approximate the distinctive qualities of his sculptures.
Intermingled with steady contours and occasional crosshatching,
dense dabs of ink and soft smudges of gouache suggest the play of
harsh light across the rugged masses of battling figures that appear
as clusters of tensed muscle chiseled in relief. While Picasso often
depicted the Minotaur as his primal alter ego, Lipchitz uses the
beast to represent Hitler being vanquished by de Gaulle in a com-
position the artist hoped would prove prophetic.[4] He also depicts
their forms as interlocking in order to suggest the blurring of good
and evil in war. *Theseus* thus serves as a summarizing statement of
battle between opposing forces, of symbolic struggles of the ancient
past, catastrophic battles of the present, and inevitable clashes to
come—all of which Lipchitz suggests are part of a seemingly
inevitable cycle of human conflict and resolution. SCW

Signed upper left: *Lipchitz*
Promised Gift, Dr. and Mrs. Philip L. Brewer Collection
Provenance: Private Collection, New York; Spanierman Gallery, New York; Dr.
and Mrs. Philip L. Brewer
Exhibited: *Intimate Expressions*, cat. no. 47, illus.: 33; *Celebration*

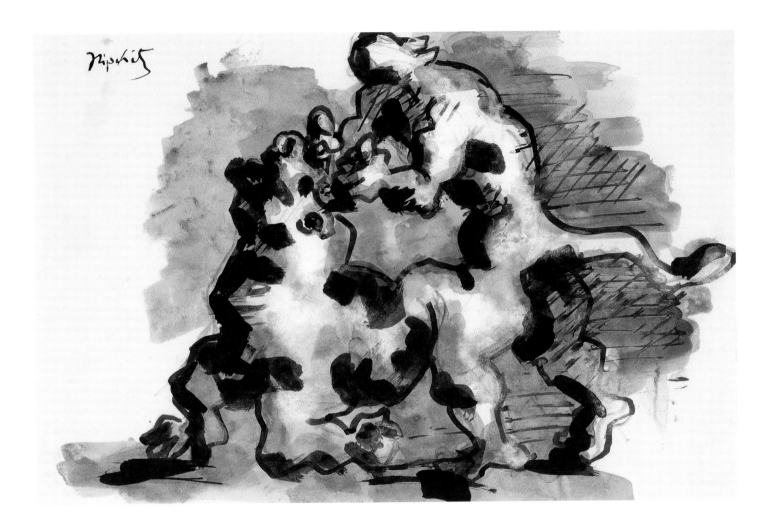

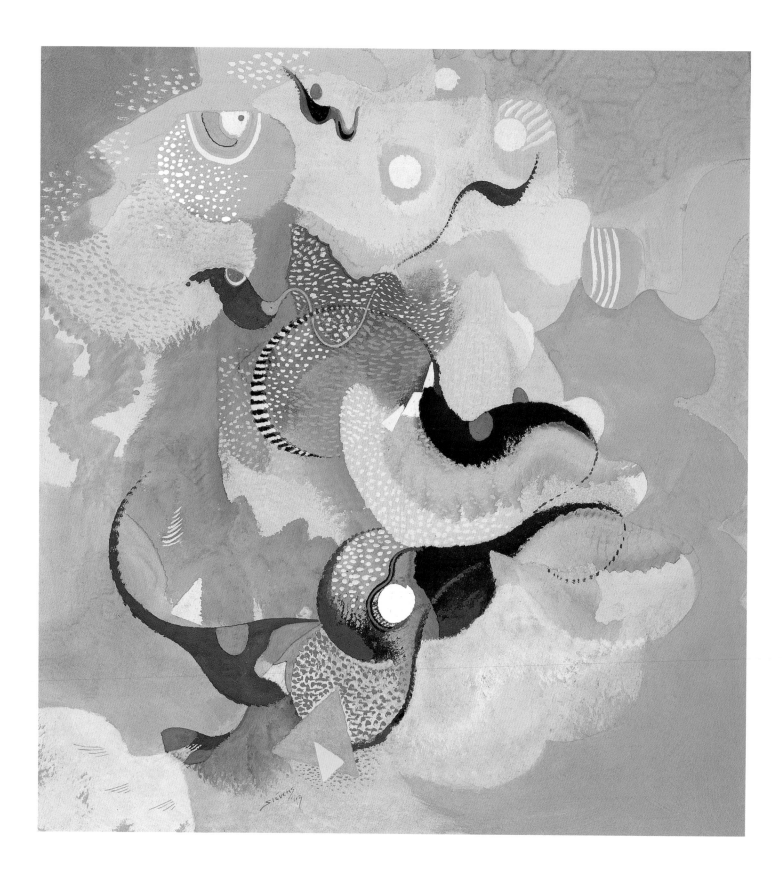

51.
Will Henry Stevens
b. Vevay, Indiana 1881 – d. New Orleans, Louisiana 1949
Abstraction 1943
Gouache on wove paper
21¾ x 19¾ inches (55.2 x 50.2 cm)

Following three years' study at the Cincinnati Art Academy and a year as a designer for Rookwood Pottery, the twenty-one-year old Stevens, like many young artists, moved to New York City. Dissatisfied with traditional studio painting, he soon joined up with a more progressive circle that included Jonas Lie, Van Dearing Perrine, and Albert Pinkham Ryder. It was on Ryder's advice—"Now, remember, you are a poet," Ryder once exclaimed to Stevens—that the younger painter began to explore Asian philosophy and art, which were to profoundly affect his subsequent development. "The best thing a human can do in life," wrote Stevens later, "is to get rid of his separateness or selfness and hand himself over to the nature of things—to this mysterious thing called the Universal Order."[1]

In 1920 Stevens joined the art faculty of New Orleans' Newcomb College, where he taught until his retirement in 1948. He spent his summers painting and sketching throughout the South, although the North Carolina mountains were a favorite retreat. Visiting an exhibition of non-objective painting at the Guggenheim Museum in the early 1930s, Stevens was instantly attracted to the works of Wassily Kandinsky, with their abstract yet deeply spiritual interpretations of nature.

Although Stevens continued to paint more "objective"— though still highly stylized—landscapes in oil, watercolor, and pastel, he also began to produce non-representational "meditations" on nature's underlying order, whose designs, shapes and colors might be inspired by organic forms or simply invented as symbolic parallels. First exhibited in 1941, Stevens's "non-objective" paintings were an immediate sensation, since nothing like them had ever been seen in Southern art. *Abstraction*, with its soft palette of grey-blues and orange-pinks and its rounded forms and undulating lines suggesting almost musical rhythms, is typical of Stevens's mature style, a style that blends delicacy and liveliness. BWC

Signed lower center: *Stevens/43*
Museum purchase made possible by the Simon Schwob Acquisition Fund and the Edward Swift Shorter Bequest Fund 98.4
Provenance: Janet McDowell (the artist's daughter), North Carolina; Richard York Gallery, New York; Richard York
Exhibited: *Will Henry Stevens*, Greenville County Museum of Art, Greenville, South Carolina, April 21, 1987 – November 13, 1988, cat. no. 32, illus.: 46; traveled to Lauren Rogers Museum of Art, Laurel, Mississippi; North Carolina Museum of Art, Raleigh; Montgomery Museum of Fine Arts, Montgomery, Alabama; Indiana State Museum and Historic Sites, Indianapolis, Indiana; Telfair Academy of Fine Arts, Savannah, Georgia; Fine Arts Museum, Cheekwood, Nashville, Tennessee; Newcomb College, New Orleans, Louisiana; and Asheville Art Museum, Asheville, North Carolina; *New Drawings*; *Celebration*
Literature: Jessie Poesch, *Will Henry Stevens* (Greenville, S.C.: Greenville County Museum of Art, 1987), cat. no. 32, illus.: 46

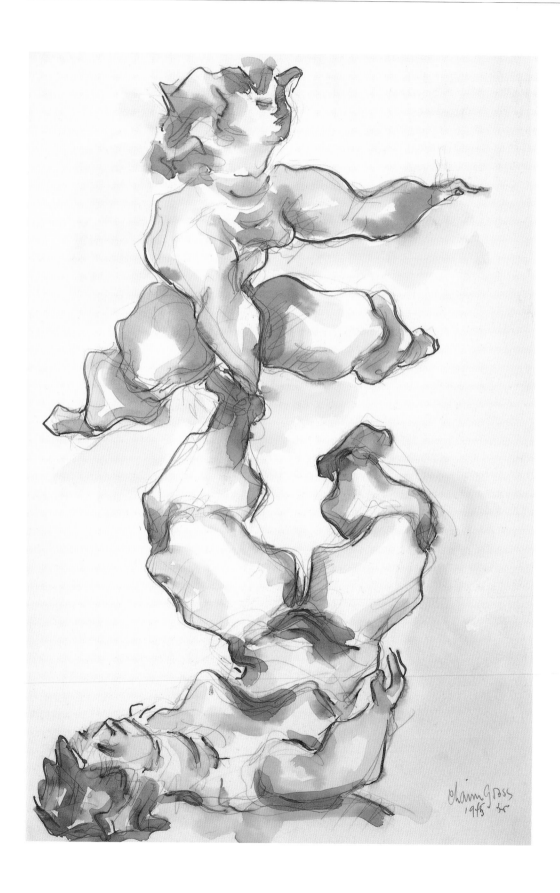

52.
Chaim Gross
b. Kolomea, Austria 1904 – d. Provincetown,
Massachusetts 1991
Gymnasts 1945
Watercolor over pencil on wove paper
20 x 12½ inches (50.8 x 31.8 cm)

This watercolor features two female acrobats, a favorite theme in the artist's carved sculpture for decades. Drawn first in pencil, and using bold strokes to capture figures in motion, Gross completed his study by outlining the two gymnasts and applying watercolor washes to define the forms. The prominence of circus figures in his art relates to Gross's childhood memories of the gypsy circus, the only entertainment he experienced in his youth in eastern Austria. Gross recalled, "Summer days meant happy times in the surrounding forests or watching the magic circus that came to town once a year. The colorful circus decorations and performances of the acrobats made so deep an impression that it later greatly influenced my work."[1] Gross invited performers to pose for him in his home, and also attended circus performances to make sketches. Here there is a sexual allusion in the use of naked females as gymnasts, and the

depiction of nude women is another frequent subject for the artist.

Gross came to the United States in 1921, and by the late 1920s had decided to concentrate on wood carving. By the early 1940s, he had created sculptures for the WPA Art project, and for the New York World's Fair of 1939. His representation of the acrobat Lillian Leitzel was commissioned by the United States Treasury Department for a post office in Pennsylvania. *Lillian Leitzel*, somewhat related to these gymnasts, was shown at the Metropolitan Museum of Art in the *Artists for Victory* exhibition of 1943. Acrobats and dancers appear in his work from the early 1930s until the end of his life. But in the early decades Gross favored robust female figures with curvaceous, even bulbous, bodies. The change to bronze in the late 1950s accounts for slimmer, more angular body types.[2] JMM

Signed and dated lower right: *Chaim Gross/ 1945*
Gift of Dr. and Mrs. Philip L. Brewer in honor of the Museum's 50th Anniversary 2003.38.2
Provenance: Spanierman Gallery, New York; Dr. and Mrs. Philip L. Brewer
Exhibited: *Intimate Expressions*, cat. no. 33, illus.: 52; *Celebration*; *Building on Strength*

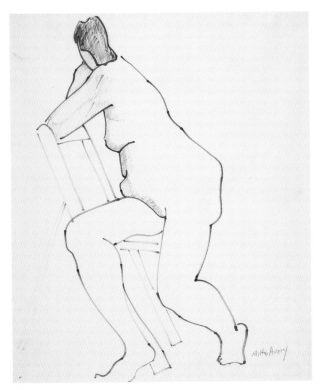

Fig. 78a

Fig. 78a
Milton Avery
b. Altmar, New York 1893 – d. New York City 1965
Nude on Chair ca. 1948–1950
Brown and black marker on wove paper
17 x 14 inches (43.2 x 35.6 cm)
Signed lower right: Milton Avery
Dr. and Mrs. Philip L. Brewer Collection, Museum purchase made possible by the Ella E. Kirven Charitable Lead Trust for Acquisitions 2003.1.10
Provenance: Grace Borgenicht Gallery, New York; Mrs. Helen Benjamin; Art Market, New York; Spanierman Gallery, New York; Dr. and Mrs. Philip L. Brewer
Exhibited: Far Gallery, New York, October 20 – 31, 1964; The Helen W. and Robert M. Benjamin Collection, Yale University Art Gallery, New Haven, Connecticut, May 4 – June 18, 1967, cat. no. 7: 68; Milton Avery, National Collection of Fine Arts, Washington, D.C.,

December 11, 1969 – January 25, 1970; Brooklyn Museum, New York, February 16 – March 29, 1970; Columbus Museum of Art, Columbus, Ohio, April 23 – May 31, 1970, cat. no. 79; Intimate Expressions, cat. no. 2, illus.: 5; Celebration
Literature: Charlotte Willard, "Drawing Today," Art in America 52, no. 5, October 1964: 49-67

NOTES TO THIS SECTION

28.

John Sloan

1. *New York Evening Sun*, April 25, 1903, as quoted in David Scott, *John Sloan* (New York: Watson-Guptill Publications, 1975): 70. For additional accounts of Sloan's life and art, see Lloyd Goodrich, *John Sloan* (New York: Macmillan Co. on behalf of the Whitney Museum of American Art, 1952); Van Wyck Brooks, *John Sloan: A Painter's Life* (New York: Dutton, 1955); E. John Bullard, *John Sloan and the Philadelphia Realists as Illustrators, 1890–1920* (Los Angeles: University of California Press, 1968); Bruce St. John, *John Sloan* (New York: Praeger, 1971); Rowland Elzea and Elizabeth Hawkes, *John Sloan: Spectator of Life* (Wilmington: Delaware Art Museum, 1988); and John Loughery, *John Sloan: Painter and Rebel* (New York: H. Holt, 1995).

2. John Kedrick Bangs (1862–1922) was a prolific American author of light social satire between 1890 and 1920. Besides *The Genial Idiot*, which in addition to its serialization in the *Philadelphia Press* in the fall of 1903 was published five years later in book form (New York and London: Harper, 1908), Bangs also wrote, among many other works, *Alice in Blunderland* (New York: Doubleday, Page & Co., 1907); *Coffee and Repartee* (New York and London: Harper Brothers, 1899); *The Enchanted Type-writer* (New York: Harper Brothers, 1899); *A House-Boat on the Styx* (New York and London: Harper Brothers, 1903); *Mollie and the Unwiseman* (Philadelphia: H.C. Coates & Co., 1902); and *Three Weeks in Politics* (New York and London: Harper Brothers, 1900). Three of Sloan's other illustrations for the Bangs story ("He discusses riches;" "He discusses poets," and an uncaptioned drawing) are in the collection of the Delaware Art Museum in Wilmington, Delaware, while another of the illustrations ("The hungry cat," Collection of Mr. and Mrs. Harold Levy, New York) is privately owned. The staff of the Delaware Art Museum notes that all three of their illustrations for this story are dated to October 18, 1903, although they believe that that date may need to be revised to account for the serialization of Bangs's story.

3. Elzea and Hawkes: 43.

29.

Glenn O. Coleman

1. *Glenn O. Coleman – Memorial Exhibition* (New York: Whitney Museum of American Art, 1932): 8.

30.

William Glackens

1. Forbes Watson, *William Glackens* (New York: Duffield and Company, 1923): 15. The definitive work on Glackens is William H. Gerdts, *William Glackens* (New York, London, and Paris: Abbeville Press in association with the Museum of Art, Fort Lauderdale, Fla., 1996). Other important publications on Glackens include: Guy Pène Du Bois, *William J. Glackens* (New York: Whitney Museum of American Art, 1931); Ira Glackens, *William Glackens and the Ashcan Group: The Emergence of Realism in American Art* (New York: Crown

Publishers, Inc., 1957); and *William Glackens in Retrospect* (St. Louis: City Art Museum, 1966).

2. Watson: 19.

32.

George Wesley Bellows

1. Leon Kroll, *A Spoken Memoir*, edited by Nancy Hale and Fredson Bowers (Charlottesville: University Press of Virginia, 1983): 51.

2. Bellows did a print of himself with Kroll, Speicher, and Henri in two states, and one of himself with Kroll and Speicher. They can be found in *The Complete Lithographs of George Bellows* (see Lauris Mason, *Catalogue Raisonné of Bellows' Lithographs*, revised edition [San Francisco: Alan Wofsky Fine Arts: 1992]). Other artists he portrayed in lithographs or drawings include Robert Aitkin, Louis Bouché, John Carroll, and Charles Rosen.

33.

Morton Schamberg

1. William C. Agee, Morton Livingston Schamberg, *The Machine Pastels* (New York: Salander-O'Reilly Galleries, Inc., 1986), unpaginated.

2. Schamberg had a machine-themed painting in the Armory Show of 1913 that included a telephone among other things. See William C. Agee, *Morton L. Schamberg* (New York, Salander-O'Reilly Galleries, Inc., 1982): 10.

3. See Agee, 1986: footnote no. 8 referring to Walter Pach's article from May 17, 1919 in *The Dial*.

4. Agee noted this resurgence of pastel and that other American modernists like Arthur Dove and Max Weber shared his fascination. Ibid: footnote no. 11 and text.

5. See Julia Ballerini, "Venus and the Stocking Machines," *Art in America* 71 (April 1983): 158.

34.

Robert Henri

1. Jessica F. Nicoll, *The Allure of the Maine Coast: Robert Henri and His Circle, 1903–1918* (Portland, Maine: Portland Museum of Art, 1995): 8. Nicoll makes the point that Henri openly admired Homer's marine paintings for their power and integrity.

2. For accounts and images of the Monhegan paintings of Bellows, Kent, Hopper, and other Henri students, see Nicoll, *passim.*

3. Nicoll: 30.

35.

Joseph Stella

1. Irma B. Jaffe, *Joseph Stella* (Cambridge, Mass.: Harvard University Press, 1970): 91.

2. Ibid: 85.

36.

Charles Burchfield

1. A concise account of Burchfield's artistic career can be found in Bruce W. Chambers, "Charles Burchfield: The

Charles Rand Penney Collection," in Charles Burchfield: *The Charles Rand Penney Collection* (Washington, D.C.: Memorial Art Gallery of the University of Rochester in collaboration with the Smithsonian Institution Traveling Exhibition Service, 1978); the classic biography of the artist is John I.H. Baur's *The Inlander: The Life and Work of Charles Burchfield, 1893–1967* (Newark, Del. and New York: University of Delaware Press and Associated University Presses Incorporated, 1982).

2. Burchfield journal entry for December 7, 1915, in J. Benjamin Townsend, ed., *Charles Burchfield's Journals: The Poetry of Place* (Albany, N.Y.: State University of New York Press, 1993): 110.

37.

Marguerite Thompson Zorach

1. Roberta K. Tarbell, *Marguerite Zorach: The Early Years, 1908–1920.* (Washington, D.C.: National Collection of Fine Arts and Smithsonian Institution Press, 1973).

2. *Marguerite and William Zorach: Harmonies and Contrasts* (Portland, Maine: Portland Museum of Art, 2001).

38.

Morgan Russell

1. Marilyn Kushner, *Morgan Russell* (New York and Montclair, N.J.: Hudson Hills Press in association with the Montclair Art Museum, 1990): 49.

2. Russell to MacDonald Wright, August 4, 1921, MacDonald Wright Papers, Archives of American Art as quoted by Kushner: 131.

3. The present whereabouts of this triptych are unknown. Despite the added inscription on the verso that dated the drawing to ca. 1930, and based upon valid archive material, the date is now established as ca. 1920. There is also a drawing in the archive which probably dates from 1917–1923 that depicts the figure of Job's God in the upper right corner as well as a drawing that references the painting entitled *Les Génies Joyeux, 1917–1923* (location unknown). We are indebted to Gregory Jay Galligan, Project Director of the Morgan Russell Archives and Collection Enhancement Project 2004–2005, and curatorial intern Sumia Ibrahim of the Montclair Art Museum for their extensive research of this drawing.

4. Russell Archives.

39.

William Zorach

1. Quoted in William Zorach, *Art is My Life: The Autobiography of William Zorach* (New York and Cleveland: World Publishing, 1967): 34.

2. Other publications on Zorach's watercolors are *William Zorach: Fifty Years of Watercolors* (New York: Bernard Danenberg Galleries, 1970) and Marilyn Friedman Hoffman, *Marguerite and William Zorach: The Cubist Years, 1915–1918* (Manchester, N.H.: Currier Gallery of Art, distributed by University Press of New England, 1987).

40.

Preston Dickinson

1. Ruth Cloudman, *Preston Dickinson 1889–1930* (Lincoln, Neb.: Sheldon Memorial Art Gallery, Nebraska Art Association, 1979): 37.

2. Duncan Phillips, *A Collection in the Making* (New York, 1926, 74–75), as quoted by Cloudman: 32. It is important to note that though critical, Duncan Phillips owned Dickinson's work.

3. *New York Times* (VIII, 10:5, May 4, 1924), as quoted by Cloudman: 31.

4. Cloudman: 26.

41.

Oscar F. Bluemner

1. The strength of his new work earned him representation in the landmark Armory Show of 1913, and a one-person exhibition at *291* in 1915.

2. Jeffrey R. Hayes, *Oscar Bluemner* (Cambridge: Cambridge University Press, 1991): 122. Hayes considers the South Braintree works as "the third and final phase" of Bluemner's career and one in which he launches into "full application of his theories that challenged both vanguard and popular standards."

3. Ibid: 129. Around 1927, Bluemner was working to develop a more vivid and durable watercolor medium capable of serving as a "less cumbersome alternative to oils."

4. Ibid: 127. The artist produced eighteen small watercolors in early 1927 featuring large moons and suns. Although not documented as part of this series, *Red House* reflects the artist's focus on celestial bodies as a complement to architectural and landscape elements.

5. Oscar Bluemner, "Introduction," *Oscar Florianus Bluemner* (Minneapolis: University of Minnesota, 1939), unpaginated. Bluemner prized medieval stained glass for its "brilliant and unrealistic color" that represented "all beauty, all emotion, never equaled by any other color, old or new, East or West."

6. Oscar Bluemner, "My Own History," Painting Diary, April 21, 1918, Bluemner Papers, Archives of American Art (339:552), translated by Jeffrey R. Hayes. Much of Bluemner's color theory is shaped by that of Goethe and Chevreul. Bluemner added color code notes to the verso of *Red House by a Stream*, thus underscoring his practice of orchestrating color prior to executing his compositions.

44.

Arshile Gorky

1. I am grateful to Melvin P. Lader for calling my attention to reproductions in this early monograph.

46.

Marsden Hartley

1. Barbara Haskell, *Marsden Hartley* (New York: Whitney Museum of American Art and New York University Press, 1980): 82. Drawings were especially important during Hartley's 1931 trip, as he was still too weak from his illness to carry anything but a sketch pad into the field. His first series of *Dogtown* canvases, there-fore, were produced from drawings or memory. Haskell also notes that, by the end of his first *Dogtown* series, the peripatetic Hartley declared himself a New England painter for the first time (p. 83).

2. Further evidence of Hartley's profound emotional response to the site is offered by Gail R. Scott. *Marsden Hartley* (New York: Abbeville Press, 1988): 90, who notes that the artist inscribed three lines from T.S. Eliot's poem "Ash Wednesday" on the back of his painting *In the Moraine, Dogtown Common, Cape Ann* (1931, Georgia Museum of Art):

Teach us to care and not to care
Teach us to sit still
Even among the rocks.

3. These traits lend support for summer 1934 as the date of the drawing. In his 1934 series, as Barbara Haskell explains, Hartley "abandoned the coldly defined massive volumes of both his alpine landscapes and his 1931 Dogtown series, replacing them with dense clusters of smaller forms. The broad expanses of closely modulated tones and uniform surface treatment gave way to either an overall scratching effect or thickly modulated paint. Hartley laid greater emphasis on the two-dimensional picture plane through this worked paint surface and through the perspectively 'incorrect' tiering of forms…" (Haskell: 96). In addition to lacking the massive volumes of the 1931 series, *Granite Rocks, Dogtown* also stands in contrast to the 1936 series, which consists largely of broad views of crumbling stone walls with protruding wooden posts in which the artist focuses on dramatic contrasts between black and white (as in *The Last Stone Walls, Dogtown*, 1936, Yale Art Gallery). Perhaps in recognition of the drawing's Cézannesque traits, Adelaide Kuntz in October of 1947 chose to make a gift of the drawing (see inscription along lower left margin) to Cézanne authority Erle Loran, who had just published his monograph *Cézanne's Compositions* (Los Angeles: University of California Press, 1946).

48.

Carl Holty

1. Holty's memoirs as cited in Virginia Rembert's unpublished biography "Carl Holty: Search for the Grail": 82. Holty will be the subject of a future comprehensive exhibition that is being organized by this author for the Georgia Museum of Art, and this drawing will be included. Rembert's manuscript is on file at the Georgia Museum of Art, Athens.

2. Holty probably knew Miró's work from gallery and museum exhibitions but he actually befriended the artist, offering him studio space in 1947. See Rembert: 133–134.

3. Ibid: 135–136. Holty and Mondrian developed a close friendship when that artist immigrated to the U.S. in 1940.

50.

Jacques Lipchitz

1. A.M. Hammacher, *Jacques Lipchitz*. Translated by James Brockway (New York: Abrams, 1975): 70.

2. Jacques Lipchitz, *My Life in Sculpture* (New York: Viking Press, 1972): 140.

3. Ibid: 159. Although previously entitled *Theseus* and dated ca. 1946, this work is directly related to a sculptural study for *Theseus and the Minotaur* (1942, Walker Art Center) and reflects minor adjustments made by the artist in extending the arms of the man and in depicting both the bull's front legs folded under in defeat. A related gouache drawing *Theseus and the Minotaur* (also 1942, present location unknown) presents a third positioning of the figures in which the beast's front legs dangle aloft as the hero raises his head in victory.

4. Ibid: 159. After the completion of the sculpture, *Theseus and the Minotaur*, the artist interpreted the blurring of their forms as symbolic of the fact that "the monster is also a part of Theseus, as though there were a Hitler in each of us whom we must destroy. Theseus is killing part of himself."

51.

Will Henry Stevens

1. Both the Ryder and Stevens quotes are taken from Bruce W. Chambers, "Will Henry Stevens (1881–1049)," in Chambers, *Art and the Artists of the South: The Robert P. Coggins Collection* (Columbia: University of South Carolina Press, 1984): 145. Other important sources of information on Stevens are: Bernard Lemann, "Will Henry's Nature: The Pictorial Ideas of W.H. Stevens," unpublished manuscript, 1947-1948, Howard Tilton Memorial Library, Tulane University; and Jessie Poesch, *Will Henry Stevens* (Greenville, S.C.: Greenville County Museum of Art, 1987).

52.

Chaim Gross

1. Chaim Gross, *The Technique of Wood Sculpture* (New York: Vista House, 1957): 43.

2. Important publications on the artist include Frank Getlein, *Chaim Gross* (New York: Abrams, 1974) and Roberta K. Tarbell, *Chaim Gross. Retrospective Exhibition: Sculpture, Paintings, Drawings, and Prints* (New York,: Jewish Museum, 1977).

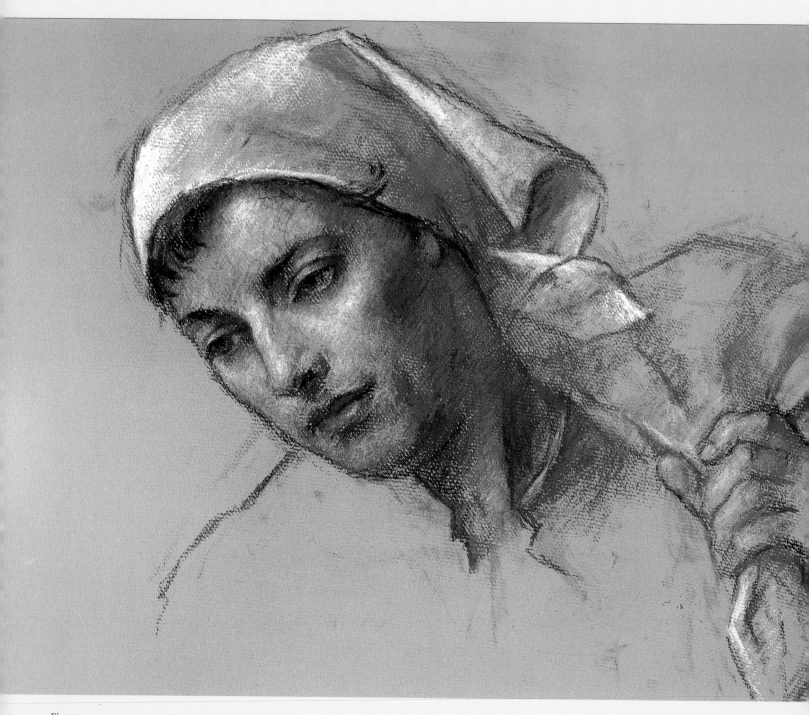

Fig. 79

Robert Brackman

b. Odessa, Russia 1898 – d. Noank, Connecticut 1980

Untitled (Head of a Peasant Woman) ca. 1920

Pastel on brown-colored wove paper

28¾ x 22 inches (73 x 55.9 cm)

Signed lower right: *Brackman*

Gift of Mr. and Mrs. Theodore Newhouse 67.340

Provenance: Mr. and Mrs. Theodore Newhouse,
New York

Exhibited: *Celebration*

4.

REGIONALISM, SOCIALISM, AND AMERICAN VISIONS

53.
Guy Pène du Bois
b. Brooklyn 1884 – d. New York City 1958
Seated Woman; recto: *Nude Study* ca. 1918–1920
Pencil on wove paper
21¼ x 14¼ inches (54 x 36.2 cm)

Guy Pène du Bois was an artist, critic, and editor of the journal *Arts and Decoration.* He studied in Europe and with such notable figures as William Merritt Chase, Robert Henri, and Kenneth Hayes Miller. *Seated Woman* appears to be a lady of social standing: proper hat, strong chin, fine coat, large ring on hand, and soft slippers. She may not be, but she certainly seems to be.

Du Bois has created a masterful, chaste, and yet provocative image. A straight-backed woman with crossed legs tugs at the lady's slipper. With chin held high and broad-bank hat in place, she looks upward. Du Bois actually releases this figure from the sheet! He achieves this by crosshatching and by using delicate values of gray. In particular, the gray pencil tones of the coat sculpt her figure and accent the revealing, sumptuous, alabaster breast. The true beauty of this figure is continuous movement—movement from the tip of the nose down to the chin and on to the neck and shoulder. The revealed breast is swathed by the folding curve of the coat. We follow this sweep of movement to the crossing of the leg and then back up again. The lines flow and pull us into the picture plane. It is this sweep of movement that releases her from the sheet.

This careful study may have been done in preparation for a later work, but it is a complete and integrated work of art in its own right. We are left to muse whether she is getting dressed or undressed, but in the end it really doesn't matter. TWolfe

Signed lower left: *Guy Pène du Bois*
Gift of Dr. and Mrs. Philip L. Brewer 2002.47.2
Provenance: James Graham and Sons, New York; Kraushaar Galleries, New York; Lucille and Walter Fillin Collection; Dr. and Mrs. Philip L. Brewer
Exhibited: *Intimate Expressions*, cat. no. 26, illus.: 47; *Celebration*
Literature: Paul Cummings, *American Drawings: The Twentieth Century* (New York: Viking Press, 1976), illus.: 66

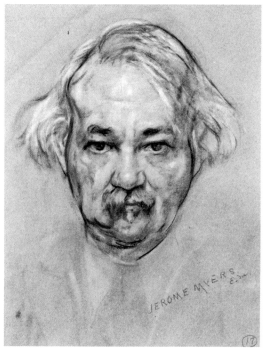

Fig. 80

Fig. 80
Jerome Myers
b. Petersburg, Virginia 1867 –
d. New York City 1940
Self-Portrait 1917
Charcoal and white chalk on prepared blue paper
13 x 10 inches (33 x 25.4 cm)
Signed lower right: *Jerome Myers, E.M.17*
Dr. and Mrs. Philip L. Brewer Collection, Museum purchase made possible by the Ella E. Kirven Charitable Lead Trust for Acquisitions 2003.1.39
Provenance: The Artist's widow; Kraushaar Galleries, New York; Dr. and Mrs. Philip L. Brewer
Exhibited: *Intimate Expressions*, cat. no. 10a, illus.: 16; *Celebration*

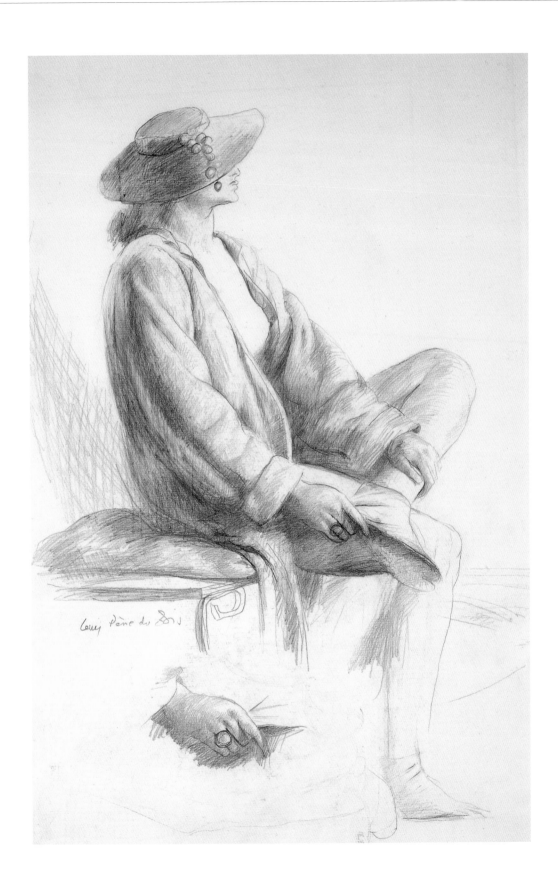

54.

George Overbury "Pop" Hart

b. Cairo, Illinois 1868 – d. New York City 1933

Bathing Beach (Palisades Interstate Park, Fort Lee, New Jersey)

1921

Watercolor and pencil on wove paper

14 x 22 inches (35.6 x 55.9 cm)

Though the artist sketched the people and landscape of such places as Egypt, Tahiti, and Mexico, "Pop" Hart delighted equally in depicting the local scene of New York and its environs. This included Coytesville, a Fort Lee, New Jersey neighborhood where he had lived since 1907. This location proved to be rewarding for the artist, offering much more than a picturesque setting. For eight years, Hart worked as a designer of stage sets for World Pictures Film Studio, one of the early silent film studios established in this community directly across the Hudson River from upper Manhattan. Hart and the burgeoning film industries made use of the proximity of the perilous Palisades Cliffs as well as the sandy beaches and marine surroundings.

The artist identified this scene as Interstate Park, which in 1921 was a lively recreational area that stretched from Fort Lee along the Palisades north into New York state. Here marinas, fishing piers, picnic pavilions, and bathing beaches attracted crowds during the warmer seasons. Hart used jewel-like tones of fluid

watercolor over an energetic and descriptive pencil line to capture this scene of leisure and relaxation.[1] His technique is reminiscent of that of Maurice Prendergast, since both artists were heirs to the tradition of expressive impressionistic watercolor developed by Winslow Homer and John Singer Sargent. Even though Hart regarded most of the important artistic figures in America at that time as his friends and colleagues, it is interesting that his relationship to Jules Pascin "seemed to have exerted a strong influence on the development of (his) work in the 1920s."[2] Such a subject inspired both artists throughout their careers, and it is evident that Hart's dedication to record the experiences of daily life had been advanced by his equal desire to fuse figural realism with modernist idioms and expressions. ML

Signed and dated lower left: *Hart/Int. Park 1921*

Dr. and Mrs. Philip L. Brewer Collection, Museum purchase made possible by the Ella E. Kirven Charitable Lead Trust for Acquisitions 2003.1.48

Provenance: Marie Sterner; Lawrence Rill Schumann Art Foundation; Ira Spanierman, New York; Mr. and Mrs. Ralph Spencer; Spanierman Gallery, New York; Dr. and Mrs. Philip L. Brewer

Exhibited: *The Spencer Collection of American Art*, Spanierman Gallery, New York, June 13 – 29, 1990, 22–23, cat. no. 10, illus.; *Local Wonders: Treasures of American Art in Columbus Collections*, Columbus Museum, February 6 – May 29, 1994; *Intimate Expressions*, cat. no. 37, not illus.; *A Collector's Pursuit of Drawing; Celebration*

Fig. 81

Fig. 81

Charles Burchfield

b. Ashtabula, Ohio 1893 –

d. Buffalo, New York 1967

Old Inn at Hammondsville Ohio

1923

Pencil, ink, charcoal, and watercolor on wove paper

13½ x 22 inches (34.3 x 55.9 cm)

Signed with monogram and dated lower left: *CB/1923*

Promised Gift, Dr. and Mrs. Philip L. Brewer Collection

Provenance: Frank Rehn Gallery, New York; Lucille and Walter Fillin; Dr. and Mrs. Philip L. Brewer

Exhibited: *A Family Collection: Drawings in Various Media by American Artists, Selected from the Collection of Lucille and Walter Fillin and their Children*, Suffolk Museum at Stony Brook, Stony Brook, New York; traveled to Everhart Museum, Scranton, Pennsylvania; Brooks Memorial Art Gallery, Memphis, Tennessee; Tennessee Fine Arts Center at Cheekwood, Nashville, Tennessee; Allentown Art Museum, Allentown, Pennsylvania; New Britain Museum of American Art, New Britain, Connecticut; Bowdoin College Museum of Art, Brunswick, Maine; Williams College Museum of Art, Williamstown, Massachusetts; *Intimate Expressions*, cat. no.10, illus.: 24; *A Collector's Pursuit of Drawing; Celebration*

Literature: Paul Cummings, *American Drawings: The Twentieth Century* (New York: Viking Press, 1976), illus.: 88

55.

George Luks

b. Williamsport, Pennsylvania 1867 – d. New York City 1933
Yes! We Have No Bananas 1923
Crayon and watercolor on wove paper
13½ x 9½ inches (34.3 x 24.1 cm)

Fig. 82

Everything George Luks did was larger than life. If it broke with convention or scandalized popular sentiment, so much the worse for convention or sentiment. From the time he was a teenager, Luks displayed an extravagant theatricality in both manner and dress. When he was not performing in vaudeville or acting the part of a prizefighter, he was "a low comedian, a poet, a profound sympathizer with human misery, and a human orchestra."[1]

In 1922, after thirty years as a quick-sketch newspaper artist, cartoonist, watercolorist, and charter member of the Eight whose paintings of *The Spielers* (1905, Addison Gallery of American Art) and *Hester Street* (1905, Brooklyn Museum) had helped define the gritty urban realism of the "Ashcan School," Luks was nonetheless close to a breakdown. He was ill, his second marriage was disintegrating, and he was drinking heavily. After spending some weeks in a hospital, he was taken in by his long-time Boston patrons Shaw and Margarett McKean, who were able to restore him to his usual irrepressibility. By early 1923, after a visit to Maine and a highly praised retrospective exhibition at Kraushaar Gallery in New York, Luks had resumed his lifelong roles of human dynamo and master of high jinks.[2]

It was in this comic spirit that Luks drew *Yes! We Have No Bananas* in 1923. He almost certainly intended it as the design for a sheet music cover for the wildly popular song of the same title, which had been written that year by the Tin Pan Alley composers and writers Frank Silver and Irving Cohn. Although Luks's design never made it into print, its image of two strolling flappers dressed in matching jodhpurs and big cloche hats perfectly captures both the lilting ragtime rhythms and lighthearted absurdity of a song about an immigrant Greek grocer who:

Just "yes"es you to death, and as he takes your dough, he tells you,
"Yes, we have no bananas, We got no bananas today!"[3]
BWC

Signed lower right: *George Luks* and inscribed lower center: *Boston 1923*
Gift of Dr. and Mrs. Philip L. Brewer 2002.47.7
Provenance: Kennedy Galleries, New York; Dr. and Mrs. Philip L. Brewer
Exhibited: *Intimate Expressions*, cat. no. 48, illus.: 21; *Celebration*

Fig. 82
George Wesley Bellows
b. Columbus, Ohio 1882 –
d. New York City 1925
The Duke and the Duchess
ca. 1922–1923
Crayon on brown-colored wove paper
14½ x 11½ inches (36.8 x 29.2 cm)
Museum purchase 81.11
Provenance: Christie's Auction House, New York, 1981
Exhibited: *People, Places, Animals*; *Celebration*

56.

Andrée Ruellan
b. New York City 1905
The Scottish Poet ca. 1923–1928
Pencil on buff-colored wove paper
12½ x 9¼ inches (31.8 x 23.5 cm)

The subject of this drawing was a man Andrée Ruellan encountered during her youthful sojourn in France between 1923 and 1928. She remembers him as "a very interesting man," but cannot recall his name. No matter, the drawing is at once a portrait of a specific individual and the image of a restless type who draws inspiration from within and who struggles with the meanings, sounds, and shapes of words. Knees and elbows, chair legs and a seat cushion create a dynamic pattern of implicit movement and instability. Viewed from above, the improbably poised chair is less furniture than an extension of the poet's sense of wonderment as well as his magical power, for it is part of an amazing balancing act of limbs and props, focus, and movement.

 The cat's cradle of lines visible in the small space between the pillow and the heel of the poet's foot, while suggesting space, also denies it in a way that betrays Ruellan's modernist sympathies and her response to Cubism. The crisp profile of the head steadies the radiant movement of the body while straddling the poet's shuttered eye and strangely alert ear. The poet's withdrawn glance directs the viewer toward two words floating above an unseen floor: The author's signature seems to exert an eerie magnetism, drawing the poet mentally and physically toward it, as if poet and painter, both of whom labor with pencil and paper and both of whom fashion images, whether verbal or visual, are bound by some mystical sympathy that connects mind and matter, heaven and earth, the divine and the real. And why not? For if the poet is the priest of the invisible, then the painter is the poet of the visible, and in this masterful drawing that is about inner concentration and outward expression, apparent stillness and frozen movement, magical balance and exploratory freedom, Ruellan composes a visual poem about the creative temperament itself. AL

Signed lower right: *Andrée Ruellan*
Dr. and Mrs. Philip L. Brewer Collection, Museum purchase made possible by the Ella E. Kirven Charitable Lead Trust for Acquisitions 2003.1.19
Provenance: Kraushaar Galleries, New York; Dr. and Mrs. Philip L. Brewer
Exhibited: *Intimate Expressions*, cat. no. 62; *Celebration*
Literature: Donald Keyes, with critical essay by Marlene Park, *Andrée Ruellan* (Athens: Georgia Museum of Art, 1993), 49, fig. 30, illus.

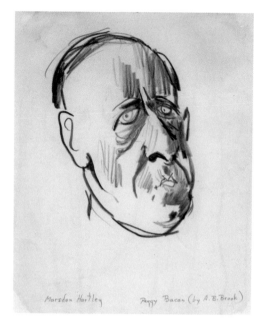

Fig. 83

Fig. 83
Peggy Bacon
b. Ridgefield, Connecticut 1895 –
d. Kennebunk, Maine 1987
Marsden Hartley ca. 1925–1930
Pencil on wove paper
7½ x 5⅝ inches (19.1 x 14.3 cm)
Signed lower right: *Peggy G Bacon (by A.B. Brook)* and inscribed lower left: *Marsden Hartley*
Dr. and Mrs. Philip L. Brewer Collection, Museum purchase made possible by the Ella E. Kirven Charitable Lead Trust for Acquisitions 2003.1.11
Provenance: Adelaide Kuntz, New York; Erle Loran, Berkeley, California; R.E. Lewis, San Rafael, California; Estate of E. Maurice Bloch; Kraushaar Galleries, New York; Dr. and Mrs. Philip L. Brewer
Exhibited: *Local Wonders: Treasures of American Art in Columbus Collections*, Columbus Museum, February 6 – May 29, 1994; *Intimate Expressions*, cat. no. 38, illus.: 5; *A Collector's Pursuit of Drawing*; *Celebration*, illus. gallery guide, unpaginated

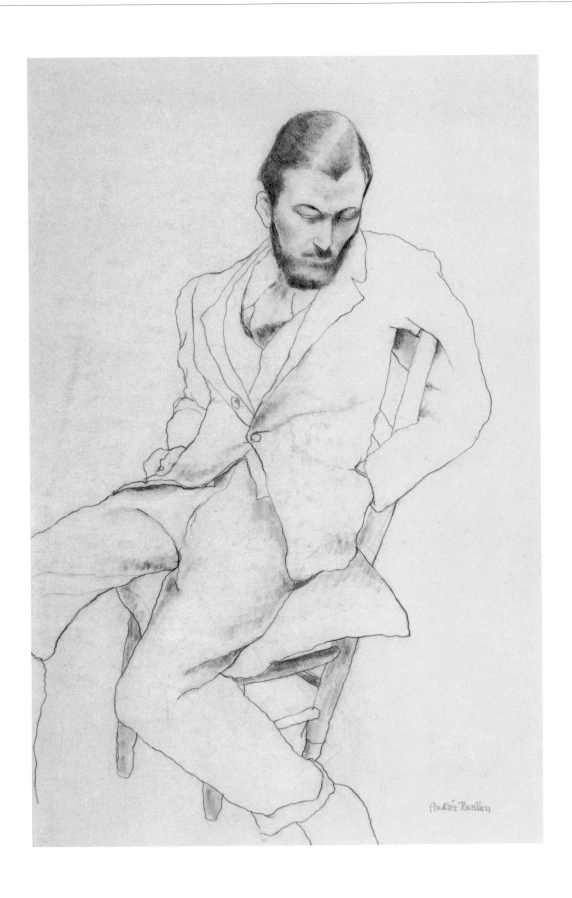

57.

James Daugherty

b. Asheville, North Carolina 1887 – d. Weston, Connecticut 1974
The Beach ca. 1930
Pencil and charcoal on wove paper
17½ x 23½ inches (44.5 x 59.7 cm)

James Daugherty was a recognized and accomplished artist by the time he completed *The Beach*.[1] He had worked as an illustrator for *The New Yorker* magazine and as a muralist, completing commissions for Lowe's Theaters in Cleveland, Ohio, and Newark, New Jersey. He had also exhibited as a member of such progressive organizations as the *Société Anonyme* as well as the Society of Independent Artists. Daugherty had been well educated in the theories of modernism earlier in his career and had created abstract work based on simultaneous color theories associated with the Synchromist movement. Nevertheless, even in this earlier period the figure dominated his art.

Moving to Weston, Connecticut, in 1923, Daugherty often took his sketchbook with him to a nearby beach.[2] Instead of fashionable figures cavorting on the sand and in the water, Daugherty's drawing seems to represent a physical struggle that causes these bodies to twist, turn, and bend. They do not appear to interact as much as intertwine from one pose into another. His depiction suggests the studies of Michelangelo, El Greco, or even Baroque artists such as Rubens, appearing, as one critic noted, "to be built up on an abstract basis of opposing linear movements that weave in and out, as well as laterally."[3] By tilting up the picture plane, the numerous figures appear closer to us making the composition, which uses strong contrasts of dark and light, more compelling. Daugherty learned these lessons by adapting the studies of the Old Masters into conceptual compositions as a young modernist, as did others like Morgan Russell and Thomas Hart Benton. Though Daugherty is often compared to Benton, it is more likely that both artists reached parallel conclusions having concerned themselves with similar ideas rather than one influencing another. ML

Gift of Charles M. and Lisa L. Daugherty 98.25
Provenance: Estate of the Artist; Charles M. and Lisa L. Daugherty
Exhibited: *Under the Influence: The Students of Thomas Hart Benton*, Albrecht-Kemper Museum of Art, St. Joseph, Missouri, April 15 – August 30, 1993, illus.: 67; *New Drawings*; *Celebration*
Literature: Marianne Berardi, *Under the Influence: The Students of Thomas Hart Benton* (St. Joseph, Mo.: Albrecht-Kemper Museum of Art, 1993): 67

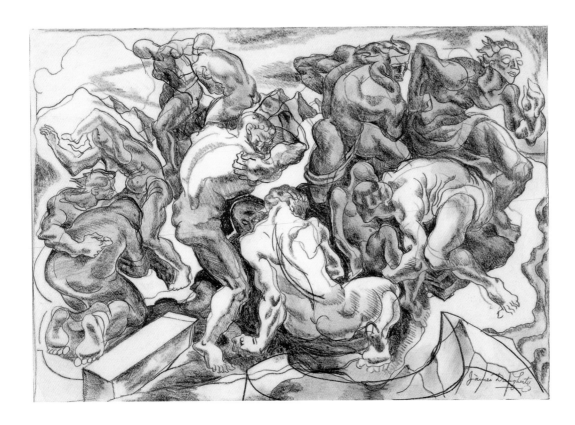

58.

Thomas Hart Benton

b. Neosho, Missouri 1889 – d. Kansas City, Missouri 1975

Wilbur Leverett, Galena, Missouri ca. 1931

Ink, sepia wash, and pencil on buff-colored wove paper

11¹¹⁄₁₆ x 9 inches (29.7 x 22.9 cm)

Thomas Hart Benton's paintings of the early 1930s often feature music. Perhaps it was because he had just learned to play the harmonica, which became a major form of relaxation for him. Benton's interest in indigenous American music is reflected in many of his works of this period, such as *The Ballad of the Jealous Lover of Lone Green Valley* (1934, Spencer Museum of Art, University of Kansas). The most important of Benton's paintings of the early 1930s, however, were three memorable mural projects: *America Today*, painted for the New School of Social Research in New York City in 1931; *The Arts of Life in America*, commissioned in 1932 for the recently established Whitney Museum of American Art; and *The Social History of Indiana*, created for the Indiana Pavilion at Chicago's Century of Progress Exposition in 1933. In these monumental works Benton introduced a new kind of mural painting that was energetic, colorful and, above all, sculptural in feel. Benton, who was only 5' 2" ("and 3/4," he would add quickly), could paint large and dramatic paintings, and the public loved them.

Of these three early mural projects, *The Arts of Life in America*, and particularly its panels on western and southern arts, most clearly emphasizes the importance of gospel, jazz, and country and western music for ordinary Americans. Benton would often travel great distances to make drawings that he could later include in his paintings. For the musicians in *The Arts of the West* panel, he included a portrait of Wilbur Leverett, whom Benton had met and sketched in Galena, Missouri, in 1931. Wilbur and his brother, Homer, were southern gospel musicians who came to meet Benton dressed in striped overalls and carrying their guitars in flour sacks.[1] For Benton, the Leverett brothers epitomized the kind of ordinary Americans he idealized, who were country-bred, self-trained and self-reliant, yet could still produce sophisticated and exciting music. BWC

Signed lower right: *Benton* and inscribed lower left: *Wilbur Leverett Galena, Mo*
Promised Gift, Dr. and Mrs. Philip L. Brewer Collection
Provenance: The Thomas Hart and Rita P. Benton Testamentary Trust, Kansas City, Missouri; Hirschl & Adler Galleries, New York; Dr. and Mrs. Philip L. Brewer
Exhibited: *Thomas Hart Benton: Drawing from Life*, Henry Art Gallery, University of Washington, Seattle, March 16 – May 6, 1990 cat. no. 32, illus.: 139; traveled to Laguna

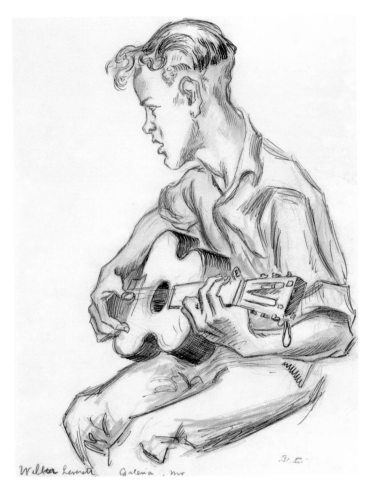

Gloria Art Museum, Austin, Texas; Minneapolis Institute of Art; *Benton's America*, Hirschl & Adler Galleries, New York, January 19 – March 2, 1991: 20; *American Regionalism: Thomas Hart Benton, Grant Wood, and John Steuart Curry, from Georgia Collections*, Marietta/Cobb Museum of Art, Marietta, Georgia, September 17– November 24, 1993; *Intimate Expressions* cat. no. 5, illus.: 17; *A Collector's Pursuit of Drawing*; *Celebration*, illus. gallery guide, unpaginated
Literature: Henry Adams, *Thomas Hart Benton: An American Original* (New York: Alfred A. Knopf, 1989), illus.: 183; Karal Ann Marling, *Tom Benton and his Drawings: A Biographical Essay and a Collection of his Sketches, Studies and Mural Cartoons* (Columbia: University of Missouri Press, 1985), illus., no. 3: 1–3

59.

Peter Takal
b. Bucharest, Romania 1905 – d. Geneva, Switzerland 1995
Girl on a Bed 1933
Pencil, ink, and wash on wove paper
11 x 7½ inches (27.9 x 19.1 cm)

A gifted artist not only produces a likeness of his subject but also renders that image with such nuance that temperament and personality are apparent. With an expressive, lucid, and yet elegantly spare line, Peter Takal suggests the ennui of the figure that skeptically eyes him from her reclining position. Was it he who asked her to disrobe from the waist up, roll her stockings down to her knees and raise her skirt to reveal her lingerie, or was this awkward pose of her own design? She seems not to be the usual compliant artist's model that demurely looks away.[1] Though intriguing, she is not beautiful in the classical sense, her profiled face with wide forehead and flaring nostril appears a bit horsy; her narrow boney shoulders, thin arms, and flattened breasts suggest a slight figure, which is contradicted by her thick thighs. However, this inelegance and wryness is exactly what makes her so captivating. She exudes the languor and cynicism that defined Paris between the wars, which was where and when this was made. Takal devoted himself to art only after first trying his hand as a Berlin cabaret performer and making movies with Billy Wilder in Paris. In 1939, having gained some critical attention for his drawings in the States and with the threat of war looming, he immigrated to New York where he worked with such figures as Alexey Brodovitch at *Harper's Bazaar.*

Takal's confident agility with line enabled him to imbue this figure with a sense of overt sexuality and severe disinterest. Even his use of color, to accentuate her undergarments, skin, and hair suggests both sensual luxuriance and clothes both old and faded. Takal's fervent line clearly defines much more than a posing model. *Girl on a Bed* is an expression of both the world-weary and the world-wise. As the artist noted, "Lines are in drawing what words are in writing. Both are media and reveal their fuller meaning between the lines."[2] ML

Signed lower left: *Takal* and dated verso: *1933, 33/132*
Gift of the Artist's Estate 2004.1.3
Provenance: Estate of the Artist

Fig. 84

Fig. 84
Peter Takal
b. Bucharest, Romania 1905 –
d. Geneva, Switzerland 1995
Family at Beach, Bausol 1931; verso:
Untitled (pencil study of figures on a beach) 1931
Ink on wove paper
8¹⁵⁄₁₆ x 7¹⁵⁄₁₆ inches (22.7 x 20.2 cm)
Signed lower left: *Takal* and inscribed and dated verso: *1931, Bausol, 31/166*
Gift of the Artist's Estate 2004.1.1
Provenance: Estate of the Artist
Exhibited: *Building on Strength*
Note: Bausol is located near Liège, Belgium.

60.

George Copeland Ault

b. Cleveland, Ohio 1891 – d. Woodstock, New York 1948
Kitchen Stove 1932
Pencil on buff-colored wove paper
15 x 10 inches (38.1 x 25.4 cm)

George Ault's drawing, *Kitchen Stove*, is a profound example of Precisionism, the American style from the 1920s and 1930s in which artists managed to combine hyperrealism with Cubist abstraction, and subjects of traditional American life with images of the machine age.[1] Ault's pristine drawing of right angles within right angles culminates with a glimpse of the stove and stovepipe against the far wall. In contrast to the series of severe perpendiculars the pipe, with its two gentle curves, rises to meet a pure, circular form at the wall. But it is the single exposed leg of the stove, with its elongated "S" curve in the center of the composition, which contributes a note of sensuality and suggests the restrained passion that lies behind the creation of this elegantly austere drawing.

Few statements have come down to us from Ault, a depressive artist troubled by alcoholism. But in a radio interview in 1936 about the significance of subject matter, he said, "The sole importance of what an artist chooses to represent is, does he, the artist 'feel' the subject which he wants to put onto canvas?"[2] In the case of *Kitchen Stove* one senses that the artist had strong feelings about this wood-burning stove, a symbol of nourishment and domesticity,

and the modest, unadorned architecture that houses it. In fact 1932, when the drawing was made, was a sad point in the artist's life. After his father died in 1929, one of Ault's brothers committed suicide the next year, and another the year after that. In 1933 Ault, who lived in New York City, began spending summers upstate in Woodstock, where he moved in 1935. The longing for the simplicities of rural life expressed in *Kitchen Stove* reflect his yearnings during this difficult period. TWolf

Signed lower left: *G. C. Ault '32*
Gift of Dr. and Mrs. Philip L. Brewer 2001.16.1
Provenance: Zabriskie Gallery, New York; Lucille and Walter Fillin; Dr. and Mrs. Philip L. Brewer
Exhibited: *A Family Collection: Drawings in Various Media by American Artists, Selected from the Collection of Lucille and Walter Fillin and their Children*, Suffolk Museum at Stony Brook, Stony Brook, New York, February 3 – March 29, 1964; traveled to Everhart Museum, Scranton, Pennsylvania; Brooks Memorial Art Gallery, Memphis, Tennessee; Tennessee Fine Arts Center at Cheekwood, Nashville, Tennessee; Allentown Art Museum, Allentown, Pennsylvania; New Britain Museum of American Art, New Britain, Connecticut; Bowdoin College Museum of Art, Brunswick, Maine; and Williams College Museum of Art, Williamstown, Massachusetts; *Intimate Expressions*, cat. no. 1, illus.: 35; *A Collector's Pursuit of Drawing; Celebration*
Literature: Lucille and Walter Fillin, *A Family Collection: Drawings in Various Media by American Artists, Selected from the Collection of Lucille and Walter Fillin and their Children* (Stony Brook, New York: Suffolk Museum at Stony Brook, 1964), no. 1, illus.

Fig. 85

Fig. 85
Miklos Suba
b. Szatmar, Poland 1880 –
d. Brooklyn, New York 1944
Hotel 1934
Pencil on wove paper
11¼ x 15½ inches (28.6 x 39.4 cm)
Signed and dated lower right: *Suba 1934*
Dr. and Mrs. Philip L. Brewer, Museum purchase made possible by the Ella E. Kirven Charitable Lead Trust for Acquisitions 2003.1.31
Provenance: Estate of the Artist; Hirschl & Adler Galleries, New York; Dr. and Mrs. Philip L. Brewer

Exhibited: *Buildings: Architecture in American Modernism*, Hirschl & Adler Galleries, New York, October 29 – November 29, 1980, no. 87, p. 84 illus.; *Realism and Abstraction: Counterpoints of American Drawing, 1900–1940*, Hirschl & Adler Galleries, New York, November 12 – December 30, 1983, no. 94, illus.: 82; *Intimate Expressions*, cat. no. 13a, illus.: 62; *A Collector's Pursuit of Drawing; Celebration*

G.C.Ault '32

61.

John Steuart Curry

b. Dunavant, Kansas 1897 – d. Madison, Wisconsin 1946

The Fugitive; verso: *Untitled* (sketch from *Manhunt* series)

ca. 1933

Charcoal on wove paper

14¾ x 11½ inches (37.5 x 29.2 cm)

Like fellow regionalists Thomas Hart Benton and Grant Wood, John Steuart Curry viewed art as a powerful agent of social change. "The social, political, and economic disturbances of the times," he proclaimed in 1937, "have brought forth those artists who, taking their themes from these issues, have produced telling and effective works for the cause of social and political justice."[1] Curry thus transformed much of his art into a condemnation of the intolerance, corruption, and injustice he observed around him.[2] Although the artist's mural projects throughout the Midwest presented his views on an epic scale for mass audiences, he created canvases and works on paper that convey such messages with a similar intensity.

One of several works Curry devoted to the heroic struggles of African Americans, *The Fugitive* distills the horrors of lynching into a single, emblematic image.[3] In a desperate attempt to elude his pursuers, a man clings to the upper limbs of a tree in the immediate foreground. Underscoring his plight, Curry encircles him with threatening rows of serrated foliage through which an approaching posse is visible. The dramatic tension is heightened by bold diagonals used to define a windblown landscape and menacing sky. While Curry's painting *The Manhunt* (1931, present location unknown) presents a close-range view of a similar lynch mob, *The Fugitive* encourages viewers to consider the humanity of the quarry rather than focusing on his pursuers.[4] The runaway is shown gazing upward helplessly, as if praying for divine deliverance, as a butterfly—a lone symbol of hope—drifts past below. Furthermore, pentimenti reveal Curry's decision to adjust the arms of the figure outward into a crucifixion-like pose, a device used several years later by the artist for the central figure in his mural, *The Freeing of the Slaves* (1942, Library of the Law School, University of Wisconsin, Madison). Of all Curry's anti-lynching images, none surpasses the immediacy and tension of this drawing. SCW

Signed lower right: *John Steuart Curry* and inscribed lower left: *The Fugitive*
Promised Gift, Dr. and Mrs. Philip L. Brewer Collection
Provenance: Kennedy Galleries, New York; Glenn C. Janss, Sun Valley, Idaho; Richard York Gallery, New York; Dr. and Mrs. Philip L. Brewer
Exhibited: *American Realism: Twentieth Century Drawings and Watercolors from the Glenn C. Janss Collection*, November 7, 1985 – September 20, 1987, San Francisco Museum of Art, San Francisco; traveled to De Cordova and Dana Museum and Park, Lincoln, Massachusetts; Archer Huntington Art Gallery at the University of Texas, Austin; Mary and Leigh Block Gallery, Northwestern University, Evanston, Illinois; Williams College Museum of Art, Williamstown, Massachusetts; Akron Art Museum, Akron, Ohio; Madison Art Center, Madison, Wisconsin; *Intimate Expressions*, cat. no. 20, illus.: 25; *Celebration*

62.

Philip Evergood

b. New York City 1901 – d. Bridgewater, Connecticut 1973
Psychological Incident ca. 1935
Ink, gouache, charcoal, and pencil on wove paper
24½ x 19 inches (62.2 x 48.3 cm)

Philip Evergood met Julia Vincent Cross in Paris in 1926. At that time, they were both finding their way in their chosen careers: she as a dancer and he as an artist. They were to meet again four years later in Paris and, after a tumultuous romance, they married in New York in 1931. Julia became a recurring subject for the artist. He admired her artistic determination, as well as her lithe dancer's body and gestures and her whimsical smile. The couple remained committed to each other even after they agreed to live separate lives. Their marriage from the onset was shrouded by the guilt, misgivings, and resentments that arise when one party feels they have sacrificed too much for the other.

Julia's youthful appearance in *Psychological Incident* suggests it may have been done in the mid-1930s when Evergood was receiving his first favorable reviews, while his wife's career languished. In a 1934 letter to her husband, Julia noted, "someday we will find some form of life which makes us both happy."[1] This wistful comment seems to have little connection to the figure in the portrait. Avoiding eye contact, she seems ambivalent or even unwilling to pose. Her crossed arms are a barricade behind which she withholds herself or perhaps stems an emotional eruption that seethes beneath the surface. The dangling cigarette from her right hand reinforces the idea of a slow emotional "burn." Evergood describes the tension of this incident through the expressive nature of his remarkable fluid but edgy line.

As a jazz aficionado, Evergood identified with the improvisational spirit. In his personal papers (possibly dating to the 1930s), he drew an analogy between himself and the jazz artist Bix Beiderbecke. In it he commented, "Bix had a loose quality and an experimental quality. Also a kind of defiance. We are akin in our totally different mediums and our rhythms and tempos are very together.[2] Much as a jazz riff that comes from the heart and mind of the musician, Evergood's calligraphic line seems to have been stimulated by the struggles of his own life, including the limitations and the triumphs that are a part of every human story. ML

Signed lower center: *Philip Evergood*
Dr. and Mrs. Philip L. Brewer Collection, Museum purchase made possible by the Ella E. Kirven Charitable Lead Trust for Acquisitions 2003.1.7
Provenance: Julia Evergood (artist's wife and model); Berry-Hill Galleries, New York; Dr. and Mrs. Philip L. Brewer
Exhibited: *Philip Evergood, Paintings and Drawings*, Kennedy Galleries, May 10 – June 2, 1972, listed but not illustrated in catalogue; *Intimate Expressions*, cat. no. 27, illus.: 44; *A Collector's Pursuit of Drawing*; *Celebration*

Fig. 86

Fig. 86
Isabel Bishop
b. Cincinnati 1902 –
d. Riverdale, New York 1988
The Ashcan ca. 1935–1938
Pen and ink on wove paper
7¼ x 6¼ inches (18.4 x 15.9 cm)
Signed lower right: *Isabel Bishop*
Promised Gift, Dr. and Mrs. Philip L. Brewer Collection
Provenance: Midtown Galleries, New York; Dr. and Mrs. Philip L. Brewer
Exhibited: *Intimate Expressions*, cat. no. 6, illus.: 38; *Celebration*

63.

Paul Cadmus
b. New York City 1904 – d. Weston, Connecticut 1999
Venus and Adonis 1936
Pen and ink on wove paper
8 x 8 inches (20.3 x 20.3 cm)

Paul Cadmus remained throughout his long career an intensely private artist whose path ran contrary to prevailing art currents. During the early twentieth century—an era in which art was dominated by abstraction—he sketched from live models daily, experimented with Renaissance painting techniques, and represented contemporary life with uncommon clarity and insight. Although a master at rendering the human form and its external structure, Cadmus utilized the figure as a potent means of revealing nuances of the psyche, especially inner drives and hidden passions. He began to create increasingly elaborate scenes of urban and suburban life, especially after being employed on a series of government-sponsored art projects in the mid-1930s. During this period the artist gained national notoriety when his tempera painting, *The Fleet's In!* (1934, United States Naval Museum, Washington, D.C.), was removed from an exhibition at the Corcoran Gallery of Art due to its suggestive portrayal of sailors on leave.

Created two years after *The Fleet's In!*, the Columbus Museum drawing is a study for *Venus and Adonis* (Forbes Magazine Collection), an egg tempera and oil painting produced the same year.[1] The scene depicts tennis sensation Fred Perry as a god-like youth struggling to escape his desperately clutching wife in order to join a match in progress.[2] Although Cadmus creates a near likeness of the British champion, he takes liberties in transforming the star's petite wife, American actress Helen Vinson, into a Rubensesque matron and mother.[3] There are numerous classical references, most notably in Perry's heroic physique, the contorted tangle of figures reminiscent of the first century BCE carving of *Laocoön*, and in the title's reference to the tragic couple from Greek mythology. In technique, the work reflects the artist's distinctive fusion of drawing and painting visible in the blend of delicate monochromatic washes and crisp crosshatching.[4] The resulting drawing is a fully realized, satirical drama bearing all the hallmarks of Cadmus's impeccable craftsmanship, theatrical flair, and caustic wit. SCW

Signed lower right: *Cadmus*
Promised Gift, Dr. and Mrs. Philip L. Brewer Collection
Provenance: Private Collection, Connecticut; Cooley Gallery, Old Lyme, Connecticut; Dr. and Mrs. Philip L. Brewer
Exhibited: *Intimate Expressions*, cat. no. 11, illus.: 25; *Celebration*
Literature: *Personal Views, American Works on Paper, 1800–1940* (Old Lyme, Connecticut: Cooley Gallery, 1992), illus.: 24

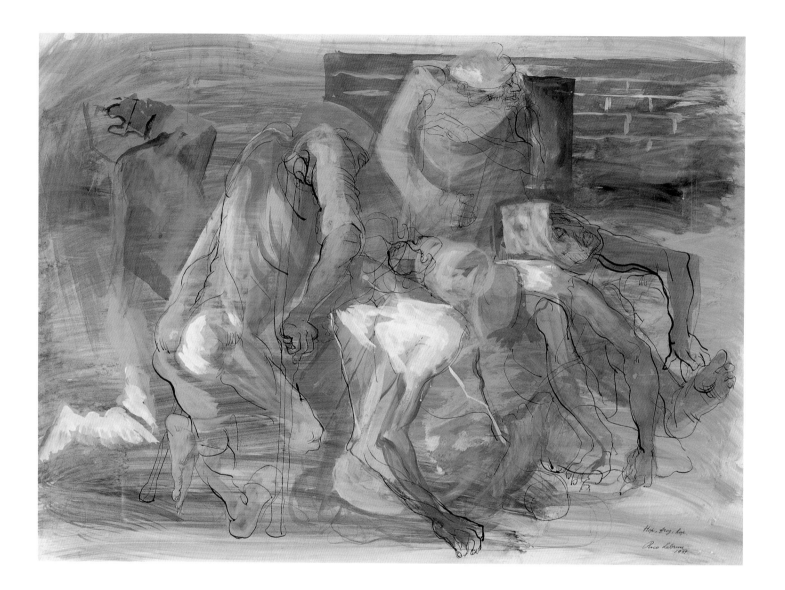

64.

Federico (Rico) Lebrun

b. Naples, Italy 1900 – d. Malibu, California 1964
Hop, Frog, Hop 1939
Ink, gouache, and watercolor on wove paper
29 x 39 inches (73.7 x 99.1 cm)

After emigrating from Italy in the 1920s, Rico Lebrun found success in New York working first for *The New Yorker* and *Vogue* and later as a teacher and muralist. However, according to art critic Henry Seldis, his distinctive visual language truly emerged in the late 1930s, after his move to California.[1] This drawing dates from that time and is reflective of his passion for the Italian and Spanish Baroque, which he had immersed himself in as a student in his native Naples. Like those artists, his compositions often transcend all corporeal and emotional limitations, challenging the static ideal of classicism "with the new concept of (a) multiple, animated image."[2] Still his recurring subject of man's inhumanity to man suggests a deep-rooted humanism that though bound to an older tradition is nonetheless compelling. Lebrun depicts the timeless drama of human endurance in spite of overwhelming suffering through the wrenching movements of these struggling figures, with a masterful facility of line that echoes the visual eloquence of the Seicento masters. As Lebrun noted later in life, "If I had to lose all my virtues as a passable draftsman for the sake of speaking truly about the unmanageable design of our condition, I would do so gladly. Talent is one thing: life another."[3]

It is intriguing to consider that Edgar Allan Poe published a short story entitled *Hop-Frog* in 1849, where a crippled dwarf's torment and his eventual retribution are revealed during the course of the story. Poe describes that "Hop-Frog could only get along by a sort of interjectional gait—something between a leap and a wiggle."[4] We do not know if Lebrun was familiar with Poe's tale, or if this drawing with its similar title is only coincidental. Nevertheless, it is a transfixing idea that both artist and writer, working almost a century apart, conceived of this subject of the shattered and afflicted Hop-Frog as "a vehicle of criticism, deeply rooted in the knowledge that even in the degradation of mental and physical despair there is still an intense significance in all fragments of life and feeling."[5] ML

Signed and dated lower right: *Rico Le Brun 1939* and inscribed lower right: *Hop, Frog, Hop*
Museum purchase made possible by the Ella Kirven Charitable Lead Trust for Acquisitions 2002.66
Provenance: Jack Rutberg Gallery, Los Angeles; Michael Rosenfeld Gallery, New York
Exhibited: *Celebration*

65.
Arthur Garfield Dove
b. Canandaigua, New York 1880 – d. Long Island, New York 1946
Gas Tank before 1939
Watercolor and ink on wove paper
5 x 7 inches (12.7 x 17.8 cm)

In the aftermath of World War I, with the waning influence of European culture, American artists and writers set out to articulate a distinctly American art. Their efforts took divergent paths. For some, the city became the epicenter, a melting pot for everything—highbrow and lowbrow—that constituted the American character. For others, the metropolis was a festering world of decadence and degradation—congested, unstable, and polluted. Money and materialism had warped basic humanitarian virtues. The ideological battle between urban and rural realms found expression in pictorial images that embodied an anti-urban, anti-technological ethos.

Arthur Dove, along with a small coterie of creative individuals who gathered around the photographer Alfred Stieglitz, embraced an agrarian-inspired nationalism. Words and phrases like "roots," "native soil," and "the American earth," coined by kindred writers and cultural critics Waldo Frank and Paul Rosenfeld, rallied the Stieglitz group in search of a usable past. Rural outposts became for them places of refuge, an alternative reality far from the chaotic metropolis.

Dove mined a cornucopia of subjects from the landscape. His was a pictorial language of equivalence and metaphor: subjective views of nature rendered abstractly. From this perspective, a watercolor like *Gas Tank*, with its gas tank and electrical tower hovering in the background as beacons of progress, or conversely, as intrusions in an otherwise pristine landscape, seems anomalous. Dove deployed industrial forms in a few other works, such as *Telegraph Pole*, 1929; *The Mill Wheel, Huntington Harbor*; *Silver Tanks and Moon*; and *Sand Barge* of 1930. In each instance, nature plays a transformative role, as progress is poeticized through abstraction. DD

Signed lower center: *Dove*
Dr. and Mrs. Philip L. Brewer Collection, Museum purchase made possible by the Ella E. Kirven Charitable Lead Trust for Acquisitions 2003.1.51
Provenance: Estate of the Artist; Downtown Gallery, New York; Terry Dintinfass Gallery, New York; Private Collection, Sausalito, California; Hirschl & Adler Galleries, New York; Dr. and Mrs. Philip L. Brewer
Exhibited: *Ten American Watercolor Painters*, Museum of Fine Arts, Boston, 1939, cat. no. 21, illus.: 9; *A Sense of Line: American Modernist Works on Paper*, Hirschl & Adler Galleries, New York, November 25, 1989 – January 6, 1990, cat. no. 39, illus.: 54; *Local Wonders: Treasures of American Art in Columbus Collections*, Columbus Museum, February 6 – May 29, 1994; *Intimate Expressions*, cat. no. 25, illus.: 70, pl. 8; *A Collector's Pursuit of Drawing; Celebration*, illus. gallery guide, unpaginated

Fig. 87
Peter Blume
b. Smorgon, Russia 1906 – d. New Milford, Connecticut 1992
Toadstools 1938
Conte on cream-colored wove paper
15¾ x 14¼ inches (40 x 36.2 cm)
Signed and dated: *Peter Blume/1938*
Promised Gift, Dr. and Mrs. Philip L. Brewer Collection
Provenance: Durlacher Brothers, New York; Kraushaar Galleries, New York; Dr. and Mrs. Philip L. Brewer
Exhibited: *Intimate Expressions*, cat. no. 8, illus.: second frontispiece; *Celebration*

Fig. 87

66.

Andrew Newell Wyeth
b. Chadd's Ford, Pennsylvania 1917
North Sutton 1940
Watercolor on wove paper
20¼ x 29¼ inches (51.4 x 74.3 cm)

Although Wyeth is best known for his tightly rendered paintings in egg tempera, watercolor was his medium of choice until the early 1940s. Like his idol Winslow Homer, Wyeth found it versatile and ideally suited to capturing life along the Maine coast. Of his attraction to the medium, the artist once explained, "With watercolor, you can pick up the atmosphere, the temperature, the sound of snow shifting through the trees or over the ice of a small pond or against a windowpane. Watercolor perfectly expresses the free side of my nature."[1] It was on the strength of his watercolors that Wyeth first attracted national attention in the late 1930s.[2] He has continued to use the medium even after shifting largely to tempera in the early 1940s.

Rich in color and bold in execution, *North Sutton* reflects the exuberance and freedom that mark Wyeth's early watercolors. The artist painted it in 1940 while in New Hampshire visiting his future wife, Betsy James, who was then attending school in nearby New London.[3] Avoiding warm hues, the artist uses a range of violet blues, dark reds, earthy greens, and pale grays to convey the frigid conditions surrounding a group of dwellings nestled within a snowy landscape. Masterful variations in brushwork and abstract formal devices activate and unify the composition. Layers of watery color form the dark crescent of a stream, which serves as a point of entry into the scene and divides the pale foreground into a series of graceful curves. Dense tongues of green-blue pigment define a dominant conifer whose tip mimics the shape of the schoolhouse bell tower. Telephone lines scratched in pencil echo the vibrant patterns formed by parallel dry brush marks used to indicate branches in the field below. Through this delicate blend of description and expression, *North Sutton* captures the full range and intensity of Wyeth's brushwork just before his transition to tempera. SCW

Signed lower right: *Andrew Wyeth*
Bequest of Edward Swift Shorter 91.7.6
Provenance: Macbeth Gallery, New York; Edward Swift Shorter
Exhibited: *Selections from the Macbeth Gallery*, Atlanta, Georgia, 1940; *Selections from the Bequest of Edward Swift Shorter, 1900–1987*, Columbus Museum, March 31, 1991 – June 7, 1992; *People, Places, Animals; Making a Mark; Celebration*

Fig. 88

Fig. 88
Andrée Ruellan
b. New York City 1905
River Men 1940
Graphite on wove paper
10 x 13 inches (25.4 x 33 cm)
Signed lower left: *Andrée Ruellan*
and on verso, lower right: *Savannah 1940* and *"River Men" – Wichita Museum*
Gift of Kraushaar Galleries in honor of Dr. and Mrs. Philip L. Brewer 97.32
Provenance: Kraushaar Galleries, New York
Exhibited: *Towards a New Century; Celebration*

67.

Yasuo Kuniyoshi

b. Okayama, Japan 1889 – d. New York City 1953
Artists' Ball ca. 1930–1940
Black ink and gouache on paper
17½ x 14 inches (44.5 x 35.6 cm)

Little information has come down to us regarding Yasuo Kuniyoshi's lively drawing, *Artists' Ball*, but judging from its style and subject we can assume it dates from the 1930s, when Kuniyoshi was becoming one of the most celebrated painters in the United States.

This buoyant drawing features a sailor dancing with a voluptuous woman in front of a tipsy, amorous couple and a waiter parading by with a dangerously balanced tray. The animated ribbon that loops across the top of the scene suggests the lively music accompanying the dancers. This scene of revelry reflects the artist's *joie de vivre* after he returned to the U.S. after two extended stays in Paris; it echoes the café depictions of Toulouse-Lautrec, as well as the festive costume parties that were a tradition at the Art Students League, where the artist studied in the 1910s and taught starting in 1933.[1]

Kuniyoshi's ability to create original fusions of Asian and occidental traditions is evident in the costumes and the cross-hatched lines which reflect European practices, while the floating space and bold black ink technique recall Japanese brush drawings. Coming from Japan, Kuniyoshi had great respect for works on paper. According to him, "Drawing has generally been mistreated and ignored, so that as a legitimate work of art it receives neither support nor encouragement," and his last works were a series of highly finished black ink drawings.[2]

In the late 1930s Kuniyoshi's art became somber, reflecting his disapproval of Japanese militarism in Asia. Although he moved from Asia to the United States at age seventeen, and spent his adult life in the U.S., immigration law made it impossible for him to become a citizen. After the bombing of Pearl Harbor in 1941 he was classified an "enemy alien" and his art became increasingly pessimistic. *Artists' Ball* evokes his happier days. TWolf

Signed lower center: *Kuniyoshi*
Dr. and Mrs. Philip L. Brewer Collection, Museum purchase made possible by the Ella E. Kirven Charitable Lead Trust for Acquisitions 2003.1.40
Provenance: Michael Rosenfeld Gallery, New York; Dr. and Mrs. Philip L. Brewer
Exhibited: *Local Wonders: Treasures of American Art in Columbus Collections*, Columbus Museum, February 6 – May 29, 1994; *Intimate Expressions*, cat. no. 44, illus.: 47; *A Collector's Pursuit of Drawing, Celebration*

Fig. 89
Jack Levine
b. Boston, Massachusetts 1915
Volpone: A Study ca. 1940–1950
Sepia ink on brown-colored laid
paper
11¼ x 17 inches (28.6 x 43.2 cm)
Dr. and Mrs. Philip L. Brewer
Collection, Museum purchase
made possible by the Ella E. Kirven
Charitable Lead Trust for
Acquisitions 2003.1.30
Provenance: The Alan Gallery, New
York; John and Dora Koch, New
York; Dr. and Mrs. Philip L. Brewer
Exhibited: *Jack Levine, Retrospective
Exhibition, Paintings, Drawings and
Graphics*, Jewish Museum, New
York, November 8, 1978 – January
28, 1979, cat. no. 119, illus.: 59; trav-
eled to Norton Gallery and School
of Art, West Palm Beach, Florida,
February 17 – April 8, 1979; Brooks
Memorial Gallery, Memphis,
Tennessee, April 30 – June 17, 1979;
Montgomery Museum of Fine Arts,
Montgomery, Alabama, July 9
–August 26, 1979; Portland Art
Museum, Portland, Oregon,
September 17 – November 4, 1979;
Minnesota Museum of Art, St. Paul,
November 26, 1979 – January 12,
1980; *Intimate Expressions*, cat.
no.8a, illus.: 61; *Celebration*
Literature: Kenneth Wade Prescott
and Jack Levine, *Jack Levine,
Retrospective Exhibition, Paintings,
Drawings and Graphics* (New York:
Jewish Museum, 1978), cat. no. 119,
illus.: 59

Fig. 90
Eugene Berman
[Yevgeny (Gustavovich)]
b. St. Petersburg, Russia 1899 –
d. Rome, Italy 1972
Design for the Duke's Costume 1951
Pen and ink and gouache on
brown-colored wove paper
12½ x 9½ inches (31.8 x 24.1 cm)
Signed with initials and dated lower
center: *EB 1951*
Inscribed, upper center, lower left,
and lower right: *Rigoletto, Act 1,
the Duke*
Dr. and Mrs. Philip L. Brewer
Collection, Museum purchase
made possible by the Ella E. Kirven
Charitable Lead Trust for
Acquisitions 2003.1.33
Provenance: M. Knoedler, New
York; Carl Van Vechten; Frank S.
Schwarz and Son, Philadelphia; Dr.
and Mrs. Philip L. Brewer
Exhibited: *Celebration*
Literature: *The Philadelphia
Collection XXVII, American
Watercolors and Drawings*
(Philadelphia: Frank S. Schwarz and
Son, summer 1985), no. 87, illus.: 88

Fig. 89

Fig. 90

68.

Lilian Westcott Hale

b. Hartford, Connecticut 1881 – d. St. Paul, Minnesota 1963

Miss Waterman ca. 1945–1946

Charcoal on wove paper

29 ¹⁵⁄₁₆ x 22 ¹⁄₁₆ inches (76 x 56 cm)

In her reminiscences of being the progeny of two artists, author Nancy Hale wrote that her mother was successful from the start, noting, "she had more portrait orders than she could fill…"[1] Lilian Westcott had arrived in Boston at the turn of the twentieth century to study at the Museum of Fine Arts School. Shortly thereafter, she married one of her teachers, Philip Leslie Hale, seventeen years her senior, who was a descendant of the prominent Boston Brahmin family that had produced both Nathan Hale and Edward Everett Hale. As a wife and mother in the early twentieth century, Hale maintained a studio at home producing both paintings and drawings, both of which she considered equally significant to her life's work.

 Hale's unique and almost obsessive charcoal technique won her much critical acclaim. According to her daughter, she would sharpen her charcoal to a needlepoint with a razor and then proceed to mark vertical lines, slowly defining her subject with breathtaking precision.[2] This disciplined and refined technique of amassing countless repetitions of linear strokes to delineate the figure's head and hands is somewhat paradoxical, since the artist then conveys the sitter's snowy white blouse with their absence. Together the result is spare, suggesting a fleeting moment of memory rather than a solid factual record.

 The subject of the portrait, Miss Waterman, reportedly was a feisty New Englander who after a career as a teacher of classical language had retired next door to the artist in Folly Cove, Rockport, Massachusetts.[3] Hale indicates the doyenne's properness through the prim bow tied at her neck and her carefully folded hands. However, her braided hair piled atop her head, still raven-colored, belies her aging face, as does her steady gaze toward some distant point. ML

Signed lower right: *Lilian Westcott Hale*

Promised Gift, Dr. and Mrs. Philip L. Brewer Collection

Provenance: Estate of the Artist; Hirschl & Adler Galleries, New York; Dr. and Mrs. Philip L. Brewer

Exhibited: *Intimate Expressions*, cat. no. 35, illus.: 27; *A Collector's Pursuit of Drawing*; *Celebration*

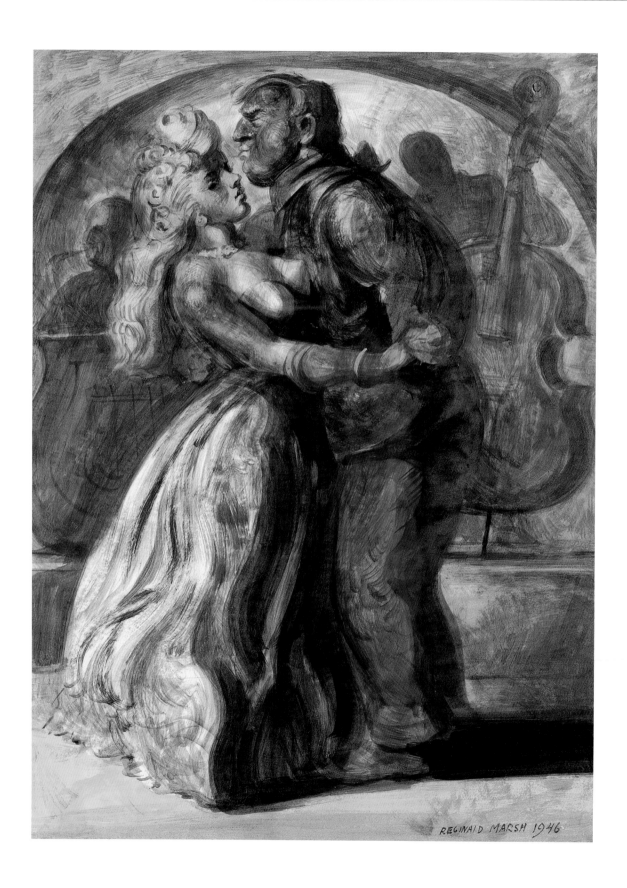

69.
Reginald Marsh
b. Paris, France 1898 – d. Dorset, Vermont 1954
Learn to Dance 1946
Egg tempera on wove paper
30¾ x 22½ inches (78.1 x 57.2 cm)

By the mid-1920s, the Yale-educated, financially comfortable Marsh, who had started out as a cartoonist and illustrator, began to aspire to loftier artistic goals. After occasional lessons with John Sloan and George Luks, he traveled to Paris, where he discovered the grand Baroque tradition of Peter Paul Rubens, in whose energetic, often sexually charged paintings Marsh found a pictorial language powerful enough to express both the vitality and vulgarity of city life. But Marsh had not yet discovered a medium that could effectively marry his restless drawing style to the rich coloring of Old Master painting. In 1929, Thomas Hart Benton introduced him to egg tempera, whose transparency enabled Marsh to fuse drawing, color washes, and glazes in complex, multilayered images.

Marsh was magnetically drawn to the social underbelly of New York, from Bowery derelicts to the sweaty throngs of Coney Island's beaches, and from seedy burlesque theaters that opened at 10 a.m. to all-night "taxi" dance halls. The latter were one of the tawdrier fixtures of New York City night life in the 1930s and 1940s. They catered exclusively to lonely men, who could "hire" a dance partner for the price of ten cents a dance. In an apt urban simile, the women that the dance halls thus rented out came to be called "taxi" dancers.

Very often, these halls styled themselves as dance schools, but very little "instruction" ever took place; with good reason, the police instead called them "rump rooms." For the women involved, taxi dancing was boring, grueling, and humiliating; for Marsh, it was an appropriate metaphor for the psychological dislocations and strident commercialization of modern life.

The ironically titled *Learn to Dance* is almost a caricature of that life. Framed by a proscenium arch under which a band is playing, a brutish merchant sailor presses up against a seductively attired "bombshell" blonde. Yet, with characteristic acuity, Marsh captures her attempt to distance herself, both physically and emotionally, from her partner's clutches. Marilyn Cohen, in her perceptive essay in *Reginald Marsh's New York*, notes that, "as lusty and inviting as [Marsh's] women may seem, they are, like pinup queens, fantastic projects, caught in permanently disconnected relationships."[1] BWC

Signed lower right: *Reginald Marsh, 1946*
Gift of the Estate of Felicia Meyer Marsh 79.32
Provenance: Artist; Felecia Meyer Marsh; Estate of Felicia Meyer Marsh
Exhibited: *A Select View*, cat. no. 39, illus.: 15; *American Drawings from the Permanent Collection*, Columbus Museum, February 22 – May 28, 1990; *Social Realism: Mid-Century Works on Paper from the Permanent Collection*, Columbus Museum, February 7 – May 30, 1993; *People, Places, Animals*; *Making a Mark*; *Celebration*
Literature: *A Select View*, illus.: 15; *Building on a Legacy*, illus.: 171

70.

Walter Inglis Anderson

b. 1903 – d. 1965, New Orleans, Louisiana
Horn Island ca. 1947–1955
Watercolor and graphite on wove typing paper
8 x 11 inches (20.3 x 27.9 cm)

Horn Island—created by forces of land and sea over thousands of years—was for artist Walter Inglis Anderson a pristine wilderness, an elemental place where he celebrated a "spiritual kinship with the universe."[1] Anderson called himself the "Islander," a term that embraced both his self-imposed isolation from society and his exuberant love for the Mississippi barrier islands. Agnes Grinstead Anderson described her husband's relationship to his most beloved island: "As long as he was on Horn Island he was in tune with the rhythms of the universe. He was part of the changing seasons. He was filled with the ecstasy of creation. He recorded it all, working endlessly. It became his world."[2]

During the last fifteen years of his life, Anderson visited Horn Island with increasing frequency, rowing there across open sea in a small wooden skiff, art supplies and food stowed in trashcans for protection from rain and surf. He would stay on the island for days or weeks, studying and detailing in drawings, paintings, and "log" entries the expanse of the island environment: here, radiant dunes and wind-formed pines framing a cerulean sea; or the communal energy of his favored bird, the pelican.

It was only after Anderson's death in 1965 that his family discovered in the crumbling Shearwater cottage—his studio and mainland refuge—the magnitude of the artist's ceaseless creative work.[3] In the midst of clutter and the brilliant murals he had painted on the walls of the "Little Room" lay thousands of small watercolors and drawings. In line and color, on sheets of ordinary typewriter paper, Walter Anderson preserved the rhythms and intricacies of life on Horn Island, his island sanctuary. ARK

Museum purchase made possible in part by the Museum Guild 80.39
Provenance: Walter I. Anderson Estate
Exhibited: *Celebration*

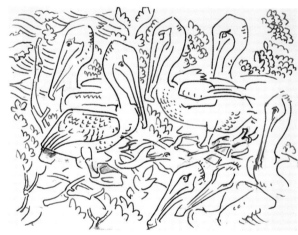

Fig. 91

Fig. 92

Fig. 91
George Cress
b. Anniston, Alabama 1921
Backyards (Athens, Georgia) 1949
Ink wash on wove paper
13¼ x 7¾ inches (33.7 x 45.1 cm)
Gift of George Cress in honor of
Barbara Golden Pound 98.58.1
Provenance: Artist
Exhibited: *Celebration*

Fig. 92
Walter Inglis Anderson
b. 1903 – d. 1965 New Orleans,
Louisiana
Pelicans ca. 1947–1955
Ink on wove typing paper
15 x 18 inches (38.1 x 45.7 cm)
Gift of the Museum Guild and
William E. Scheele 85.41.32
Provenance: Walter I. Anderson
Estate
Exhibited: *Celebration*

NOTES TO THIS SECTION

54.

George Overbury "Pop" Hart

1. Hart painted at least one other scene from this exact vantage point. See Gregory Gilbert, *George Overbury "Pop" Hart: His Life and Art, New Brunswick* (New Brunswick, N.J.: Rutgers University Press, 1986), illus.: 51. Gilbert also noted that this image served as a basis for Hart's 1925 print, *Bathing Beach, Coytesville on Hudson*. See Gilbert's essay in *The Spencer Collection of American Art* (New York: Spanierman Gallery, 1990): 22–23, cat. no. 10, illus.

2. Gilbert: 44.

55.

George Luks

1. Quoting the art critic James Huneker, *Bedouins* (New York: Charles Scribner's Sons, 1920): 108.

2. Stanley L. Cuba, "George Luks (1866–1933)," in *George Luks: An American Artist* (Wilkes-Barre, Pa.: Wilkes College, Sordoni Art Gallery, 1987): 39.

3. The tune of "Yes! We Have No Bananas" can be found at www.duchessathome.com/music/wehavenobananas.html and, in printed form, at sniff.numachi.com/~rickheit/dtrad/pages/tiNOBANANA;ttNOBANANA.html, and the complete lyrics at www.geocities.com/Cag03/NovYesBananas.html.

57.

James Daugherty

1. See Rebecca E. Lawton, *Heroic America: James Daugherty's Mural Drawings from the 1930's* (Poughkeepsie, N.Y.: Vassar College, 1998).

2. Telephone interview with daughter-in-law Lisa Daugherty, and author, March 31, 2005.

3. Norman Kent, *Drawings by American Artists* (New York: Watson-Guptill Publications, Inc., 1947), cat. no. 58.

58.

Thomas Hart Benton

1. Henry Adams, *Thomas Hart Benton: An American Original* (New York: Alfred A. Knopf, 1989): 183. Benton would also include Wilbur Leverett in his painting *Missouri Musicians* (1931, private collection), and would incorporate his sketch of the guitar-playing Homer Leverett into *Lord, Heal the Child* (1934, private collection); see Adams: 212–213. Benton's *Ballad of the Jealous Lover of Lone Green Valley*, which features a portrait of Benton's student, Jackson Pollock, playing the harmonica, is based on a Leverett Brothers recording of the tune of the same name.

59.

Peter Takal

1. Interview with artist's son Pierre Takal, November 24, 2003, New York City.

2. Peter Takal, "Between the Lines," 1958, as reprinted in *Peter Takal on Paper* (Little Rock: Arkansas Arts Center, 2000): 15. Also, Peter Takal, *About the Invisible in Art*

[reprinted from lecture at American Federation of Arts, New York] (Beloit, Wisc.: Theodore Lyman Wright Art Center, Beloit College, 1965).

60.

George Copeland Ault

1 Several photographs from 1917 by Charles Sheeler, one of the most celebrated Precisionists, center on a New England stove. Theodore E. Stebbins, Jr. and Norman Keyes, Jr., *Charles Sheeler: the Photographs* (Boston: Little, Brown and Museum of Fine Arts, Boston, 1987): plates 11, 12.

2. "Subject Matter in Art," George Ault Papers, Archives of American Art, Reel 247, Frame 254.

61.

John Steuart Curry

1. John Steuart Curry, "Speech before the Madison Art Association, January 19, 1937," typescript, microfilm roll 165, Curry Papers, Archives of American Art.

2. Curry was undoubtedly aware of widespread anti-lynching sentiment during the early 1930s sparked by the highly publicized Scottsboro affair of 1931 and other incidents. Members of Congress had proposed a new bill, the Costigan-Wagner Act, which called for federal trials for any law enforcement officers who failed to exercise their responsibilities during a lynching incident. The bill was not passed despite overwhelming public support.

3. M. Sue Kendall, *Rethinking Regionalism: John Steuart Curry and the Kansas Mural Controversy* (Washington, D.C.: Smithsonian Institution Press, 1986): 79–80. Curry had already produced images related to lynching by the time he was invited to participate in *An Art Commentary on Lynching*, a groundbreaking and highly controversial exhibition held at the Arthur U. Newton Galleries, New York, February 15 – March 2, 1935. The exhibition was sponsored by the NAACP and included artists such as Isamu Noguchi, Paul Cadmus, and Jose Orozco.

4. Although previously assumed to be from 1935, evidence supports 1933 as a more likely date for the Columbus Museum drawing. Documented versions of *The Fugitive* include an oil-and-tempera painting executed between 1933 and 1940, and a lithograph of 1933 (Kendall: 80). Furthermore, the verso of the Columbus Museum drawing contains a portion of a red chalk sketch that appears related to the artist's painting *The Manhunt* (1931) and its related studies. This would seem to offer additional support for the date of 1933 for the Columbus Museum drawing.

62.

Philip Evergood

1. Kendall Taylor, *Philip Evergood: Never Separate from the Heart* (London and Toronto: Associated University Presses and Bucknell University Press, 1987): 85. See footnote 28: 96.

2. Taylor: 72. See footnote 27: 78.

63.

Paul Cadmus

1. Cadmus only makes slight changes from the Columbus drawing to the egg tempera painting, most notably in the position of the foreground dog as well as the addition of a second dog, a large sun hat below the woman's feet and drinking glasses on a wicker cart.

2. Perry was Wimbledon champion 1934–1936, and won both the U.S. and French championships in 1935. He turned professional in 1936. In its date and subject, *Venus and Adonis* is closely related to Cadmus's suite of paintings entitled "Aspects of Suburban Life" (1935–1936), which presents unflattering views of the upper classes at leisure.

3. Henry McBride, *New York Sun* (November 14, 1936). Despite these liberties, Vinson (1907–1999), like Venus, was older than her mate (Perry lived from 1909 to 1995).

4. Guy Davenport, *The Drawings of Paul Cadmus* (New York: Rizzoli, 1989): 7. In a 1988 interview with Judd Tully, Cadmus credits the frescoes of Renaissance master Luca Signorelli (ca. 1450 – d. 1523) that he saw during a 1932 trip to Europe as inspiring him to begin using crosshatching to define shadows (March 22, 1988, Archives of American Art, Smithsonian Institution).

64.

Federico (Rico) Lebrun

1. Henry J. Seldis, *Beyond Virtuosity, Rico Lebrun (1900–1964): An Exhibition of Drawings and Paintings* (Los Angeles: Los Angeles County Museum of Art, 1967): 19.

2. Rico Lebrun as quoted by Seldis: 33.

3. Ibid: 27.

4. Edgar Allan Poe, *Hop-Frog, Prose by Edgar Allen Poe* – e Text at Literature Classics.com, p. 2 of 8

5. Donald Bear, as quoted by Seldis: 19-20

66.

Andrew Newell Wyeth

1. Thomas Hoving, *Two Worlds of Andrew Wyeth: A Conversation with Andrew Wyeth* (Boston: Houghton Mifflin, 1978): 33.

2. Wyeth was awarded his first one-man exhibition in 1937 at William Macbeth Gallery, New York, which earned him immediate critical praise and comparisons to Homer; his first one-man museum exhibition at the Currier Museum of Art in 1939; and election into the National Watercolor Society as its youngest member ever in 1940.

3. Museum files. This information was provided to the Museum on November 26, 1991 by Mary Landa, Curator of the Andrew Wyeth Collection. Wyeth and James were married in 1940, the same year he painted *North Sutton*.

67.

Yasuo Kuniyoshi

1. Kuniyoshi lived in Paris in 1925 and 1928. He owned

one of Toulouse Lautrec's posters of a nightclub scene, and regularly attended the artists' balls—in 1935 he was described at one: "Yasuo Kuniyoshi, one of the stars of the Downtown Galleries, was dressed as an Oriental version of a Swiss yodeler." *Telegram*, March 10, 1935, Kuniyoshi Papers, Archives of American Art, reel D176, frame 0067. He taught at the League until the end of his life in 1953.

2. Kuniyoshi, "Notes for an Autobiography," collection of Sara Mazo Kuniyoshi.

68.
Lilian Westcott Hale

1. Nancy Hale, *The Life in the Studio* (Boston: Little, Brown and Company, 1969): 14.

2. Hale: 39.

3. When identifying this drawing for the estate, Nancy Hale noted that Miss Waterman, who had been her Latin teacher, was a strong-willed New Englander very set in her ways. See curatorial correspondence, Columbus Museum.

69.
Reginald Marsh

1. Marilyn Cohen, *Reginald Marsh's New York: Paintings, Drawings, Prints and Photographs* (New York: Whitney Museum of American Art in association with Dover Publications, 1983): 27. In this regard, it might be instructive that, in 1930, Richard Rodgers and Lorenz Hart wrote a song for Florenz Ziegfield's musical, *Simple Simon*, titled "Ten Cents a Dance," whose lyrics read in part:

I work at the Palace ballroom, but gee that place is cheap
When I get back to my chilly hallroom, I'm much too tired to sleep
I'm one of those lady teachers, a beautiful hostess you know;
One that the palace features, at exactly a dime a throw.
Ten cents a dance, that's what they pay me
Gosh how they weigh me down.
Ten cents a dance, pansies and rough guys,
tough guys who tear my gown….
Sometimes I think, I've found my hero
But it's a queer romance;
All that you need is a ticket,
Come on big boy, ten cents a dance.

The much-acclaimed Broadway performance of this song eventually led to the banning of taxi-dance halls in many cities. The more recent 1966 musical, *Sweet Charity* (Neil Simon, book; Cy Coleman, music; Dorothy Fields, lyrics), also included an enormously popular song—"Hey, Big Spender"—that satirized taxi dancing.

70.
Walter Inglis Anderson

1. John Paul Driscoll, *Walter Anderson: Realizations of the Islander* (Ocean Springs, Miss.: Walter Anderson Estate, 1985): 7.

2. Agnes Grinstead Anderson, *Approaching the Magic Hour: Memories of Walter Anderson* (Jackson and London: University Press of Mississippi, 1989): 148.

3. In late August 2005 Hurricane Katrina came ashore along the Mississippi coast line in Ocean Springs and destroyed Shearwater Cottage. Most of Anderson's remaining ceramics and paper works were severely damaged or destroyed by the rising water and accompanying violent storm. At press time, the fate of much of these works in the family's possession is still unknown.

Joseph Hirsch

POSTWAR MODERNISM
AND A RESURGENCE IN REALISM

Fig. 93
Joseph Hirsch
b. Philadelphia 1910 – d. New York City 1981
Woman Listening 1977
Red conté crayon on blue-colored wove paper
21¼ x 15 inches (54 x 38.1 cm)
Signed lower left: *Joseph Hirsch*
Gift of Dr. and Mrs. Philip L. Brewer in honor of the
Museum's 50th Anniversary 2003.38.3
Provenance: Kennedy Galleries, New York; Dr. and Mrs.
Philip L. Brewer
Exhibited: *Joseph Hirsch: Recent Paintings and Drawings*,
Kennedy Galleries, New York, May 28 – June 13, 1980, cat.
no. 26, illus.; *The Spontaneous Eye: American Drawings of
the Twentieth Century*, Kennedy Galleries, New York,
September 10 – October 5, 1985, cat. no. 40, illus.; *Intimate
Expressions*, cat. no. 41, illus.: cover; *Celebration*

71.
Burgoyne Diller
b. 1906 – d. 1965, New York City
Study for Wall Construction 1950
Graphite and crayon on tissue paper
16 x 7½ inches (40.6 x 19.1 cm)

Burgoyne Diller was part of the generation of American modernists that came to maturity in the early 1930s. His sophistication and thorough knowledge of current art trends in Europe was so well respected that a friend suggested to Juliana Force, director of the Whitney Museum of American Art, that "a meeting with Diller might illuminate (her) understanding of abstract art."[1] In 1937, Diller became head of the mural division of the Works Project Association/Federal Arts Project for New York City and though most of the murals created during his tenure were representational, he was indispensable in the promotion of abstract art in the United States at a time when many saw it as suspect.

Diller first completed several wall reliefs in 1934, which reveal his understanding of Constructivism and De Stijl abstraction. During the Great Depression, his art reflected a search for structure and rationality in a world that seemed to have collapsed into uncertainty. The measured spatial clarity and the vitality of his primary colors were a conscientious rejection of the sentimentalism and pretense that he thought no longer represented the world. Raised by engineers in industrial towns like Battle Creek and Buffalo, Diller regarded "rationality and modernization as central components of the American landscape."[2]

This preparatory drawing for the wall construction in the Columbus Museum's permanent collection is representative of the simplified vertical compositions that he made at the very end of his most productive decade, the 1940s. Diller had turned to drawing more frequently because it allowed greater spontaneity and experimentation in the articulation of his ideas.[3] In this drawing Diller's

desire to make his art an irrefutable expression of intellectualized absolutes seems also to have been inspired by the Catholicism of his youth. The aesthetic spirituality inherent in this work is expressed through the simplest of compositions, the symbolic cruciform. Diller's cross suggests both contemplative serenity through his choice of luminescent gray and human vitality in the bold black lines and the glow of the small rectangle of radiant yellow. ML

Marked lower right: *(illegible) 50*
Gift of Michael Rosenfeld and halley k harrisburg 98.8
Provenance: Estate of the Artist; Michael Rosenfeld and halley k harrisburg
Exhibited: *Burgoyne Diller: The Third Dimension, Sculpture and Drawings,* Michael Rosenfeld Gallery, New York, November 13, 1997 – January 17, 1998, no. 17, color illus.; *Towards a New Century: Contemporary Art from the Permanent Collection,* Columbus Museum, October 31, 1999 – January 23, 2000; *Celebration*

Fig. 94

Fig. 96

Fig. 95

Fig. 94
Burgoyne Diller
b. 1906 – d. 1965, New York City
Untitled ca. 1950
Tempera, pencil, and ink on wove
paper
8¾ x 8¾ inches (22.2 x 22.2 cm)
Stamped with estate stamp lower
right and inscribed verso: *G–3–1197,
Kp87–178/Archive 565*
Promised Gift, Dr. and Mrs. Philip
L. Brewer Collection
Provenance: Estate of the Artist;
Michael Rosenfeld Gallery, New
York; Dr. and Mrs. Philip L. Brewer
Exhibited: *Intimate Expressions*, cat.
no. 24, illus. 75, pl. 16; *Celebration*

Fig. 95
Charles Burchfield
b. Ashtabula, Ohio 1893 – d. Buffalo,
New York 1967
The Tree that Reached the Sky ca.
1950–1960
Charcoal on assembled cream-
colored wove paper
22 x 13 inches (55.9 x 33 cm)
Estate stamp lower left: *CE
Burchfield Foundation–8*
Promised Gift, Dr. and Mrs. Philip
L. Brewer Collection
Provenance: Estate of the Artist;
Frank Rehn Galleries, New York;
Chapellier Galleries, New York; Sid
Deutsch Gallery, New York; Dr. and
Mrs. Philip L. Brewer Collection
Exhibited: *Collectors Choice*,
Mississippi Museum of Art,

Jackson, Mississippi, November 27,
1979 – January 6, 1980; *Intimate
Expressions*, cat. no. 3a, illus.: 5;
Celebration
Literature: *American Art Selections*
(New York: Chapellier Galleries,
Vol. IX, 1979), cat. no. 42, illus.
John H. Baur, *The Inlander: The Life
and Work of Charles Burchfield,
1893–1967* (Newark, Del. and New
York: University of Delaware Press
and Associated University Presses
Incorporated, 1982), fig. 208, illus.:
253

Fig. 96
William Kienbusch
b. 1914 – d. 1980 New York City
Tidal Basin 1952
Casein on wove paper
21½ x 26½ inches (54.6 x 67.3 cm)
Signed lower right: *Kienbusch 52*
Gift of Mrs. Peggy Brooks 2002.15.1
Provenance: Peggy Brooks, New
York
Exhibited: *Celebration*

Fig. 97

Fig. 97
Howard Thomas
b. Mt. Pleasant, Ohio 1889 –
d. Chapel Hill, North Carolina 1971
Triad 1950 (reworked 1961)
Gouache on wove paper
26½ x 32 inches (67.3 x 81.3 cm)
Signed lower left: Howard Thomas
Gift of the Artist 61.42
Provenance: Acquired directly
from the Artist
Exhibited: *Annual Art Auction*,
University of Georgia, 1961; *Old
Friends, Howard Thomas and Lamar
Dodd*, Columbus Museum, July 2 –
September 24, 2000; *Celebration*

Fig. 98

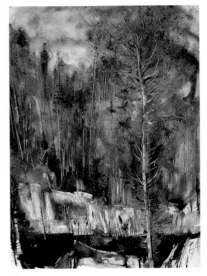

Fig. 99

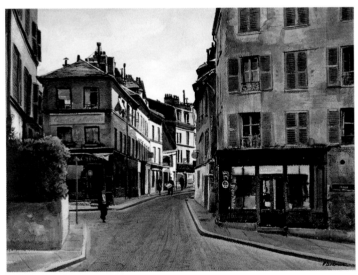

Fig. 100

Fig. 98
A. Henry Nordhausen
b. Hoboken, New Jersey 1901 –
d. Columbus, Georgia 1993
Rome, Italy 1953
Ink on wove paper
12¾ x 16⅝ inches (32.4 x 42.2 cm)
Signed and dated lower left:
Nordhausen '53
Gift of the Artist 2003.11
Provenance: Artist
Exhibited: *Celebration*

Fig. 99
Ben Edgar Shute
b. Altoona, Wisconsin 1905 –
d. Atlanta, Georgia 1986
Edge of the Forest ca. 1963
Watercolor on wove paper
39 x 34 inches (99.1 x 86.4 cm)
Gift of Philip H. Giddens 65.330
Provenance: Artist; Philip H.
Giddens
Exhibited: *Celebration*

Fig. 100
Ogden M. Pleissner
b. Brooklyn, New York 1905 –
d. London, England 1983
Montmartre ca. 1960
Watercolor on wove paper
18½ x 24 inches (47 x 61 cm)
Signed lower right: *Pleissner*
Gift of the Artist 69.62
Provenance: Ogden Pleissner
Exhibited: *Celebration*

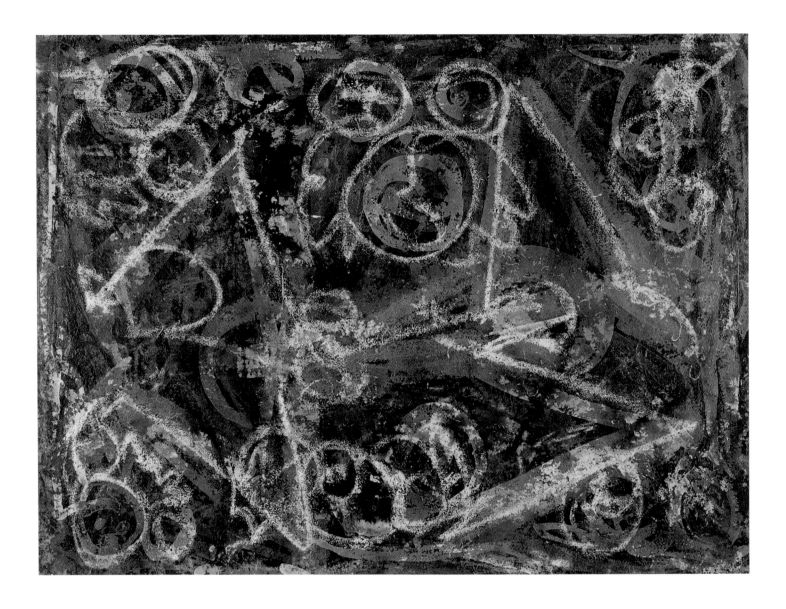

72.

Alfonso Ossorio

b. Luzon, Philippines 1916 – d. New York City 1990
Untitled 1951
Ink, watercolor and wax on handmade paper
19⅝ x 25½ inches (49.8 x 64.8 cm)

The turbulent works of Alfonso Ossorio were fueled by emotions and convictions that ran deep. As a surgical illustrator during World War II, he witnessed catastrophic human suffering. Although a fixture in New York's avant-garde art circles by the 1940s, he was estranged from his family and wrestled with feelings of isolation as a bisexual immigrant of Eurasian descent.[1] A devout Catholic, he studied Christian iconography at Harvard and later struggled to infuse his tightly controlled surrealism with spiritual significance and expressive force. Like Jackson Pollock and Jean Dubuffet, who both befriended and influenced him, Ossorio shunned conventional art and found greater meaning in that produced through revelation, ritual, irrational thought, and emotional impulse.[2]

In 1950, Ossorio was commissioned to paint a mural depicting the Last Judgment for the Chapel of St. Joseph the Worker, Victorias, Philippines. His first return to the Philippines since childhood, the visit sparked a period of introspection and triggered a series of experimental wax-resist drawings marked by a new urgency and immediacy.[3] An example of the artist's so-called "Victorias" drawings, *Untitled* indicates his internalization of Dubuffet's advice that, in order to achieve maximum expressive power, an artist must distill a composition to its most primitive state and present it through an unhindered application of materials.[4] *Untitled* presents a cryptic, visceral composition devoid of any apparent references to the external world. At the center of a swirling atmosphere of embryonic imagery is an archetypal figure, reduced to a network of glyph-like scrawls.[5] Produced on heavy, textured paper through multiple applications of wax, watercolor, and ink, the drawing possesses an archaic character and a pronounced physicality largely absent from his earlier works.[6] Exemplified by *Untitled*, the Victorias drawings thus represent for Ossorio an unprecedented expressive freedom and intensity, and anticipate the artist's growing interest in sculptural surfaces that would eventually culminate in his extensive *Congregations* series. SCW

Signed and dated verso: *AO* '51
Museum purchase made possible by the Art Acquisition and Restoration Fund 2004.3
Provenance: Estate of the Artist; Collection of Mike Solomon, Easthampton, New York; Michael Rosenfeld Gallery, New York
Exhibited: *Building on Strength*

73.

Morris Coles Graves
b. Fox Valley, Oregon 1910 – d. Loleta, California 2001
Standing Crow 1956
Sumi ink on rice paper
13¼ x 18 inches (33.7 x 45.7 cm)

Mark Tobey was Morris Graves's teacher and friend. They were both influenced greatly by Far Eastern spirituality and calligraphy, but they used the calligraphic line in very different ways. Tobey abandoned his portrait work, using calligraphy to create his own personal abstract visual language. Graves, on the other hand, has used the calligraphic line to express the representational visual poetry of nature. Often, his subject matter involves the plant and animal kingdom—fishes, insects, and creatures great and small.

 Standing Crow is a consummate example of this. His expressive use of the calligraphic line, using sumi ink on rice paper, is absolutely masterful. The dramatic stance of the crow is created by the sureness of Morris's brush—indeed the crow occupies the space with such determination that he, alone, controls the composition.

The black, powerful head with set and curved beak is a wonderful contrast to his sleek, graceful arching back. Noteworthy too is the angle of the wing, coupled with the textured pattern under the wing. Together these elements create the crow's god-like presence. The artist has rendered this crow utterly still, at rest, and yet waiting patiently for his next prey! Once again, Graves has released the spirit and soul of nature with immense power and lyrical expression. TWolfe

Signed and dated lower right: *Graves 56*
Museum purchase made possible by the Art Acquisition and Restoration Fund, the Edward Swift Shorter Bequest Fund, and the Museum's general acquisition fund 99.9
Provenance: Jack Lawrence, Connecticut; Private Collection, New York; Schmidt-Bingham Gallery, New York
Exhibited: *New Drawings*; *Towards a New Century: Contemporary Art from the Permanent Collection*, Columbus Museum, October 31, 1999 – January 23, 2000; *Celebration*

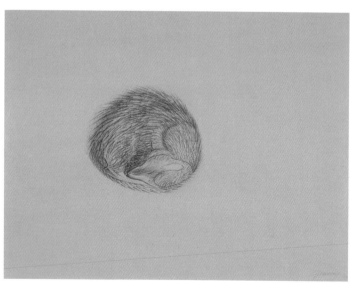

Fig. 101

Fig. 101
Morris Coles Graves
b. Fox Valley, Oregon 1910 –
d. Loleta, California 2001
Sleeping Animal 1954
Pencil on Kraft paper
15½ x 20 inches (39.4 x 50.8 cm)
Signed lower right: *Graves '54*
Dr. and Mrs. Philip L. Brewer
Collection, Museum purchase
made possible by the Ella E. Kirven
Charitable Lead Trust for
Acquisitions 2003.1.26
Provenance: Kennedy Galleries,
New York; Dr. and Mrs. Philip L.
Brewer
Exhibited: *Summits III, American
Master Paintings, Watercolors,
Drawings and Prints*, Kennedy Galleries, New York, October 21 –
November 28, 1987, cat. no. 24, illus;
Intimate Expressions, cat. no. 32,
illus.: 2; *Celebration*

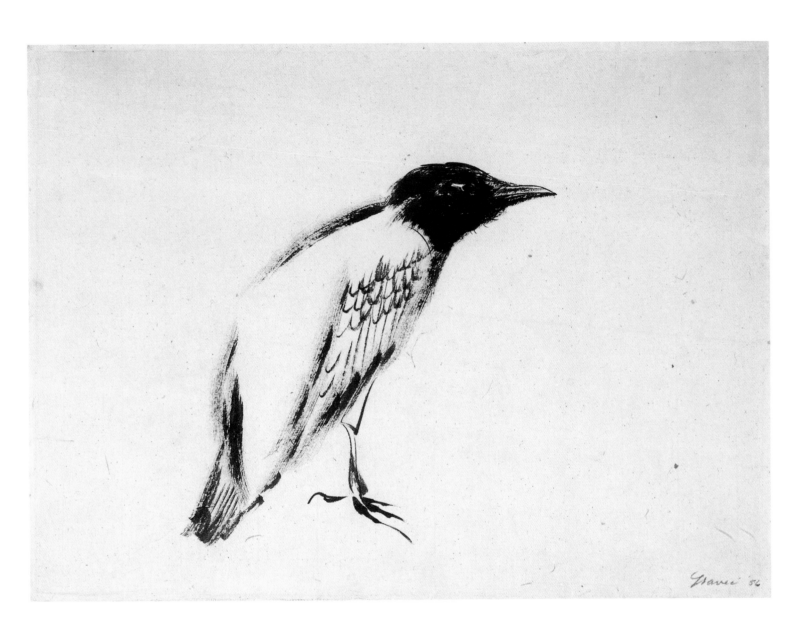

74.

Theodore Roszak

b. Poznań, Poland 1907 – d. New York City 1981

Untitled *(Winter Sun)* ca. 1954

Pen and ink on wove paper

40¾ x 36½ inches (103.5 x 92.7 cm)

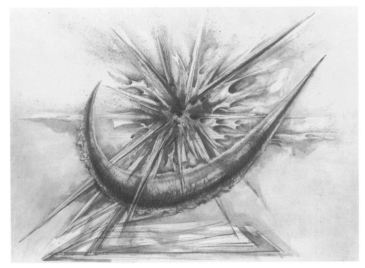

Fig. 102

World War II completely altered Theodore Roszak's world-view and the direction of his art. Death, destruction, and the devastation of two Japanese cities revealed the darker side of technological progress. What had previously been a positivistic embrace of utopian systems was seriously in question by the war's end. Roszak's shattered faith in science and technology was replaced by a renewed faith in nature, in change and transformation, and in atavistic motifs that reaffirmed basic values. In his rejection of Constructivism and conversion to Expressionism, drawing played a catalytic role.

Drawing was the backbone of Roszak's sculptural sensibility. A facile draftsman who preferred inks and washes in tandem with various pens and nibs, he drew prolifically on all scales from modest notebook sketches to monumental sheets extending more than six feet across. The character of any given drawing depends on its formal constitution. Some, like *Cosmic-Scape* (see Fig. 102), focus on clearly delineated configurations: a starburst nova and crescent-shaped form; others, like *Untitled*, record the spontaneous creation of a primordial landscape.

Untitled epitomizes Roszak's postwar ethos with the inclusion of a simple crescent-shaped motif, a ubiquitous form that reappears repeatedly in his sculptures, drawings, and prints from 1932 onward. During the thirties, the half-moon, c-shaped configuration was quintessentially Constructivist, technological, and geometric. After 1945 the same motif is rendered as an anthropomorphic entity, a female principle, a concave pocket, a passive receptor that absorbs rather than deflects.

Whenever time permitted, Roszak and his family traveled outside New York City to the quiet town of Pigeon Cove on the North Shore of Massachusetts. From the serene environs of this costal retreat he dreamed an apocalyptic image of unsettling magnitude. DD

Signed lower right: *Theodore Roszak, Pigeon Cove MA;* inscribed middle left: *WM;* marked: *Winter Sun*

Museum purchase made possible by the Art Acquisition and Restoration Fund 99.1

Provenance: Fair Weather Hardin Gallery, Chicago, Illinois; Private Collection; Hirschl & Adler Galleries, New York

Exhibited: *Theodore Roszak: Sculpture and Drawings, 1942–1963*, Hirschl & Adler Galleries, New York, September 24 – October 26, 1994, cat. no. 28, illus.: 20; *New Drawings; Towards a New Century: Contemporary Art from the Permanent Collection*, Columbus Museum, October 31, 1999 – January 23, 2000; *Celebration*

Fig. 102

Theodore Roszak

b. Poznań, Poland 1907 – d. New York City 1981

Cosmic-Scape ca. 1954

Brown ink and wash on wove paper

22¼ x 29⅞ inches (56.5 x 75.9 cm)

Signed lower right: *Theodore Roszak*

Dr. and Mrs. Philip L. Brewer Collection, Museum purchase made possible by the Ella E. Kirven Charitable Lead Trust for Acquisitions 2003.1.41

Provenance: Estate of the Artist; Hirschl & Adler Galleries, New York; Dr. and Mrs. Philip L. Brewer

Exhibited: *Theodore Roszak: The Drawings*, organized by the Drawing Society, August 28, 1992 – November 9, 1993, illus. (Elvehjem Museum of Art, Madison, Wisconsin; Arkansas Art Center, Little Rock, Arkansas; Butler Institute of American Art, Youngstown, Ohio; Colby College Museum of Art, Waterville, Maine); *Theodore Roszak: Sculpture and Drawings, 1942–1963*, Hirschl & Adler Galleries, New York, September 24 – October 26, 1994; cat. no. 29, illus.: 14; *Intimate Expressions*, cat. no. 61, illus.: 31

Literature: Joan M. Marter, *Theodore Roszak: The Drawings* (New York and Seattle: Drawing Society and University of Washington Press, 1992), cat. no. 29, illus.: 14

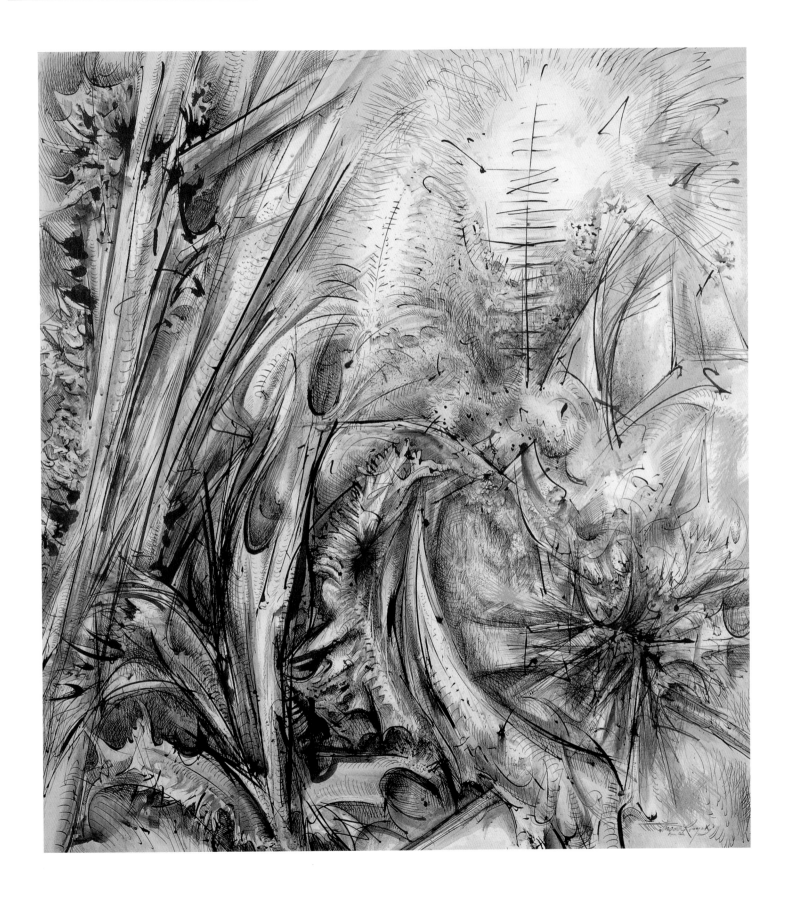

75.
David Smith
b. Decatur, Illinois 1906 – d. Bennington, Vermont 1965
Study for Tanktotems 1954
Purple-black egg ink on wove paper
22½ x 18 inches (57.2 x 45.7 cm)

David Smith, preeminent American sculptor of the twentieth century, drew the way most people speak. It came to him as naturally as breathing, and he did it incessantly. He used drawing as an empirical means of tapping the subconscious—a way of bypassing conscious constraints that might otherwise deflect the graphic representation of a flash intuition. Drawing enabled him to dream a steady stream of ideas without having to worry about their actual construction. Drawing was usually an evening reprieve from the blazing oxyacetylene torch with its spray of dangerous sparks, the promethean struggle with heavy metals that took place during daylight hours in the Terminal Iron Works, the cinder-block edifice that was his primary studio.

Rarely an end to sculpture, drawing functioned as a vehicle for the exploration of form. Smith drew on all scales, from pocket-sized notepads and 14-by-10-inch coil-ring notebooks to more expansive sheets of the finest fabrico paper. He came to prefer brushes—soft sable or stiffer pig-bristle—to pens, and his experimentation with black Chinese ink and egg tempera during the

early fifties, as seen in *Study for Tanktotems,* was a natural outgrowth of his search for a medium responsive to the nuances of a spontaneously executed line.

Study for Tanktotems is one of an extended series of brush drawings begun in the early fifties in which Smith explored an abstracted figuration. In many of his drawings, representation morphs into abstraction. Between three and nine totemic-like personages appear on any given sheet. The sheer proliferation of configurations per sheet is a testament to his protean imagination. No two figures are alike; each embodies a distinct geometric, calligraphic, or gestural demeanor signifying the limitless permutations of the human form. DD

Signed and dated lower right: *David Smith 6–1954*
Dr. and Mrs. Philip L. Brewer Collection, Museum purchase made possible by the Ella E. Kirven Charitable Lead Trust for Acquisitions 2003.1.49
Provenance: Estate of the Artist; M. Knoedler and Co., New York; Spanierman Gallery, New York; Dr. and Mrs. Philip L. Brewer
Exhibited: *David Smith: The Drawings*, Whitney Museum of American Art, New York, December 5, 1979 –February 10, 1980, fig. 75, illus.: 86; traveled to Serpentine Gallery, London, England, May 3 – June 8, 1980; Detroit Institute of Art, Michigan, February 1 – April 12, 1981; *Intimate Expressions*, cat. no. 68, illus.: 31; *A Collector's Pursuit of Drawing; Celebration*
Literature: Paul Cummings, *David Smith: The Drawings* (New York: Whitney Museum of American Art, 1979), cat. no. 75: 86

Fig. 103
Seymour Lipton
b. New York City, 1903 – d. Locust Valley, New York 1986
Untitled – Sketch for a Sculpture 1955
Oil crayon on wove paper
11 x 8½ inches (27.9 x 21.6 cm)
Signed: *Lipton 55*
Gift of Alan and Michael Lipton
91.12.1
Provenance: Estate of the Artist; Babcock Galleries, New York; Alan and Michael Lipton
Exhibited: *Making a Mark*

Fig. 103

76.
Milton Avery
b. Altmar, New York 1893 – d. New York City 1965
Trees of Summer 1956
Monotype on Japan paper
18 x 23⅜ inches (45.7 x 59.4 cm)

In Milton Avery's monotype *Trees of Summer* his imagery remains firmly rooted in nature despite a high level of abstraction. The horizontal format with distinct ground, sky, and trees recalls more traditional landscape depictions, even though his arbitrary choice of colors and patterned textures relate only loosely to actual forms in nature. Relying on the primary colors of red, blue, and yellow against a gray sky area, Avery confounds our normal expectations of a blue sky, green leaves on trees, and brown or green land. He has said, "I try to construct a picture in which shapes, spaces, colors form a set of unique relationships, independent of any subject matter. At the same time I try to capture and translate the excitement and emotion aroused in me by the impact with the original idea."[1]

Unable to endure the physical exertion of painting after suffering a serious heart attack in 1949, Avery began to make monotypes in the early 1950s. He painted images on glass plates and printed them by hand. The spontaneity of the monotype process gave free rein to his imagination, and the whimsical nature of much of his imagery reveals the delight he took in the medium. He used a wide variety of techniques to create his compositions: painting, wiping, scratching, saturation with turpentine or oil, stick and brush work, overpainting, stencils, and numerous combinations of each. He relished the element of chance introduced by the transfer process, as well as the varieties of texture that resulted from pulling the printed impressions off the still-wet plate. Moreover, the monotype process encouraged the reductive expression and flattening of form evident in *Trees of Summer*, which mirrored the direction his paintings took in his later years. JM

Signed and dated lower left: *Milton Avery 56*
Gift of Dr. and Mrs. Philip L. Brewer 2001.16.2
Provenance: Dr. and Mrs. Philip L. Brewer
Exhibited: *Intimate Expressions*, cat. no. 3, illus.: 74, pl. 15; *A Collector's Pursuit of Drawing; Celebration*

Fig. 104

Fig. 104
Byron Browne
b. Yonkers, New York 1907 –
d. New York City 1961
Abstract 1956
Pen and ink and gouache on wove paper
25¼ x 19½ inches (64.1 x 49.5 cm)
Signed and dated lower right: *Byron Browne April 25, 1956*
Dr. and Mrs. Philip L. Brewer Collection, Museum purchase made possible by the Ella E. Kirven Charitable Lead Trust for Acquisitions 2003.1.5
Provenance: Dr. and Mrs. Philip L. Brewer
Exhibited: *A Collector's Pursuit of Drawing; Celebration*

77.
Gray Foy
b. Dallas, Texas 1922
Thicket 1958
Pencil on buff-colored wove paper
16 x 14¼ inches (40.6 x 36.2 cm)

A consummate draftsman, Gray Foy produced a small, but exceptional body of Surrealist drawings during his active artistic career. After finishing his art studies at Columbia University in 1947, he was soon mingling with prominent New York-based Surrealists such as Max Ernst, Salvador Dali, and close friend Pavel Tchelitchew. However, Foy preferred to work in relative isolation and remained independent of organized art circles.[1] During the 1950s and 1960s, Foy's pencil drawings were regularly included in exhibitions at the Whitney Museum of American Art and at Durlacher Gallery, which represented his work. During the period in which he was actively producing drawings, which spanned the early 1940s until 1975, Foy created fewer than fifty works.[2]

Although in the early 1940s Foy specialized in delicate floral images rendered from nature, he soon abandoned direct observation when he began to concentrate on drawing meticulous Surrealist compositions. A bold example of his mature style, *Thicket* depicts a dense tangle of bizarre plant forms set against a blank background. Using the compositional method that he favored, the drawing developed from a single point outward with no preconceived plan or erasures. By incorporating a complex network of imperceptibly tiny dots and squiggles, Foy gave form to the exquisite, velvety surfaces of his hallucinatory landscape imagery over a period of several months.[3] He drew from his extensive botanical knowledge, fertile imagination, and technical skill to produce with convincing naturalism elements resembling lichen, soil, moss, and bark. This rich array of textures serves as a seductive skin beneath which the artist's plant forms appear to germinate, writhe and wither in an unnatural cycle of growth and decay. In following the tendencies of his fellow Surrealists, Foy at times reveals hints of human anatomy, but never actually allows overt elements to appear. The resulting effect underscores Foy's ability to create surrealist compositions of uncommon craftsmanship and visionary force. SCW

Signed and dated lower right: *Gray Foy 1958*
Dr. and Mrs. Philip L. Brewer Collection, Museum purchase made possible by the Ella E. Kirven Charitable Lead Trust for Acquisitions 2003.1.13
Provenance: Lloyd Goodrich, New York; Spanierman Gallery, New York; Ann Adler Rogin, New York; Dr. and Mrs. Philip L. Brewer
Exhibited: *Intimate Expressions*, cat. no. 29, illus.: 49; *A Collector's Pursuit of Drawing*; *Celebration*

78.
Jared French
b. Ossining, New York 1905 – d. Rome, Italy 1988
Syzygy 1965
Pencil, ink, and crayon on wove paper
26 x 39½ inches (66 x 100.3 cm)

Shunning the latest non-objective painting trends of his day, Jared French produced taut figurative compositions inspired by classical and Italian Renaissance art. Along with close friends and fellow artists Paul Cadmus and George Tooker, he celebrated the external reality of the human body and frequently portrayed people at work or leisure during the 1930s. After discovering the theories of Jung in 1939, French rendered figures in the same controlled style but began transforming them into archetypal symbols of the subconscious mind. He developed an ambitious series during the 1940s and 1950s entitled "Aspects of Man," in which he explored individual voluntary and involuntary behaviors through sexually charged allegory. Figures appear as statuesque nudes standing or wandering about immaculate, well-ordered spaces as if in a trance, their symmetrical features and graceful bodily proportions derived from Etruscan and archaic Greek sculpture.

In 1964, shortly after settling in Rome, French embarked on a series of large surrealist drawings of fragmented anthropomorphic imagery.[1] *Syzygy* consists of a pale, floating mass that has mutated into a series of undulating organic forms punctuated by gaping orifices and sockets.[2] The drawing is the basis for a tempera painting of similar size, *Nest* (1968–1969, private collection), which differs primarily in the addition of pronounced color and a definite landscape context.[3] Each passage is vividly described in French's masterful crosshatching applied with pencil and successive applications of gray, dark brown, and yellow ochre inks. Suggesting natural cycles of death and rebirth, a fractured ovoid shape swells promisingly while a human torso is devoured by a shriveled head in a manner reminiscent of Goya's *Saturn*.[4] Although interpreted by some as a sudden shift in direction, French regarded *Syzygy* and other late works as a natural progression in his continuing efforts to express the internal landscape of the human subconscious in the most potent visual terms.[5] SCW

Signed lower right: *Jared French*
Museum purchase made possible by the Edward Swift Shorter Bequest Fund
2004.4
Provenance: Midtown Payson Galleries, New York; Sotheby's Auction House, New York, Sale 1734, lot 1044, December 19, 2003
Exhibited: *20 New Works* (listed in the program as *Twenty Drawings by Jared French*), Banfer Gallery, New York, November 15 – December 2, 1967; *Jared French: 25 Years of Paintings and Drawings from 1944 to 1969*, Banfer Gallery, New York, February 19 – March 8, 1969; *Jared French: Drawings from the 1960s*, Midtown Payson Galleries, October 13 – November 13, 1993, New York; *Building on Strength*
Literature: "Artists on their Art: Jared French," *Art International* 12 (April 20, 1968): 54; Midtown Payson Galleries invitation cover, 1993

Fig. 105
Hyman Bloom
b. Brinoviski, Latvia 1913
Abattoir III 1955
Red crayon on wove paper
10¼ x 8 inches (26 x 20 cm)
Signed with monogram lower left:
HB
Promised Gift, Dr. and Mrs. Philip L. Brewer Collection
Provenance: Kennedy Galleries, New York; Dr. and Mrs. Philip L. Brewer
Exhibited: *Celebration*

Fig. 105

79.
Norman Bluhm
b. Chicago 1921 – d. East Wallingford, Vermont 1999
Untitled 1961
Ink on wove paper
24 x 18 inches (61 x 45.7 cm)

In an essay written about Norman Bluhm in 1998, curator James Harithas noted that looking at the work from the 1960s, "the effect is of tremendous immediacy and power. I am reminded of Jiddu Krishnamurti's statement that 'beauty is fury.'"[1] In this drawing inscribed to the sculptor David Slivka, Bluhm revealed through gesture, drips, surface, and structure an architectonic monumentality that may recall his beginnings as Mies van der Rohe's youngest student.[2] There is also an unmistakable immediacy, risk-taking, and rapid-fire intensity to the work. It speaks not only to his artistic self-assuredness but also to his personal experience as a World War II bomber pilot—and the ensuing events that directed and motivated his fifty-year career, which has been characterized as both "methodical and mystical."[3] Norman Bluhm as a second-generation Abstract Expressionist was heir to the heroic lyrical gestures developed by Jackson Pollock, Willem de Kooning, and Franz Kline, but he was not content to limit himself to repeating their assessments.

Scale, color, and openness to accident are important aspects of Bluhm's paintings, but all of this also originates within the smaller drawings. As James Harithas noted, "he draws and makes studies continuously until the moment he is inspired to paint on a monumental scale."[4] In this drawing Bluhm defined beams or girders that lean into one another as if shoring up the edge of the drawing in order to secure the open central space which is spanned by a sweeping archway at the center bottom. The tumultuous movement of ink across paper is far from calligraphic. Instead, it suggests massive formations on what appears to be a much larger scale than the actual intimacy of this drawing. Bluhm is not only able to evoke power from his explosive brushstrokes that shatter across the surface but he is also able to entice us with a depiction of space that is both unyielding and momentary. ML

Signed and dated lower right: *Bluhm '61* and inscribed lower right: *to David*
Purchase made possible by the Edward Swift Shorter Bequest for Acquisitions 2004.2
Provenance: David Slivka (by trade with artist); Rose Slivka; Joan Washburn Gallery, New York
Exhibited: *Building on Strength*

Fig. 106
Ary Stillman
b. Slutzk, Russia 1891 – d. Houston, Texas 1967
From the Temple of the Young Prince 1961
Gouache and watercolor on wove paper
17½ x 13¾ inches (44.5 x 34.9 cm)
Signed lower left: *Ary Stillman* and *Ary*; inscribed lower right: *#58*
Gift of the Stillman-Lack Foundation 2003.3
Provenance: Estate of the Artist; Stillman-Lack Foundation
Exhibited: *Celebration*

Fig. 106

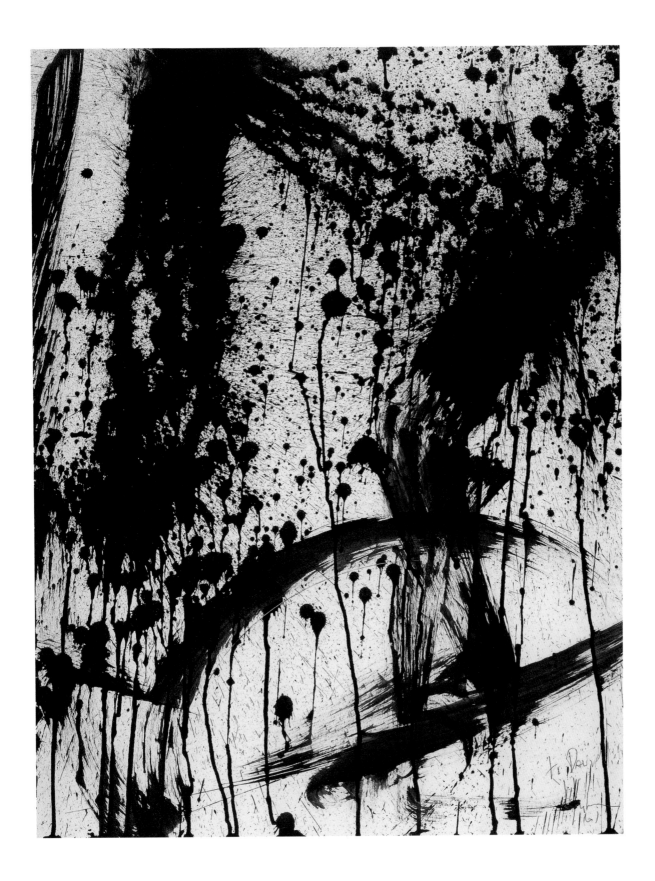

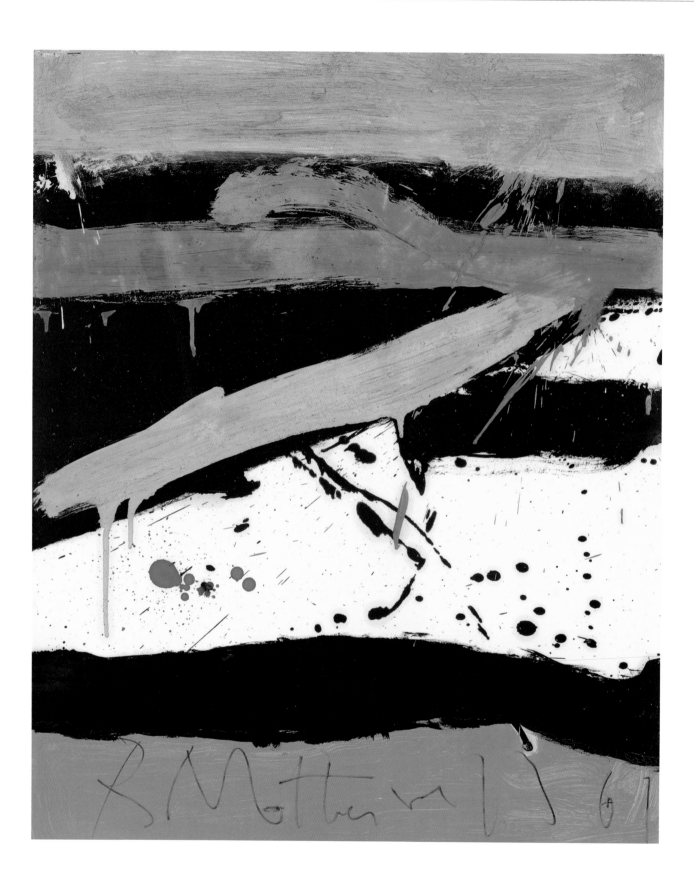

80.

Robert Motherwell

b. Aberdeen, Washington 1915 – d. Provincetown, Massachusetts
1991
Untitled 1961
Oil on wove paper
29 x 23 inches (73.7 x 58.4 cm)

Paintings on paper are essential to Robert Motherwell's oeuvre, and this *Untitled* sheet is a splendid example. Without the heroic requirements often attached to large canvases, Motherwell swiftly set down the elegant painterly surfaces for which he is well known. Immediacy and freshness mark the sheet, with Motherwell's elegant gestures juxtaposed with the by-product of their making: the spatters and drips; the distinctive brush marks that are often more visible on paper than canvas due to variations in the manner in which these substrates absorb paint; and areas where paint appears to have been blotted. *Untitled* is composed of several strong horizontal bands countered by one equally strong diagonal, both contrasted with the curved gesture at top center. Motherwell's signature color world is here as well: what might be called "Motherwell Blue" with the yellow ochre, white, and black that reappear in his work over the decades.

Now more than forty years old, *Untitled* has altered considerably from the time it was created, and the history it carries with it adds to its visual interest. Surface cracks in the lower black band reveal the blue paint over which black was layered; and halo-like forms created by oil seepage contribute to the composition with which today's viewer is confronted. As a work whose meaning is intertwined with its making *Untitled* is also about its aging, offering an opportunity to consider the element of time as manifested by Motherwell in the process of creation and as it contributes to the painting's evolving appearance after leaving the artist's studio. This concern about how a work was made and has changed is essential to any consideration of Motherwell's Abstract Expressionist aesthetic. Indeed, awareness of materials and process is a central component of twentieth-century and contemporary aesthetic concerns. RF

Signed and dated across image bottom: *Motherwell 61*
Museum purchase made possible by Etta Dykes Blackmon, in memory of Natilu McKenney Dykes; Annie Ruth Baker Davis; Gail B. Greenblatt; Rebecca H. King; Edith Landrum; Marjorie Newman; Laura P. Porter, in memory of Mary F. Passailaigue; Thelma M. Robinson; Miriam Tidwell; special assistance from the Ella E. Kirven Charitable Lead Trust for Acquisitions; and a gift of the Dedalus Foundation 2000.13.1
Provenance: Collection of the Artist; Estate of the Artist; Dedalus Foundation, New York
Exhibited: *Robert Motherwell: Works on Paper*, Museum of Modern Art, New York, 1965; *Robert Motherwell at the Columbus Museum*, Columbus Museum, March 15 – June 11, 2000, gallery brochure, illus., unpaginated; *Celebration*

Fig. 107a

Fig. 107b

Fig. 107c

Fig. 107d

Fig. 107e

Fig. 107f

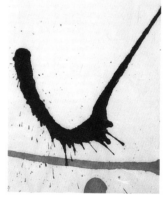

Fig. 107g

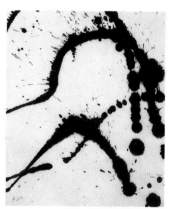

Fig. 107h

Fig. 107a. – Fig. 107h.
Robert Motherwell
b. Aberdeen, Washington 1915 – d.
Provincetown, Massachusetts 1991
Lyric Suite 1965
Ink on rice paper
8 sheets, approximately 9 x 11 inches
(22.9 x 27.9 cm) or 11 x 9 inches
(27.9 x 22.9 cm) each
Signed in various locations: *RM*
Gift of the Dedalus Foundation in
honor of Tom Butler 2000.13.6–13
Provenance: Collection of the
Artist; Estate of the Artist; Dedalus
Foundation, New York
Exhibited: *Robert Motherwell at the
Columbus Museum*, Columbus
Museum, March 15 – June 11, 2000,
gallery brochure, illus., unpaginat-
ed; *Celebration*

Lyric Suite 1965
Initialed upper right: *RM*; marked
verso: *D65–143 A1*
2000.13.6

Lyric Suite 1965
Initialed lower right: *RM*; marked
verso: *D65–165 A1*
2000.13.7

Lyric Suite 1965
Initialed and dated upper right: *RM
65*; marked verso: *D65–1662*
2000.13.8

Lyric Suite: Bleeding Black #8
1965
Initialed and dated lower left: *RM
65*; marked verso: *D65–947*
2000.13.9

Lyric Suite 1965
Initialed lower right: *RM*; marked
verso: *D65–1829*
2000.13.10

Lyric Suite 1965
Initialed lower right: *RM*; marked
verso: *D65–189 A1*
2000.13.11

Lyric Suite 1965
Marked verso: *D65–2565*
2000.13.12

Lyric Suite 1965
Initialed lower left: *RM*; marked
verso: *D65–87*
2000.13.13

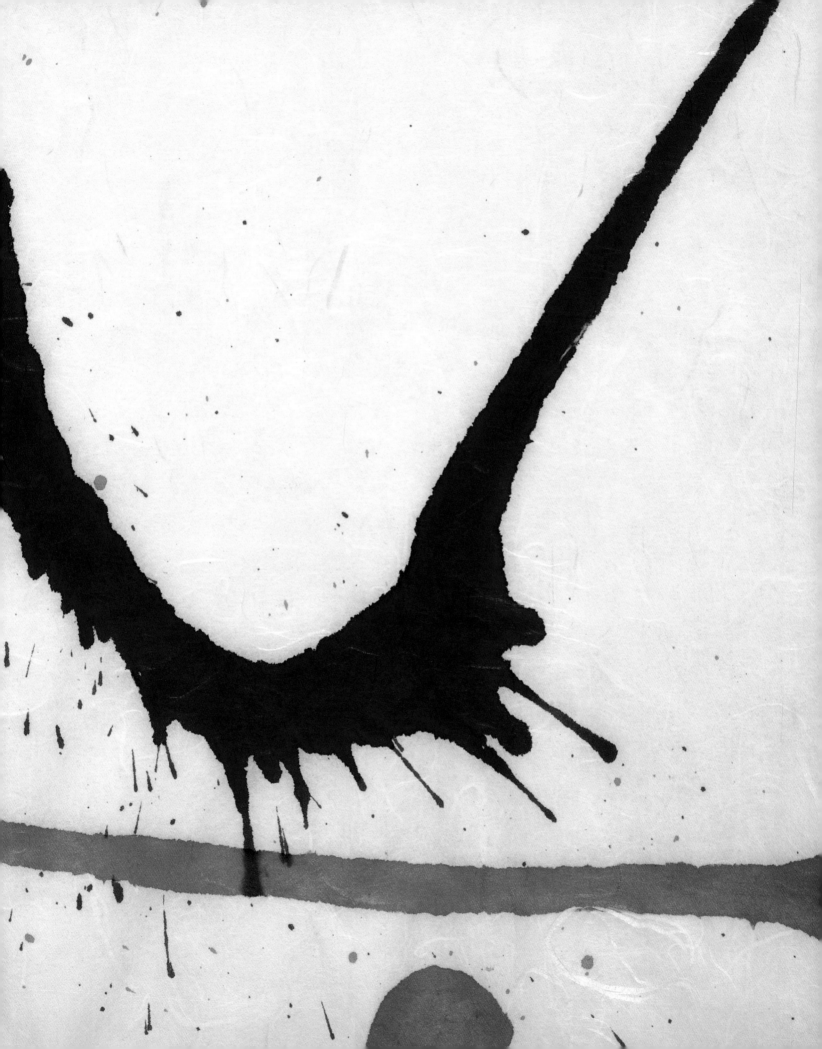

81.
Philip Pearlstein
b. Pittsburgh, Pennsylvania 1924
Male Nude 1962
Sepia Ink on wove paper
16 x 13½ inches (40.6 x 34.3 cm)

Philip Pearlstein is known for his paintings and drawings of nudes that, while precisely rendered, are strikingly devoid of emotional and narrative content. Trained at the Carnegie Institute of Technology in his hometown of Pittsburgh, the artist settled in New York by the late 1940s at a time when Abstract Expressionism prevailed. Although Pearlstein's early work is largely comprised of landscapes rendered in an Abstract Expressionist mode, he grew weary of the style's angst-ridden brushwork by the early 1960s. He instead developed a method of applying pigment with a minimal degree of gesture and nuance. The artist also discovered a new interest in depicting the human figure in a straightforward manner free of sentiment, narration, expression, academic devices, and any other elements that interfered with the formal qualities of his compositions.

Male Nude represents a very early example of the artist's application of the human body as a vehicle for exploring abstract aesthetic qualities. The drawing is a study for *Reclining Nude* (1962, collection of the artist), notable as his first canvas painted directly from the model.[1] It depicts a nude whose prostrate form is further depersonalized by the work's compressed space and truncated composition. The artist defines the figure with a distinctive sepia-wash drawing method he developed in the late 1950s featuring contours that vary in width and density, but reveal little emotion or gesture.[2] Running-dash outlines define borders between triangular washes of ink in a manner resembling divisions on the surface of a map or quilt. The angular placement of the model hints at spatial recession, but greater emphasis is placed on the figure and the surrounding fabric as a single, continuous pattern across the flat surface of the paper. By representing the human figure without academic conventions, narrative content, or pictorial illusion, Pearlstein presents it anew as a dynamic form of abstract beauty and endless compositional possibilities. SCW

Signed and dated lower left: *Pearlstein/2–3–62 62*
Dr. and Mrs. Philip L. Brewer Collection, Museum purchase made possible by the Ella E. Kirven Charitable Lead Trust for Acquisitions 2003.1.25
Provenance: John and Dora Koch, New York; Dr. and Mrs. Philip L. Brewer
Exhibited: *Intimate Expressions*, cat. no. 58, illus.: 41; *Celebration*

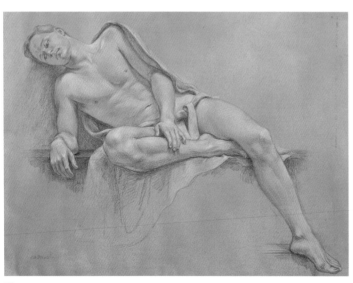

Fig. 108

Fig. 108
Paul Cadmus
b. New York City 1904 – d. Weston, Connecticut 1999
Male Nude (NM6) 1965
Colored crayon on ochre-colored wove paper
17 x 21½ inches (43.2 x 54.6 cm)
Signed lower left: *Cadmus*
Museum purchase made possible by Norman S. Rothschild in honor of his parents Aleen and Irwin B. Rothschild 98.53
Provenance: D.C. Moore Gallery, New York

Exhibited: *Works on Paper by Paul Cadmus, D.C. Moore Gallery, New York, 1998; New Drawings Towards a New Century: Contemporary Art from the Permanent Collection,* Columbus Museum, October 31, 1999 – January 23, 2000; *Celebration*

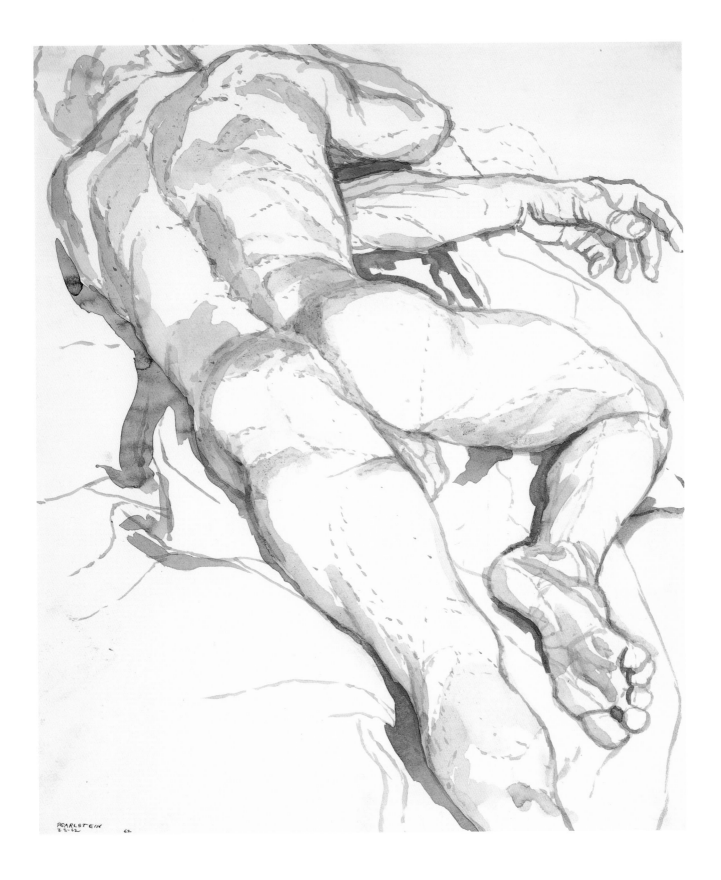

82.

Edwin Walter Dickinson

b. Seneca Falls, New York 1891 – d. Cape Cod, Massachusetts 1978
Young Man's Tombstone 1962
Pencil on wove paper
11 x 9½ inches (27.9 x 24.1 cm)

Edwin Dickinson took drawing seriously and did it conscientious-
ly, sometimes in tandem with intense periods of painting, other
times as a discrete and concentrated activity. When he traveled,
which was often, his drawing kit usually went with him. For the
artist, drawing became the creative middle ground between his
labor-intensive symbolical compositions conceived over long
stretches of time in the studio and those impulsive pictures paint-
ed on the spot in the landscape.

Dickinson's drawings display impeccable control. They can
be architectonic and linear, diaphanous and ethereal. Using only
graphite and charcoal, and when necessary the tip of his little fin-
ger, he achieved palpable textures and a broad tonal range. Many
of the drawings issue from a specific site. Still, the worlds repre-
sented in them often seem inhabited by mysterious forces.

In the twilight of life, Dickinson developed what was proba-
bly Alzheimer's disease, though at the time, during the early seven-
ties, no one knew what it was or what was happening to him. With
his ability to paint hampered, drawing persisted as a creative life-
line. Traveling with his wife Pat became a favorite pastime. Their
trips abroad, begun in 1959 to the Middle East and Greece, became
more frequent as time went on.

During a trip to Athens, he came across a young man's tomb
in Keramikos Cemetery. Captivated by the ancient form of a

funerary lekythos, he rendered it in this drawing: a haunting image
beset by disquieting shadows surrounded by luminous light. It is
no coincidence that a cross-like element appears in the distance to
the right of the vessel; death, a poignant trope given the somber
circumstances of Dickinson's childhood, hovers around many of
his works like a spectral cloud. DD

Signed and dated upper right: *E. W. DICKINSON / 1962*
Inscribed lower right: *KERAMEIKOE*
Gift of Dr. and Mrs. Philip L. Brewer in honor of Dr. and Mrs. Sidney H. Yarbrough
III for their generosity and long years of service to the Columbus Museum 2004.17.1
Provenance: Mr. and Mrs. Robert C. Graham, New York; Graham Gallery, New
York; Dr. and Mrs. Philip L. Brewer
Exhibited: *A Decade of American Drawings*, Whitney Museum of American Art,
April 28 – June 6, 1965, illus.: 24; *Edwin Dickinson*: Whitney Museum of American
Art, October 20 – November 28, 1965, cat. no. 144; *Alumni Fine Arts Show*, Pratt
Institute, New York, 1977; *Edwin Dickinson: Draftsman-Painter*, National Academy
of Design, New York; Museum of Fine Arts, Springfield, Massachusetts; Norton Art
Gallery, West Palm Beach, Florida, April 7 – May 9, 1982, illus.: 73; *Edwin Dickinson:
Rare Perspectives*, Graham Gallery, New York, October 29 – December 20, 1986, cat.
no. 23. illus.; *Intimate Expressions*, cat. no. 22, illus.: 34; *Edwin Dickinson: Dreams
and Realities*, Albright-Knox Art Gallery, Buffalo, New York, April 27 – July 14,
2002; traveled to Pennsylvania Academy of the Fine Arts, Philadelphia, September
14 – December 1, 2002; National Academy of Design, New York, January 31 – April
13, 2003; Arkansas Arts Center, Little Rock, May 9 – July 20, 2003; and Sheldon
Memorial Art Gallery and Sculpture Garden, University of Nebraska, Lincoln,
August 29 – November 9, 2003, cat. no. 92, illus.
Literature: Paul Cummings, *Edwin Dickinson* (New York: Whitney Museum of
American Art, 1965), no. 144; John H. Dobkin, *Edwin Dickinson: Draftsman-Painter*
(New York: National Academy of Design, 1982): 73; Douglas Dreishpoon, Mary
Ellen Abell, and Francis V. O'Connor, *Edwin Dickinson: Dreams and Realities* (New
York: Hudson Hills Press and Buffalo Fine Arts Academy, 2002), no. 92, illus.

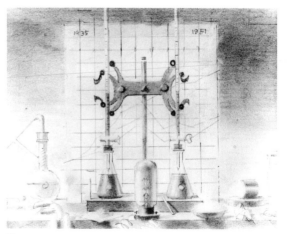

Fig. 109

Fig. 109
Walter Murch
b. Toronto, Canada 1907 – d. New
York City 1967
Chemistry Still Life ca. 1960
Pencil on wove paper
8 x 10 inches (20.3 x 25.4 cm)
Museum purchase made possible
by the Ella E. Kirven Charitable
Lead Trust for Acquisitions
2003.1.54
Provenance: Jill Newhouse, New
York; Dr. and Mrs. Philip L. Brewer
Exhibited: *Intimate Expressions*, cat.
no. 9a, illus.: 62; *Celebration*

Literature: *Drawings and
Watercolors, Catalogue II* (New
York: Jill Newhouse and Eric
Carlson, fall 1982): cat. no. 42, illus.

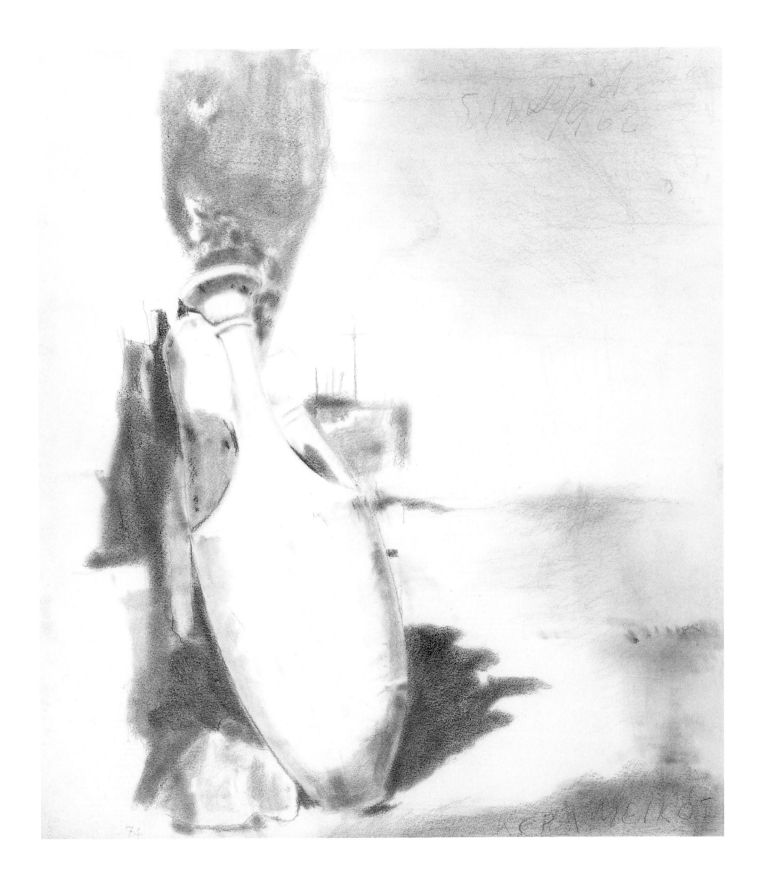

83.

Lucas Samaras

b. Kastoria, Greece 1936

George Segal and His Wife 1968

Pencil and cutout design on wove paper

18 x 25½ inches (45.7 x 64.8 cm)

Since the late 1950s, Lucas Samaras has produced inventive, provocative works in which he explores such themes as transformation, deception, aggression, and mortality. Before immigrating to America from Greece in 1948, he witnessed the devastation of World War II and the ensuing Greek Civil War—traumatic experiences that deeply affected his artistic course. Samaras settled in New Jersey and studied art at Rutgers University, where he befriended Allan Kaprow, George Segal, Claes Oldenburg, and other vanguard artists. They staged performance art events known as "Happenings," which appealed to Samaras in their rebelliousness and theatricality. By the late 1950s, he was producing a wide variety of works, from intricate drawings of ordinary objects to elaborate boxes filled with nails, knives, fragmented images of his body, and other assorted objects. In 1969, he embarked on an extended series of influential photographic self-portraits achieved through playful manipulations of Polaroid film.

Despite his experiments in various media, Samaras has remained a devoted and prolific draftsman.[1] In *George Segal and His Wife*, he uses a razor to cut from a single sheet of paper an intricate mesh trimmed to reveal the silhouette busts of close friends George and Helen Segal. White silhouettes of Samaras's probing hand and a dangling razor protrude into the center of the busts in a manner that introduces the artist's controlling presence, advertises the method of execution and lends an element of danger.[2] The artist's uncharacteristic choice of white may refer to the color of many of Segal's trademark plaster sculptures, for which Samaras modeled later in the year.[3]

In its unconventional format, meticulous execution, provocative imagery, and overt autobiographical references, the drawing bears the hallmarks of Samaras's distinctive artistic vision. In the following year, the artist would again wield a razor as one of many tools used to create his groundbreaking Polaroid self-portraits. SCW

Initialed and dated verso: *LS Feb. 16/68* and inscribed: *no. 48*

Gift of Michael Rosenfeld and halley k harrisburg 2005.29

Provenance: Collection of the Artist; Collection of B.H. Friedman (gift from the artist); Michael Rosenfeld and halley k harrisburg, New York

Exhibited: *Building on Strength*

84.
Alma Thomas
b. Columbus, Georgia 1891 – d. Washington, D.C. 1978
Untitled ca. 1974
Watercolor on wove d'Arches paper
8⅞ x 10⅞ inches (22.5 x 27.6 cm)

By 1971 Columbus-born Alma Thomas's abstract works were often of a single hue, evolving by 1974, a proposed date for this sensuous untitled sheet, as a monochromatic field, frequently reddish-orange, as here, or a deep blue, similar to that in the two vertical bands. This vertical punctuation, a contrast to the field in color and in the nature of the mark, is characteristic of Thomas's spare, dramatic work from this period.[1]

Essential to this watercolor is a Post-Impressionist impulse toward painterly form defined by patches of color. For Thomas this was inspired by views from the windows of her Washington, D.C. home: the trees, shrubs, and flowers in her city garden as articulated by a flickering light that varied with time of day and weather. Layered onto this perceptual experience are her readings of Johannes Itten's *The Art of Color*,[2] published in 1961, and her fascination with the growing body of data generated by explorations of outer space (titles of Thomas's paintings from 1970 include *Launch Pad* and *Blast Off* [both paintings National Air and Space Museum, Washington, D.C.]). This last component may have played a crucial role in *Untitled*, a small work that suggests great scale. In it Thomas moved toward what on the one hand may be seen as a more minimalist bent than heretofore, but on the other hand may reveal her emphasis on this expanding understanding of the world: her visual arena suggests immense vastness modified with details that bring into play encounters of a more intimate nature.

Thomas's field is not homogeneous or flat; she painted and repainted the sheet, developing subtle modulations. Oranges of varying translucency permit the brilliance of the white d'Arches paper to glow through more fully in some areas than others, with further activation offered by blue and green spatter adjacent to the vertical bands, the bands themselves additionally highlighted by unpainted paper surrounding them in places, and by occasional spatters of orange. This various spatter and evidence of blue painted over green in some places and green over blue in others, to say nothing of areas of hot orange on top of both of these cool hues suggests that Thomas worked from field to band and back again, depending to some degree on an accidental interplay rather than a program that would require her to finish one area and then move on to another. A certain amount of preliminary planning is suggested, however, by graphite lines that mark the locations of the bands. RF

Gift of Miss John Maurice Thomas in memory of her parents, John H. and Amelia W. Cantey Thomas, and her sister, Alma Woodsey Thomas 94.20.38
Provenance: Collection of the Artist; John Maurice Thomas (the artist's sister)
Exhibited: *Celebration; Two Columbus Legacies, Alma Thomas and Lamar Baker*, Columbus Museum, November 14, 2004 – February 27, 2005

Fig. 109a

Fig. 109a
Alma Thomas
b. Columbus, Georgia 1891 – d. Washington, D.C. 1978
Study No. Two ca. 1970
Watercolor on wove paper
9 x 11⅞ inches (22.9 x 30.2 cm)
Gift of Miss John Maurice Thomas in memory of her parents, John H. and Amelia W. Cantey Thomas, and her sister, Alma Woodsey Thomas 94.20.41
Provenance: Collection of the Artist; Maurice Thomas
Exhibited: Celebration, illus. gallery guide, unpaginated

85.
William T. Wiley
b. Bedford, Indiana 1937
Faybo's Dream and the Dust Brush 1971
Watercolor and marker on wove paper
12¼ x 16⅛ inches (31.1 x 41 cm)

William T. Wiley's art privileges a variety of approaches: painting, sculpture, drawing, and printmaking are all essential to his visual explorations. Rooted in autobiography, the work tends to be inclusive of motifs both conjured and observed, is often socially or politically inspired, and incorporates both images and words. Dreams may be suggested in titles (*Rhino's Dream*, 1966; *Shark's Dream*, 1967), but even without so naming his images Wiley's juxtapositions of marks, spaces, and things born in his imagination often bring us to dream-like situations.

Faybo's Dream and the Dust Brush, however, is based entirely on observations of what Wiley has called a place "looking like it was pre-set up for me," the light-filled courtyard at artist Arnoldo Pomodoro's country home outside Milan, Italy.[1] Wiley and his family lived there during the summer of 1971 while he created a body of work for exhibition the following fall at Milan's Studio Marconi. He kept this lovely sheet to bring home when he returned to California.

Faybo of the title, resting center stage, was Pomodoro's groundskeeper's pet. The brush at the lower right, used to dust ledges that were part of the courtyard's architectural structure, closely resembles a paint brush and understandably would have attracted Wiley who frequently incorporates studio objects in his compositions.

Wiley's rich portrayal of shifting sunlight across the stone courtyard punctuated by potted bright orange flowering plants, perhaps geraniums, reveals his extraordinary skills as an observer, both as painter and draftsman. He depended primarily on transparent watercolor enhanced with body color to establish opaque touches, contrasting these diverse painted surfaces with his highly personalized line: extended arabesques and truncated dashes that function as both outline and surface activation, enlivening the field throughout this tightly structured composition. RF

Signed lower right: *Wm. T. Wiley 1971*
Inscribed lower right: *FAYBO'S DREAM AND THE DUST BRUSH*
Promised Gift, Dr. and Mrs. Philip L. Brewer Collection
Provenance: Frumkin/Adams Gallery, New York; Dr. and Mrs. Philip L. Brewer
Exhibited: *Intimate Expressions*, cat. no. 77, illus.: 57; *Celebration*

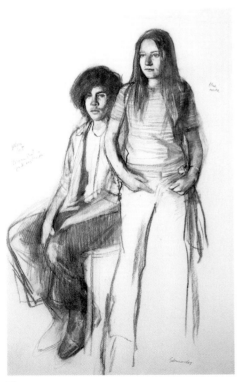

Fig. 110
Burton Silverman
b. Brooklyn, 1928
Flower Kids 1967
Charcoal pencil on wove paper
48 x 33 inches (121.9 x 83.8 cm)
Promised Gift of Eileen and
Wesley Porter
Provenance: Artist; Eileen and
Wesley Porter, New York

Fig. 110

86.

Nancy Grossman
b. New York City 1940
Gunhead #2 1973
Pencil on paper
19 x 24 inches (48.3 x 61 cm)

During the early seventies Nancy Grossman dreamt a most bizarre image: a human head married to a lethal weapon. The notion of a head literally bound to a gun, as surreal as it is unsettling, fueled the artist's imagination through an extended series of works. In some of these paint and collage are deployed, sometimes in combination with drawing; in others, such as *Gunhead #2*, the image is rendered in graphite, a soft medium that belies its subject's hardened and horrific overtones.

When a head becomes a gun, reason gives way to irrational impulses. "In my original *Gunhead* image," Grossman recently explained, "the most compelling thing was the physical manifestation of the most dangerous aspect of humankind which resides between the ears taking aim with lethal results."[1] The mind can be a dangerous thing. Blinded by myopic points of view, captive and delusional, it can lash out violently.

The potential for violence and death in an image so classically constructed is uncanny: the dark underside of civilization's rational veneer. Various subtexts—political, social, and personal—bleed through. Conceived during a tumultuous period in American history, when the specter of Vietnam still loomed, *Gunhead* speaks to that troubled time with poignant acuity. It also speaks to a burgeoning feminism: women taking control of their lives with forceful determination. Grossman understood that bondage and armament might lead to liberation but never without risk.

Gunhead signifies a state of perpetual ambivalence, a warning against excessive hubris still relevant after thirty years. "Today," Grossman contends, "to my great consternation, we Americans are seen as a nation of Gun-Heads—ready to shoot with impunity. The Gunhead stares back at me from this moment in history. I confront the image as a national portrait as well as a self-image of internal conflict."[2] DD

Signed and dated lower center: *N. Grossman '73*
Dr. and Mrs. Philip L. Brewer Collection, Museum purchase made possible by the Ella E. Kirven Charitable Lead Trust for Acquisitions 2003.1.37
Provenance: Cordier and Ekstrom Gallery; New York; Private Collection, New York; Spanierman Gallery, New York; Dr. and Mrs. Philip L. Brewer
Exhibited: *Nancy Grossman*, Cordier and Ekstrom Gallery, New York, October 9 – November 3, 1973; *Intimate Expressions*, cat. no. 34, illus.: 53; *Celebration*
Literature: *American Works on Paper II* (New York: Spanierman Gallery, 1988), cat. no. 27, illus.

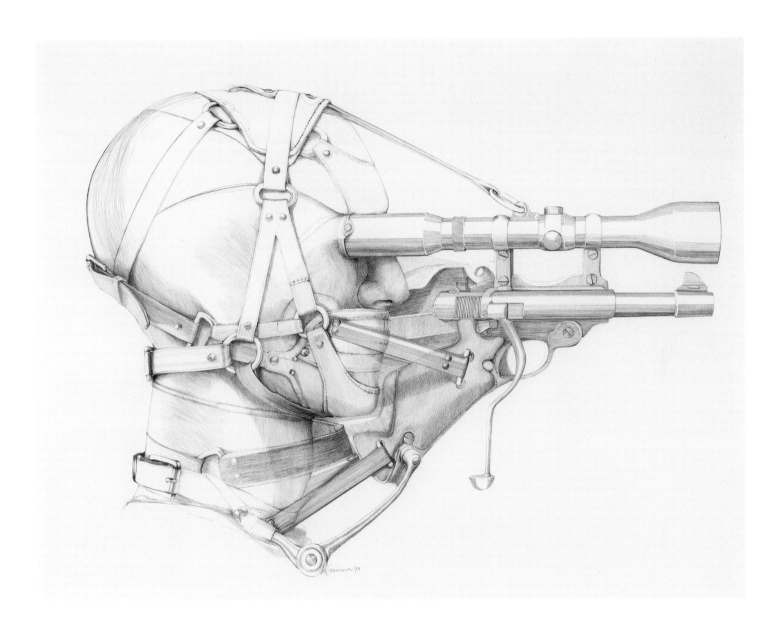

87.

Richard Pousette-Dart
b. St. Paul, Minnesota 1916 – d. New York City 1992
Untitled 1976
Titanium white oil paint, graphite, ink, and gouache on d'Arches paper, laid on board
22½ x 29¾ inches (57.2 x 75.6 cm)

The early career of Richard Pousette-Dart took shape during the economic despair and global conflict of the 1930s and 1940s, yet his mature artistic vision focused on concepts of transcendence, renewal, and illumination. Unlike many of his older New York School counterparts who painted quickly and directly on the canvas, he built delicate Abstract Expressionist compositions by slowly applying successive layers of color.[1] He viewed art as a mystical, spiritual act manifested in a universal language of abstract forms, and he drew inspiration from various sources including African and Native American art, Eastern philosophy, medieval stained glass, photography, and modern theories about the subconscious mind. In 1951, the artist left Manhattan for the more tranquil surroundings of nearby Rockland County, where he began producing images with the aim of "going beyond the surface and cloth of things to that which is eternally significant."[2]

Untitled reflects Pousette-Dart's increasing interest in intensifying the metaphysical weight and meditative power of his compositions by reducing pictorial variables to solitary, archetypal forms rendered in subtle gradations of tone. Multiple layers of pencil and white pigment enliven the surface of the drawing while giving shape to a vibrant atmosphere that appears lit from within. Angular scribbles define a pulsating aura around a dominant circular form and delineate irregular compartments at its center. Besides being an elemental symbol of unity and perfection, the circle appealed to the artist as a symbol suggesting portals, apertures, orbs, windows, single-cell organisms and a variety of other visual phenomena associated with passage, growth, and transformation. As evident in *Untitled*, the circle was vital to his search for an art whose "transcendental language of form, spirit, harmony means one universal eternal presence."[3] SCW

Signed and dated verso: *Pousette Dart 76*
Museum purchase made possible by Dr. Franklin and Barbara Broda Star, in memory of Donald F. Broda, Jr. 2004.10
Provenance: Andrew Crispo Gallery, New York; Ms. Lita Hornick; Estate of Ms. Lita Hornick; Private Collection, New York; Spanierman Gallery, New York
Exhibited: *Richard Pousette-Dart Drawings*, Andrew Crispo Gallery, March 30 – April 22, 1978, cat. no. 9; traveled to Arts Club of Chicago, May 15 – June 21, 1978; *Building on Strength*

88.

Yvonne Jacquette

b. Pittsburgh, Pennsylvania 1934

Searsport Harbor with Salt Tanker 1982

Pastel on gray wove paper

15¾ x 14 inches (40 x 35.6 cm)

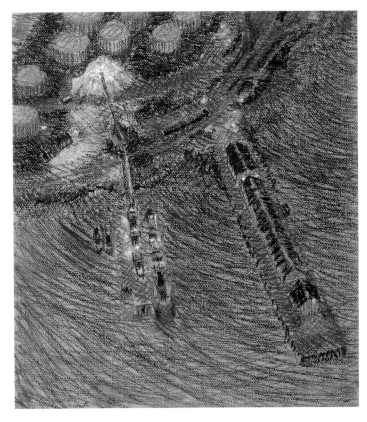

An aerial perspective of the contemporary landscape is a particularly unique vantage point from which to explore perceptual and representational ideas. Yvonne Jacquette has made this distinctive prospect her own since the mid-1970s, and by day and night, she has examined both the urban and rural scene through painting, printmaking, and drawing. She has recorded her insightful observations in various seasons and in diverse parts of the world, but has concentrated on those places she calls home—Maine and New York City. Her provocative imagery directs our attention toward the precarious relationship that exists between the natural world and our fabricated environment, noting how an airborne perspective alters the land into a series of abstract patterns.

This drawing of an industrial site nestled into a remote deep-water inlet in Maine was done from the seat of a Cessna flown by a favorite pilot.[1] Jacquette's unique approach necessitated a custom-built pastel box and a lapboard that fit into the confines of the plane.[2] In spite of the technical challenges inherent in working out of an aircraft suspended in the night sky, the artist realizes the specifics of this place with fluid certainty.

Docked at this industrial pier with its rusting derricks is a tanker offloading salt from the Caribbean that will be used to melt winter snows on Maine highways. The nocturnal scene is punctuated by the twinkling lights on the pier and tanker and by the eerie glow of the salt pile fed by the conveyor belt. Similar to the hillock shape of the salt, oil storage tanks stand like shadowy sentinels guarding a gleaming treasure. A second pier projects into the dark waters defined by loose blue and black hatches that purposefully expose the underlying sheet of gray-brown paper. The irony of this romantic rendering of flickering lights in a blanket of inky darkness is that without this shimmering but corrosive mountain of salt, most of Maine is impassable for much of the year. ML

Signed lower left: *Jacquette*

Museum purchase made possible by the Edward Swift Shorter Bequest Fund

2003.34

Provenance: Brooke Alexander Galleries; Private Collection; Sotheby's Auction House, New York, Sale 1730, lot 187, 2003

Exhibited: *Building on Strength*

89.
Jack Beal
b. Richmond, Virginia 1931
Self-Portrait at Age 51 1982
Pastel on wove paper
25⅛ x 19½ inches (63.8 x 49.5 cm)

After spending his early career painting in an Abstract Expressionist manner, Jack Beal came to realize his work had become "derivative" and lacked the "pictorial geometry" and intellectual rigor he sought.[1] He left New York City in the summer of 1962, and spent the season at a rustic upstate cottage in order to reconsider his artistic direction. The experience of *plein-air* painting awakened Beal's interest in bringing natural color and form into compositions that clearly described the visible world. By 1964, he had tightened his brushwork out of a new desire to give more "faithful attention to reality."[2] He soon began producing crisp interior scenes with reclining figures, boldly patterned fabrics and assorted furnishings—each element carefully chosen for its effect on mood as well as formal structure. Mirrors, diagonal lines, and dramatic shadows transformed ordinary rooms into spatially abstracted, emotionally charged settings.

Within his body of figurative work, Beal has produced a wide variety of inventive self-portraits in which psychological and pictorial concerns are delicately balanced. *Self-Portrait at Age 51* was created following the artist's return from a nine-month hiatus in 1981 due to a debilitating illness.[3] Beal suffered from lingering weakness and frequently turned to pastel as an attractive and less physically demanding alternative to painting. In this atypically stark composition, the artist depicts himself as an aging figure gazing over half-glasses with an expression that is both worn and wary. The theme of mortality is reinforced by the prominent signature "Jack Beal at 51" looming overhead, and by the dark shadows that invade his features and exaggerate his wrinkled brow. The artist dematerializes his own image by repeatedly revealing the colored support between areas of pastel. Through these measures, Beal effectively transforms *Self-Portrait at Age 51* into a subtle meditation on the fragility and transience of life. SCW

Inscribed upper right: *Jack Beal at 51*
Purchase made possible by the Hardaway Foundation and the Ella E. Kirven Charitable Lead Trust for Acquisitions 2001.10
Provenance: Glenn C. Janss, Sun Valley, Idaho; George Adams Gallery, New York
Exhibited: *American Realism: Twentieth Century Drawings and Watercolors from the Glenn C. Janss Collection*, November 7, 1985 – September 20, 1987, San Francisco Museum of Art, San Francisco; traveled to De Cordova and Dana Museum and Park, Lincoln, Massachusetts; Archer Huntington Art Gallery at the University of Texas, Austin; Mary and Leigh Block Gallery, Northwestern University, Evanston, Illinois; Williams College Museum of Art, Williamstown, Massachusetts; Akron Art Museum, Akron, Ohio; Madison Art Center, Madison, Wisconsin; *Abstract Expressionism and the New American Realism, Paintings by Jack Beal and Philip Pearlstein*, Columbus Museum, April 1 – June 17, 2001, cat. no. 24, illus.: 19; *Celebration*

Fig. 111
Jerald Silva
b. Sacramento, California 1939
Dupee #1, Little Eve Steps Out ca. 1983
Watercolor on wove paper
59 x 69 inches (149.9 x 175.3 cm)
Museum purchase 85.9
Provenance: Artist; Sherry French Gallery, New York
Exhibited: *Photo-Realist Painting*, Columbus Museum, 1985; *People, Places, Animals*; *Towards a New Century: Contemporary Art from the Permanent Collection*, Columbus Museum, October 31, 1999 – January 23, 2000; *Celebration*

Fig. 111

90.

Jay DeFeo

b. Hanover, New Hampshire 1929 –
d. San Francisco, California 1989
Summer Image 1982
Oil and collage on wove paper
51 x 41¾ inches (129.5 x 106 cm)

Although years and attitudes away from Jay DeFeo's legendary painting *The Rose* (1958–1966, Whitney Museum of American Art), *Summer Image* shares with it a focus on a centralized image. Created around the time of DeFeo's mother's final illness, her series of "summer image" paintings on paper figure, in part, as elegies. While we don't know the specific origin of the large tri-footed object that dominates the painting, we do know that DeFeo was looking at architecture magazines at this time. The form also evokes a photographer's tripod, an image that appears in other of her works.

During the previous decade, DeFeo had developed a practice that consisted of working from photographs she made of swim goggles, a tape dispenser, and other ordinary things found around her house and studio—objects neither symbolic nor even particularly recognizable, but serving as formal starting points for improvisational compositions.

Summer Image is a successful balancing act where bright orange and yellow contrast with areas of deep brown and black, where glossy surfaces abut matte expanses and carefully hard-edged geometric forms are interrupted by casual drips of paint. A sense of immediacy is further enhanced by marks of the process that DeFeo habitually reveals—here she allowed a strip of masking tape, evidently used to create a precisely painted edge, to float casually off the surface. CL

Signed and dated lower right: *J. DeFeo 1982*
Museum purchase made possible by the Ella E. Kirven Charitable Lead Trust for Acquisitions 2001.6
Provenance: Estate of the Artist; Michael Rosenfeld Gallery, New York
Exhibited: *Celebration*

Fig. 112

Fig. 112
Abe Ajay
b. Altoona, Pennsylvania 1919 –
d. New York City 1998
Collage #21 1996
Mixed media on paper
8¼ x 14¼ inches (21 x 36.2 cm)
Signed lower left: *embossed Abe Ajay*
and on verso: *Abe Ajay*
Gift of Mrs. Betty Raymond Ajay
2002.40.2
Provenance: Artist; Mrs. Betty Raymond Ajay; Babcock Galleries, New York

91.

Joyce Treiman
b. Evanston, Illinois 1922 – d. Los Angeles 1991
Self-Portrait 1989
Pencil watercolor and pastel on paper
12 x 9 inches (30.5 x 22.9 cm)

Joyce Treiman is a realist, beginning and ending with recognizable subject matter, but seeing and composing beyond the obvious and superficial. In 1990 she had an exhibition entitled *The Artist's Series, Monotypes by Joyce Treiman*, in which this self-portrait was shown alongside head studies of William Merritt Chase, Edwin Dickinson, Thomas Eakins, Winslow Homer, Walter Murch, Georgia O'Keeffe, and Albert Pinkham Ryder. As I wrote in an earlier essay for the exhibition *Joyce Treiman: An Appreciation*: "Artists exhibit their works with bared vulnerability, hoping that whatever is worthy and unique in their vision will emerge from the encounter between the viewer and object."[1]

In her drawing *Self-Portrait* Treiman goes way beyond the norm of vulnerability. She sees herself as a subject—a subject that she knows so well. This portrait is head-on, up close and personal, deep penetrating eyes, morning tussled hair and tight lips. Treiman stares back at herself and us with an omnipotent, intense look of wonderment. Through her soft smudges of pastel tones, we see her face and flesh pulsate with life. In fact, we can almost feel her breath. Treiman's use of the gentle pencil line gives definition and accent to the character of this honest, secure artist. This is a woman who believes in herself. The fresh and lively loose watercolor washes add a touch of freedom. Therefore, the drawing becomes delightfully both serious and free-spirited, which is exactly how I imagine she was. TWolfe

Signed and dated lower right: *Treiman/'89*
Dr. and Mrs. Philip L. Brewer Collection, Museum purchase made possible by the Ella E. Kirven Charitable Lead Trust for Acquisitions 2003.1.32
Provenance: Estate of the Artist; Schmidt-Bingham Gallery, New York; Dr. and Mrs. Philip L. Brewer
Exhibited: *Intimate Expressions*, cat. no. 72, illus.: 73, pl. 13; *Drawing Attention: Treiman on Paper*, Augustana Art Gallery, Rock Island, Illinois, September 1 – October 6, 2001; traveled to Nora Eccles Harrison Museum of Art, Logan, Utah, November 1 – December 14, 2001; Carnegie Art Museum, Oxnard, California, June 9 – July 21, 2002; Laband Art Gallery, Loyola Marymount University, Los Angeles, September 14 – November 16, 2002; Schmidt-Bingham Gallery, New York, January 9 – February 16, 2002; *Celebration*
Literature: Michael Duncan, *Drawing Attention: Treiman on Paper* (New York and Rock Island, Ill.: Augustana Art Gallery and Schmidt-Bingham Gallery, 2001), unpaginated

Fig. 113
Pablo Cano
b. Havana, Cuba, 1961
Untitled 2001
Ink on wove paper
23 x 18 inches (58.4 x 45.7 cm)
Signed lower right: *Pablo Cano 2001*
Gift of the Artist 2002.21
Provenance: Gift of the Artist
Exhibited: *Pablo Cano: To Sin or Not to Sin*, Columbus Museum Uptown, April 25 – June 1, 2002; *Celebration*

Fig. 113

Fig. 114

Fig. 115

Fig. 114
Art Rosenbaum
b. Ogdensburg, New York 1938
Farewell, Last Day Goin' 1992
Charcoal on wove paper
38 x 50 inches (96.5 x 127 cm)
Signed and dated lower right:
Rosenbaum/'92
Museum purchase made possible
by the Edward Swift Shorter
Bequest Fund in honor of Karol P.
Lawson 99.5.1
Provenance: Artist
Exhibited: *Celebration*

Fig. 115
David Levine
b. Brooklyn, New York 1926
Past and Present 1993
Watercolor on wove paper
14¹³⁄₁₆ x 10 inches (37.6 x 25.4 cm)
Signed and dated lower right:
D. Levine 93
Museum purchase made possible
by Norman S. Rothschild in honor
of his parents Aleen and Irwin B.
Rothschild 98.51
Provenance: Artist; Forum Gallery,
New York
Exhibited: *David Levine: Past and
Present*, Forum Gallery, New York,
May 14 – June 12, 1998, cover illus.;
New Drawings; *Towards a New
Century: Contemporary Art from the
Permanent Collection*, Columbus
Museum, October 31, 1999 –
January 23, 2000; *Celebration*
Literature: Pete Hamill, with com-
mentary by David Levine, *David
Levine: Past and Present* (New York:
Forum Gallery, 1998), cover illus.

92.
John Wilde
b. Milwaukee, Wisconsin 1919
Myself, Age 22 1992
Silverpoint on prepared paper
10 x 8 inches (25.4 x 20.3 cm)

One cannot fit John Wilde into any one aesthetic pigeonhole. He certainly has a kinship with Albrecht Dürer through his masterly use of silverpoint, the treatment of the female figure and, of course, Dürer's self-portrait, age twenty-two. Many fifteenth-century Italian, Flemish, and other German artists have made their mark on him, as well. Additionally, Wilde's uncommon imagery has surrealist tinges.

Myself, Age 22, looks inward as well as backward in time. In this drawing, John sculpts the forms from the paper much like Michelangelo sculpted *David* from the Carrara marble. His partial face is blown up and placed diagonally on the sheet. In short, he's *right in our face* and *larger than life* with the exaggerated eye, nose, and lips. Created with precise tones of silverpoint, the intense, penetrating, and glaring one-eyed stare is convincing as well as disturbing. The flaring nostril, the symbolic leaping fish and flower blossom and the psychological eyeball portrait make us confront uncomfortable parts of our own reality. This drawing, at the very least, forces us to reckon with unanswered or unanswerable questions that are part of the human condition. The artist lets us accompany him in his investigation of the conscious and unconscious, a courageous gift that was already in evidence in his early great pencil drawings *Wedding Portrait [Male]* and *Wedding Portrait [Female]* (both 1943, Whitney Museum of American Art). We also see this gift in his writings as he leads us to places in the mind—places that we tend to avoid. John sees way down deep, and through his art allows us a glimpse into our own reality. TWolfe

Signed and inscribed lower center: *More Work Reconsidered VII Myself, Age 22 John Wilde–1992*
Dr. and Mrs. Philip L. Brewer Collection, Museum purchase made possible by the Ella E. Kirven Charitable Lead Trust for Acquisitions 2003.1.28
Provenance: Schmidt-Bingham Gallery, New York; Dr. and Mrs. Philip L. Brewer
Exhibited: *Intimate Expressions*, cat. no. 76, illus.: 37; *Celebration*

Fig. 116

Fig. 116
Theo (Theodore) Wujcik
b. Detroit, Michigan 1936
Portrait of James Rosenquist
(previously erroneously entitled as
Robert Rauschenberg) 1980
Silverpoint on prepared wove paper
10¹⁵⁄₁₆ x 13⅞ inches (27.8 x 35.2 cm)
Signed and dated lower right: *Theo*

Wujcik, 1980
Promised Gift, Dr. and Mrs. Philip
L. Brewer Collection
Provenance: Galerie Biedermann,
Munich, Germany; Dr. and Mrs.
Philip L. Brewer
Exhibited: *Celebration*

93.

William Beckman
b. Maynard, Minnesota 1942
Overcoat Series no. 3 ca. 1995–2002
Charcoal on wove Stonehenge paper
86½ x 77½ inches (219.7 x 196.9 cm)

William Beckman loves to draw. He concedes that because his drawing process is entirely different from his method of meticulous painting, it is a welcome aspect of his studio work.[1] In his drawings, particularly a piece of the monumental scale of *Overcoat Series no. 3*, Beckman finds a remarkable freedom and energy in moving a line through a single motion from top to bottom in seconds. His fluidity with charcoal results in intriguing details as well as passages of rich black that leap out of the vast whiteness of the paper. Beckman often makes his drawings as an alternative version of his paintings, which he works on simultaneously.[2]

The male and female pairings that recur in the *Overcoat* series vary greatly. In some, both are cloaked, while in others both are nude, or as in this drawing, one is nude while one is not.[3] Beckman has noted that the clothed figure, shrouded in textures and complicated details, is often the less powerful of the two. Though they are presented as a couple, they do not touch or interact as they confront the viewer as separate and equal. Furthermore, the striking boldness of the outer contours of the two figures encourages the viewer to see them as flat cut-outs separated from the surrounding space.

The figures are Beckman and his ex-wife Diana, and the origins of this piece date to the mid-1980s when they were still married. The first drawing was destroyed, but a second related drawing is in the Yale University Art Gallery (*Man and Woman [After Cézanne]*, 1988). Beckman began this third drawing in the mid-1990s but left it unfinished until 2000, completing it two years later. The artist usually draws from live models but here he has relied upon an earlier image of his ex-wife, which accounts for her youthfulness in contrast to his maturing self-portrait. Therefore, the drawing becomes an allegory for memory, recognizing that the impression we hold of someone who is no longer part of our daily life becomes static or frozen in time. It is also about human relationships, and acknowledges that for this artist the psychological conflict that exists between men and women is like the tension between land and sky in the vast open expanses of his native upper Midwest. It is a delicate balance of opposites that are both complementary and in concert. ML

Signed lower left: *WB*
Gift of the Collections Committee and an Anonymous Donor in Honor of Philip and Lorraine Brewer 2005.7
Provenance: Artist; Forum Gallery, New York
Exhibited: *William Beckman: Paintings*, Forum Gallery, Los Angeles, November 30, 2001 – January 12, 2002; *Painting on the Edge. William Beckman: Paintings and Drawings*, Forum Gallery, New York, April 10 – May 17, 2003

Fig. 117

Fig. 117
Nancy Grossman
b. New York City 1940
Untitled 1984
Graphite on wove paper
60 x 89½ inches (152.4 x 227.3 cm)
Signed lower right: *N. Grossman '84*
Museum purchase made possible by Norman S. Rothschild in honor of his parents Aleen and Irwin B. Rothschild 98.27
Provenance: Michael Rosenfeld Gallery, New York
Exhibited: *New Drawings; Towards a New Century: Contemporary Art from the Permanent Collection*, Columbus Museum, October 31, 1999 – January 23, 2000; *Celebration*

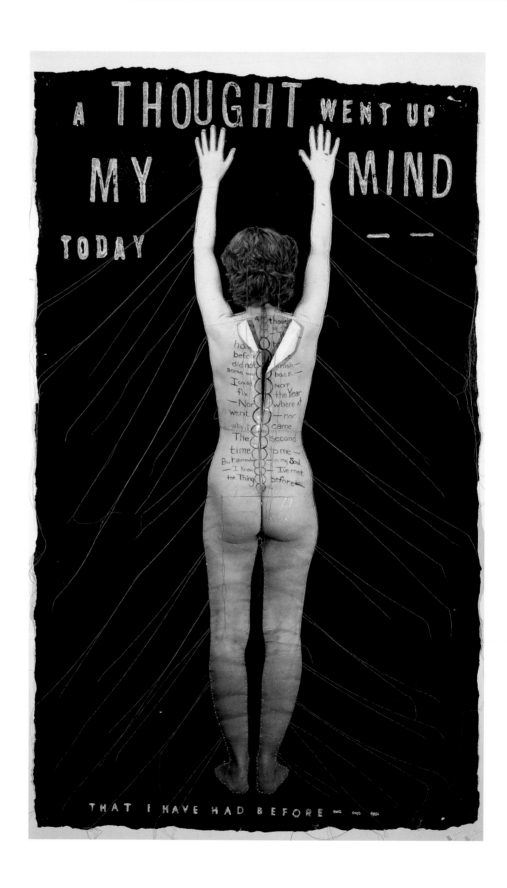

94.
Lesley Dill
b. Bronxville, New York 1950
A Thought Went Up My Mind Today 1996
Ink, thread, and photograph on silver print paper
69 x 41 inches (175.3 x 104.1 cm)

Since the early 1980s, Lesley Dill has combined text, media, and non-traditional materials to produce works of art of exceptional subtlety and refinement. Her versatility as a painter, sculptor, photographer, printmaker, and performance artist stems from a desire to communicate on multiple levels through diverse means. A student of literature, Dill has long understood the power of words to express ideas and shape reality.[1] In 1990, she rediscovered this power in the writings of Emily Dickinson (1830–1886) and soon began to use the poet's passages in intricately crafted, metaphoric constructions dealing with the body and the role of language in cloaking or revealing truth.

A Thought Went Up My Mind Today represents the evocative power Dill achieves through her delicate orchestration of text, image, and material. The drawing is one of a series of four unique mixed-media works on paper from 1995–1996. It presents a cut-out photograph of a fully extended nude woman sewn onto a roughened, jet-black paper surface along with text from the first line of Dickinson's poem of the same title stamped in white paint.[2]

A meditation on the mysterious nature of inspiration, the entire poem appears stained onto the woman's back, which is partially flayed to reveal a deeper layer. Distressed, sewn, cut, peeled and bent, the paper effectively emulates human skin and hints at the fragility and vulnerability of the body.[3] Hair-like strands of white thread trail from the edge of the figure into the surrounding abyss as if antennae pulled by unseen stimuli. In this way, Dill's materials and techniques contribute potent meaning to her poetic reflections on the transience of human experience, the enduring power of words, and the truths hidden beneath external reality. SCW

Gift of Gail B. Greenblatt in memory of Benjamin M. Greenblatt 2004.8
Provenance: George Adams Gallery
Exhibited: *Lesley Dill in Black and White*, George Adams Gallery, New York, April 8 – May 10, 1997; *Lesley Dill: The Poetics of Form*, Widner Gallery, Trinity College, Hartford, Connecticut, November 4 – December 10, 1998, cat. no. 6, illus.: unpaginated; traveled to Portland Art Museum, Portland, Maine, December 22, 1998 – February 21, 1998; List Gallery, Swarthmore College, Swarthmore, Pennsylvania, August 27 – September 27, 1999; Selby Gallery, Ringling School of Art and Design, Sarasota, Florida, October 22 – November 24, 1999; *Lesley Dill: A Ten Year Survey*, Samuel Dorsky Museum of Art, State University of New York at New Paltz, March 9 – April 21, 2002, illus.: 27; traveled to Chicago Cultural Center, May 4 – June 30, 2002; Colorado University Art Galleries at the University of Colorado, Boulder, September 5 – November 2, 2002; Contemporary Museum, Honolulu, November 22, 2002 – January 12, 2003; Scottsdale Museum of Contemporary Art, Scottsdale, Arizona, February 9 – May 11, 2003; illus.: 27; *Building on Strength*

Fig. 118

Fig. 119

Fig. 118
Linda Robinson Sokolowski
b. Utica, New York 1943
The Visit 1984
Monotype on wove paper
22 x 17¾ inches (55.9 x 45.1 cm)
Signed lower right: *L. Robinson Sokolowski 84*
Gift of Katherine Kaplan 2001.19
Provenance: Artist; Katherine Kaplan
Exhibited: *Celebration*

Fig. 119
Gail Foster
b. Providence, Rhode Island 1955
Vivace 1998
Charcoal on wove paper
17 x 14 inches (43.2 x 35.6 cm)
Signed lower right: *Foster*
Museum purchase made possible by the Edward Swift Shorter Bequest Fund 99.26
Provenance: Artist
Exhibited: *Gail Foster: Recent Paintings and Drawings*, Columbus Museum, Columbus, Georgia, September 12 – November 7, 1999; *Celebration*

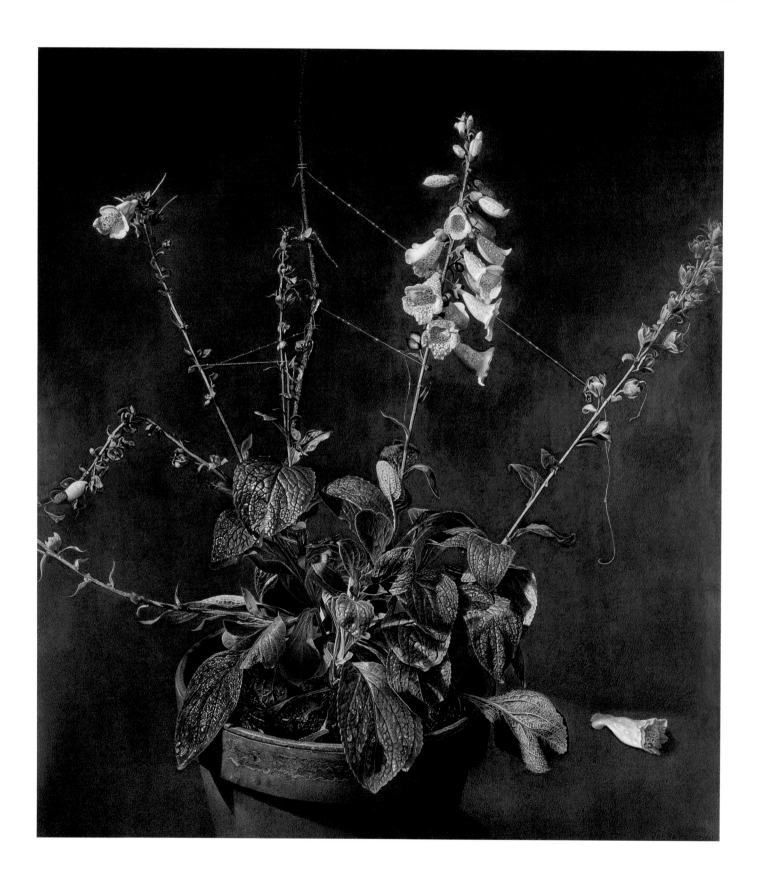

95.
James Valerio
b. Chicago 1938
Foxglove 2000
Graphite on wove paper
33 x 28¾ inches (83.8 x 73 cm)

With James Valerio it is difficult to decide which is more meaningful—how he draws or what he selects to draw. It truly doesn't matter for what we see is what he has chosen to reveal. Here, Valerio states with precise clarity the drama of a potted foxglove plant. We can feel the unfolding leaves and blossoms strung together. We witness from above their twists and turns much like a howling sea gone quiet.

He has shown us with his impeccable surfaces the hardship of growing, living and fading away with intrigue, beauty, and grace. Each shape and form is an individual entity made true with his dramatic use of light and shade. This complex pattern of leaves moves toward and then away from us. Virginal white trumpets arise from this sea of leaves. Valerio's foxglove is placed on the very edge of the frontal plane to convey its power and majesty. Obviously, the curving edge of the pot does much more than simply contain the foxglove—it also stabilizes the composition through its dramatic light and dark shadows while pulling us into the picture plane.

We are aware of the time and labor that is necessary to execute such a drawing. However, Valerio, with his eye and technical ability, just seems to *make it happen*. We do not feel his pain as we would our own. We only experience the joy of his creation, which is *good and pure* in the absolute sense.

If I stop to think what kind of effect James Valerio has on me, I realize that he's a distiller, and I'm reminded of a passage in Richard Ford's *Independence Day*:

"Now you know, Frank, Shakespeare must've been a pretty damn smart cookie…I took a look at everything he wrote this year, okay? And I think history's writers just haven't moved the bar up much since sixteen-whatever…" "I don't really think literature has anything to do with moving the bar up, I say distastefully (I was right). It has to do with being good in an absolute sense, not better."[1]
TWolfe

Signed lower right: *Valerio*
Museum purchase made possible by the Art Acquisition and Restoration Fund 2000.26
Provenance: George Adams Gallery
Exhibited: *James Valerio Drawings*, George Adams Gallery, New York, February 14 – March 31, 2001, illus.: 15; *Celebration*

Fig. 120
Steven Graber
b. Newton, Kansas 1950
The Seven, Near Kingsgate 2001
Charcoal on watercolor on Mylar paper
19½ x 14½ inches (49.5 x 36.8 cm)
Signed lower right: *Graber*
Museum purchase made possible by the Edward Swift Shorter Bequest Fund 2001.5
Provenance: David Findlay, Jr. Gallery, New York
Exhibited: *Celebration*

Fig. 120

96.
John Himmelfarb
b. Chicago 1946
Hello Again 2000
Ink, graphite, and acrylic on wove paper
90 x 70¾ inches (228.6 x 179.7 cm)

Looking at this immense drawing is akin to discovering the Rosetta Stone. The artist has filled the paper with information starting from left to right and top to bottom. He has also layered it with what seem indecipherable codes and symbols as well as graffiti and the notations of someone beset by both the mass media and his own frenetic impulses.[1] The effect is a palimpsest that conflates the two-dimensional flat marks of language with shape and form that suggest the illusion of three-dimensional space. This bewildering complexity of signification is made somewhat comprehensible through the intelligent wit of the artist who disarms and delights us with such written passages as "*It's a Carl Jungle out there,*" referring to the physical and emotional nightmare of modern life as both a Jungian conscious and subconscious experience. Surrounding this particular text are renderings of fantastic flora and fauna that have been flourishing in John Himmelfarb's art since childhood.

Himmelfarb began this drawing with black ink brush marks reminiscent of Korean calligraphy. He then obliterated them with a wash of white acrylic but intentionally left their shadows visible beneath the surface. Using graphite, he drew another layer of

ciphers over the first, which reverberate with one another like pieces of a puzzle that should, but do not, fit together. Alternatively, they might be architectural footprints of a structure long lost, or a key to an unknown lock.

Tucked in and around these well-anchored glyphs exists a compendium of Himmelfarb's drawing styles from the last three decades. There are references to the industrial scenes and areas suggestive of maps and roads that dominated his art in the late 1990s. There are areas filled with the lush vegetation and bizarre monsters of his *Meeting* series from the 1980s (see Fig. 121), and there are areas filled with language. Sometimes his text is enigmatic and reads like stream of consciousness, other times it is readable and full of humor. Then there are passages where it disappears into illegible riffs of textural drawing. Larger than life not only in its scale, but also in its rich configuration of meaning and communication, *Hello Again* expresses the apprehension, anxiety, and curious humor that have long characterized this artist's work. ML

Signed, dated and titled, lower right: *John D. Himmelfarb, Hello Again 2000*
Promised Gift from Susan Himmelfarb
Provenance: Artist; Susan Himmelfarb, Oak Park, Illinois
Exhibited: *American Graffiti*, Centre of Contemporary Art, Christchurch, New Zealand, 2001

Fig. 121

Fig. 121
John Himmelfarb
b. Chicago 1946
Meeting Alone 1986
Ink and ink wash on Saunders watercolor paper
56½ x 90 inches (143.5 x 228.6 cm)
Signed and dated lower right:
John Himmelfarb '86
Gift of Paul and Nell Schneider
2005.59
Provenance: Artist; Paul Schneider, Oak Park, Illinois
Exhibited: *John Himmelfarb: Recent Work*, Terry Dintenfass Gallery, New York, October 11 – October 31, 1986

Fig. 122
David Bates
b. Dallas, Texas 1952
Study for Cherry Branch 2001
Charcoal and watercolor on
Aquarelle d'Arches paper
41 x 26 inches (104.1 x 66 cm)
Signed lower right: Bates
Museum purchase made possible
by the Ella E. Kirven Charitable
Lead Trust for Acquisitions
2002.52
Provenance: DC Moore Gallery,
New York
Exhibited: David Bates, DC Moore
Gallery, New York, November 1 –
December 8, 2001; Celebratio

Fig. 123
Wolf Kahn
b. Stuttgart, Germany 1927
Three Barns in a Row 2001
Pastel on wove paper
22 x 30 inches (55.9 x 76.2 cm)
Signed lower left center: *W Kahn*
Museum purchase with funds pro-
vided by the Swift Family
Foundation in honor of Mrs.
Gunby Jordan 2001.23.2
Provenance: Reynolds Gallery,
Richmond, Virginia
Exhibited: *Wolf Kahn: New Work,*
Reynolds Gallery, Richmond,
Virginia, November 9 – December
22, 2001; *A Summer Potpourri:
Curator's Selections from the
Permanent Collection,* Columbus
Museum, May 19 – July 28, 2002;
Celebration

Fig. 122

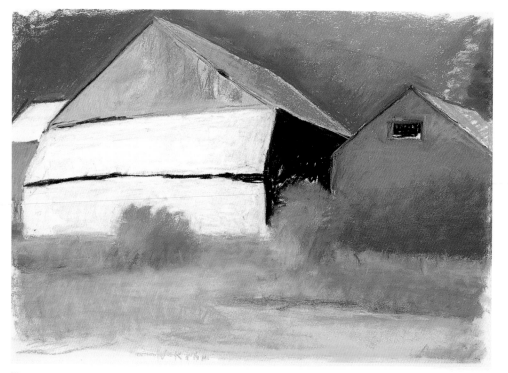

Fig. 123

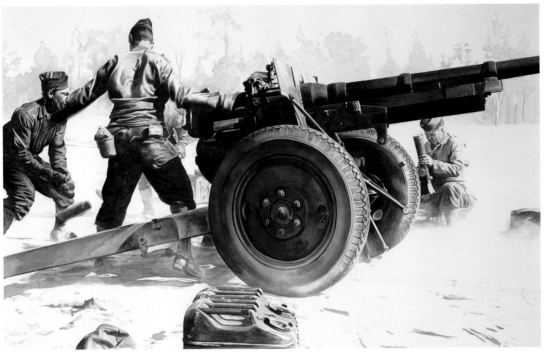

Fig. 124

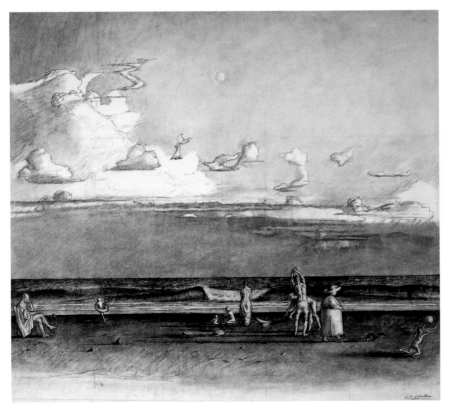

Fig. 125

Fig. 124
Kevin Haran
b. 1964, Staten Island, New York
Painting History VII 2003
Watercolor on Aquarelle d'Arches
paper
26⅛ x 40⅞ inches (66.4 x 103.8 cm)
Signed and dated lower right: *Kevin Haran 2003*
Gift of the Artist 2005.17
Exhibited: *Painting History*, A
Shenere Velt Gallery/The
Workmen's Circle, Los Angeles,
California, March 14 – April 29,
2005; *7th All Media Juried Online
International Art Exhibition*,
Upstream People Gallery, Omaha,
Nebraska, January 1 – 31, 2005;
*National View at Grandview, The
ACC National Exhibition*, Atlanta
Artists Center, Decatur, September
10 – 30, 2004; *Watermedia 2004,
22nd National Juried Exhibition*,
Montana Watercolor Society, Bigfork
Art and Cultural Center, Bigfork,
Montana, October 5 – 30, 2004; *Art
Faculty Exhibition*, University of
Central Florida Art Gallery,
Orlando, Florida, January 13 –
March 5, 2004

Fig. 125
J. Douglas Balentine
b. 1968, Charleston, South Carolina
The Venus of Sullivan's Island 2000
Charcoal and graphite on wove
paper
38½ x 42½ inches (97.8 x 108 cm)
Promised Gift of Mr. and Mrs.
Richard M. Olnick
Provenance: Artist; Collection of
Richard and Helen Olnick,
Columbus, Georgia

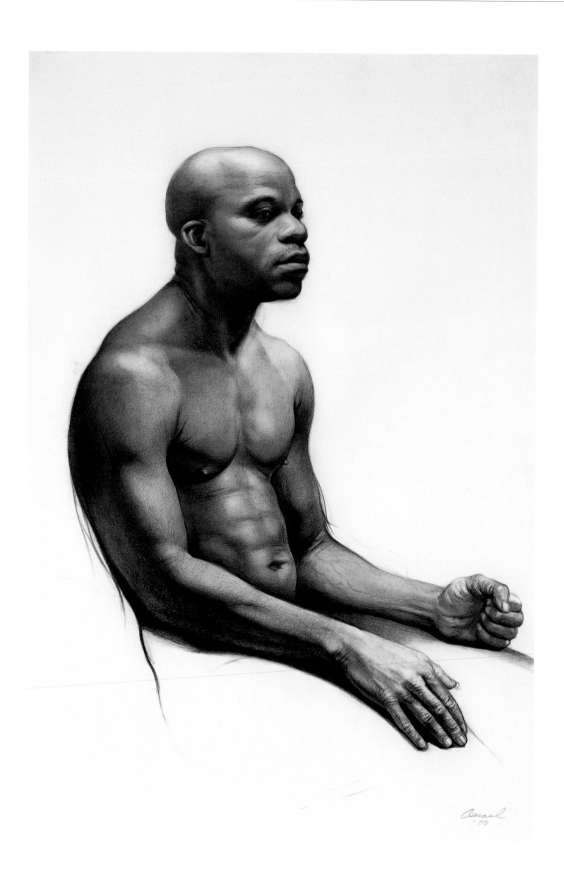

97.
Steven Assael
b. New York City 1957
Michael 2000
Crayon and graphite on paper
18½ x 12⅛ inches (47 x 30.8 cm)

In an era dominated by installation and digitally based art, Steven Assael has maintained a singular focus on the traditional practice of painting and drawing directly from live models.[1] Since the early 1980s, the artist has produced a distinguished body of work in which he explores the human figure in all its formal and psychological complexity. Assael's academic training is evident in his masterful rendering of anatomy and the play of light across varying surfaces. Although his dramatically lit interiors and controlled brushwork recall Velázquez, his subjects and their environments are unmistakably contemporary. The artist's drawings differ from his large, highly finished paintings in being more focused on incisive studies of the body and its ability to reveal or cloak the human soul. Assael avoids the cropped, emotionally neutralized figures of Philip Pearlstein by presenting his subjects as distinct, psychologically charged individuals whose identity and humanity are of central importance.

Michael depicts a seated adult male drawn in near-profile. The confidence of Assael's vigorous use of charcoal and graphite adds vitality to the already powerful physique of his sitter. The man's dark form stands out dramatically against the blank sheet, its outer contour defined by a series of graceful curves. The subject's distinctive facial features and the artist's use of a specific name in the title indicate that the sitter is a particular individual rather than a generic model.[2] Assael has paid great attention to the smallest anatomical details, such as veins along the figure's inner forearm and creases of skin at points of movement. The man's state of mind appears calm and meditative based upon his facial expression. A rounded back, slouched shoulders and slightly distended abdomen indicate physical relaxation. However, his clenched fist suggests otherwise. Is he reliving or anticipating a moment of conflict? Assael presents in this drawing a compelling figure infused with psychological tension and leaves us to ponder the story behind it. SCW

Signed and dated lower right: *Assael/00*
Gift of Thornton and Sue Jordan 2006.1
Provenance: Forum Gallery, New York; Sue and Thornton Jordan, Columbus
Exhibited: *Building on Strength*

Fig. 126

Fig. 126
Brian Cobble
b. Bowling Green, Ohio 1953
King Sky 2002
Pastel on wove paper
24 x 35 inches (61 x 88.9 cm)
Signed lower left: *Cobble*
Gift of Virginia Swift 2002.54
Provenance: Artist; Virginia Swift, New York
Exhibited: *Celebration*; *Recent Works by Brian Cobble*, McKinney Avenue Contemporary, Dallas, Texas, September 12 – October 26, 2003

NOTES TO THIS SECTION

71.

Burgoyne Diller

1. Barbara Haskell, *Burgoyne Diller* (New York: Whitney Museum of American Art, 1990): 36. Note: This is the final study for the construction by the same title (98.7) in the Columbus Museum's collection.

2. Haskell: 75.

3. Haskell: 103.

72.

Alfonso Ossorio

1. Frances V. O'Connor, "Alfonso Ossorio's Expressionist Paintings on Paper," in O'Connor, *Alfonso Ossorio – The Child Returns, 1950, Philippines: Expressionist Paintings on Paper* (New York: Michael Rosenfeld Gallery, 1998): 6. The author wishes to thank halley k harrisburg for providing a copy of this catalogue.

2. B.H. Friedman, *Alfonso Ossorio* (New York: Harry N. Abrams, 1972): 33–34.

3. O'Connor: 10–11. In his Philippine diary entries, the artist raises fundamental questions about his birth, childhood, and sexuality and discusses the use of related motifs in his drawings. According to O'Connor, the vast majority of the 294 known Victorias drawings are titled, with most relating to themes of birth, family, childhood, and religion.

4. Ibid: 9.

5. Ibid: 11. O'Connor suggests Ossorio drew inspiration for his Victorias drawings from *The Search for the Beloved: A Clinical Investigation of the Trauma of Birth and Pre-Natal Conditioning* (Trenton, N.J.: Hermitage Press, 1949), a book by psychoanalyst Nandor Fodor to which the artist refers repeatedly in his Philippine diaries. The book probes pre-natal experience, birth trauma, and their effects on human sexuality.

6. Ossorio also tore and cut certain works in the series to underscore further their status as objects and remove any vestiges of two-dimensionality and illusion. O'Connor and Friedman cite the influence of Dubuffet's *Corps de Dame* series.

76.

Milton Avery

1. Milton Avery, as quoted by Robert Warnick in "A Quiet American Painter Whose Art Is Now Being Heard," *Smithsonian* (October 1982): 113.

77.

Gray Foy

1. Lisa N. Peters, "Gray Foy," Spanierman Gallery, 2004.

2. Related to the author during a conversation with the artist at his home, March 11, 2005. The artist also produced numerous classical album covers for Columbia Records and Epic Records. Foy's demanding magazine work and mounting personal demands on his time contributed to his relatively small output. The author wishes to thank the artist for providing biographical information as well as a

copy of Steve Martin's article, "The Masterpiece in the Hallway," *New York Times* (November 7, 2004): 24.

3. Ibid.

78.

Jared French

1. French's exploration of biomorphic surrealism began prior to the 1960s drawings, as is evident in his tempera painting *Introduction*, produced ca. 1944, which includes the cutaway view of a fetus within a womb placed inside a floating pelvic bone. The author wishes to thank John Whitney Payson, Midtown Payson Galleries, for suggesting *Introduction* as a predecessor to the late drawings.

2. In its title, *Syzygy* refers to a term used by Jung to express the notion of the conjunction of opposites (male and female, sun, and moon, etc.) as being one of the core aspects of the human psyche. Other late drawings bear Jungian titles such as *Libido* (1966, location unknown). Syzygy is also a term used to describe a twice-monthly condition in which the earth, sun, and moon are most closely in alignment.

3. Given Jung's definition of syzygy, this drawing can be seen as perhaps symbolizing a reproductive prelude to *Nest*.

4. In his dissertation on French, "Jared French (1905–1988)," vol. 1 of 2 (University of Delaware, 1999): 302, Mark Cole contends that the compositions for *Syzygy* and *Nest* are based largely on Jean Arp's sculpture *Head and Shell* (ca. 1933, Guggenheim Museum).

5. French described the genesis of this new phase in a published interview: "…In 1964, without conscious pre-vision, I began a series of sketches that led to my present work. It may seem at first sight that this work marks a break with what went before. But it is in reality a development and a further clarification." ("Artists on their Art: Jared French," *Art International* 12, April 20, 1968: 54.) *Syzygy* is dated 1965 and listed as no. 31 of thirty-six total works in an exhibition program for *Jared French: 25 Years of Paintings and Drawings from 1944 to 1969*, Banfer Gallery, New York, February 19 – March 8, 1969. It also appears as no. 5 in a Banfer Gallery program for the 1967 exhibition *20 New Works* (listed in the program as *Twenty Drawings by Jared French*). The author wishes to thank Heidi Lange and Mark Cole for providing copies of these programs and other information relevant to French's late work.

79.

Norman Bluhm

1. James Harithas, "Norman Bluhm," in *Norman Bluhm: A Tribute Exhibition* (Howland, Ohio: Butler Institute of American Art, 1999): 4.

2. Bluhm attended the Armour Institute of Technology in Chicago, later called the Illinois Institute of Technology, from 1936 until 1941 when he joined the Air Force as a B-26 pilot following the attack on Pearl Harbor.

3. Amy Finnerty, "Norman Bluhm," in *Norman Bluhm: Works on Paper* (New York: James Graham & Sons, 2005): unpaginated.

4. Harithas: 4.

81.

Philip Pearlstein

1. Russell Bowman, "The Art of Philip Pearlstein: Introduction," in *Philip Pearlstein: The Complete Paintings* (New York: Alpine Fine Arts Collection, Ltd., 1983): XXVIII. Bowman explains the artist's usual practice at this time was to make paintings from his drawings. Pearlstein painted *Reclining Nude* (no. 183) during the summer of 1962 while teaching at the Pratt Institute, New York, and later that summer painted *Seated Male* (no. 184, collection of the artist) using the same model. The first exhibition of Pearlstein's figurative works was held at Alan Frumkin Gallery, New York, in 1962, and was devoted to the artist's drawings. Frumkin presented the first exhibition of Pearlstein's figurative canvases the following year.

2. John Perreault, *Philip Pearlstein: Drawings and Watercolors* (New York: Harry N. Abrams, 1988): 111. By the mid-1970s, Pearlstein's sepia-wash drawings feature solid contours, more fully defined forms, a greater use of color, and less reliance on line.

83.

Lucas Samaras

1. Samaras often produced series of drawings at a time, as is suggested in this drawing by its verso notation, "no.48."

2. Although perhaps a reference to the Vietnam War, Samaras's recurrent use of the razor as both tool and symbol relates to his childhood in war-torn Macedonia. According to a 1968 *TIME* magazine article on Samaras, "in a household of overwrought women, he [Samaras] was often left alone as a small boy to play with forbidden toys: sharp umbrella spokes and matches from the kitchen, pins and needles from the sewing box, mirrors and broken glass from a chandelier. These perilous play-things metamorphosed themselves in his mind into icons against the savage man-made destruction out-side." "Forbidden Toys," *TIME* (September 20, 1968, vol. 92, no. 12): 74

3. Segal made a plaster casting of Samaras as a "despon-dent" figure in his sculpture *Motel* (1968). "Presences in Plaster," *TIME* (December 13, 1968, vol. 92, no. 24): 84.

84.

Alma Thomas

1. This watercolor is one of a large body of Thomas's watercolors that her sister donated, along with several paintings and a large amount of family memorabilia, in 1994.

2. Johannes Itten, *The Art of Color: The Subjective Experience and Objective Rationale of Color* (New York: Reinhold Pub. Corp., 1961).

85.
William T. Wiley
1. This watercolor has neither been reproduced in color nor discussed in detail previously. Data provided here is based on a telephone conversation between the artist and author on March 25, 2005.

86.
Nancy Grossman
1. Curatorial correspondence files, Nancy Grossman, as quoted from a written statement faxed to Douglas Dreishpoon, February 18, 2005.
2. Ibid.

87.
Richard Pousette-Dart
1. Joanne Kuebler, "Concerning Pousette-Dart," in Robert Hobbs and Joanne Kuebler, *Richard Pousette-Dart*, (Indianapolis: Indianapolis Museum of Art, 1990): 54.
2. Richard Pousette-Dart, Notebook, ca. 1970s, Evelyn Pousette-Dart files. The author wishes to thank Evelyn Pousette-Dart for her assistance in identifying the drawing and confirming the materials the artist used. See curatorial correspondence files, April 26, 2005.
3. Lowery Stokes Sims, "Ciphering and Deciphering: The Art and Writings of Richard Pousette-Dart," in Lowery Stokes Sims and Stephen Polcari, *Richard Pousette-Dart (1916–1992)* (New York: Metropolitan Museum of Art, 1997): 21. The artist's quote is excerpted from Notebook B 158, entry dated February 1964.

88.
Yvonne Jacquette
1. This pilot became quite intuitive about approaching a site, having accompanied the artist on many working trips. Telephone interview with the artist, May 23, 2005.
2. Jacquette has also worked out of commercial airliners and most recently a helicopter as well as the upper levels of skyscrapers.

89.
Jack Beal
1. Eric Shanes, *Jack Beal* (New York: Hudson Hills Press, 1993): 14.
2. Ibid: 26.
3. Ibid: 74. In 1981, Beal and his wife were stricken with Chronic Fatigue Syndrome.

91.
Joyce Treiman
1. *The Artists' Series, Monotypes by Joyce Treiman* (New York: Schmidt-Bingham Gallery, 1990).

93.
William Beckman
1. Beckman's painting process is a laborious course of reworking, scraping, sanding, removing figures, changing poses, or otherwise altering the composition. He usually works on a panel for over a year. Most of the information for this essay comes from a telephone interview with the artist, May 26, 2005.
2. A close inspection of his large oil painting *Man and Woman* (1986, private collection) reveals pentimenti very much like the composition of the Columbus Museum drawing. Beckman later changed the poses to reflect a different dynamic. Telephone interview with the artist, May 26, 2005.
3. The title of the *Overcoat* series stems from a short story, *The Overcoat*, by Nikolai Gogol (1809–1852) that reflects how this protective clothing was not only a necessity for surviving a brutal Russian winter (Beckman grew up in Minnesota), but could in fact alter a man's sense of himself, sometimes with tragic results.

94.
Lesley Dill
1. Dill received her Bachelor of Arts in English from Trinity College, Hartford, Connecticut, in 1972.
2. Robert M. Murdock, *Lesley Dill: The Poetics of Form* (Hartford, Conn.: Widener Gallery, Trinity College, 1998): 2. Produced between 1995 and 1996, all four works are of a similar format and are illustrated as nos. 5, 6, 7, and 8.
3. Murdock: 1. Inspired by women's use of henna to adorn their skin during a residency in India from 1991 to 1992, Dill became increasingly interested in creating works on paper modified by staining, scraping, and the addition of thread and other sewn materials

95.
James Valerio
1. Richard Ford, *Independence Day* (New York: Vintage Contemporaries, Vintage Books, 1996): 227–228.

96.
John Himmelfarb
1. Most of the information for this essay comes from a conversation with the artist on June 17, 2005.

97.
Steven Assael
1. David Shapiro, "Drawing on Experience: Interview with Steven Assael," *Museo* 4 (spring 2001): unpaginated.
2. Assael identified the model as a volunteer firefighter in New York City who has appeared in several of the artist's works, most notably *Michael and James* (1994, Kemper Museum of Contemporary Art), in which he is shown wearing his uniform as he holds a limp child in his arms. Related to the author in a phone conversation with the artist, April 22, 2005.

GENERAL TEXTS ON AMERICAN DRAWINGS

125 Years of American Watercolor Painting. New York: Spanierman Gallery, 1998.

Abstract Expressionist Drawings, 1941–1955. New York: Janie C. Lee Master Drawings, 1988.

Adams, Henry. *American Drawings and Watercolors in the Museum of Art*. Pittsburgh, Pa.: Carnegie Institute, 1985.

_____. *American Drawings and Watercolors from the Kansas City Region*. Kansas City, Mo.: Nelson-Atkins Museum of Art, 1992.

Adams, Henry; Dreishpoon, Douglas; and Keyes, Donald. *Intimate Expressions: Two Centuries of American Drawings*. Athens: Georgia Museum of Art, 1997.

American Art from the Colonial and Federal Periods. New York: Hirschl & Adler Galleries, 1982.

American Art in the Newark Museum: Paintings, Drawings, Sculpture. Newark, N.J.: Newark Museum, 1981.

American Art Notes. New York: Janet Marqusee Fine Arts, Spring 1990.

American Art Selections. New York: Chapellier Galleries (Vol. IX, 1979).

American Drawings: Benjamin West to Ben Shahn: Selections from the Paul Magriel Collection. New Britain, Conn.: New Britain Museum of American Art, 1981.

American Drawings and Watercolors. New York: Hirschl & Adler Galleries, 1979.

American Drawings and Watercolors: From the Collection of Susan and Herbert Adler. Purchase, N.Y.: Neuberger Museum, 1977.

American Drawings & Watercolors from the Munson-Williams-Proctor Institute. Sacramento: E.B. Crocker Art Gallery, 1974.

American Drawings of the Sixties: A Selection. New York: New School Art Center, 1969.

American Drawings, Pastels and Watercolors, Part One: Works of the Eighteenth and Early Nineteenth Centuries. New York: Kennedy Galleries, Inc., 1967.

American Drawings, Pastels and Watercolors, Part Two: The Nineteenth Century: 1825–1890. New York: Kennedy Galleries, Inc., 1968.

American Master Prints and Drawings. Oakland, Calif.: Catherine E. Burns, 1989.

American Masterworks on Paper. New York: Hirschl & Adler Galleries, 1985.

American Works on Paper. New York: Spanierman Gallery, 1987.

American Works on Paper II. New York: Spanierman Gallery, 1988.

American Works on Paper, 1850–1925. Schenectady, N.Y.: Schenectady Museum, 1980.

Amory, Dita and Symmes, Marilyn F. *Nature Observed, Nature Interpreted: Nineteenth-century American Landscape Drawings and Watercolors from the National Academy of Design and Cooper-Hewitt, National Design Museum, Smithsonian Institution*. New York: National Academy of Design with Cooper-Hewitt, National Design Museum, 1995.

Art on Paper. Greensboro: Weatherspoon Art Gallery, University of North Carolina at Greensboro, 1981.

Arthur, John. *Realist Drawings and Watercolors: Contemporary American Works on Paper*. Boston: New York Graphic Society, 1980.

Ashton, Dore. *One Hundred Contemporary American Drawings*. Ann Arbor: University of Michigan, Museum of Art, 1965.

Avery, Kevin J. *American Drawings and Watercolors in the Metropolitan Museum of Art*. New York and New Haven: Metropolitan Museum of Art and Yale University Press, 2002.

Ballinger, James K. *Beyond the Endless River: Western American Drawings and Watercolors of the Nineteenth Century*. Phoenix, Ariz.: Phoenix Art Museum, 1979.

Barter, Judith A. *American Figure Drawings from the Paul Magriel Collection*. Amherst, Mass.: University Gallery, University of Massachusetts, 1980.

_____. *American Drawings and Watercolors from Amherst College*. San Francisco: Art Museum Association of America, 1985.

_____. *American Drawings and Watercolors from the Wadsworth Atheneum*. New York: Hudson Hills Press, 1987.

Belanger, Pamela J. *Inventing Acadia: Artists and Tourists at Mount Desert*. Rockland, Maine: Farnsworth Art Museum, 1999.

Bloch, E. Maurice. *Faces and Figures in American Drawings*. San Marino, Calif.: Huntington Library and Art Gallery, 1989.

Bolger, Doreen, et al. *American Pastels in the Metropolitan Museum of Art*. New York: Metropolitan Museum of Art, 1989.

Bolton, Theodore. *Early American Portrait Draughtsmen in Crayons*. New York: Kennedy Graphics (reprint), 1970.

Brutvan, Cheryl A.; Costello, Anita Coles; and Raye, Helen. *Masterworks on Paper from the Albright-Knox Art Gallery*. New York and Buffalo: Hudson Hills Press and Albright-Knox Art Gallery, 1987.

Buildings: Architecture in American Modernism. New York: Hirschl & Adler Galleries, 1980.

Burger, Gary. *One Hundred American Drawings from the Collection of John Davis Hatch*. London and Dublin: Heim Gallery and National Gallery of Ireland, 1976.

Burroughs, Alan. *A History of American Watercolor Painting*. New York: L.F. White & Company and Whitney Museum of American Art, 1942.

Butler, Charles T., ed. *American Art in the Columbus Museum*. Seattle and Columbus, Georgia: Marquand, Inc. and Columbus Museum, 2003.

Catalogue of the 14th Annual Philadelphia Watercolor Exhibition and the 15th Annual Exhibition of Miniatures. Philadelphia: Pennsylvania Academy of the Fine Arts, 1916.

Chambers, Bruce W. *Selections from the Robert P. Coggins Collection of American Painting*. Rochester, N.Y.: Memorial Art Gallery of the University of Rochester, 1976.

_____. *Art and Artists of the South: The Robert P. Coggins Collection*. Columbia, S.C.: Columbia Museum of Art and University of South Carolina Press, 1985.

Chapman, John Gatsby. *The American Drawing Book: A Manual for the Amateur and a Basis of Study for the Professional Artist*. New York: J.S. Redfield, 1847 (reprinted by W.J. Widdleton, 1864).

Clark, Carol. *American Drawings and Watercolors*. New York and Princeton: Metropolitan Museum of Art and Princeton University Press, 1992.

Cohn, Marjorie B. *Wash and Gouache: A Study of the Development of the Materials of Watercolor*. Boston and Cambridge, Mass.: Center for Conservation and Technical Studies, Fogg Art Museum and the Foundation of the American Institute for Conservation, 1977.

Coolidge, Herman W. *Four Naturalists and their Drawings of American Birds: Some Notes on the Work of Catesby, Abbot, Wilson, and Audubon for an Exhibition of their Drawings at the Georgia Historical Society in September 1970*. Savannah: Georgia Historical Society, 1970.

Cooper, Helen A. *Winslow Homer Watercolors*. Washington and New Haven: National Gallery of Art and Yale University Press, 1986.

Cummings, Paul. *American Drawings: The Twentieth Century*. New York: dViking Press, 1976.

_____. *Twentieth-Century American Drawings: The Figure in Context*. Washington, D.C.: International Exhibitions Foundation, 1984.

_____. *20th Century Drawing from the Whitney Museum of American Art*. New York: Whitney Museum of American Art and W.W. Norton & Co., 1987.

Davis, Bruce. *Master Drawings from the Los Angeles County Museum of Art*. Los Angeles and New York: Los Angeles County Museum of Art with Hudson Hills Press, 1997.

Davis, Elliot Bostwick. "Training the Eye and the Hand: Drawing Books in Nineteenth Century America." Unpublished Ph.D. dissertation, Columbia University, 1992.

A Decade of American Drawings. New York: Whitney Museum of American Art, 1965.

Dee, Elaine Evans. *Nineteenth-Century American Landscape Drawings in the Collection of the Cooper-Hewitt Museum, the Smithsonian Institution's National Museum of Design*. New York: Cooper-Hewitt Museum, 1982.

Drawn from Nature/Drawn from Life: Studies and Sketches by Frederic Church, Winslow Homer, Daniel Huntington from the Collection of the Cooper-Hewitt Museum of Decorative Arts and Design. Ithaca, N.Y.: Ithaca College Museum of Art, 1971.

Drawings. Fort Worth, Tex.: Fort Worth Art Center and Museum, 1969. *Drawings and Watercolors, Catalogue II*. New York: Jill Newhouse and Eric Carlson, 1982.

Drawings from the Collection of Dorothy and Herbert Vogel. Little Rock: University of Arkansas at Little Rock, 1986.

Dreishpoon, Douglas. *Realism and Abstraction: Counterpoints in American Drawing, 1900–1940*. New York: Hirschl & Adler Galleries, 1983.

_____. *American Masterworks on Paper: Drawings, Watercolors, and Prints*. New York: Hirschl & Adler Galleries, 1985.

_____. *Modern Times: Aspects of American Art, 1907–1956*. New York: Hirschl & Adler Galleries, 1986.

_____. *Between Transcendence and Brutality: American Sculptural Drawings from the 1940s and 1950s: Louise Bourgeois, Dorothy Dehner, Herbert Ferber, Seymour Lipton, Isamu Noguchi, Theodore Roszak, David Smith*. Tampa, Fla.: Tampa Museum of Art, 1994.

_____. *The Terese and Alvin S. Lane Collection: Twentieth-Century Sculpture and Sculptor's Works on Paper*. Madison, Wisc.: Elvehjem Museum of Art, 1995.

_____. *From a Curator's Point of View: Making Selections and Forging Connections*. Greensboro: Weatherspoon Art Gallery, University of North Carolina at Greensboro, 1996.

_____. *Highlights from the Dillard Collection of Works on Paper*. Greensboro: Weatherspoon Art Gallery, University of North Carolina at Greensboro, 1999.

Dreppard, Carl William. *American Drawing Books*. New York: New York Public Library, 1945.

Eitner, Lorenz, et al. *Stanford University Museum of Art: The Drawing Collection.* Stanford, Calif.: Stanford University Museum of Art, 1993.

Elderfield, John. *The Modern Drawing: 100 Works on Paper from the Museum of Modern Art.* New York: Museum of Modern Art, 1983.

Fabri, Ralph. *The History of the American Watercolor Society: The First One Hundred Years.* New York: American Watercolor Society, 1969.

Feld, Stuart P. *200 Years of Watercolor Painting in America: An Exhibition Commemorating the Centennial of the American Watercolor.* New York: Metropolitan Museum of Art, 1966.

Felker, Tracie. *Master Drawings of the Hudson River School.* Hamilton, N.Y.: Gallery Association of New York State in association with the Metropolitan Museum of Art, 1993.

Ferber, Linda S. and Gallati, Barbara Dayer. *Masters of Color and Light: Homer, Sargent and the American Watercolor Movement.* Brooklyn, N.Y. and Washington, D.C.: Brooklyn Museum of Art and Smithsonian Institution Press, 1998.

Fillin, Lucille and Walter. *A Family Collection: Drawings in Various Media by American Artists, Selected from the Collection of Lucille and Walter Fillin and their Children.* Stony Brook, N.Y.: Suffolk Museum at Stony Brook, 1964.

Finch, Christopher. *American Watercolors.* New York: Abbeville Press, 1986.

Fine, Ruth E.; Hernandez-Duran, Raymond; and Pascale, Mark. *Contemporary American Realist Drawings: The Jalane and Richard Davidson Collection at the Art Institute of Chicago.* New York: Hudson Hills Press, 2000.

Fink, Lois Marie and Taylor, Joshua. *The Academic Tradition in American Art: an Exhibition Organized on the Occasion of the One Hundred and Fiftieth Anniversary of the National Academy of Design, 1825–1975.* Washington, D.C.: Smithsonian Institution Press on behalf of the National Collection of Fine Arts, 1975.

Flexner, James Thomas. *America's Old Masters: First Artists of the New World.* New York: Viking Press, 1939.

Forerunners of American Abstraction, Painters: Charles Demuth, Arthur G. Dove, John Marin, Georgia O'Keeffe, Charles Sheeler, and Joseph Stella; Sculptors: John B. Flannagan, John Storrs. Pittsburgh, Pa.: Carnegie Institute, 1971.

Foster, Kathleen Adair. "Makers of the American Watercolor Movement: 1860–1890." Unpublished Ph.D. dissertation, Yale University, 1982.

Gallatin, A.E. *American Water-Colorists.* New York: E.P. Dutton & Company, 1922.

Gardner, Albert Ten Eyck. *History of Water Color Painting in America.* New York: Reinhold Publishing Company, 1966.

Goodrich, Lloyd. *American Watercolor and Winslow Homer.* Minneapolis: Walker Art Center and American Artists Group, 1945.

Greer, Gina. *Fifty Works on Paper.* New York: Vance Jordan Fine Art Inc., 2000.

Haverkamp Begemann, Egbert; Lawder, Standish D.; and Talbot, Charles W. *Drawings from the Clark Art Institute; a Catalogue Raisonné of the Robert Sterling Clark Collection of European and American Drawings, Sixteenth through Nineteenth Centuries, at the Sterling and Francine Clark Art Institute, Williamstown.* New Haven: Yale University Press, 1964.

Hayes, Bartlett H. *Drawings of the Masters: American Drawings.* Boston: Little, Brown and Co., 1965.

_____. *American Drawings.* Boston: Little, Brown and Co., 1975. *The Helen W. and Robert M. Benjamin Collection.* New Haven: Yale University Art Gallery, 1967.

Hill, John. *The Art of Drawing Landscapes; Being Plain and Easy Directions for the Acquirement of this Useful and Elegant Accomplishment.* Baltimore: Fielding Lucas Jr., 1820.

Hoppin, Martha J. *Late 19th Century American Drawings and Watercolors.* Amherst: University Gallery, University of Massachusetts, 1977.

_____. *Arcadian Vales, Views of the Connecticut River Valley.* Springfield, Mass.: George Walter Smith Art Museum, 1981.

Howat, John K. and Koshkin-Youritzin, Victor. *American Watercolors from the Metropolitan Museum of Art.* New York: American Federation of Arts and Harry N. Abrams, 1991.

Huneker, James *Bedouins.* New York: Charles Scribner's Sons, 1920.

Insights and Outlooks: A Selection of American Twentieth Century Watercolors and Drawings. New York: Kennedy Galleries, 1986.

Jaffe, Irma. *The Italian Presence in American Art, 1760–1860.* New York and Rome: Fordham University Press and Istituto della Enciclopedia Italiana, 1989.

Johnson, Fridolf. *Treasury of American Pen-and-Ink Illustrators, 1881–1938.* New York: Dover Publications, 1982.

Johnson, Robert Flynn. *American Monotypes: 100 Years,* New York: Marilyn Pearl Gallery, 1979.

_____ and Goldyne, Joseph R. *Master*

Drawings from the Achenbach Foundation for Graphic Arts. San Francisco and Geneva, Switzerland: Fine Arts Museums of San Francisco and Richard Burton, 1985.

Kent, Norman, ed. and Kent, Rockwell. *Drawings by American Artists.* New York: Watson-Guptill Publications, Inc., 1975.

Keyes, Donald. *Hudson River in Private Collections in Georgia.* Athens: Georgia Museum of Art, 1995.

Koke, Richard J., et al. *American Landscape and Genre Painting in the New-York Historical Society: A Catalogue of the Collection.* 3 vols. New York and Boston: New-York Historical Society and G.K. and Co., 1982.

Koshkin-Youritzin, Victor and Rubin, Stephen. *American Watercolors from the Metropolitan Museum of Art.* New York: Metropolitan Museum of Art and American Federation of Arts in association with Harry N. Abrams, 1991.

Kren, Alfred. *Drawing Distinctions: American Drawings of the Seventies.* Copenhagen: Louisiana Museum of Modern Art, 1981.

Latrobe, Benjamin Henry; Carter, Edward Carlos; Van Horne, John C.; and Brownell, Charles E. *Latrobe's View of America, 1795–1820: Selections from the Watercolors and Sketches.* Baltimore and New Haven: Maryland Historical Society and Yale University Press, 1985.

Lee, Pamela M. and Mehring, Christian. *Drawing is Another Kind of Language: Recent American Drawings from a New York Private Collection.* Cambridge, Mass. and Stuttgart: Harvard University Art Museums and Daco-Verlag Günter Bläse, 1997.

Lee, Sherman E. "A Critical Survey of American Watercolor Painting." Unpublished Ph.D. dissertation, Western Reserve University, Cleveland, 1941.

Looking at Drawings. New York: Achim Moeller Fine Art, spring and summer 1988.

MacAdam, Barbara J. *Marks of Distinction: Two Hundred Years of American Drawings and Watercolors from the Hood Museum of Art.* New York: Hudson Hills Press, 2005.

Martin, Alvin; foreword by Henry T. Hopkins; introduction by Glenn C. Janss. *American Realism: Twentieth Century Drawings and Watercolors from the Glenn C. Janss Collection.* San Francisco and New York: San Francisco Museum of Art and Harry N. Abrams, 1986.

Marzio, Peter C. *The Art Crusade: An Analysis of American Drawing Manuals, 1820–1860.* Washington: Smithsonian Institution Press, 1976.

Master Drawings, 1500–1990. New York: Janie

C. Lee Master Drawings, 1991.

Master Drawings, 1859–1989. New York: Janie C. Lee Master Drawings, 1989.

Master Drawings, 1907–1993. New York: Janie C. Lee Master Drawings, 1993.

Master Drawings, 1918–1985. New York: Janie C. Lee Master Drawings, 1986.

Messinger, Lisa Mintz. *Abstract Expressionism: Works on Paper.* New York and Atlanta, Ga.: Metropolitan Museum of Art and High Museum of Art, 1992.

Miller, Jo. *Drawings of the Hudson River School, 1825–1875.* Brooklyn, N.Y.: Brooklyn Museum, 1969.

Modern Times: Aspects of American Art 1907–1956. New York: Hirschl & Adler Galleries, 1986.

Moore, Bridget L. and Cohen, Ronny. *The Reflective Image: American Drawings, 1910–1960.* New York: Midtown Galleries, 1990.

Morrin, Peter and Zafran, Eric. *Drawings from Georgia Collections, 19th and 20th Centuries.* Atlanta, Ga.: High Museum of Art, 1981.

Moser, Joann. *Singular Impressions: The Monotype in America.* Washington, D.C.: National Museum of American Art, 1997.

Murray, Mary E. and Schweizer, Paul D. *Lifelines: American Master Drawings, 1788–1962 from the Munson-Williams-Proctor Institute.* Utica, N.Y.: Munson-Williams-Proctor Institute, 1994.

Nordland, Gerald and Pasquine, Ruth. *Twentieth Century American Drawings from the Arkansas Arts Center Foundation Collection.* Little Rock and Miami Beach, Fla.: Arkansas Arts Center Foundation and Grassfield Press, 1998.

Nygren, Edward J. and Robertson, Bruce. *Views and Visions, American Landscape before 1830.* Washington, D.C.: Corcoran Gallery of Art, 1986.

Nygren, Edward J. and Simmons, Linda Crocker. *American Masters: Works on Paper from the Corcoran Gallery of Art.* Washington, D.C.: Smithsonian Institution Traveling Exhibition Service and the Corcoran Gallery of Art, 1986.

Old Master, Nineteenth Century European and American Works on Paper and Paintings from the Estate of E. Maurice Bloch, Part II. New York: Christie's Auction House, 1991.

The Painterly Print: Monotypes from the Seventeenth to the Twentieth Century. New York: Metropolitan Museum of Art, 1980.

Personal Views, American Works on Paper, 1800–1940. Old Lyme, Conn.: Cooley Gallery, 1992.

Pilgrim, Dianne. *Painters in Pastel: A Survey of American Works.* New York: Hirschl & Adler Galleries, 1987.

Princeton Alumni Collections: Works on Paper.

Princeton, N.J.: Art Museum, Princeton University, in association with Princeton University Press, 1981.

Reaves, Wendy Wick. *Eye Contact: Modern American Portrait Drawings from the National Portrait Gallery.* Washington, D.C.: National Portrait Gallery and Smithsonian Institution, 2002.

"Recent Drawings USA." *Museum of Modern Art Bulletin* 23, no. 4. (1956): 32.

Reed, Sue Welsh, et al. *Awash in Color: Homer, Sargent and the Great American Watercolor.* Boston: Museum of Fine Arts, Boston in association with Bulfinch Press/ Little, Brown and Co., 1993.

Roscoe, Lynda. *Made with Passion: The Hemphill Folk Art Collection.* Washington, D.C.: National Museum of American Art, 1990.

Rose, Bernice. *Drawing Now.* New York: Museum of Modern Art, 1976.

Ross, Barbara T. *American Drawings in the Art Museum. Princeton University: 130 Selected Examples.* Princeton, N.J.: Princeton Art Museum, 1976.

Rossiter, Henry P. *M. & M. Karolik Collection of American Water Colors and Drawings, 1800–1875.* 2 vols. Boston: Museum of Fine Arts, Boston, 1962.

Ruskin, John. *Elements of Drawing.* New York: Dover Publications (reprint), 1971.

Sadik, Marvin S. and Pfister, Harold Francis. *American Portrait Drawings.* Washington, D.C.: National Portrait Gallery and Smithsonian Institution Press, 1980.

Schwartz, Sheila. *A Sense of Line: American Modernist Works on Paper.* New York: Hirschl & Adler Galleries, 1989.

Simmons, Linda Crocker. *American Drawings, Watercolors, Pastels, and Collages in the Collection of the Corcoran Gallery of Art.* Washington, D.C.: Corcoran Gallery of Art, 1983.

Slatkin, Charles E. *Treasury of American Drawings.* New York: Oxford University Press, 1947.

Solomon, Marilyn. *American Drawings, 1963–1973.* New York: Whitney Museum of American Art, 1973.

Spencer, Florence and Spencer, Ralph. *The Spencer Collection of American Art.* New York: Spanierman Gallery, 1990.

The Spontaneous Eye: American Drawings of the Twentieth Century. New York: Kennedy Galleries, 1985.

Stebbins, Theodore E.; Caldwell, John; and Troyen, Carol. *American Master Drawings and Watercolors.* New York: Harper & Row and the Drawing Society, 1976.

Strickler, Susan E., ed. *American Traditions in Watercolor: The Worcester Art Museum Collection.* Worcester, Mass.: Worcester Art Museum with Abbeville Press, 1987.

Summits III, American Master Paintings, Watercolors, Drawings and Prints. New York: Kennedy Galleries, 1987.

Tedeschi, Martha. *Great Drawings from the Art Institute of Chicago: The Harold Joachim Years, 1958–1983.* New York and Chicago: Hudson Hills Press and the Art Institute of Chicago, 1985.

Ten American Watercolor Painters. Boston: Museum of Fine Arts, 1939.

Ten Americans: Masters of Watercolor. New York: Andrew Crispo Gallery, 1974.

Tenth Anniversary Collection: Paintings, Watercolors and Drawings from the Taggert and Jorgenson Gallery. Washington, D.C.: Taggert and Jorgenson Gallery, 1989.

Timpano, Anne. *A Select View: American Paintings from the Columbus Museum.* Columbus, Georgia: Columbus Museum, 1987.

Troyen, Carol L. *A Private Eye: Fifty Nineteenth-Century American Paintings, Drawings and Watercolors from the Stebbins Collection.* Huntington, N.Y.: Heckscher Museum, 1977.

Truettner, William H. and Stein, Roger B., eds. *Picturing Old New England: Image and Memory.* New Haven and London: Yale University Press, 1999.

Two Hundred Years of American Watercolors, Pastels, and Drawings. New York: Spanierman Gallery, 2001.

Tyler, Francine. *American Etching of the 19th Century.* New York: Dover Press, 1984.

Walt, Reed, ed. *The Illustrator in America, 1900–1960s.* New York: Reinhold Publications Corp., 1966.

Watercolors and Drawings of the Nineteenth Century. New York: Kennedy Galleries, 1981.

Weber, Bruce. *The Fine Line: Drawing with Silver in America.* West Palm Beach, Fla.: Norton Gallery of Art, 1985.

_____. *Drawn from Tradition: American Drawings and Watercolors from the Susan and Herbert Adler Collection.* New York and West Palm Beach, Fla.: Hudson Hills Press in association with the Norton Gallery of Art, 1989.

Wechsler, Jeffrey. *Watercolorists from Abstract Expressionist Era.* Katonah, N.Y.: Katonah Museum of Art, 1990.

Willard, Charlotte. "Drawing Today," *Art in America* 52, no. 5 (October 1964): 46–67.

Wilmerding, John and Andrus, Lisa Fellows. *American Light: The Luminist Movement, 1850–1875: Paintings, Drawings, Photographs.* Washington, D.C.: National Gallery of Art, 1980.

Wilmerding, John; Foster, Kathleen A.; Giles, Laura M.; Cozzolino, Robert T.; Mitchell, Mark D.; and Tuite, Diana K. *American Art in the Princeton University Art Museum. Vol. 1: Drawings and Watercolors.* Princeton, N.J.: Princeton University Art Museum, 2004.

Winn, William W.; Lawson, Karol Peard; Schnell, Frank; and Butler, Charles T. *Building on a Legacy: The Columbus Museum.* Columbus, Georgia: Columbus Museum, 1996.

Wolfe, Townsend. *Twentieth-Century American Drawings from the Arkansas Arts Center Foundation Collection.* Little Rock: Arkansas Arts Center, 1984.

_____. *American Abstract Drawings, 1930–1987: Selections from the Arkansas Arts Center Foundation Collection.* Little Rock: Arkansas Arts Center, 1988.

_____. *National Drawing Invitational, 1994.* Little Rock: Arkansas Arts Center Foundation, 1994.

_____. *National Drawing Invitational, 1996.* Little Rock: Arkansas Arts Center Foundation, 1996.

_____. *About Face: Collection of Jackye and Curtis Finch, Jr.* Little Rock: Arkansas Arts Center Foundation, 2001.

Wolfe, Townsend; Anderson, Missy; and Preble, Michael; *Revelations: Drawing – America.* Little Rock: Arkansas Arts Center, 1988.

Wolfe, Townsend and Pasquine, Ruth. *Large Drawings and Objects.* Little Rock: Arkansas Arts Center Foundation, 1996.

Wolfe, Townsend and Flam, Jack D. *Powerful Expressions: Recent American Drawings.* New York: National Academy of Design, 1996.

Works on Paper from Thomas Cole to Andrew Wyeth. Washington, D.C.: Adams Davidson Galleries, 1980.

INDIVIDUAL ARTISTS

Abbot

Pachter, Marc and Stevenson, Wein Frances. *Abroad in America: Visitors to the New Nation, 1776–1914.* Reading, Mass. and Washington, D.C.: Addison-Wesley Pub. Co. in association with the National Portrait Gallery, Smithsonian Institution, 1976.

Ajay

Abe Ajay, Selections 1964–1978. Purchase, N.Y.: Neuberger Museum, State University of New York College at Purchase, 1978.

Ajay, Abe: *Constructions and Collages.* University Park, Pa.: Palmer Museum of Art, 2000.

King, Elaine A. and Akram, Midani. *Abe Ajay: Selected Works 1964 through 1984.* Pittsburgh, Pa.: Hewlett Gallery, Carnegie-Mellon University, 1985.

Alexander

Alexander, Constance Grosvenor. *Francesca Alexander, a Hidden Servant.* Cambridge, Mass.: Harvard University Press, 1927.

Anderson

Anderson, Agnes Grinstead. *Approaching the Magic Hour: Memories of Walter Anderson.* Jackson and London: University Press of Mississippi, 1989.

Driscoll, John Paul. *Walter Anderson: Realizations of the Islander.* Ocean Springs, Miss.: Walter Anderson Estate, 1985.

King, Anne R. and Lawrence, John. *Walls of Light: The Murals of Walter Anderson.* Jackson: University Press of Mississippi, 1999.

Sugg, Redding S., Jr., ed. *The Horn Island Logs of Walter Inglis Anderson,* rev. ed. Jackson: University Press of Mississippi, 1985.

Assael

Steven Assael: New Paintings and Drawings. New York: Forum Gallery, 1998.

Wolfe, Townsend and Raven, Arlene. *Steven Assael: Selected Drawings.* New York: Linden Hills Books, 2000.

Ault

Ault, Louise. *Artist in Woodstock. George Ault: The Independent Years.* Philadelphia: Dorrance, 1978.

Lubowsky, Susan T. *George Ault.* New York: Whitney Museum of American Art, 1988.

"Subject Matter in Art," *George Ault Papers,* Archives of American Art, Reel 247, Frame 254.

Avery

Breeskin, Adelyn D. *Milton Avery.* Washington, D.C.: National Collection of Fine Arts, 1969.

Brutvan, Cheryl A. *Milton Avery, Works on Paper.* Williamstown, Mass.: Sterling and Francine Clark Art Institute, 1980.

Chernow, Burt. *The Drawings of Milton Avery.* New York: Taplinger Pub. Co., 1984.

Haskell, Barbara. *Milton Avery.* New York: Whitney Museum of American Art and Harper & Row, 1982.

Johnson, Una E. and Rothko, Mark. *Milton Avery: Prints and Drawings, 1930–1964.* Brooklyn, N.Y.: Brooklyn Museum and Shorewood Publishers, New York, 1966.

Kramer, Linda Konheim. *Milton Avery in Black and White: Drawings, 1929–59.* Brooklyn, N.Y.: Brooklyn Museum, 1990.

Nordland, Gerald and Barnett, David J. *Milton Avery: A Retrospective of Forty-eight Oils, Watercolors, Gouaches, Drawings, Monotypes, and Original Prints.* Milwaukee, Wisc.: D. Barnett Gallery, 1984.

Owens, Carlotta J. *Milton Avery: Works on Paper.* Washington, D.C.: National Gallery of Art, 1994.

Price, Marla. *Milton Avery, Early and Late.* Annandale-on-Hudson, N.Y.: Edith C. Blum Art Institute, Milton and Sally Avery Center for the Arts, Bard College, 1981.

Warnick, Robert. "A Quiet American Painter Whose Art Is Now Being Heard," *Smithsonian* (October 1982): 113.

Bacon

Murrell, William. *Peggy Bacon.* Woodstock, N.Y.: W.M. Fisher, 1922.

Peggy Bacon, Personalities and Places. Washington, D.C.: National Collection of Fine Arts, 1975.

Peggy Bacon: Starting from Scratch, An Album of Drawings. New York: J. Messner, Inc., 1945.

Bates

Mitchell, Charles Dee. *David Bates: The Gulf Coast.* Galveston, Tex.: Galveston Arts Center, 1997.

Morgan, Dahlia and Gallati, Barbara. *David Bates.* Miami, Fla.: Art Museum at Florida International University, 1993.

Van Keuren, Philip. *David Bates, Poems.* Dallas, Tex.: Dunn and Brown Contemporary, 2003.

Beal

Henry, Gerrit. *Jack Beal: Images on Paper.* Binghamton, N.Y.: Roberson Center for the Arts and Sciences, 1987.

Shanes, Eric. *Jack Beal.* New York: Hudson Hills Press, 1993.

Beckman

Belz, Carl. *William Beckman.* Seattle and Greenwich, Conn.: Frye Art Museum and Seven Bridges Foundation, 2002.

Mularkey, Maureen. "William Beckman at Steibel." *Arts* 66, no. 7 (March 1992): 72.

Bellows

George Bellows: Paintings, Drawings and Prints. Chicago: Art Institute of Chicago, 1946.

George Bellows, A Retrospective Exhibition. Washington, D.C.: National Gallery of Art, 1957.

George Wesley Bellows: Paintings, Drawings, and Prints. Columbus, Ohio: Columbus Museum of Art, 1979.

Morgan, Charles H. *Drawings of George Bellows.* Alhambra, Calif.: Borden Pub. Company, 1973.

Benton

Adams, Henry. *Thomas Hart Benton: An American Original.* New York: Alfred A. Knopf, 1989.

_____. *Thomas Hart Benton: Drawing from Life.* New York: Abbeville Press, 1990.

Baigell, Matthew. *Thomas Hart Benton.* New York: Harry N. Abrams, 1974.

A Collection of Drawings by Thomas Hart Benton. Columbia, Mo.: University of Missouri Press, 1968.

Craven, Thomas. *Thomas Hart Benton.* New York: Associated American Artists, 1939.

Gruber, Richard J. *Thomas Hart Benton and the American South.* Augusta, Ga.: Morris Museum of Art, 1998.

Marling, Karal Ann. *Tom Benton and His Drawings: A Biographical Essay and a Collection of His Sketches, Studies and Mural Cartoons.* Columbia, Mo.: University of Missouri Press, 1985.

Berman

Amberg, George. *The Theatre of Eugene Berman.* New York: Museum of Modern Art, 1947.

Duncan, Michael. *High Drama: Eugene Berman and the Legacy of the Melancholic Sublime.* New York: Hudson Hills Press, 2005.

Levy, Julien. *Eugene Berman.* New York: American Studio Books, 1947.

The Graphic Work of Eugene Berman. New York: C.N. Potter, distributed by Crown Publishers, 1971.

Soby, James Thrall. *Eugene Berman: Paintings, Drawings, Illustrations and Designs.* Boston: Institute of Modern Art, 1941.

Birch

Birch, William Russell; Birch, Thomas; and Barker, William. *The City of Philadelphia, in the State of Pennsylvania, North America; as it Appeared in the Year 1800, Consisting of Twenty Eight Plates.* Springland Cot, Pa.: W. Birch & Son, 1800.

Snyder, Martin P. "William Birch: His Philadelphia Views," *Pennsylvania Magazine of History and Biography* 73, no. 3 (July 1949): 270–315.

Teitelman, S. Robert and Heaney, Howell J. *Birch's Views of Philadelphia* (originally published as *The City of Philadelphia, in the State of Pennsylvania, North America, as it appeared in the Year 1800, Philadelphia,*

1800). Philadelphia: Free Library of Philadelphia, 1982.

Thomas Birch, 1779–1851: Paintings and Drawings, with a Selection of Miniatures by His Father, William Russell Birch, 1755–1834, and a Group of Paintings by other Artists of the Philadelphia Maritime Tradition. Philadelphia: Philadelphia Maritime Museum, 1966.

Bishop

Isabel Bishop: A Retrospective. Tucson: University of Arizona Museum of Art, 1974.

Johnson, Una. *Isabel Bishop: Prints and Drawings, 1925–1964.* Brooklyn, N.Y.: Brooklyn Museum, 1964.

St. John, Bruce. *Isabel Bishop, the Affectionate Eye: Paintings, Drawings, Etchings and Aquatints 1925–1982.* Los Angeles: Loyola Marymount University, 1985.

Yglesias, Helen. *Isabel Bishop.* New York: Rizzoli, 1988.

Bloom

Dervaux, Isabelle and Updike, John. *Color and Ecstasy: the Art of Hyman Bloom.* New York: National Academy of Design, 2002.

Drawings of Hyman Bloom. Storrs, Conn: University of Connecticut Museum of Art, 1968.

Sadik, Marvin S. *The Drawings of Hyman Bloom.* Storrs, Conn.: University of Connecticut Museum of Art, 1968.

Thompson, Dorothy Abbott. *Hyman Bloom: the Spirits of Hyman Bloom, the Sources of his Imagery.* New York: Chameleon Books and Fuller Museum of Art, 1996.

_____. and Cotter, Holland. *Hyman Bloom: Paintings and Drawings.* Durham, N.H.: University of New Hampshire, 1992.

Bluemner

Haskell, Barbara and Weinberg, Adam D. *Oscar Bluemner: A Passion for Color.* New York: Whitney Museum of American Art, 2005.

Hayes, Jeffrey Russell. *Oscar Bluemner: A Retrospective Exhibition.* New York: Barbara Mathes Gallery, 1985.

_____. *Oscar Bluemner.* Cambridge and New York: Cambridge University Press, 1991.

Oscar Bluemner: Paintings and Drawings. New York and Teaneck, N.J.: New York Cultural Center in association with Farleigh Dickinson University, 1970.

Oscar Bluemner: Works on Paper. New York: Linda Hyman Fine Arts, 1988.

Bluhm

Freidman, B.H. "Passages – Norman Bluhm." *Artforum* 37, no. 8 (1999): 30.

Norman Bluhm at the Everson Museum of Art. Syracuse, N.Y.: Everson Museum of Art, 1973.

Salzillo, William and Yau, John. *Norman Bluhm: Works on Paper 1947–1987.* Clinton, N.Y.: Hamilton College, 1987.

Schwabsky, Barry. "Norman Bluhm." *Arts* 66, no.1 (September 1991): 61.

Blume

Peter Blume in Retrospect: Paintings and Drawings, 1925–1964. Manchester, N.H.: Currier Gallery of Art, 1964.

Trapp, Frank. *Peter Blume.* New York: Rizzoli Press, 1987.

Bouché

Louis Bouché: A Memorial Exhibition. New York: Kraushaar Galleries, 1970.

Brackman

Bates, Kenneth. *Brackman, His Art and Teaching.* Noank, Conn.: Noank Pub. Studio, 1951.

Bricher

Brown, Jeffrey. *Alfred Thompson Bricher, 1837–1908.* Indianapolis: Indianapolis Museum of Art, 1973.

Preston, John D. "Alfred Thompson Bricher, 1837–1908." *Arts Quarterly* 25, no. 2 (summer 1962): 150.

Bridges

Hill, May Brawley. *Fidelia Bridges, American Pre-Raphaelite.* New Britain, Conn. and New York: New Britain Museum of American Art and Berry-Hill Galleries, 1981.

Randall, Alice Sawtelle. "Connecticut Artists and Their Work: Miss Fidelia Bridges in her Studio at Canaan," *Connecticut Magazine* 7 (1903): 583–588.

Sharf, Frederic Alan. "Fidelia Bridges," *Essex Institute Historical Collections* 104, no. 3 (July 1968): 217–238.

Stott, Annette. "Floral Femininity: A Pictorial Definition." *American Art* 6, no. 2 (spring 1992): 60–77.

Burchfield

Baur, John I.H. *Charles E. Burchfield at Kennedy Galleries. The Early Years, 1915–1929.* New York: Kennedy Galleries, 1977.

_____. *The Inlander: The Life and Work of Charles Burchfield 1893–1967.* Newark, Del. and New York: University of Delaware Press and Associated University Presses Incorporated, 1982.

Chambers, Bruce W. and Czestochowski, Joseph S. *Charles Burchfield: The Charles Rand Penney Collection.* Washington, D.C.: Smithsonian Institution, 1978.

Charles Burchfield Memorial Exhibition; Paintings and Drawings. New York: Spiral Press and American Academy of Arts and Letters, 1968.

Townsend, J. Benjamin, ed., *Charles Burchfield's Journals: The Poetry of Place.* Albany, N.Y.: State University of New York Press, 1993.

Cadmus

Davenport, Guy. *The Drawings of Paul Cadmus.* New York: Rizzoli, 1989.

Johnson, Una E. *Paul Cadmus: Prints and Drawings, 1922–1967.* Brooklyn, N.Y.: Brooklyn Museum, 1968.

Kirstein, Lincoln. *Paul Cadmus.* New York: Imago, 1984.

Spring, Justin. *Paul Cadmus: The Male Nude.* New York: Universe, 2002.

Cafferty

Hull, David Stewart. *James Henry Cafferty, NA (1819–1869). A Catalogue Raisonné.* New York: New-York Historical Society, 1986.

Cano

Pablo Cano: Paisajes. Madrid: Fundación Concha Marquez and Galería Azteca, 2000.

Cassatt

Barter, Judith A. and Hirshler, Erica E. *Mary Cassatt, Modern Woman.* New York and Chicago: Art Institute of Chicago in association with Harry N. Abrams, 1998.

Breeskin, Adelyn Dohme. *Catalogue, and Exhibition of Pastels, Water-colors, Pencil Drawings, Soft-ground Etchings, Aquatints, Color Prints, and Dry-points.* Baltimore: Baltimore Museum of Art, 1936.

_____. *Mary Cassatt: A Catalogue Raisonné of the Oils, Pastels, Watercolors, and Drawings.* Washington, D.C.: Smithsonian Institution Press, 1970.

Bullard, John E. *Mary Cassatt: Oils and Pastels.* New York: Watson-Guptill, 1972.

Mary Cassatt, Pastels and Color Prints. Washington: Smithsonian Institution Press on behalf of the National Collection of Fine Arts, 1978.

Castellon

Federico Castellon: Surrealist Drawings, 1933–1939. New York: Michael Rosenfeld Gallery, 1996.

Chapman

Bassham, Ben L. *Conrad Wise Chapman: Artist and Soldier of the Confederacy.* Kent, Ohio and London: Kent State University Press, 1998.

Chamberlain, Georgia Stamm. *Studies on John Gadsby Chapman, American Artist, 1808–1889.* Annandale, Va.: Turnpike Press, 1963.

John Gadsby Chapman, Painter and Illustrator. Washington, D.C.: National Gallery of Art, 1962.

Chase

Roof, Katherine M. *The Life and Art of William Merritt Chase.* New York: Hacker Books (reprint), 1975.

Cole

Merritt, Howard S. *To Walk with Nature: The Drawings of Thomas Cole.* Yonkers, N.Y.: Hudson River Museum, 1981.

Noble, Louis Legrand. *The Course of Empire, Voyage of Life, and Other Pictures by Thomas Cole, N.A.* New York: Cornish, Lamport & Company, 1853.

_____. *The Life and Works of Thomas Cole, N.A.* Cambridge, Mass.: Harvard University Press and Belnap Press, 1964; new edition ed. by Elliot S. Vesell. Hensonville, N.Y.: Black Dome Press, 1997.

Parry, III, Ellwood C. *The Art of Thomas Cole: Ambition and Imagination.* Newark, Del. and London: University of Delaware Press and Associated University Presses, 1988.

Truettner, William H. and Wallach, Alan. *Thomas Cole: Landscape into History.* New Haven: Yale University Press in association with the National Museum of American Art, 1994.

The Voyage of Life by Thomas Cole: Paintings, Drawings and Prints. Utica, N.Y.: Munson-Williams-Proctor Institute, 1985.

Coleman

Glassgold, C. Adolph. *Glenn O. Coleman.* New York: Whitney Museum of American Art, 1932.

Glenn O. Coleman – Memorial Exhibition. New York: Whitney Museum of American Art, 1932.

Hapgood, Hutchins and Coleman, Glenn O. *Types from City Streets.* New York: Funk & Wagnalls, 1910.

Colman

Benjamin, S.G.W. *Our American Artists.* Boston: D. Lothrop & Company, 1879.

Copley

Barratt, Carrie Rebora and Staiti, Paul. *John Singleton Copley in America.* New York: Metropolitan Museum of Art, 1995.

Neff, Emily Ballew and Pressly, William T. *John Singleton Copley in England.* Houston, Tex. and London: Museum of Fine Arts and Merrell Holberton Publishers, 1995.

Plate, Robert. *John Singleton Copley: America's First Great Artist.* New York: McKay, 1969.

Prown, Jules David. *John Singleton Copley.* Cambridge, Mass.: Harvard University Press, 1966.

Cox

Morgan, H. Wayne. *An Artist of the American Renaissance: The Letters of Kenyon Cox, 1883–1919.* Kent, Ohio: Kent State University Press, 1995.

_____. *Keepers of Culture: The Art-Thought of Kenyon Cox, Royal Cortissoz, and Frank Jewett Mather, Jr.* Kent, Ohio: Kent State University Press, 1989.

_____. *Kenyon Cox: 1856–1919, A Life in Art.* Kent, Ohio: Kent State University Press, 1994.

Cress

George Cress, Twenty Years. Chattanooga, Tenn.: University of Tennessee-Chattanooga, 1971.

White, E. Alan. *George Cress: 50 Years of Painting.* Chattanooga, Tenn.: Hunter Museum of Art, 1990.

Cropsey

Barratt, Carrie Rebora. *Jasper Cropsey Watercolors: Catalogue and Essay.* New York: National Academy of Design, 1985.

Bermingham, Peter. *Jasper F. Cropsey, 1823–1900: A Retrospective View of America's Painter of Autumn.* College Park: University of Maryland Art Gallery, 1968.

Brennecke, Mishoe, et al. *Jasper F. Cropsey, Artist and Architect: Paintings, Drawings, and Photographs from the Collection of Newington-Cropsey Foundation and the New-York Historical Society.* New York: New-York Historical Society, 1987.

Maddox, Kenneth W. *An Unprejudiced Eye: The Drawings of Jasper F. Cropsey.* Yonkers, N.Y.: Hudson River Museum, 1980.

Rebora, Carrie and Blaugrund, Annette. *Jasper Cropsey Watercolors.* New York: National Academy of Design, 1985.

Talbot, William S. "Jasper F. Cropsey, 1823–1900." Unpublished Ph.D. dissertation, New York University, 1972.

Curry

Cole, Sylvan. *The Lithographs of John Steuart Curry: A Catalogue Raisonné.* New York: Associated American Artists, 1976.

Curry, John Steuart. "Speech before the Madison Art Association, January 19, 1937," typescript, microfilm roll 165, Curry Papers, Archives of American Art.

John Steuart Curry: A Retrospective Exhibition of his Work. Lawrence, Kans.: University of Kansas, 1970.

Junker, Patricia A. and Adams, Henry. *John Steuart Curry: Inventing the Middle West.* New York: Hudson Hills Press, 1998.

Kendall, M. Sue. *Rethinking Regionalism: John Steuart Curry and the Kansas Mural Controversy.* Washington, D.C.: Smithsonian Institution Press, 1986.

Daingerfield

Hobbs, Robert Carleton. *Elliott Daingerfield Retrospective Exhibition.* Charlotte, N.C.: Mint Museum of Art, 1971.

Pennington, Estill Curtis and Gruber, J. Richard. *Victorian Visionary: The Art of Elliott Daingerfield.* Augusta, Ga.: Morris Museum of Art, 1994.

Darley

Finlay, Nancy. *Inventing the American Past: The Art of F.O.C. Darley.* New York: New York Public Library in association with the Brandywine River Museum and Stokes Gallery, 1999.

"… illustrated by Darley": An Exhibition of Original Drawings by the American Book Illustrator Felix Octavius Carr Darley (1822–1888). Wilmington: Delaware Art Museum, 1978.

Reed, Sue. "F.O.C. Darley's Outline Illustrations." *The American Illustrated Book in the Nineteenth Century.* Edited by Gerald W.R. Ward. Winterthur, Del.:

Henry Francis du Pont Winterthur Museum, 1987.

Davies

Arthur B. Davies: A Centennial Exhibition. Utica, N.Y.: Munson-Proctor-Williams Institute, 1962.

Davis

Henning, Edward B. *David E. Davis: Artist and Humanist, Sculpture 1967–2002.* Cleveland, Ohio: Sculpture Studio Books, 2003.

DeFeo

Green, Jane and Levy, Leah. *Jay DeFeo and the Rose.* Berkeley and New York: University of California Press and Whitney Museum of American Art, 2003.

Jay DeFeo: Doctor Jazz and Works on Paper, 1952–1989. Logan, Utah: Nora Eccles Harrison Museum of Art, 2001.

Jay DeFeo, Selected Works, Past and Present. San Francisco: Emanuel Walter and Atholl McBean Galleries, San Francisco Art Institute, 1984.

Lewallen, Constance. *Jay DeFeo, Selected Works, 1952–1989.* Philadelphia: Goldie Paley Gallery, Moore College of Art, 1996.

Stich, Sidra. *Jay DeFeo: Works on Paper.* Berkeley: University Art Museum, University of California at Berkeley, 1989.

Dehner

Dorothy Dehner: Poetry of Line, a Retrospective of Work on Paper. Boulder, Colo.: Boulder Art Center, 1994.

Glaubinger, Jane. *Dorothy Dehner: Drawings, Prints, Sculpture.* Cleveland: Cleveland Museum of Art, 1995.

Marter, Joan M. *Dorothy Dehner: Sixty Years of Art.* New York: Katonah Museum, 1993.

Dickinson, E.

Cummings, Paul. *Edwin Dickinson.* New York: Whitney Museum of American Art, 1965.

Dobkin, John H. *Edwin Dickinson: Draftsman-Painter.* New York: National Academy of Design, 1982.

Dreishpoon, Douglas; Abell, Mary Ellen; and O'Connor, Francis V. *Edwin Dickinson: Dreams and Realities.* New York and Buffalo, N.Y.: Hudson Hills Press and Buffalo Fine Arts Academy, 2002.

Edwin Dickinson, Drawings. New York: Babcock Galleries, 1993.

Goodrich, Lloyd. *The Drawings of Edwin Dickinson.* New Haven: Yale University Press, 1963.

Kingsley, April. *Edwin Dickinson, 1891–1978: Rare Perspectives.* New York: Graham Gallery, 1986.

Shannon, Joe. *Edwin Dickinson: Selected Landscapes.* Washington, D.C.: Hirshhorn Museum and Sculpture Garden, 1980.

Dickinson, P.

Cloudman, Ruth H. *Preston Dickinson 1889–1930.* Lincoln: Nebraska Art

Association, 1979.

Rubenfeld, Richard Lee. "Preston Dickinson, An American Modernist." Unpublished Ph.D. dissertation, Ohio State University, 1985.

Dill

Lesley Dill: In Black and White. New York: George Adams Gallery, 1997.

Lesley Dill: A Ten-Year Survey. New Paltz, N.Y.: Samuel Dorsky Museum of Art, State University of New York, 2002.

Murdock, Robert M. *Lesley Dill: The Poetics of Form.* Hartford, Conn.: Widner Gallery, Trinity College, 1998.

Diller

Agee, William C. *Burgoyne Diller: Drawing and the Abstract Tradition in America.* Houston, Tex.: Meredith Long & Co., 1984.

Burgoyne Diller: Paintings, Sculptures, Drawings. Minneapolis: Walker Art Center, 1971.

Burgoyne Diller: Paintings, Drawings, and Collages, 1938–1962. New York: Meredith Long Contemporary, 1979.

Burgoyne Diller, Paintings, Sculpture, Collages, Drawings, 1938 to 1964. New York: André Emmerich Gallery, 1981.

Burgoyne Diller: Drawings 1945 to 1964. New York: André Emmerich Gallery, 1984.

Burgoyne Diller: The Early Geometric Work, Paintings, Constructions and Drawings. San Francisco: Harcourts Gallery, 1990.

Burgoyne Diller: The 1960s, Paintings, Sculpture and Drawings. New York: Michael Rosenfeld Gallery, 2004.

Haskell, Barbara. *Burgoyne Diller.* New York: Whitney Museum of American Art, 1990.

Rosenfeld, Michael. *Burgoyne Diller: The Third Dimension, Sculpture and Drawings.* New York: Michael Rosenfeld Gallery, 1997.

Dove

Haskell, Barbara. *Arthur Dove.* San Francisco: San Francisco Museum of Art, 1974.

Rich, Daniel. *Paintings and Watercolors by Arthur G. Dove.* Worcester, Mass.: Worcester Art Museum, 1961.

Doyle

Butler, Charles T. *Towards the Horizon: Recent Works on Paper by Mary Ellen Doyle.* Washington, D.C. and Columbus, Ga.: Susan Conway Gallery and Columbus Museum, 1999.

Mary Ellen Doyle: Works on Paper. Washington, D.C.: Phillips Collection and Susan Conway Gallery, 1997.

Evergood

Baur, John I.H. and Irvine, Rosalind. *Philip Evergood.* New York: Praeger, 1960.

Lippard, Lucy R. *The Graphic Work of Philip Evergood.* New York: Crown Publishers, 1966.

Philip Evergood: Paintings and Drawings. New York: Kennedy Galleries, 1972.

Taylor, Kendall. *Philip Evergood Never Separate from the Heart,* London and Toronto: Associated University Presses and Bucknell University Press, 1987.

Falconer

Catalogue of the Interesting and Valuable Collection of Oil Paintings, Watercolors and Engravings Formed by the Late John M. Falconer. Brooklyn, N.Y.: Anderson Auction Company, 1904.

Ferber, Linda S. "Our Mr. John M. Falconer," in *Brooklyn Before the Bridge: American Paintings from the Long Island Historical Society.* Brooklyn, N.Y.: Brooklyn Museum, 1982.

Flannagan

Forsyth, Robert J. *John B. Flannagan: Sculpture, Drawings, Paintings, Woodcuts.* Notre Dame, Ind.: Notre Dame University, 1963.

John B. Flannagan: Sculpture and Drawings, 1924–1938. Saint Paul: Minnesota Museum of Art, 1973.

Foy

Martin, Steve. "The Masterpiece in the Hallway," *New York Times* (November 7, 2004): 24.

Peters, Lisa N. "Gray Foy," Spanierman Gallery, 2004.

French

Cole, Mark. "Jared French (1905–1988)." Ph.D. dissertation, University of Delaware, 1999.

Grimes, Nancy. *Jared French's Myths.* San Francisco: Pomegranate Artbooks, 1993.

Wechsler, Jeffrey. *The Rediscovery of Jared French.* New York and Amherst, Mass.: Midtown Payson Galleries and Mead Art Museum, Amherst College, 1992.

Ganso

Broeder, F.A. Den. *Emil Ganso.* Storrs, Conn.: University of Connecticut, 1976.

Emil Ganso. New York: Whitney Museum of American Art, 1941.

Gaul

Gilbert Gaul, American Realist. Nashville and Memphis, Tenn.: Tennessee State Museum and Dixon Gallery and Gardens, 1992.

Reeves, James F. *Gilbert Gaul.* Huntsville, Ala.: Huntsville Museum of Art, 1975.

Gifford

Hall, Elton Wayland. *R. Swain Gifford, 1840–1905.* New Bedford, Mass.: Old Dartmouth Historical Society, 1974.

Millet, Francis Davis. *Illustrated Catalogue of Oil Paintings and Water Colors by the Late R. Swain Gifford, N.A., to be Sold at Unrestricted Public Sale.* New York: J.J. Little & Co., 1906.

Glackens

Gerdts, William H. *William Glackens.* New York, London, and Paris: Abbeville Press

in association with the Museum of Art, Fort Lauderdale, Fla., 1996.

Glackens, Ira. *William Glackens and the Ashcan Group: The Emergence of Realism in American Art.* New York: Crown Publishers, Inc., 1957.

———. *William Glackens and the Eight: The Artists Who Freed American Art.* New York: Horizon Press, 1984.

Pène Du Bois, Guy. *William J. Glackens.* New York: Whitney Museum of American Art, 1931.

Watson, Forbes. *William Glackens. William Glackens in Retrospect.* St. Louis: City Art Museum, 1966.

Gorky

Herrera, Hayden. *Arshile Gorky: His Life and Work.* New York: Farrar, Straus, and Giroux, 2003.

Jordan, Jim. *Arshile Gorky: Drawings.* New York: Knoedler and Co., 1969.

Joyner, Brooks. *The Drawings of Arshile Gorky.* College Park, Md.: J. Millard Tawes Art Center, University of Maryland, 1969.

Lader, Melvin P. and Lee, Janie C. *Arshile Gorky: A Retrospective of Drawings.* New York: Whitney Museum of American Art, 2003.

Levy, Julian. *Arshile Gorky.* Harry N. Abrams, 1966.

Morley, Simon; Spender, Matthew; Rose, Barbara. "Arshile Gorky and the Genesis of Abstraction–Drawings from the Early 1930s." *Times Literary Supplement* no. 4836 (1995): 16.

Rose, Barbara; Spender, Stephen, et al., *Arshile Gorky and the Genesis of Abstraction, Drawings from the Early 1930s.* Princeton and Seattle: Stephen Mazoh & Co. and the University of Washington Press, 1994.

Waldman, Diane. *Arshile Gorky: A Retrospective.* New York: Harry N. Abrams and Solomon R. Guggenheim Museum, 1981.

Graves

Cage, John. *The Drawings of Morris Graves, with Comments.* Boston: New York Graphic Society on behalf of the Drawing Society, 1974.

Kass, Ray. *Morris Graves, Vision of the Inner Eye.* New York and Washington, D.C.: Braziller and Phillips Collection, 1983.

Morris Graves, a Retrospective. Eugene, Ore.: University of Oregon Museum of Art, 1966.

Rubin, Ida E., ed.; Cage, John; and Daniels, David. *The Drawings of Morris Graves.* Boston: New York Graphic Society, 1974.

Sky of the Mind: Morris Graves, 1937–1987. New York: Schmidt Bingham Gallery, 1988.

Wolff, Theodore F. *Morris Graves, the Early Works.* La Conner, Wash.: Museum of Northwest Art, 1998.

Gross

Flint, Janet A. *Chaim Gross: Sculpture and Drawings.* Washington, D.C.: National

Collection of Fine Arts, 1974.

Getlein, Frank. *Chaim Gross*. New York: Harry N. Abrams, 1974.

Jaffe, Irma B. *Chaim Gross: Watercolors, Drawings and Sculpture*. Provincetown, Mass.: Provincetown Art Association and Museum, 1984.

Tarbell, Roberta K. *Chaim Gross. Retrospective Exhibition: Sculpture, Paintings, Drawings, and Prints*. New York: Jewish Museum, 1977.

Werner, Alfred. *Chaim Gross, Watercolors and Drawings*. New York: Harry N. Abrams, 1979.

Grossman

Nancy Grossman: Loud Whispers. New York: Michael Rosenfeld Gallery, 2000.

Raven, Arlene. *Nancy Grossman*. Brookville, N.Y.: Hillwood Art Museum, Long Island University, 1991.

Haberle

Haberle Retrospective Exhibition. New Britain, Conn.: New Britain Museum of American Art, 1962.

Sill, Gertrude Grace. *John Haberle, Master of Illusion*. Springfield, Mass.: Museum of Fine Arts, 1985.

Hale, L.W.

Dempsey, Kate E. "Lilian Westcott Hale: The Development of Style." Unpublished Honors Thesis, Smith College, 2004.

Five American Women Impressionists: Lilla Cabot Perry, Lilian Westcott Hale, Anna Wood Brown, Jane Peterson, May Wilson Preston. Santa Fe, N.M.: Santa Fe Gallery East, 1982.

Hirschler, Erica Eve. "Lilian Westcott Hale (1880–1963): A Woman Painter of the Boston School." Unpublished Ph.D. dissertation, Boston University, 1992.

The Works of Lilian Westcott Hale. Charlottesville: University of Virginia Museum of Fine Arts, 1965.

Hale, P.

Paintings and Drawings by Philip Leslie Hale, from the Folts Collection. Boston: Vose Galleries, 1966.

Philip Leslie Hale, A.N.A., 1865–1931: Paintings and Drawings. Boston: Vose Galleries, 1988.

Hallowell

Downes, William Howe. "George H. Hallowell's Pictures," *The American Magazine of Art* 15, no. 9 (September 1922): 455.

Hart

Bradshaw, Elinor Robinson and Jarden, Margaret A. *George Overbury "Pop" Hart, 1868–1933: Catalog of an Exhibition of Oils, Water Colors, Drawings and Prints*. Newark, N.J.: Newark Museum, 1935.

Gilbert, Gregory. *George Overbury "Pop" Hart: His Life and Art*. New Brunswick, N.J.: Rutgers University Press and Jane

Voorhees Zimmerli Art Museum, 1986.

Porter, James A. *A Retrospective Exhibition of Paintings, Prints and Drawings by George O. "Pop" Hart, 1868–1933*. Washington, D.C.: Howard University Gallery of Art, 1956.

Hartley

Barnett, Vivian Endicott. "Marsden Hartley's Return to Maine." *Arts Magazine* 54 (October 1979): 172–176.

Cassidy, Donna M. "On the Subject of Nativeness: Marsden Hartley and New England Regionalism." *Winterthur Portfolio* 29, no. 4 (1994): 227–450.

Hartley, Marsden, with Ryan, Susan Elizabeth, ed. *Somehow a Past: The Autobiography of Marsden Hartley*. Cambridge, Mass.: MIT Press, 1995.

Haskell, Barbara. *Marsden Hartley*. New York: Whitney Museum of American Art and New York University Press, 1980.

Kornhauser, Elizabeth Mankin and Birkmaier, Ulrich. *Marsden Hartley*. Hartford, Conn. and New Haven: Wadsworth Atheneum Museum of Art in association with Yale University Press, 2002.

Ludington, Townsend. *Marsden Hartley: The Biography of an American Artist*. Boston: Little, Brown, 1992.

Robertson, Bruce. *Marsden Hartley*. New York and Washington, D.C.: Harry N. Abrams and National Museum of American Art, 1995.

Harvey

100 Years Ago in North America: Watercolor Drawings by George Harvey. New York: Kennedy Galleries, 1940.

Parker, Barbara N. "George Harvey and his Atmospheric Landscapes." *Bulletin of the Museum of Fine Arts* 41, no. 243 (February 1943): 7–9.

Shelley, Donald A. "George Harvey and his Atmospheric Landscapes of North America." *The New-York Historical Society Quarterly* 32, no. 2 (April 1948): 104–113.

Shelley, Donald A. "George Harvey, English Painter of Atmospheric Landscapes in America." *American Collector* 17, no. 3 (April 1948): 10–13.

Hassam

Catalogue of an Exhibition of Paintings, Watercolors, Pastels and Etchings by Childe Hassam, N.A. Buffalo, N.Y.: Fine Arts Academy, Albright Art Gallery, 1916.

Exhibition of Paintings, Watercolors, Pastels and Etchings by Childe Hassam. Chicago: Art Institute of Chicago, 1917.

Exhibition of Pictures by Childe Hassam. New York: Montross Gallery, 1914.

Paintings, Pastels and Etchings by Childe Hassam. Boston: St. Botolph Club, 1914.

Paintings, Watercolors, Pastels and Etchings by Childe Hassam. St. Louis: City Museum, 1917.

Weinberg, H. Barbara; Larkin, Susan G.;

Troyen, Carol, et al. *Childe Hassam: American Impressionist*. New York, New Haven, and London: Metropolitan Museum of Art and Yale University Press, 2004.

Henri

Nicoll, Jessica F. *The Allure of the Maine Coast: Robert Henri and His Circle, 1903–1918*. Portland, Maine: Portland Museum of Art, 1995.

Perlman, Bennard B. *Robert Henri: His Life*. New York: Dover Publications, 1991.

Robert Henri (1865–1929). Cold Harbor, N.Y.: Harbor Gallery, 1973.

Valente, Alfredo. *Robert Henri: Painter, Teacher, Prophet*. New York: New York Cultural Center, 1969.

Hill, J.H.

Koke, Richard J. *A Checklist of the American Engravings of John Hill (1770–1850) Master of Aquatint, together with a List of Prints Colored by Him and a List of his Extant Original Drawings*. New York: New-York Historical Society, 1961.

Koke, Richard J. "John Hill, Master of Aquatint, 1770–1850." *New-York Historical Society Quarterly* 43, no. 1 (January 1959): 51–117.

Scott, John. "The Hill Family of Clarksville." *South of the Mountains* (The Historical Society of Rockland County) 19, no. 1 (January–March 1975): 5–18.

Hill, J.W.

Hill, John Henry. *John William Hill: An Artist's Memorial*. New York, 1888.

John William Hill and John Henry Hill. New York: Washburn Gallery, 1973.

Himmelfarb

Himmelfarb, John. *The Family Dog: Drawings*. Chicago: Himmelfarb (self-published), 1973.

John Himmelfarb. Davenport, Iowa: Davenport Art Gallery, 1986.

John Himmelfarb: Floor to Ceiling. Sioux City, Iowa: Sioux City Art Center, 2000.

Laufer, Marilyn and Butler, Tom. "John Himmelfarb: Drawings and Prints," *Artifact* (Sioux City, Iowa: Sioux City Art Center, March–April 1985): unpaginated.

Nordland, Gerald. *John Himmelfarb: Inland Romance*. Des Plaines, Ill.: Oakton Community College, 2001.

Sheridan, Helen and Bonesteel, Michael. *Meeting in the Garden – John Himmelfarb*. Kalamazoo, Mich.: Kalamazoo Institute of Arts, 1989.

Hirsch

Joseph Hirsch: Recent Paintings and Drawings. New York: Kennedy Galleries, 1980.

Hoffman

Connor, Janis C. *A Dancer in Relief: Works by Malvina Hoffman*. Yonkers, N.Y.: Hudson River Museum, 1984.

Exhibition of Recent Sculpture and Drawings by Malvina Hoffman. Washington, D.C.: Corcoran Gallery of Art, 1929

Moore, Marianne. *Malvina Hoffman, 1887–1966*. New York: National Sculpture Society, 1966.

Hofmann

Friedel, Helmut and Dickey, Tina. *Hans Hofmann*. New York: Hudson Hills Press, 1998.

Goodman, Cynthia. *Hans Hofmann*. New York: Abbeville Press, 1986.

_____; and Sandler, Irving, et al. *Hans Hofmann*. New York and Munich: Whitney Museum of American Art and Prestel Verlag, 1990.

Hunter, Sam. *Hans Hofmann*. New York: Harry N. Abrams, 1960.

Seitz, William C. *Hans Hofmann*. New York: Museum of Modern Art, 1963.

Holty

Carl Holty: Memorial Exhibition. New York: Andrew Crispo Gallery, 1974.

Danoff, I. Michael. *Carl Holty: The World Seen and Sensed*. Milwaukee: Milwaukee Art Museum, 1980.

Rembert, Virginia. "Carl Holty: Search for the Grail" (unpublished biography). On file at Georgia Museum of Art, Athens.

Homer

Cicovsky, Nicolai, et al. *Winslow Homer*. Washington, D.C.: National Gallery of Art, 1995.

Cooper, James F. "Winslow Homer Exhibit in Vivid Black and White," *New York City Tribune* (December 26, 1986).

Gerdts, Abigail Booth. *Winslow Homer in Monochrome*. New York: Knoedler-Modarco Gallery, 1986.

Goodrich, Lloyd. *Winslow Homer*. New York: G. Braziller, 1959.

Hunt

Angell, Henry C. *Records of William M. Hunt*. Boston: James R. Osgood and Co., 1881.

Hoppin, Martha J. and Adams, Henry. *William Morris Hunt, A Memorial Exhibition*. Boston: Museum of Fine Arts, 1979.

Knowlton, Helen M. *Art-life of William Morris Hunt*. Boston: Little, Brown and Co., 1899.

Landgren, Marchal E. *The Late Landscapes of William Morris Hunt*. College Park: University of Maryland Art Gallery, 1976.

Shannon, Martha A.S. *Boston Days of William Morris Hunt*. Boston, Mass.: Marshall Jones, 1923.

Vose, Robert. *The Return of William Morris Hunt*. Boston: Vose Gallery, 1986.

Webster, Sally. *William Morris Hunt, 1824–1879*. Cambridge, England and New York: Cambridge University Press, 1991.

William Morris Hunt on Painting and Drawing. New York: Dover Publications, 1976.

Huntington

Benjamin, S.G.W. "Daniel Huntington: President of the National Academy of Design." *American Art Review* 2, part 1

(1881): 223–228; part 2 (1881): 1–6.
Greenhouse, Wendy. "Daniel Huntington and the Ideal of Christian Art." *Winterthur Portfolio* 31, nos. 2–3 (summer–autumn 1996): 103–140.

Jacquette
Berlind, Robert. "Eye in the Sky – Yvonne Jacquette Paints Expansive Aerial Views of Cities around the World." *Art in America* 92, no. 3 (2004): 104ff.
Faberman, Hilarie; Berkson, Bill; Katz, Vincent; and Fraise, Jeanne W. *Aerial Muse: the Art of Yvonne Jacquette.* New York and Stanford, Calif.: Hudson Hills Press and Iris B. Gerald Cantor Center for the Visual Arts at Stanford University, 2002.
Ratcliff, Carter. *Yvonne Jacquette: Paintings, Frescoes, Pastels, 1988–1990.* New York and San Francisco: Brooke Alexander and John Berggruen Gallery, 1990.
Yvonne Jacquette: Recent Drawings and Pastels, 1982–83. St. Louis: City Art Museum, 1984.

Johnson
Baur, John I.H. "'…the exact brushwork of Mr. David Johnson,' An American Landscape Painter, 1827–1908." *American Art Journal* 12, no. 4 (autumn 1980): 1–6.
_____. and Conrads, Margaret C. *Meditations on Nature: the Drawings of David Johnson.* Yonkers, N.Y.: Hudson River Museum, 1987.
Owens, Gwendolyn. *Nature Transcribed: The Landscape and Still Lifes of David Johnson (1827–1908).* Ithaca, N.Y.: Herbert F. Johnson Museum of Art, Cornell University, 1988.

Kahn
Novak, Barbara and Kahn, Wolf. *Wolf Kahn Pastels.* New York: Harry N. Abrams, 2000.
Wolf Kahn: 50 Years of Pastels. Charlotte, N.C.: Jerald Melberg Gallery, 2000.
Wolf Kahn, Continuity and Change: Paintings and Works on Paper 1958–66/2000–03. New York: Ameringer Yohe Fine Art, 2003.
Wolf Kahn, New Paintings and Pastels. New York: Grace Borgenicht Gallery, 1991.

Kensett
Driscoll, John Paul. *John F. Kensett Drawings.* University Park, Pa. and New York: Museum of Art, Pennsylvania State University and Babcock Galleries, 1978.
_____; and Howat, John K., et al. *John Frederick Kensett: An American Master.* New York and London: Worcester Art Museum and W.W. Norton and Company, 1985.

Kent
Adams, Henry. "Rockwell Kent's Illustrations for *Moby Dick.*" *Rockwell Kent Collector* XIX, no. 1 (summer 1992): 3–8; and XIX, no. 2 (fall 1992): 3–8.

Johnson, Fridolf and Gorton, John F.H. *The Illustrations of Rockwell Kent.* New York: Dover Publications, 1976.
Kent, Rockwell. *This is My Own.* New York: Duell, Sloan and Pearce, 1940.
_____. *It's Me O Lord: The Autobiography of Rockwell Kent.* New York: Dodd, Mead and Co., 1955.
Melville, Herman (illustrated by Rockwell Kent). *Moby Dick or the Whale.* New York: Random House, 1930.
Traxel, David. *An American Saga: The Life and Times of Rockwell Kent.* New York: Harper & Row, 1980.

Kienbusch
Belanger, Pamela J.; Hoopes, Donelson F.; Larsen, Susan C.; and William, Carl Little. *Kienbusch: A Retrospective Exhibition, 1946–1979.* Rockland, Maine: Farnsworth Art Museum, 1996.
Moore, Marianne. *William Kienbusch.* New York: Kraushaar Galleries, 1963.
William Kienbusch and an Artistic Dialogue. New York: Kraushaar Galleries, 1997.
Yau, John. *William Kienbusch.* Waterville, Maine: Colby College, 1981.

Kollner
Kollner, Augustus. *Common Sights on Land and Water.* Philadelphia: American Sunday School Union, 1852.
_____. *Country Sights for City Eyes.* Philadelphia: American Sunday-School Union, 1860.
_____. *Views in the United States.* New York: Goupil, Vibert & Co., 1848–1851.
Wainwright, Nicholas Biddle. "Augustus Kollner, Artist." *Pennsylvania Magazine of History and Biography* LXXXIV, no. 3 (July 1960): 325–351.

Kroll
Hale, Nancy and Bowers, Fredson. *Leon Kroll, A Spoken Memoir.* Charlottesville: University Press of Virginia, 1983.

Kuniyoshi
Goodrich, Lloyd. *Yasuo Kuniyoshi.* New York: Macmillan Co., 1948.
Yasuo Kuniyoshi. New York: American Artists Group, 1945.

Lachaise
Gaston Lachaise, 1882–1935: Sculpture and Drawings. Los Angeles: Los Angeles County Museum of Art, 1963.
Holverson, John. *Gaston Lachaise: Sculpture and Drawings.* Portland, Maine: Portland Museum of Art, 1984.
Hunter, Sam and Finn, David. *Lachaise.* New York: Cross River Press, 1993.
Nordland, Gerald. *Gaston Lachaise: The Man and his Work.* New York: G. Braziller, 1974.

La Farge
Cortissoz, Royal. *John La Farge, a Memoir and a Study.* Boston and New York: Houghton Mifflin Company, 1911.
Yarnell, James L. *John La Farge, Watercolors*

and Drawings. Yonkers, N.Y.: Hudson River Museum, 1990.

Lawson
Ernest Lawson Retrospective. New York: ACA Galleries, 1976.
Pène Du Bois, Guy. *Ernest Lawson.* New York: Whitney Museum of American Art, 1931.

Lazzell
Blanche Lazzell: American Modernist. New York: Michael Rosenfeld Gallery, 2000.
Olson, Kristina; Bridges, Robert; and Snyder, Janet. *Blanche Lazzell: The Life and Work of An American Modernist.* Morgantown: West Virginia University Press, 2004.

Lebrun
Baskin, Leonard. *Rico Lebrun, Memorial Exhibition: Paintings and Drawings.* New York: American Academy of Arts and Letters, 1966.
Oppler, Ellen C. *Rico Lebrun: Transformations/Transfiguration.* Syracuse, N.Y.: Joe and Emily Lowe Art Gallery, Syracuse University, 1983.
Rico Lebrun: Paintings and Drawings. Boston: Boston University Art Gallery, 1959.
Rico Lebrun Drawings. Berkeley: University of California Press, 1961.
Rico Lebrun: Paintings and Drawings, 1946–1961. Los Angeles: University of Southern California, 1961.
Rico Lebrun: Works on Paper: 1945–1950. Los Angeles: Mekler Gallery, 1979.
Seldis, Henry J. *Beyond Virtuosity, Rico Lebrun (1900–1964): An Exhibition of Drawings and Paintings.* Los Angeles: Los Angeles County Museum of Art, 1967.

Levine, D.
Hamill, Pete and Levine, David. *David Levine: Past and Present.* New York: Forum Gallery, 1998.

Levine, J.
Getlein, Frank. *Jack Levine.* New York: Harry N. Abrams, 1966.
Hamill, Pete. *Jack Levine at 90.* New York: D.C. Moore Gallery, 2004.
Prescott, Kenneth Wade and Levine, Jack. *Jack Levine, Retrospective Exhibition, Paintings, Drawings and Graphics.* New York: Jewish Museum, 1978.

Lipchitz
Barrio-Garay, José L. *Selected Master Drawings of Jacques Lipchitz: 1910–1958.* Athens: Trisolini Gallery of Ohio University, 1974.
Drawings of Jacques Lipchitz. New York: C. Valentin, 1944.
Hammacher, A.M. *Jacques Lipchitz* (trans. by James Brockway). New York: Abrams, 1975.
Helfenstein, Josef; Mendelson, Jordana; and Fineberg, Jonathan David. *Lipchitz and the Avant-Garde: From Paris to New York.* Champaign, Ill. and Seattle: Krannert Art Museum and Kinkead Pavilion, University of Illinois at Urbana-

Champaign with the University of Washington Press, 2002.
Lipchitz, Jacques. *My Life in Sculpture.* New York: Viking Press, 1972.
A Tribute to Jacques Lipchitz: Lipchitz in America, 1941–1973. New York: Marlborough Gallery, 1973.

Lipton
Elsen, Albert Edward. *Seymour Lipton.* New York: Harry N. Abrams, 1970.
Rand, Harry. *Seymour Lipton, Aspects of Sculpture.* Washington, D.C.: National Collection of Fine Arts and Smithsonian Institution Press, 1979.
Seymour Lipton: A Decade of Recent Work. Milwaukee: Arrow Press, 1969.
Seymour Lipton: Sculptures, Maquettes and Drawings. New York: Maxwell Davidson Gallery, 1995.
Verderame, Lori. "The Sculpture of Seymour Lipton: Themes of Nature in the 1950s." Unpublished Ph.D. dissertation, Pennsylvania State University, 1996.

Luks
Catalog of an Exhibition of the Work of George Benjamin Luks. Newark, N.J.: Newark Museum Association, 1934.
Cuba, Stanley L. "George Luks (1866–1933)," *George Luks: An American Artist.* Wilkes-Barre, Pa.: Sordoni Art Gallery, Wilkes College, 1987.
George Luks, 1866–1933: An Exhibition of Paintings and Drawings Dating from 1889–1931. Utica, N.Y.: Munson-Williams-Proctor Institute, Museum of Art, 1973.
George Luks Drawings. Bronx, N.Y.: Olana Gallery, 1970–1979.
George Luks, Expressionist Master of Color: The Watercolors Rediscovered. Canton, Ohio: Canton Museum of Art, 1994.
Huneker, James. *Bedouins.* New York: Charles Scribner's Sons, 1920.

Marin
Fine, Ruth. *John Marin.* Washington, D.C. and New York: National Gallery of Art and Abbeville Press, 1990.
_____. and Gourley, Hugh J. *The John Marin Collection of the Colby College Museum of Art.* Waterville, Maine: Colby College Museum of Art, 2003.
Norman, Dorothy, ed. *The Selected Writings of John Marin,* New York: Pellegrini & Cudahy, 1949.
Reich, Sheldon. *John Marin Drawings: 1886–1951.* Salt Lake City: Utah Museum of Fine Arts, 1969.
_____. *John Marin: A Stylistic Analysis and Catalogue Raisonné.* 2 vols. Tucson: University of Arizona Press, 1970.
Rosenfeld, Paul. "The Water-Colours of John Marin." *Vanity Fair* 18 (April 1922): 92.

Marsh
Cohen, Marilyn. *Reginald Marsh's New York: Paintings, Drawings, Prints, and*

Photographs. New York: Whitney Museum of American Art and Dover Publications, 1983.

Goodrich, Lloyd. *Reginald Marsh.* New York: Harry N. Abrams, 1972.

Laning, Edward. *The Sketchbooks of Reginald Marsh.* Greenwich, Conn.: New York Graphic Society, 1973.

Matulka

Jan Matulka. Washington, D.C.: Smithsonian Institution Press on behalf of the National Collection of Fine Arts and the Whitney Museum of American Art, 1980.

McEntee

Feldman, Sandra K. *A Selection of Drawings by Jervis McEntee from the Lockwood DeForest Collection.* New York: Hirschl & Adler Galleries, 1976.

Sweeny, J. Gray. *McEntee and Company.* New York: Beacon Hill Fine Art, 1997.

Weir, John F. "Memorial Address: Jervis McEntee, American Landscape Painter." *Liberal Review* (1891): 8.

Metcalf

Brinton, Christian. "Willard L. Metcalf." *Century Illustrated Magazine* 77 (November 1908): 155.

Chambers, Bruce W.; Boyle, Richard J.; and Gerdts, William H. *Willard Metcalf, Yankee Impressionist.* New York: Spanierman Gallery, 2003.

Miller

Carlock, Grace Miller. "William Ricarby Miller (1818–1893)." *New-York Historical Society Quarterly* 31, no. 4 (October 1947): 199–209.

Moran

Anderson, Nancy K. *Thomas Moran.* Washington, D.C. and New Haven: National Gallery of Art and Yale University Press, 1997.

Clark, Carol. *Thomas Moran: Watercolors of the American West.* Austin and Fort Worth: University of Texas Press and Amon Carter Museum of Western Art, 1980.

Dee, Elaine Evans. *The Drawings and Watercolors of the West.* New York: Washburn Gallery, 1974.

Fern, Thomas S. *The Drawings and Watercolors of Thomas Moran (1837–1926).* Notre Dame, Ind.: Art Gallery, University of Notre Dame, 1976.

Gerdts, William H. *Thomas Moran, 1837–1926.* Riverside: University of California Press, 1963.

Morand, Anne. *Thomas Moran, the Field Sketches, 1856–1923.* Norman and Tulsa: University of Oklahoma Press and Thomas Gilcrease Institute of American History and Art, 1996.

Motherwell

Arnason, H. Harvard; Ashton, Dore; and Diamonstein, Barbaralee. *Robert Motherwell.* New York: Harry N. Abrams, 1982.

Carmean, E. A. *The Collages of Robert Motherwell.* Houston: Museum of Fine Arts, 1972.

Caws, Mary Ann. *Robert Motherwell: With Pen and Brush.* London: Reaktion Press, 2003.

Flam, Jack D. *Robert Motherwell: Drawings. A Retrospective, 1941 to the Present.* Houston: Janie C. Lee Gallery, 1979.

_____. *Robert Motherwell: The Collaged Image.* Minneapolis: Walker Art Center, 1985.

_____. *Robert Motherwell: The Dedalus Sketchbooks.* New York: Harry N. Abrams, 1988.

Jeannet, Frédéric-Yves. *Motherwell: Drawings, 1951–1986.* New York: Marlborough Gallery, 1999.

Motherwell at the Columbus Museum. Columbus, Ga.: Columbus Museum, 1999.

Motherwell, Robert; Terenzio, Stephanie; and Cummings, Hildegard. *Robert Motherwell and Black.* Storrs, Conn.: William Benton Museum of Art, 1979.

O'Hara, Frank. *Motherwell.* New York: Museum of Modern Art, 1965.

Robert Motherwell. Barcelona: Fundació Antoni Tapies, 1997.

Robert Motherwell: Selected Drawings. New York: Marisa del Re Gallery in cooperation with M. Knoedler & Co., 1988.

Rosand, David. *Robert Motherwell on Paper: Drawings, Prints, Collages.* Miriam and Ira D. Wallach Gallery. New York: Columbia University, 1997.

Murch

Collischan, Judy; Cummings, Paul, et al. *Walter Murch, Paintings and Drawings.* Greenvale, N.Y.: Hillwood Art Gallery, Long Island University, 1986.

Walter Murch, a Retrospective Exhibition. Providence: Museum of Art, Rhode Island School of Design, 1966.

Myers

Artist in Manhattan. New York: American Artists Group, 1940.

Holcomb, Grant. *Jerome Myers, 1867–1940.* New York: Kraushaar Galleries, 1970.

Jerome Myers: Memorial Exhibition. New York: Whitney Museum of American Art, 1941.

Nadelman

Baur, John I.H. *The Sculpture and Drawings of Elie Nadelman, 1882–1946.* New York: Whitney Museum of American Art, 1975.

Kirstein, Lincoln. *Elie Nadelman Drawings.* New York: H. Bittner, 1949.

Nadelman, Cynthia. "Elie Nadelman's Beauport Drawings," *Drawing* VII, no. 4: 75–78.

Nadelman: Heads. New York: Zabriskie Gallery, 1980.

Schwartz, Sanford. *Elie Nadelman.* New York: Zabriskie Gallery, 1974.

Nevelson

Glimcher, Arnold B. *Louise Nevelson.* New York: Praeger, 1972.

Johnson, Una E. *Louise Nevelson: Prints and Drawings, 1953–1966.* Brooklyn, N.Y. and New York: Brooklyn Museum and Shorewood Publishers, 1967.

Noguchi

Altshuler, Bruce. *Isamu Noguchi.* New York: Abbeville Press, 1978; 2nd edn, 1994.

_____. *Isamu Noguchi.* Seattle: Bryan Ohno Editions and University of Washington Press, 2000.

Nordhausen

Schmeckebier, Laurence Eli. *The Art of A. Henry Nordhausen.* Canaan, N.H.: Phoenix Pub., 1980.

Ochtman

Larkin, Susan G. *The Ochtmans of Cos Cob: Leonard Ochtman (1854–1934), Mina Fonda Ochtman (1862–1924), Dorothy Ochtman (1892–1971), Leonard Ochtman, Jr. (1894–1976).* Greenwich, Conn.: Bruce Museum, 1989.

Ossorio

Alfonso Ossorio – Horror Vacui. Filling the Void: A Fifty-Year Survey. New York: Michael Rosenfeld Gallery, 2002.

Dubuffet, Jean. *Peintures Initiatiques d'Alfonso Ossorio.* Paris: La Pierre Volante, 1951.

Friedman, B.H. *Alfonso Ossorio.* New York: Harry N. Abrams, 1972.

Kertess, Klaus; Landau, Ellen G.; Close, Leslie Rose. *Alfonso Ossorio: Congregations.* Southampton, N.Y.: Parrish Art Museum, 1997.

O'Connor, Francis V. *Alfonso Ossorio – The Child Returns, 1950, Philippines: Expressionist Paintings on Paper.* New York: Michael Rosenfeld Gallery, 1998.

Pascin

Werner, Alfred. *Pascin.* New York: Harry N. Abrams, Inc., 1959.

_____. *Pascin: 110 Drawings.* New York: Dover Publications, 1971.

Pearlstein

Bowman, Russell. *Philip Pearlstein: The Complete Paintings.* New York: Alpine Fine Arts Collection, Ltd., 1983.

Perreault, John. *Philip Pearlstein: Drawings and Watercolors.* New York: Harry N. Abrams, 1988.

Philip Pearlstein. Athens: Georgia Museum of Art, 1970.

Philip Pearlstein: Watercolors and Drawings. New York: Allan Frumkin Gallery, 1977.

Pène Du Bois

Cortissoz, Royal. *Guy Pène Du Bois.* New York: Whitney Museum of American Art, 1931.

Fahlman, Betsy. *Guy Pène Du Bois, Artist about Town.* Washington, D.C.: Corcoran Gallery of Art, 1980.

Guy Pène Du Bois. New York: Graham Gallery, 1983.

Pennell

Pennell, Elizabeth Robins. *The Life and Letters of Joseph Pennell.* Boston: Little, Brown, 1929.

Pennell, Joseph. *The Adventures of an Illustrator, mostly in following his Authors in America and Europe.* Boston: Little, Brown, 1925.

Pennell, Elizabeth Robins and Pennell, Joseph. *French Cathedrals, Monasteries and Abbeys, and Sacred Sites of France.* New York: The Century Co., 1909.

Van Rensselaer, Mrs. Schuyler and Pennell, Joseph. *English Cathedrals.* New York: Century Co., 1892.

Pleissner

Bergh, Peter. *The Art of Ogden M. Pleissner.* Boston: D.R. Godine, 1984.

Ogden M. Pleissner, Watercolors and Oils. New Britain, Conn.: New Britain Museum of Art, 1976.

Recent Work by Ogden Pleissner. New York: Hirschl & Adler Galleries, 1972.

Pousette-Dart

Ehrhardt, Ingrid; Hilbig, Katja; and Cumbers, Pauline. *The Living Edge: Richard Pousette-Dart 1916–1992: Works on Paper.* Frankfurt am Main: Schirn Kunsthalle, 2001.

Gordon, John. *Richard Pousette-Dart.* New York: Whitney Museum of American Art and Praeger, 1963.

Hobbs, Robert Carleton and Kuebler, Joanne. *Richard Pousette-Dart.* Indianapolis: Indianapolis Museum of Art in cooperation with Indiana University Press, 1990.

Richard Pousette-Dart Drawings. New York: Andrew Crispo Gallery, 1978.

Sims, Lowery Stokes and Polcari, Stephen. *Richard Pousette-Dart (1916–1992).* New York: Metropolitan Museum of Art, 1997.

Prendergast

Clark, Carol; Mathews, Nancy Mowll; and Owens, Gwendolyn. *Maurice Brazil Prendergast, Charles Prendergast: A Catalogue Raisonné.* Williamstown, Mass. and Munich, Germany: Williams College Museum of Art and Prestel, 1990.

Milliken, William M. "Maurice Prendergast, American Artist." *The Arts* 9 (April 1962): 182.

Rhys, Hedley Howell. *Maurice Prendergast.* Cambridge, Mass.: Harvard University Press, 1960.

Sketches by Maurice Prendergast, 1899. Boston: Museum of Fine Arts, 1960.

Wattenmaker, Richard J. *Maurice Prendergast.* New York and Washington, D.C.: Harry N. Abrams and National Museum of American Art, 1994.

Richards

Ferber, Linda S. *William Trost Richards: American Landscape & Marine Painter.* New York: Garland Pub. Co., 1980.

_____. *Tokens of a Friendship: Miniature Watercolors by William T. Richards,* New York: Metropolitan Museum of Art, 1982.

_____. *Never at Fault: The Drawings of W. T. Richards.* Yonkers, N.Y.: Hudson River Museum, 1986.

_____. *Watercolors by William Trost Richards.* New York: Berry-Hill Galleries, 1989.

_____ and Welsh, Caroline Mastin. *In Search of a National Landscape: William Trost Richards and the Artists' Adirondacks, 1850–1870.* Blue Mountain Lake, N.Y.: Adirondack Museum, 2002.

Force, Debra J. and Ferber, Linda S. *William Trost Richards Rediscovered: Oils, Watercolors and Drawings from the Artist's Family.* New York: Beacon Hill Fine Art and Jill Newhouse, 1996.

Morris, Harrison S. *Masterpieces of the Sea: William T. Richards, A Brief Outline of His Life and Art,* Philadelphia: J.B. Lippincott Company, 1912.

"Mr. Richard's Works. Pencil Drawings and Small Watercolors by Him, on View at the Fogg Art Museum." *Boston Evening Transcript* (March 11, 1918): 11.

Robinson

Adams, Henry. *Boardman Robinson, American Muralist and Illustrator, 1876–1952.* Colorado Springs: Colorado Springs Fine Art Center, 1996.

Biddle, George. *Ninety-three Drawings by Boardman Robinson.* Colorado Springs: Colorado Springs Fine Arts Center, 1937.

Reed, John and Robinson, Boardman. *The War in Eastern Europe.* New York: C. Scribner's Sons, 1916.

Robinson, Boardman. *Cartoons on the War.* New York, E.P. Dutton & Company, 1915.

Roszak

Arnason, H. Harvard. *Theodore Roszak.* Minneapolis and New York: Walker Art Center in collaboration with the Whitney Museum of American Art, 1956.

_____. *Theodore Roszak: Constructivist Works, 1931–947. Paintings, Constructions, Drawings, Photograms.* New York: Hirschl & Adler Galleries, 1992.

Dreishpoon, Douglas. *Theodore Roszak: Paintings and Drawings from the Thirties.* New York: Hirschl & Adler Galleries, 1989.

Marter, Joan M. *Theodore Roszak: The Drawings.* New York and Seattle: Drawing Society and University of Washington Press, Seattle, 1992.

Theodore Roszak: Sculpture and Drawings, 1942–1963. New York: Hirschl & Adler Galleries, 1994.

Rowse

Hills, Patricia. "Gentle Portraits of the Longfellow Era: Drawings of Samuel Worcester Rowse," *Drawing* II, no. 6 (March–April 1981): 121–126.

Ruellan

Keyes, Donald, with critical essay by Marlene Park, *Andrée Ruellan.* Athens: Georgia Museum of Art, 1993.

Ladis, Andrew. "Andrée Ruellan: Ever Young," in *Andrée Ruellan at 100.* Athens, Columbus, and Savannah: Georgia Museum of Art, Columbus Museum, and Telfair Museum of Art, 2005, unpaginated.

Russell

Kushner, Marilyn S. *Morgan Russell.* New York and Montclair, N.J.: Hudson Hills Press in association with the Montclair Art Museum, 1990.

Saint-Memin

Decatur, Stephen. "Charles Balthazar Julien Févret de Saint-Memin," *American Collector* (June 1944): 9.

Miles, Ellen G. *Saint-Memin and the Neoclassical Profile Portrait in America.* Washington, D.C.: National Portrait Gallery and Smithsonian Press, 1994.

Samaras

Doty, Robert M. *Lucas Samaras.* New York: Whitney Museum of American Art, 1972.

Glenn, Constance and Jack. *Lucas Samaras: Sketches, Drawings, Doodles, and Plans.* New York: Harry N. Abrams, 1987.

Levin, Kim. *Lucas Samaras.* New York: Harry N. Abrams, 1975.

McEvilley, Thomas; Kuspit, Donald B.; and Smith, Roberta. *Lucas Samaras – Objects and Subjects, 1969–1986.* New York: Abbeville Press, 1988.

Prather, Martha. *Unrepentant Ego: Self Portraits by Lucas Samaras.* New York: Whitney Museum of American Art, 2004.

Samaras: Chairs, Heads, Panoramas. New York: Pace/MacGill and Pace Gallery Publications, 1984.

Sargent

Herdrich, Stephanie L. and Weinberg, H. Barbara. *American Drawings in the Metropolitan Museum of Art Volume 3: John Singer Sargent.* New York and New Haven: Metropolitan Museum of Art and Yale University Press, 2000.

Hills, Patricia, et al. *John Singer Sargent.* New York: Whitney Museum of American Art and Harry N. Abrams, 1986.

Little, Carl. *The Watercolors of John Singer Sargent.* Berkeley: University of California Press, 1998.

Paintings and Watercolors by John Singer Sargent, RA. Newport, R.I.: Knoedler & Co., 1933.

Prettejohn, Elizabeth. *Interpreting Sargent.* London: Tate Gallery, 1998.

Watercolors by John Singer Sargent. Pittsfield, Mass.: Berkshires Museum, 1944.

Schamberg

Agee, William C. *Morton Livingston Schamberg, The Machine Pastels.* New York: Salander-O'Reilly Galleries, 1982.

_____. *Morton Livingston Schamberg.* New York: Salander-O'Reilly Galleries, 1986.

Wolf, Ben. *Morton Livingston Schamberg: A Monograph.* Philadelphia: University of Pennsylvania Press, 1963.

Seager

Feldman, Sandra K. *The Drawings of Edward Seager.* New York: Hirschl & Adler Galleries, 1983.

Seager, E. *No. 1 of Progressive Studies of Landscape Drawing.* Boston: J.H. Bufford, 1849.

Shattuck

Adams, Nettie Wright. "A.D. Shattuck, Artist, Granby, Connecticut." *The Lure of Litchfield Hills* 27–29 (summer 1967 – spring/summer 1969), Part 1, 27: 4–7, 31–35; Part 2, 27: 27, no.14 (winter 1967–68): 20–21, 45–46; Part 3, 28, no. 1 (spring/summer 1968): 12–15, 37–39; Part 4, no. 2 (fall/winter 1968): 21–23, 34, 40, 44; and Part 5, no. 1 (spring/summer 1969): 22–23, 41.

Myers, John Walker. "Aaron Draper Shattuck, 1832–1928." Unpublished Ph.D. dissertation, University of Delaware, 1981.

Shinn

DeShazo, Edith. *Everett Shinn, 1876–1953, A Figure in his Time.* New York: C.N. Potter and Crown Publishers, 1974.

Everett Shinn, 1876–1953. Pittsburgh: Henry Clay Frick Fine Arts Department, University of Pittsburgh, 1959.

Wong, Janay. *Everett Shinn: The Spectacle of Life.* New York: Berry-Hill Galleries, 2000.

Shute

Laufer, Marilyn. *Ben Shute: The Teacher as Artist.* Athens: Georgia Museum of Art, 2002.

Silva

Frank, Peter and Silva, Jerald. *Intimate and Incorrect: Paintings in Watercolor.* Sacramento, Calif.: Solomon Dubnick Press, 1995.

Jerald Silva and His World. Sacramento, Calif.: E.B. Crocker Art Gallery, 1975.

Silverman

Sight and Insight: The Art of Burton Silverman. New York: Madison Square Press, 1998.

Sloan

Bangs, John Kendrick. *The Genial Idiot: His Views and Reviews.* New York and London: Harper & Row, 1908.

Bullard, E. John. *John Sloan and the Philadelphia Realists as Illustrators, 1890–1920.* Los Angeles: University of California Press, 1968

Elzea, Rowland and Hawkes, Elizabeth. *John Sloan: Spectator of Life.* Wilmington: Delaware Art Museum, 1988.

Goodrich, Lloyd. *John Sloan.* New York: Whitney Museum of American Art and the Macmillan Co., 1952.

John Sloan, 1871–1951. Washington, D.C.: National Gallery of Art, 1971.

Loughery, John. *John Sloan: Painter and Rebel.* New York: H. Holt, 1995.

Scott, David. *John Sloan.* New York: Watson-Guptill Publications, 1975.

Smith, D.

Clark, Trinkett. *The Drawings of David Smith.* Washington, D.C.: International Exhibitions Foundation, 1985.

Cummings, Paul. *David Smith: The Drawings.* New York: Whitney Museum of American Art, 1979.

Fry, Edward F. *David Smith.* New York: Solomon R. Guggenheim Museum, 1969.

_____ and McClintic, Miranda. *David Smith, Painter, Sculptor, Draftsman.* New York and Washington, D.C.: G. Braziller and Hirshhorn Museum and Sculpture Garden, 1982.

Merkert, Jörn; Kersting, Hannelore; and Kirby, Rachel. *David Smith, Sculpture and Drawings.* Munich: Prestel, 1986.

Wilkin, Karen. *David Smith: The Formative Years. Sculptures and Drawings from the 1930s and 1940s.* Edmonton, Alberta: Edmonton Art Gallery, 1981.

Smith, F.H.

Catalogue of an Exhibition of Watercolors and Charcoal Drawings by F. Hopkinson Smith. Buffalo, N.Y.: Fine Arts Academy, Albright Gallery, 1915.

Smith, Francis Hopkinson. *American Illustrators.* New York: C. Scribner's Sons, 1892.

_____. *Charcoals of New and Old New York.* Garden City, N.Y.: Doubleday, Page & Company, 1912.

_____. *Outdoor Sketching.* New York: Charles Scribner's Sons, 1915.

Sokolowski

Linda Sokolowski: The Graphic Works. Binghamton: University Art Gallery, State University of New York at Binghamton, 1978.

Sokolowski, Linda. "Attempts at Quiet." Unpublished M.F.A. thesis, University of Iowa, 1971.

Steinberg

Rosenberg, Harold. *Saul Steinberg.* New York: Knopf, 1978. *Saul Steinberg – The Catalogue: A Selection of Drawings.* Cleveland: World Pub. Co. 1962.

Steinberg 1953. Paris: Maeght, 1953.

Stella

Baur, John I.H. *Joseph Stella.* New York: Praeger, 1971.

Haskell, Barbara. *Joseph Stella.* New York: Whitney Museum of American Art and Harry N. Abrams, 1994.

Moser, Joann. *Visual Poetry: The Drawings of Joseph Stella.* Washington, D.C.: Smithsonian Institution Press on behalf of the National Museum of American Art, 1990.

Rose, Barbara and Eaton, Timothy A. *Joseph*

Stella: Flora. West Palm Beach, Fla.: Eaton Fine Art, 1997.

Stevens

Chambers, Bruce W. "Will Henry Stevens (1881–1949)," in *Art and Artists of the South: The Robert P. Coggins Collection.* Columbia: University of South Carolina Press, 1984.

Lemann, Bernard. "Will Henry's Nature: The Pictorial Ideas of W.H. Stevens," unpublished manuscript. Howard Tilton Memorial Library, Tulane University, 1947–1948.

Poesch, Jessie. *Will Henry Stevens.* Greenville, S.C.: Greenville County Museum of Art, 1987.

Stillman

Ary Stillman. Houston, Tex.: Stillman-Lack Foundation, 1967.

Hirsch, Richard Teller. *Ary Stillman, 1891-1967.* Houston, Tex.: Museum of Fine Arts, 1972.

Suba

Miklos Suba. Kalamazoo, Mich.: Kalamazoo Institute of Arts, 1964.

Miklos Suba: Line by Line, a Portfolio of Brooklyn Drawings. New York: James Graham & Sons, 2001.

Takal

Goll, Yvan. *Takal: Dessins, 1930–1990.* Geneva: Galerie Editart D. Blanco, 1990.

Roditi, Edouard. *Peter Takal: Selected Works.* New York: International University Press, 1945.

Takal, Peter and Ishikawa, Joseph. *About the Invisible in Art* [reprinted from lecture at American Federation of Arts, New York]. Beloit, Wisc.: Theodore Lyman Wright Art Center, Beloit College, 1965.

Wolfe, Townsend. *Peter Takal on Paper.* Little Rock: Arkansas Arts Center, 2000.

Tchelitchew

Kirstein, Lincoln. *Pavel Tchelitchew Drawings.* New York: Hacker Art Books, 1970.

Tyler, Parker. *The Divine Comedy of Pavel Tchelitchew, a Biography.* New York: Fleet Publishing Corporation, 1967.

Thayer

White, Nelson C. *Abbott H. Thayer, Painter and Naturalist.* Hartford, Conn.: Connecticut Printers (revised edition), 1967.

Thomas, A.

Foresta, Merry A. *A Life in Art: Alma Thomas, 1891–1978.* Washington, D.C.: National Museum of American Art, 1981.

Thomas, H.

Engelhardt, Myra L. *Red Rising: The Transcendent Paintings of Howard Thomas.* Gainesville, Fla.: Samuel P. Harn Museum of Art, 1995.

Howard Thomas: A Retrospective Exhibition. Atlanta: High Museum of Art, 1967.

Lynes, Gary Lamar. "Howard Thomas: the Formation of a Style." Unpublished M.A.

thesis, Vanderbilt University, 1976.

Treiman

Drawings by Joyce Treiman. Chicago: Art Institute of Chicago, 1979.

Duncan, Michael. *Drawing Attention: Treiman on Paper.* New York and Rock Island, Ill.: Schmidt-Bingham Gallery and Augustana Art Gallery, 2001.

Duncan, Michael and Wolff, Theodore F. *Joyce Treiman.* New York: Hudson Hills Press, 1997.

Longman, Lester Duncan and Bloch, E. Maurice. *Joyce Treiman.* Los Angeles: Hennessey and Ingalls, 1978.

Twachtman

John Henry Twachtman: A Retrospective Exhibition. Cincinnati: Cincinnati Art Museum, 1966.

_____. *John Henry Twachtman: An American Impressionist.* Atlanta and New York: High Museum of Art and Hudson Hills Press, 1999.

Peters, Lisa N. "John Twachtman (1853-1902) and the American Scene in the Lathe Nineteenth Century: The Frontier within the Terrain of the Familiar." 2 vols. Unpublished Ph.D. dissertation, City University of New York, 1995.

Spanierman, Ira. *John Henry Twachtman, 1853–1902: An Exhibition of Paintings and Pastels.* New York: Spanierman Gallery, 1968.

Valerio

Heartney, Eleanor. "Valerio's Allegorical Realism." *Art in America* 92, no. 1, (2004): 92ff.

James Valerio: Drawings. New York: George Adams Gallery, 2001.

Vedder

Dillenberger, Jane. *Between Faith and Doubt: Subjects for Meditation, Perceptions and Evocations: The Art of Elihu Vedder.* Washington, D.C.: Smithsonian Institution Press, 1979.

Drawings by Elihu Vedder. New York: Kennedy Galleries, 1979.

Elihu Vedder, 1836–1923: Paintings and Drawings. Glens Falls, N.Y.: Hyde Collection, 1975.

Soria, Regina. *Paintings and Drawings by Elihu Vedder.* Washington, D.C.: Smithsonian Institution, 1966.

_____. *Elihu Vedder: American Visionary Artist in Rome.* Rutherford, N.J.: Farleigh Dickinson University Press, 1970.

Walkowitz

Abraham Walkowitz: One Hundred Drawings. New York: B.W. Huebsch, 1925.

Smith, Kent. *Abraham Walkowitz, Figuration 1895–1945.* Long Beach, Calif.: Long Beach Museum of Art, 1982.

Zabriskie, Virginia and Homer, William Innes. *Abraham Walkowitz: Watercolors from 1905 through 1920 and other Works on

Paper.* New York: Zabriskie, 1994.

Wall

Comstock, Helen. "The Connoisseur in America: The Watercolors of William Guy Wall." *The Connoisseur* 120, no. 505 (September 1947): 38–44.

Kugler, Richard C. *William Allen Wall, an Artist of New Bedford.* New Bedford, Mass.: Old Dartmouth Historical Society, 1978.

Miller, Angela L. "American Expansionism and Universal Allegory: William Allen Wall's Nativity of Truth." *New England Quarterly* 63, no. 3 (September 1990): 446–467.

Shelley, Donald A. "William Guy Wall and His Watercolors for the Historic *Hudson River Portfolio.*" *New-York Historical Society Quarterly* 31, no. 1 (October 1947): 25–45.

West

Abrams, Ann Uhry. *The Valiant Hero: Benjamin West and Grand-style History Painting.* Washington, D.C.: Smithsonian Institution Press, 1985.

Alberts, Robert C. *Benjamin West: A Biography.* Boston: Houghton Mifflin, 1978.

Benjamin West, 1738–1820. Philadelphia: Philadelphia Museum of Art, 1938.

Exhibition of Paintings and Drawings by Benjamin West and Engravings Representing His Work. Brooklyn, N.Y.: Brooklyn Museum, 1922.

Evans, Dorinda. *Benjamin West and His American Students.* Washington, D.C.: National Portrait Gallery and Smithsonian Institution Press, 1980.

Kraemer, Ruth S. *Drawings by Benjamin West and His Son, Raphael Lamar West.* New York: Pierpont Morgan Library, 1975.

Morgan, Charles H. and Toole, Margaret C. *Benjamin West: His Times and His Influence.* Springfield, Mass.: Art in America, 1950.

Staley, Allen. *Benjamin West, American Painter at the English Court.* Baltimore: Baltimore Museum of Art, 1989.

Staley, Allen and von Erffa, Helmut. *The Paintings of Benjamin West.* New Haven and London: Yale University Press, 1986.

Weintraub, Stanley and Plogg, Randy. *Benjamin West Drawings from the Historical Society of Pennsylvania.* College Park, Pa.: Palmer Museum of Art, 1987.

Wilde

John Wilde: Drawings, 1940–1984. Madison, Wisc.: Elvehjem Museum of Art, University of Wisconsin-Madison, 1985.

Yapelli, Tina and Wilde, John. *Eros and Thanatos.* Madison, Wisc.: Madison Art Center, 1993.

Wiles

Irving Ramsey Wiles. New York: Chapellier Galleries, 1967.

Paul, William D. *The Art of Irving Ramsey

Wiles.* St. Joseph, Mo.: Albrecht Gallery and Museum of Art, 1971.

Wiley

Richardson, Brenda. *WIZDUMB: William T. Wiley.* Berkeley: University Art Museum, Berkeley, 1971.

Sultan, Terrie and French, Christopher C. *William T. Wiley: Struck! Sure? \Sound/Unsound.* Washington, D.C.: Corcoran Gallery of Art, 1991.

William T. Wiley. Shawnee Mission, Kans.: Morgan Gallery, 1982.

William T. Wiley. Vancouver and New York: Charles H. Scott Gallery and Allan Frumkin Gallery, 1981.

William T. Wiley: What is Not Drawing? Venice, Calif.: L.A. Louver, 1987.

Wujcik

Kramer, Hilton. "American Drawings of the 1970s at Brooklyn." *New York Times* (November 28, 1980): C1.

Miller, Margaret. *Theo Wujcik: 30-year Retrospective.* Largo, Fla.: Gulf Coast Museum of Art, 2000.

Wyeth

Andrew Wyeth: Temperas, Water Colors, and Drawings. Buffalo, N.Y.: Albright-Knox Art Gallery and Buffalo Fine Arts Academy, 1962.

Corn, Wanda. "Andrew Wyeth: The Man, His Art and His Audience." Unpublished Ph.D. dissertation, Institute of Fine Arts, New York University, 1974.

Hoving, Thomas. *Two Worlds of Andrew Wyeth: A Conversation with Andrew Wyeth.* Boston: Houghton Mifflin, 1978.

Richardson, Edgar Preston and Wyeth, Andrew. *Andrew Wyeth: Temperas, Watercolors, Dry Brush, Drawings, 1938 into 1966.* Philadelphia: Pennsylvania Academy of the Fine Arts, 1966.

Zorach, M.

Hoffman, Marilyn Friedman. *Marguerite and William Zorach: The Cubist Years, 1915–1918.* Manchester, N.H.: Currier Gallery of Art, distributed by University Press of New England, 1987.

Marguerite Zorach: The Early Years, 1908–1919. Washington, D.C.: National Collection of Fine Arts and the Smithsonian Institution Press, 1973.

Marguerite Zorach, Cubism and Beyond. New York: Kraushaar Galleries, 1991.

Nicoll, Jessica; Tarbell, Roberta K.; and MacDougal, Margaret. *Marguerite and William Zorach: Harmonies and Contrasts.* Portland, Maine: Portland Museum of Art, 2001.

Tarbell, Roberta K. *Marguerite Zorach: The Early Years, 1908–1920.* Washington, D.C.: National Collection of Fine Arts, 1973.

Tarbell, Roberta K. *William and Marguerite Zorach: The Maine Years.* Rockland, Maine: William A. Farnsworth Library

and Art Museum, 1980.

Zorach, W.

Nicoll, Jessica; Tarbell, Roberta K.; and MacDougal, Margaret. *Marguerite and William Zorach: Harmonies and Contrasts.* Portland, Maine: Portland Museum of Art, 2001.

William Zorach: Fifty Years of Watercolors. New York: Bernard Danenberg Galleries, 1970

William Zorach: Memorial Exhibition; Sculpture, Drawings and Watercolors. New York: American Academy of Arts and Letters, 1969.

Zorach, William. *Art is My Life: An Autobiography of William Zorach.* Cleveland and New York: World Publishing Company, 1967.

INDEX

Numbers in bold refer to catalogue numbers

Photographic Acknowledgments

© 2006 Artists Rights Society (ARS), New
York: p. 119
© 2006 Milton Avery Trust / Artists Rights
Society (ARS), New York: pp. 135, 190
Art © T.H. Benton and R.P. Benton
Testamentary Trusts/UMB Bank
Trustee/Licensed by VAGA, New York,
NY: pp 11 (Fig. 12), 149
Art © Estate of Peter Blume/Licensed by
VAGA, New York, NY: p. 162
Art © Dedalus Foundation, Inc./Licensed by
VAGA, New York, NY: pp. 15 (Fig. 19),
198, 200, 201
© 2006 Estate of Jay DeFeo / Artists Rights
Society (ARS), New York: p. 217
Art © Estate of Burgoyne Diller/Licensed by
VAGA, New York, NY/Est. Represented
by the Michael Rosenfeld Gallery: pp. 178,
179 (Fig. 94)
Art © John Himmelfarb/Licensed by VAGA,
New York, NY: pp. 228, 229
© 2006 Estate of Hans Hofmann / Artists
Rights Society (ARS), New York: p. 125
Art © Wolf Kahn/Licensed by VAGA, New
York, NY: p. 230 (Fig. 123)
Art © Estate of Yasuo Kuniyoshi/SPDA,
Tokyo/VAGA, New York: p. 167
Art © Jack Levine/Licensed by VAGA, New
York, NY: p. 168 (Fig. 89)
© Estate of Jacques Lipchitz/Courtesy of
Marlborough Gallery, New York: p. 131
© 2006 Estate of John Marin / Artists Rights
Society (ARS), New York: pp. 17 (Fig. 21), 93
© 2006 Estate of Reginald Marsh / Art
Students League, New York / Artists
Rights Society (ARS), New York: p. 170
© 2006 Estate of Louise Nevelson / Artists
Rights Society (ARS), New York: p. 126
(Fig. 76)
Art © Estate of Theodore Roszak/Licensed by
VAGA, New York, NY: p186, 187
Art © Burton Silverman/Licensed by VAGA,
New York, NY: p. 209
Art © Estate of David Smith/Licensed by
VAGA, New York, NY: p. 188
© Andrew Wyeth: p. 165
© 2006 The Saul Steinberg Foundation /
Artists Rights Society (ARS), New York:
p. 24 (Fig. 27)
Courtesy of the Tate Gallery, London: p. 28
(Fig. 32)
Courtesy of the National Portrait Gallery,
London: p. 28 (Fig. 33)